Be Seeing You ...

For my mother and father and my daughter Awena

Be Seeing You ...

Decoding the Prisoner

Chris Gregory

UNIVERSITY

UP of

LUTON PRESS

British Library Cataloguing in Publication Data
A catalogue record for this book is available from the British Library

ISBN: 1 86020 521 6

Published by
John Libbey Media
Faculty of Humanities
University of Luton
75 Castle Street
Luton
Bedfordshire LU1 3AJ
United Kingdom
Tel: +44 (0) 1582 743297; Fax: +44 (0) 1582 743298
e-mail: ulp@luton.ac.uk

Cover Design by Peter Corri
Typeset in Sabon and Village (*The Prisoner* typeface, a version of Albertus,
see page 43)
Printed in Hong Kong by Da Hua Printing Co Ltd

Contents

Acknowledgements

Thanks to John-Paul Wayfare for his help and encouragement with this book, Taffy Davies for the loan of invaluable research material, Laurence Rogerson for helping me 'surf the net', Darryl Spears for some initial inspiration, Katrina Millhagen and Leif Christensen for German translations, Satori for some useful suggestions, Carol Burns and Mike Hughes for support when it was needed, the Goethe Institut for locating 'Hammer Into Anvil', and to all my fellow 'prisoners', especially Di, Connal, Jacqui, Jess, Kyran, Tamsin, Yarrow, Ian, Kerri, Sherry, Sue, Mike, Dawn, Nixie, Marlon, Shey, Jeff, Barry, Martin, Kathy, Charlie, Pamela, Karen, Jonathan, Mark, Nikki and Andy ...

The following songs are quoted in the text:
Desolation Row and *It's Alright Ma, I'm Only Bleeding* – copyright Bob Dylan 1965.
All You Need Is Love – copyright John Lennon and Paul McCartney 1967.
Thunderball – copyright Don Black and John Barry 1965.

'Six Of One', *The Prisoner* Appreciation Society, are currently based at P.O. Box 66, Ipswich, IP 9TZ, England.

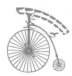

Introduction

What was your Question?

PRISONER: Where am I?
NUMBER 2: In the Village ...
PRISONER: What do you want?
NUMBER 2: Information ...
PRISONER: You won't get it!
NUMBER 2: By hook or by crook, we will!
PRISONER: Whose side are you on?
NUMBER 2: That would be telling ...
 The Prisoner opening sequence.

The initial screening of *The Prisoner* in 1967/68 represented an extraordinary moment in the history of modern popular culture – what purported to be a mass-audience adventure series transformed itself, before the viewers' eyes, first into a surreal political and social satire, then an intense study of psychological depths and finally into a symbolic statement of the human condition. Yet the series was able to generate enough excitement, controversy and most importantly, mystery, to hold a mass audience right up to its final episode. Almost thirty years later interest in the series (as witnessed by its continued re-runs, its release on video, its eccentric Appreciation Society and the influence of its imagery on advertising) highlights not only its status as a 'classic text' of television but also the continued relevance of the questions it poses.

There are a number of important questions in *The Prisoner*, many of which were crucial to keeping the mass audience intrigued as the series devel-

oped. *Where* exactly is the mysterious Village in which our hero is impris-
oned? *Whose* side, East agent? *What* is the Prisoner's name? *Will* he escape?
And, most importantly, Who is the apparently omniscient, all-powerful con-
troller of the Village, Number 1? Part of what kept the mass audience glued
to the programme was a desire to find an answer to these questions. Yet none
were ever answered by the series, at least in the terms the majority of the
audience expected. When the final episode, 'Fall Out', was transmitted, the
refusal to provide a 'conventional' ending which would 'explain' the mys-
teries caused widespread incomprehension and outrage. But, as Patrick
McGoohan insisted in a 1983 interview:[1]

> ... it was an allegory. An allegory I think is defined as a story in which
> things, people, places, happenings, conceal a reason or a symbolism.

Certainly it is easy for the 'sophisticated' viewer of today to see that *The
Prisoner* is not a 'realist' drama. Reading the series on an allegorical level, it
is possible to see it as being a dream, a hallucination, a vision, and to con-
ceive of all the events as occurring within the Prisoner's mind. Yet this only
provokes more difficult questions. Namely, what does the Village *represent*?
What is the series telling us about the place of the individual, the rebel, the
iconoclast, in a society in which technology gives the powers-that-be the abil-
ity to control and tame the independent spirit? This book is firstly an attempt
to answer some of these questions. In Part One: '*The Prisoner* As Television
Text', I have begun by examining how *The Prisoner* uses the narrative and
visual conventions of popular film and television genres to achieve the loy-
alty of the mass audience. I have gone on to explore parallels and differences
with other (superficially) similar genre products of the 1960s and have
attempted to explain the conditions of production which led to Patrick
McGoohan being given a unique chance in the television context to take
'authorial' control over the series and to turn it into a vehicle for his own
very personal vision. I have also discussed the cinematic and theatrical qual-
ities of the series and its approach to language.

Part Two: '*The Prisoner* As Allegory', consists of a detailed study of the
series, which attempts to decode the implied political and social satire in
many of the episodes and to trace the development of its allegorical message.
In doing so my intention is also to identify the qualities that mark *The
Prisoner* out as a 'classic' television text, one of the small number of televi-
sion shows that has really used and stretched the possibilities of the medium.

In Part Three: '*The Prisoner* Today', there is an examination of gender-
relations within the series, together with some thoughts on its status as both
cultural artifact and consumer item in today's 'video age'. I have tried to take
some measure of the influence *The Prisoner* has had on popular culture in

1 Patrick McGoohan, from an interview in *Six Of One: The Prisoner File*, Channel 4
 Documentary (1984).

the years since it was first shown, and have focused through the series on the differences between the viewer's experience of television today as compared to that of three decades ago. I have also examined the series as a work of 'prophecy' and looked at the relevance of its message to today's society. Thus, this book is not only about *The Prisoner* but is also an examination of the wider cultural status of television, its potential as an art form, its 'mythological' and 'ritual' status and how it differs in its communicative modes from literature and the cinema.

Part One
The Prisoner as Television Text

Once Upon a Time
The Uses of Genre in The Prisoner

The adventure of the hero represents the moment in his life when he achieved illumination – the nuclear moment when, while still alive, he found and opened the road to the light beyond the dark walls of our living death.
 Joseph Campbell *The Hero With The Thousand Faces*[1]

PRISONER: I'm not for hire.
JUDGE: You've turned in your badge.
PRISONER: And my gun ...
 From 'Living In Harmony'

In *The Prisoner*, Patrick McGoohan plays an intricate game with his audience. He invites them to share in the vicarious 'thrills' of the action adventure, secret agent and science fiction genres, whilst confronting them with a series of political, psychological and philosophical concerns. In the fusion of these elements he poises the relationship between reality and fantasy, and between significance and pure escapism. on a knife-edge. In order to examine the way in which the series achieves its effects an important first step is to look at the nature of *The Prisoner* as a genre product, and

1 Joseph Campbell, *The Hero With A Thousand Faces*, p.259.

to identify the features that distinguish it from other mainstream genre products of its day.

Genre products have always dominated popular film and television culture. The reasons for this are partly economic in origin – film and television both require considerable financial investment and backers are far more likely to favour an established form such as a Western, a horror story or a detective thriller, which has a proven audience, than any piece with a non-genre narrative. This is particularly true in modern Hollywood filmmaking, where the most successful films (eg *Jaws, Star Wars, Raiders Of The Lost Ark, Home Alone, Batman*) will generate any number of sequels. But there is also no doubt that genre products are more appealing to a mass audience than non-genre products. The audience can lose itself in the fantasy world of an established genre like horror or the Western, can imagine itself being pursued by the dinosaurs in *Jurassic Park* or the Daleks in *Dr Who*, yet the 'thrills' experienced will ultimately be 'safe' as viewers knows that the figure of sympathy they are identifying with will inevitably survive and triumph.

In many ways modern genre products replicate the function of traditional stories and myths in pre-literate societies – confronting individuals with archetypal dangers in a secure setting (with the cinema seat or home sofa substituting for the traditional fireside), so that they can cope psychologically with living in a world full of death, danger and tragedy. Traditional folk tales and fairy stories can themselves be considered genre products, and it is thus not surprising that they have provided the plots of many extremely popular cinema and television productions. The Disney empire, for example, is almost entirely built on its retelling of traditional stories, from *Snow White and The Seven Dwarfs* to *Aladdin*. Many Hollywood 'blockbusters' of the modern era, such as the *Star Wars* series, have included strong folktale elements.

In his pioneering work of structural analysis, *Morphology Of The Russian Folktale*,[2] Vladimir Propp discovered that the hundreds of traditional stories he studied all contained a similar basic narrative structure; characteristically being based on a male hero figure who, often with the assistance of some 'mystical' helper (usually an old man), and a 'magical agent' of some kind, sets out on a quest which involves him defeating a villain and then returning home in triumph. The *Star Wars* saga, which begins with the words: 'A Long Time Ago in a Galaxy Far Away'[3] presents us with such a story, featuring a young hero (Luke Skywalker) who fights with an Excalibur-like laser sword, a princess in distress (Princess Leia), an archetypal 'dark' villain (Darth Vader) and a Merlin-like magical adviser (Ben Obi-Wan Kenobi). As Propp pointed out, characters in the different folktales, although superficially variable, often had similar functions in terms of their role in the story's development. This can also be seen to be true in many

2 Vladimir Propp, *Morphology Of The Russian Folktale.*
3 Quoted from the opening credits of *Star Wars* (directed by George Lucas, 1977).

popular genres, where again character is typically sublimated to plot. In a horror film (particularly 'cheapies' of the late-night variety) it is frequently easy to recognise a potential 'victim' by the role they play in the story. Such moments of recognition are crucial to generic storytelling, which works essentially with elements that the audience recognises from previous stories. The audience is thus assumed to have an inbuilt knowledge of the narrative codes which the particular type of genre product displays.

Genres such as horror, the Western and science fiction are most frequently criticized for their lack of 'realism'. But the often fantastical events that take place in genre stories can be understood as attempts to create not a physical but a psychological reality. Characters, events and settings thus have an inbuilt symbolic significance. In this way the genre product appropriates some of the power of the traditional story. As Joseph Campbell has commented:[4]

> ... it is the business of mythology proper, and of the fairytale, to reveal the specific dangers and techniques of the dark interior way from triumph to tragedy. Hence the incidents are fantastic or 'unreal'- they represent psychological, not physical, triumphsin dream-like figurations ... the passage of the mythological hero may be overground ... [but] ... fundamentally it is inward – into depths where obscure resistances are overcome, and long lost, forgotten powers are revivified, to be made available for the transfiguration of the world.

The figure of the hero is central to both traditional stories and genre products, providing a focus for the audience's psychological identification. Traditional stories and genre narratives are characteristically built around one central character and very often bear the name of that character – be it *Beowulf*, *Batman* or *The Terminator*. The hero's quest also follows a typical pattern:[5]

> A hero ventures forth from the world of common clay into a region of supernatural wonder: fabulous forces are there encountered and a decisive victory is won: the hero comes back from this mysterious adventure with the power to bestow boons on his fellow man.

Campbell identifies the standard path of what he calls this 'monomyth' in three stages:

(1) *Separation* – from the 'normal' world into the supernatural.

(2) *Initiation* – during which the hero resists various temptations and overcomes various obstacles, eventually achieving some kind of power.

4 Joseph Campbell, *The Hero With A Thousand Faces*, p.29.
5 Joseph Campbell, *The Hero With A Thousand Faces*, p.30.

(3) *Return* – the hero triumphs and returns, to bring great benefits to his society.

The mythological hero is thus invariably a person who possesses exceptional personal gifts, who is always resourceful and ready to overcome any obstacle. The Prisoner himself is one such hero. At various times in the series he is shown to be almost endlessly inventive. In 'Many Happy Returns' he builds a raft with his bare hands and sails it back to England. He is revealed to be an artist (in 'The Chimes Of Big Ben'), a hypnotist ('A Change Of Mind'), a fencing and boxing champion ('Schizoid Man'), and an expert gunfighter ('Living In Harmony'). Throughout the series he demonstrates his tremendous physical and psychological strengths. Like Campbell's hero he is separated from his 'normal' world by his abduction after his resignation. The new world of the Village which he is initiated into is every bit as fantastical as the dragon and wizard-inhabited worlds of many traditional stories. The setting of the polyglot architectural fantasy of Portmeirion on the Welsh Coast; together with the bizarre, brightly-coloured costumes and surreal objects such as the Penny-Farthing bicycle which is the main symbol of the Village and 'Rover', the strange white ball which captures and smothers possible escapees or transgressors; all place the story in a dream-like fantasy world.

It could certainly be argued that at the end of the series the Prisoner does 'return' and bring the benefit of his knowledge to society. But this is only one of a number of apparently equally valid interpretations, whereas in a typical genre product of its time the ending would be likely to be clear-cut, unambiguous and representative of a clear moral view. It is worth mentioning that the series does include three 'false returns' (in 'The Chimes Of Big Ben', 'Many Happy Returns' and 'Do Not Forsake Me Oh My Darling') where the Prisoner has apparently, in some sense, already 'escaped'. But in each case he only ends up back in the Village, with the bars slamming over his face to announce the final credits as usual.

Like the hero of the traditional tale, the Prisoner's fundamental quest is an inward one. His triumphs, when they do occur; as in the end of 'The General' where he destroys the Village computer with the unanswerable question ... Why? ... and at the climax of 'Hammer Into Anvil' where he reduces Number 2 to a quivering wreck; are essentially psychological triumphs. The main purpose of the Controllers of the Village throughout the series is to break his spirit, and he has to rely on his fantastical, heroic inner strength to fight them. Even the forced administration of hallucinogenic truth drugs in episodes such as 'A, B and C', 'A Change Of Mind', 'Once Upon A Time' and others cannot make him talk. Throughout the series the Controllers try time and time again to make him tell them why he resigned, a piece of information which might not seem of the greatest importance to an organisation like the Village, and which arguably becomes more and more irrelevant as the series progresses. But in their continual posing of the question, the Controllers are trying to gain access to his private thoughts and

feelings, and these he will steadfastly never reveal. As he frequently tells them, 'my life is my own'.

Like Jesus, Buddha or Shakespeare's Hamlet (heroes all) the Prisoner's inner struggles represent the archetypal conflicts and temptations that each individual goes through in order to withstand the slings and arrows of outrageous fortune.[6] When Hamlet declares Denmark's a prison,[7] 'Denmark', like the Village, is essentially a state of mind. Mythological elements and generic codes are used in the series to focus on universal human dilemmas, and the Prisoner himself is an 'Everyman' figure, whose 'nameless' quality serves to further underline the fact that his experience stands for that of us all. (The assumption that a male character can be presented as a representative figure for both sexes is, however, a problematical one; the implications of which are discussed in greater depth in the section on gender-relations in the series in Chapter 9.)

Like Propp's folktales or Campbell's myths, genre products tend to follow an established narrative pattern or formula – a structured series of actions that results in a predictable or familiar ending or 'closure'. The basic conflict (which is invariably between good and evil) is familiar from past viewing. Within the formula there are narrative conventions – specific units of narrative such as the showdown in the Western or the 'love duet' in the musical- which recur time and time again, often in remarkably similar detail. There are also formal conventions – particular styles of camerawork, lighting, editing, dress or scenery- the presence of which creates meaning in a particular way for the audience. Fast editing in action/adventure or shadowy lighting in horror are two examples. Genre products also rely on the use of iconography. Icons are smaller elements still – specific objects, clothes or elements of design which the audience is familiar with from previous viewing experience, and which carry a particular resonance or meaning. Charlie Chaplin's hat and cane, Woody Allen's glasses and Bogart's cigarette are classic examples from the movies. Performers themselves – especially those Hollywood stars (like Monroe, Schwarzenegger, Wayne, Stallone, Eastwood) who tend to use the same persona repeatedly can themselves come to be regarded as icons. The iconography of The Prisoner – such as the bizarre 'uniforms' of the Villagers, devices like the white balloon 'Rover', Number 2's automatic chair, and the ubiquitous Penny-Farthing symbol, is the element of the series which often sticks in viewers' minds the most.

In *The Prisoner*, the audience is presented with all the outward appearances of the genre product. The secret agent genre is most prominent. Like James Bond, who is also frequently captured by his enemies, the Prisoner is a top-level agent for the British government. He is captured by an unknown organisation which, it seems, may be working in the service of either East or West. Given who the Prisoner is, it appears at first most likely that the

6 William Shakespeare, *Hamlet*, Act III Scene I, line 58.
7 William Shakespeare, *Hamlet*, Act II Scene II, line 243.

Village is run by the Eastern bloc. When the Prisoner first enters the Village shop in the opening episode 'Arrival' he overhears some Villagers speaking in what sounds like an Eastern European language. As soon as they see him they change abruptly into English. In the course of the episode he meets Cobb, a former colleague in the British secret service, who turns out to be part of the conspiracy against him. At the end of the episode Cobb departs with ... Mustn't keep my new masters waiting ... suggesting, perhaps, that he has defected. In the second episode, 'The Chimes Of Big Ben', the Prisoner apparently escapes from the Village with a woman called Nadia, who we are led to believe is a former Soviet agent. We are also told that the Village is in Lithuania. But the supposed 'escape' turns out to be a deception – the Prisoner has never actually left the Village. At the end of the episode, two of his former superiors (The Colonel and Fotheringay) are clearly shown to be in its service . So we may now suspect that the Village is run by 'our side'. In 'Many Happy Returns', when our hero makes his first 'real' escape, he has problems convincing his former bosses that his story about the Village is true:

COLONEL: You see, we have a problem. Tell him our problem, Thorpe.

THORPE: You resign. You disappear. You return. You spin a yarn that Hans Christian Andersen would reject for a fairytale.

COLONEL: And we must be sure. People defect. An unhappy thought, but a fact of life. They defect, from one side to the other.

PRISONER: I also have a problem ... I'm not sure which side runs this Village.

COLONEL: A mutual problem.

PRISONER: Which I'm going to solve.

COLONEL: Quite.

PRISONER: If not here, then elsewhere ...

As the series progresses it becomes more likely that the Village is a 'third force', independent of East or West, yet ultimately threatening both; a powerful, secret organisation whose tentacles spread out across the globe; so powerful that it is even prepared, in 'Many Happy Returns', to let the Prisoner escape to London, knowing that he can easily be returned to the Village. The idea of such an organisation was already an established convention within the spy genre. James Bond's principal opponents in most of his films were SPECTRE, a world-wide criminal 'corporation' led by the sadistic, cat-stroking 'evil genius' Ernst Stavro Blofeld, portrayed memorably by Donald Pleasance in You Only Live Twice. In the American television series The Man From U.N.C.L.E., the heroes were an American (Napoleon Solo) and a Russian (Ilya Kuryakin) working for a United Nations type organisation, the 'United Network Command For Law and Enforcement' against another 'third force' for evil in the world: T.H.R.U.S.H. (the even

more memorably named 'Technological Hierarchy for the Removal of Undesirables and the Subjugation of Humanity'). In one scene from the Bond film *Thunderball* (1965), the head of SPECTRE is referred to only as 'Number One'and his main operatives are all called by numbers rather than names. Thus it was hardly surprising that the mass television audience, familiar as it was with the conventions of the 'secret agent' genre, expected that The Prisoner's Number 1 would finally be revealed as a Blofeld-type villain. Instead, in the final episode 'Fall Out' (discussed in detail in Chapter 6) the audience were given an answer that completely violated their generic expectations. As a consequence, the ITV switchboards were jammed with calls of protest. As McGoohan expressed in a 1983 interview:[8]

> ... a lot of people watched the last episode and expected a sort of conventional end – that the evil person personified as the Number 1 we'd never seen ... this mystery character that brooded over everything ... What was he like? Was he a Jekyll and Hyde? ... More a sort of James Bond villain at the end ... I think they felt they'd been robbed with what they'd got

Generic codes are deliberately used in *The Prisoner* to 'tease' the audience, to draw them into the kind of philosophical debates which normally have no place within the confines of genre structures. As the viewer's involvement is achieved, the signifying elements of the codes shift or 'slide', so causing the viewer to experience the mixture of confusion and fascination so typical of popular responses to the series.

Umberto Eco, in his *The Role Of The Reader*,[9] distinguishes between what he calls 'open' and 'closed' texts. He identifies closed texts as those which use predictable narrative structures, and which are full of the commonplace conventions of the particular generic form. Eco goes on to discuss Superman comics and Ian Fleming's Bond novels as examples of closed texts. 'Open texts', on the other hand, are said to be works in which the 'reader' is called upon to 'deconstruct' the message of the story; and for which no one interpretation will ever completely suffice. Eco cites as open texts the works of Franz Kafka and Bertolt Brecht and lists James Joyce's *Finnegan's Wake* as a prime example. In the terms of this analysis, the vast majority of fictional commercial films and television series can be seen as closed texts.

In *The Prisoner*, McGoohan disguises his open text as a closed text by building up audience expectations towards a conventional ending and then conspicuously failing to provide the expected closure, thus leaving the answers to the series open. In order for this process to work, an assumption had to be made that the audience would be very familiar with the narrative codes of the spy, action adventure and science fiction genres. But given the

8 Interview with McGoohan in *Six Of One:* The Prisoner *File*, Channel 4 Documentary (1984).
9 Umberto Eco, *The Role Of The Reader*, Chapter 2.

popularity of these forms in the 1960s, such an assumption could easily be made.

The popularity of certain genre forms has often been seen to reflect the values and vital concerns of a society at any given time. As we have seen, genre functions in many ways as a mythological construction. In *Mythologies*, Roland Barthes points out that:[10]

> ... myth is a type of speech chosen by history; it cannot possibly evolve from the 'nature of things'.

Modern myths are the result of system of images and beliefs which society constructs so as to sustain and authenticate its own sense of being. Thus, the Western, which at the beginning of the decade was still the most popular film and television genre, declined during the 1960s as the essentially simplistic and outmoded values it represented were steadily discredited. The secret agent genre, however, blossomed through the decade, and grew to ever greater heights of popularity in literature, cinema and television. In the post-Cuban missile crisis era of the Cold War the figure of the secret agent became a kind of 'moral guardian' of Western society, and as such a powerful focus of public anxiety. The Cold War itself was a 'secret war', and secret agents the 'warriors' in the 'front line' of their battle, for which literally the whole future of civilisation was at stake.

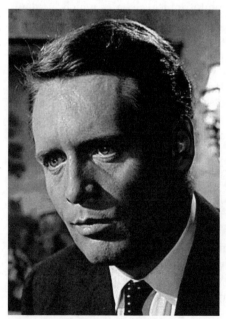

The spy with no guns and no girls: Patrick McGoohan as *Danger Man.*

Beyond the basic paradigm of the sexy, violent, 'cool' spy as personified by Bond it had two other basic forms – the 'realist' approach as personified by Le Carre's *The Spy Who Came In From The Cold* where spying was unglamorous – a 'dirty job', a matter of intrigue and psychological suspense – and the 'fantasy' television spy series like *The Man From U.N.C.L.E.* and *The Avengers* where the violence was heavily stylized and the sexual element, though prominent, was usually softened (partly due to the 'family viewing' restrictions on television at this time).

It has always been a matter of debate whether McGoohan's character in *The Prisoner* is based on his

10 Roland Barthes, 'Myth Today' in *Mythologies*, p. 110.

role as John Drake in *Danger Man*. *Danger Man*, which ran intermittently from 1960 to 1967, was a massively successful TV series on an international scale, and it made McGoohan a major TV star. McGoohan's 'resignation' from the part parallels the Prisoner's resignation at the beginning of the series. Like Drake, the Prisoner is a top-level agent with priceless information in his head. And like Drake, the Prisoner maintains a position of sexual ambivalence. Though he encounters, and is sometimes tempted by, a number of attractive women, no actual sexual contact ever occurs onscreen or is even inferred to happen offscreen. McGoohan undoubtedly had some strong (if perhaps unfashionable) views on this subject:

> ... I intended on a family programme that children could watch without the sex and all that rubbish.[11]

The implications of this attitude are discussed further in Chapter 7, but what is relevant here is the way in which McGoohan's TV spy heroes are distinguished from the Bond model. McGoohan, who is said to have twice refused the (immensely lucrative) offer of the part of Bond,[12] insisted from the outset of *Danger Man* that Drake should be 'the spy with no gun and no girls'. In contrast to Bond, who kills casually and often jokes about it as he does it, Drake never kills and fights only with his bare hands. He is presented with a number of attractive female leads but (in great contrast to Bond) never gets as far as sexual contact with any of them. Dave Rogers[13] quotes McGoohan on this ...

> I don't believe for one moment that Drake would chase any of the girls he meets. He is the sort of man who has a healthy enough respect for women to realise it would not be fair on a girl to ask him to marry him while he is away on dangerous missions ... to do so would interfere with the life of adventure he has chosen.

This 'healthy respect' for women, which the Prisoner certainly shares, is in sharp contrast to the highly misogynistic attitude of Bond, of whom the theme song for *Thunderball* proudly proclaims:[14]

> Any woman he wants he'll get,
> He will break any heart without regret ...

11 Patrick McGoohan quoted in *The Official Prisoner Companion* by Matthew White and Jaffer Ali, p.179.
12 According to Matthew White and Jaffer Ali in *The Official* Prisoner *Companion* (p.123), McGoohan was the producers' first choice to play Bond and it was he who suggested Sean Connery for the role. White and Ali also assert that McGoohan was also offered the role after Connery left, but again he refused.
13 Patrick McGoohan quoted in Dave Rogers' *The Prisoner and Danger Man*, p. 11/12.
14 *Thunderball* – lyrics by Don Black, music by John Barry, sung by Tom Jones. Theme song from the film *Thunderball* (directed by Terence Young, 1965).

One episode of *The Prisoner*, 'The Girl Who Was Death', can be read as a parody of the Bond films. The episode dramatizes a story the Prisoner tells to some of the Village children; which involves him foiling a plot by the 'evil genius' Schnipps, who aims to destroy London with a nuclear bomb, just as SPECTRE threatens to do in *Thunderball*. Both Bond and the Prisoner are mediators in the Cold War scenario, both almost 'superhuman' in their resourcefulness, and both are hero-identification figures for the audience. The highly technological underground cave setting at the end of 'Fall Out', where the Prisoner finally meets Number 1, has a great resemblance to the SPECTRE headquarters at the end of *You Only Live Twice*. But whilst Bond is morally rather ambivalent, both the Prisoner and Drake are clearly shown to have 'responsible' moral attitudes. McGoohan has stated his attitude towards this quite clearly:[15]

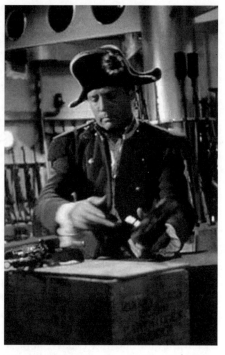

The Girl Who Was Death: The Prisoner spoofs Bond

> ... too many heroes on television are not heroes at all. They are villains. Real heroes are moral people ...

The Prisoner uses many of the 'action-adventure' conventions that characterize the 'spy' and similar generic forms. The dramatic helicopter flights in 'Arrival' and 'Many Happy Returns', and the highly choreographed fight scenes in 'The Schizoid Man', 'Hammer Into Anvil', 'A Change Of Mind' and many other episodes are examples. The action scenes are dominated by the fast editing associated with building up excitement in the audience. We see this in the 'escape' scenes at the beginning of 'Many Happy Returns', in the strange game of Kosho in 'Hammer Into Anvil' and on many other occasions. The Prisoner is in every sense an action-adventure hero, and as such has apparently inexhaustible reserves of energy, inventiveness and many hidden talents to call upon.

There is also a prominent science fiction element in the series. This is

15 From an interview in *The Listener* (New Zealand) quoted in *The Village Observer* (Six Of One publication) Summer 1986.

visually noticeable in the contrast between the architecture of the Village (shot at Portmeirion) and the interior shots (filmed in studios). The design of these interiors, which is discussed in greater detail in Chapter 3, displays a comprehensive range of futuristic technology and, like Ridley Scott's 1983 film *Blade Runner*, shows the visual influence of Fritz Lang's silent science fiction classic *Metropolis* (1926). We see much of the sophisticated, futuristic observation screens which are monitored by the Controllers of the Village. In 'Arrival' Number 2 casually flicks through a book showing images of the Prisoner's life, and these are immediately projected onto one of the screens by some unknown technological process. Advanced technological devices are used throughout the series to brainwash the inhabitants of the Village or to extract information. The Village also uses futuristic devices such as the portable telephone, which have now come to be accepted as part of everyday life.

On a narrative level, *The Prisoner* is clearly linked to a specific branch of science fiction, the distopian fantasy. The world of the Village is similar in many ways to that of Huxley's *Brave New World* and Orwell's *1984*; both of which picture future societies where technology is used to control the population. In *Brave New World* the control is medical, and this is echoed by the Village 'hospital', which is actually a centre for experimentation in techniques of brainwashing and mind control. In *1984* the Controllers of the society keep their subjects under constant surveillance, notably by the use of TV screens in the home. Orwell's Winston Smith only manages to write his diary by finding a corner of his room where the television cannot see him. Exactly the same device is used in *The Prisoner*, where the Prisoner's house is fitted with a screen through which the Controllers can observe him at all times. *The Prisoner*, like these earlier distopian texts, portrays a totalitarian society where virtually all resistance, except that of the protagonist, has been eliminated. McGoohan's distopian fantasy echoes not only the very obvious totalitarian control evident in twentieth-century societies such as Hitler's Germany, Stalin's Soviet Union and Mao-Tse-Tung's China, but also the more subtle forms of social control used in politics, advertising and popular entertainment in modern Western society.

McGoohan's concern in *The Prisoner* is primarily with the place and role of the Individual within society and the series is a warning of the drift of modern societies towards subtle forms of 'mind control' of their citizens. The inhabitants of the Village are superficially happy but all real emotion has been programmed out of them. In many ways McGoohan is parodying television viewers themselves, who 'unthinkingly' watch television media product in the same way as they consume other 'product'. He deliberately distorts the generic elements of mass entertainment in order to expose the techniques of 'mind control' inherent in the medium of television. which he shows to have uncomfortable parallels with those of totalitarian societies. Perhaps this is why television itself appears in many forms in the Village, always in the service of social control. Commenting on the public uproar which followed

the showing of 'Fall Out', McGoohan professed to being 'delighted' with such a reaction:

> ... As long as people feel something ... that's the great thing. It's when they're walking around not thinking and feeling ... that's ... that's tough ... because when you get a mob like that you can turn them into a gang like Hitler had ... we don't want that ... [16]

As the series progresses, the theme of the dangers of passivity and conformity in modern society becomes more prominent. Having established the secret agent and science fiction elements McGoohan also allows the series to expand into other generic areas. One episode, 'Living In Harmony', is a Western, where the basic situation of a man imprisoned by powerful authority is transferred to the Western genre, with the Prisoner as a Sheriff who hands in his badge and gun and then attempts, unsuccessfully, to leave town. Although this is given a (somewhat dubious) explanation by the revelation that it has all been an attempt by the Village to crack the Prisoner using cardboard-cut out settings and hallucinogenic drugs, the episode clearly indicates McGoohan's conception of the Prisoner's situation as being a universal one, which can exist in any place, time or generic mode.

The meaning of McGoohan's allegory is still a matter of considerable debate amongst present-day viewers of the series. This is especially true with regard to the final two episodes, Once Upon A Time and Fall Out, where generic conventions tend to fall away and the viewer is faced with elements of absurdist drama and cinematic surrealism. The ending of Fall Out (which is discussed in detail in Chapter 6) is deliberately left open to interpretation and, as I have already suggested, it is very doubtful whether the series could be said to achieve the kind of closure which normally characterizes a genre product. *The Prisoner* is thus an open text constructed out of the materials of closed texts. It distinguishes itself from the vast majority of genre products made in the 1960s firstly by the way it intermingles generic elements, and secondly by the way it uses generic conventions in the service of its allegorical message. It does not allow its story, or its meaning, to be dictated by those conventions. Ultimately, it transcends genre.

16 From an interview in *Six Of One:* The Prisoner *File.* Channel 4 documentary (1984).

I am not a Number
Television and The prisoner

We must make allowance for the complex and unstable process whereby discourse can be both an instrument and effect of power, but a hindrance, a stumbling block, a point of resistance and a starting point for an opposing strategy ...
 Michel Foucault[1]

I am not a number ... I am a free man.
 The Prisoner Credit Sequence

PRISONER: I was rebelling against the figures ...
 From 'Once upon A Time'

Just as *The Prisoner* cannot be tied down to one particular genre, it is also an amalgam of the two most prominent forms of television drama – the serial and the series. In the manner of a serial, it has an opening episode ('Arrival') and a closing episode ('Fall Out'). The penultimate 'Once Upon A Time' also clearly segues into 'Fall Out'. In the final two episodes there are many flashbacks to earlier parts of the series, clearly indicating a linear passage of time between events. The serial form, however, implies continual

1 Michel Foucault – *The History Of Sexuality, Vol. I: An Introduction*, p.101.

development of characters and dramatic conflict in what may evolve into a complex structure of intersecting narratives (especially in the form's most extreme manifestation, the soap opera). In *The Prisoner*, only the Prisoner himself appears as a major character in every episode. Up to 'Once Upon A Time' his character undergoes only slow and subtle changes. In many ways the episodes from 'The Chimes of Big Ben' through to 'The Girl Who Was Death' (Episodes 2–15) are self-contained narratives, characteristic of the series form. It can even be argued that their order is rearrangeable.[2]

The series form is perhaps the most distinctly 'televisual' of all the modes of presentation of drama on television. The main impetus for its early development was the arrival of videotape in the early 1950s, which meant that television drama need no longer be merely a forum for the broadcast of live theatre plays. Like the cinema, television could now use techniques of pre-recording and editing and the intercutting of location and studio footage became possible. There were also strong economic reasons for the series' rise to prominence over the next decade. The production of a series involves a more industrialized and economically efficient process than that of single dramas. Actors and crew can be employed for a given period of contract and sets can be constantly re-used. Series are also easier to schedule, and by putting them in a regular time slot every week, TV stations hope to gain audience loyalty. A complete series can be sold to TV stations as a package, which can be extremely lucrative. Thus, commercial pressures tend to favour the production of long series. An established series can attract a 'target audi-ence' which is identifiable to advertisers. This allows products to be adver-tised during the series which are likely to appeal to that audience. Thus,

2 There is considerable debate amongst fans and scholars of *The Prisoner* over the 'correct' running order of the series. The order followed in this book is that of the original screening on British TV, which has also been adopted as the 'official order' in the subsequent video release. However, as production on the series was still going on when the first episodes were aired, it can be argued that some episodes were shown earlier in the series than intended due to them being completed first. White and Ali in *The Prisoner Companion* argue that the order the series was first shown in on U.S. TV is a more accurate guide to McGoohan's intentions, as by then the entire series had been made and McGoohan could choose a correct order. But it seems highly unlikely that McGoohan would have had such control over American TV stations. It is also worth pointing out that certain episodes – particularly 'Dance Of The Dead' and 'Checkmate' – were definitely filmed at an early point but then 'shelved' until their 'proper' place in the series could be taken. The penultimate 'Once Upon A Time' was filmed almost a year before its sequel 'Fall Out'. This would also indicate that the original order is the most definitive. The U.S. order rearranges the sequence of Episodes 9 to 15. Whilst the British order runs 'Checkmate', 'Hammer Into Anvil', 'It's Your Funeral', 'A Change Of Mind', 'Do Not Forsake Me, Oh My Darling' and 'Living In Harmony'; the American order is 'Do Not Forsake Me', 'It's Your Funeral', 'Checkmate', 'Living In Harmony', 'A Change Of Mind', 'Hammer Into Anvil'. Dave Rogers, in the official Channel 4 book of the series, *The Prisoner and Danger Man* uses a completely re-arranged order for no apparent reason. Their are various arguments which may favour one order over another, and to some extent the order of many of the episodes is essentially interchangeable. But the screening order adopted by Channel 4 in 1984, with 'Many Happy Returns' shown as the second episode of the series, was disastrous – the effect on the viewer of the Prisoner waking to a deserted Village being considerably weakened by its being placed so early on in the overall story.

advertisers (who provide the finance for commercial stations) favour the relative stability of 'audience placement' that the series can provide.

The experience for the viewer of a weekly series at a regular time is an essential element of its effect. Marshall McLuhan[3] described television as a 'cool' medium – one which, like modern pop music, does not necessarily have to engage the full attention of its audience. Whereas in the cinema the setting demands full attention, TV programmes tend to be interspersed with domestic conversation, meals and other distractions. Thus TV series become woven into the fabric of the viewers' lives. Regular recurring characters become extremely familiar to their audiences, in a mode of dramatic intimacy that is uniquely 'televisual'. According to Robert C. Allen,[4] this may be one reason why the television series is still generally regarded as a less prestigious art form than the film or the novel:

> ... for many people ... television has the same status in their lives as the food they eat for breakfast or the way their faces look in the mirror in the morning; it is something so close, so much a part of day-to-day existence, that it remains invisible as something to be analysed or consciously considered.

Attempts to assess TV series using conventional methods of literary or cinematic analysis tend to criticize them for their use of repetitious or predictable plots and stereotyped characters. The very fact that the main characters must return every week, and therefore must continually win out in (or at least survive) whatever conflicts they are engaged in, is a convention that limits character development in the modern literary sense. Yet this element of continuity is a key factor in structuring the narratives of popular series. The strict time limitations of the series, fitted as it must be into one-hour or half-hour time-slots (themselves divided by advertising breaks) can be seen as a further limiting factor, encouraging the production of a formularised product. Production schedules for TV series generally demand a very rapid turnover of shows on tight budgets, as opposed to the far greater time and finances expended in the cinema. Whilst the development of the 'auteur' theory in the 1950s did much for the intellectual respectability of the cinema through its identification of certain directors as 'authors' of their films, TV series are very rarely dominated by a single authorial voice. As Raymond Williams put it, they are a ... collective, but more often a corporate dramatic enterprise.[5]

TV series are also hidebound by commercial constraints, dependent as they are for their continued existence on very high viewing figures. In order to ensure continuous, predictable profits the TV companies naturally tend to

3 Marshall McLuhan, *Understanding Media*.
4 Robert C. Allen, from the Introduction to *Channels of Discourse Reassembled : TV and Contemporary Criticism*, p. 3.
5 Raymond Williams, *TV, Technology and Cultural Form*, p.60.

favour safe, predictable stories. Filmed television series often involve the necessity for high production costs, and investment in them often does not turn to profit until the episodes become syndicated as reruns in the global TV market. Large numbers of episodes of a series may need to be produced before it is deemed a commercial 'success', and this may strain a series' credibility.

As has been established in the previous chapter, the main narrative forms of the TV series are genre-based, and the genres that TV relies on can be identified as modern equivalents of traditional mythological stories. John Fiske and John Hartley[6] have written of television's 'bardic' function. In their view the TV series can function as the modern equivalent of the traditional storyteller or 'bard', whose function was to adapt traditional tales to current circumstances. Though such a story may contain a high degree of pre-dictability, it is the way the story is told rather than its outcome which most concerns its audience.

The characters in a TV series need to reach mass popularity for a series to survive. Therefore the most popular characters are often reflective of society's popular obsessions and current moral viewpoints. The differences between a popular character of the early 1960s such as the TV Western series *Bonanza*'s cheerfully patriarchal head of the 'frontier' Cartwright family, Ben Cartwright, and a popular TV series hero of the 1990s such as the paranoid, conspiracy-driven Fox Mulder in *The X Files*, are an indication of consider-able shifts in social and moral values. The same could be said about the dif-ferences between the original *Star Trek* with its values of universal, if naive, optimism, and its 1990s offshoot, the corruption and realpolitik-filled *Deep Space Nine*. The 'heroes' of TV series are thus figures that reflect the con-cerns and anxieties of their time.

In this light the late 1960s origins of *The Prisoner* must be taken into account. The 1960s saw the growth of youth culture and what became known as the 'alternative society'. This was reflected most prominently in popular music, a medium which the work of Bob Dylan, The Beatles, Jimi Hendrix, Brian Wilson and others transformed a largely innocuous form of entertainment into one with the potential for cultural and social critique and poetic, psychological and spiritual exploration. This can be measured by the tremendous cultural distance between the simplistic early Beatles songs such as *I Want To Hold Your Hand* (1963) or *Can't Buy Me Love* (1964) and their psychedelic works of just a few years later, such as *Tomorrow Never Knows* (1966), *A Day In The Life* (1967) or *I Am The Walrus* (1967). As McGoohan was making *The Prisoner*, The Beatles were engaged in record-ing their meisterwork, *Sgt. Pepper's Lonely Hearts Club Band* (1967). The figure of McGoohan as an 'Individual against the establishment' in *The Prisoner* was one with which many young people identified, just as they did with Jagger, Dylan, Lennon or Jim Morrison. McGoohan's deep suspicion of modern technology's potential role in social control echoed the anti-techno-

6 John Fiske and John Hartley, *Reading Television*.

logical feelings of the 'counter-culture' of the time. As the Prisoner's double reminds us in 'The Schizoid Man', ... 'science can be perverted'.

Consciousness-altering drugs, another prominent feature of the new 1960s 'alternative culture', also feature throughout the series. But they are used as agents of social control or brainwashing rather than for recreation. In episodes like 'A Change Of Mind' and 'A, B and C' the Prisoner is force-fed such chemicals. The special camera effects used to depict such sequences explore hallucinatory states. The final episode, 'Fall Out', contains scenes of hallucinatory surrealism which satirise the 'establishment'. The 'hippie' character played by Alexis Kanner in this episode is said to ... symbolise youthful rebellion ... a rebellion which the 'establishment' of the Village feels it is its duty to put down. The soundtrack of 'Fall Out' makes ironic use of The Beatles' *All You Need Is Love* to counterpose its repressive scenario.

Marshall McLuhan's views on how the nature of consciousness had been changed by the immersion of the post-war generation in the mass media were very influential in the late 1960s, particularly with elements of the 'counter-culture'. In *Understanding Media* (1964) and *The Medium Is The Massage* (1967), McLuhan described the mass media era as a new stage in human culture in which the dominance of a literary or print-orientated consciousness (what he called the 'Gutenberg Galaxy') had been superseded by a 'Global Village' of instant communication, with television as its main agent. Those who had grown up with TV's ability to present 'instant' images from around the world now practised a new mode of thought, which embraced ideas and images from many different cultures and which was visually-oriented and globally conscious, more immediate and multi-dimensional than that of the previous generation. According to McLuhan, this change in consciousness explained the 'generation gap' of the 1960s. He was clearly on the side of 'youth' in the struggle, considering this new mode of consciousness to be the appropriate one for the modern technological age. The presentation of technology and its likely results on the future in *The Prisoner* is in sharp contrast to such an optimistic outlook. One exchange of dialogue in the second episode 'The Chimes Of Big Ben' places a new slant on the notion of a 'Global Village':

NUMBER 2: It doesn't matter which side runs the Village.
PRISONER: It's run by one side or the other.
NUMBER 2: Oh certainly, but both sides are becoming identical. A perfect blueprint for World Order. When the sides facing each other suddenly realise they're looking into a mirror, they'll see that this is the pattern for the future.
PRISONER: The whole earth as the Village.
NUMBER 2: That is my hope ...

While McLuhan sees technology as liberating, in *The Prisoner* it is the main agent of social control. In McLuhan's 'Global Village' television is the

main consciousness-changing element of that technology, whereas in *The Prisoner* it is used as a means of surveillance and brainwashing. It can certainly be argued that the TV series form itself generally uses a kind of social control. The audience's emotions are often manipulated to make them willing and passive consumers of the products being sold to them in the commercial breaks which follow moments of particularly heightened emotion. Few series of *The Prisoner*'s era ever contained any socially challenging or critical notions, or encouraged debate amongst their audience on important contemporary issues. *The Prisoner* can thus be viewed as a 'subversive' text which, despite remaining within the conventional structures of the action-adventure TV series (at least until the last few episodes), challenges its audience to see the world in a new light.

Perhaps the major distinguishing convention of the TV series is its essential predictability. This was particularly noticeable in the action-adventure series of *The Prisoner*'s era, whose plots were generally constructed around a particular formula – ie the hero (and his assistants) encounter some threat to the established order, which they then proceed to eliminate. As a result 'good' almost inevitably triumphs over 'evil'. As Umberto Eco[7] suggests:

> With a series one believes one is enjoying the novelty of the story (which is always the same) while in fact one is enjoying it because of the recurrence of a narrative scheme that remains constant ... The series in this sense responds to the infantile need of always hearing the same story, of being controlled by the 'return of the identical'- superficially disguised The series consoles us ... because it rewards our ability to foresee: we are happy because we discover our ability to guess what will happen. We are satisfied because we find again what we had expected.

Predictability is thus a feature of the basic nature of the TV series. Viewers know perfectly well that the hero – be it *Gunsmoke*'s Marshall Dillon in a Western setting, Perry Mason in the courtroom or *Star Trek*'s Captain Kirk in space – will inevitably end each episode in triumph. Yet *The Prisoner* demonstrates that this convention of predictability is not necessarily a limitation, but merely a conventional dramatic framework no more restrictive than, say, the limitations imposed on the novel in the nineteenth century. (Many novels of that era now considered to be 'classics' were originally written as tailor-made 'episodes' for popular magazines) Although it is in the nature of the series that the Prisoner cannot immediately triumph (as an immediate escape would obviously kill the series stone dead), the Prisoner's weekly victory is in his constant refusal to be, as he puts it in 'Arrival', ... PUSHED, FILED, STAMPED, INDEXED, BRIEFED, DEBRIEFED OR NUMBERED ... Despite the various attempts of his captors to brainwash and

7 Umberto Eco, *The Limits Of Interpretation*, p. 86.

disorientate him with drugs or technological devices, or to arrange elaborate tricks such as the false escapes of 'The Chimes Of Big Ben' or 'Many Happy Returns', the Prisoner never cracks. He never reveals to the authorities why he resigned and never accedes, like nearly all of the rest of his fellow Prisoners, to Village life. His triumphs may be psychological, but in many ways they are just as 'predictable' as those of Dillon, Mason or Kirk.

The predictability of a series is reflected in its narrative structures which, tied into a medium which demands a preset narrative outcome and which works towards staged climactic moments before each commercial break, naturally tend towards the formulaic. *The Prisoner*, in the manner of commercial TV series of its day, is constructed around three segments of roughly fifteen minutes each. Despite the liberties it may take with the kind of subject matter and visual presentation normally used in a series, it follows this basic convention throughout. and the dramatic tension characteristically rises to climactic points at the ends of these segments.

Another convention of the series is that each story should be a self-contained narrative. This allows new viewers to 'join' a series at any time. Thus, references to previous episodes are generally kept to a minimum to avoid 'losing' the new viewer. Although, as we have seen, *The Prisoner* has many of the characteristics of the serial form, only its final two episodes are explicitly 'connected' in a linear way. Each of the stories up to Episode 16 is a self-contained narrative. Every episode (except for 'Living In Harmony' and 'The Girl Who Was Death') uses the same credit sequence to establish 'the story so far'. In each case the Prisoner, despite his ingenuity and great stubbornness, fails to escape, yet on many occasions he manages to subvert and weaken the power structure of the Village. In many ways, each episode sets out a moral fable from the same starting point.

Where *The Prisoner* certainly breaks with convention is in its positioning of character. Although the TV series of the 1960s was usually dominated by one male hero-figure, that central character would invariably be accompanied by at least one 'helper'. Examples in the 'fantasy spy' genre were Ilya Kuryakin in *The Man From U.N.C.L.E.* and Emma Peel in *The Avengers*. The length of a series gave opportunities for a number of central characters to be created and their weaknesses, strengths and foibles to be thoroughly explored. But in *The Prisoner*, apart from the eponymous hero himself, only minor characters like the Butler and the Supervisor appear repeatedly. New characters appear and disappear on a weekly basis, and this is never explained.

Over the course of a series, the viewer becomes increasingly familiar with the main characters, expects them to behave an established way and generally to appear in 'appropriate' settings. But in *The Prisoner*, when such expectations are subverted, powerful defamiliarizing effects can result. An example occurs in 'Living In Harmony', where the hero suddenly appears in a traditional small-town Western setting. The switch helps to universalize the character of the Prisoner as a psychological archetype, an 'Everyman' figure

who can appear in any situation. The consistency of the character – the Prisoner is equally rebellious and contemptuous of authority as a 'cowboy' as he is as a 'spy'- positions him more obviously as a symbolic representation of the struggle of the Individual against the 'establishment'.

The TV series is essentially a melodramatic form, and depends on highly structured moments of heightened emotion in its major characters. Peter Brooks[8] defines melodrama as:

> ... indulgence of strong emotionalism, moral polarization, and schematization; extreme states of being ... overt villainy ... inflated and extravagant expression, dark plottings, suspense.

The Prisoner can certainly be said to utilize all these areas of dramatic excess. Its central character has an apparently unbending will and limitless stubbornness and resourcefulness. The moral polarization of his fight against the evil of the Village is made manifest throughout the series. He is subjected, through drugs and brainwashing, to extreme psychological states. Frequently he paces the bounds of his 'prison', full of repressed tension. The plots of the series depend on suspense and often consist of situations which the Prisoner, as the 'all-round action hero' is able to resolve through his apparently infinite resourcefulness. In 'A, B and C' he breaks into the Village Hospital to rig the brainwashing device which enables Number 2 to see his dreams on a screen. In 'Many Happy Returns', after surviving many days alone on an open boat he is still able to beat up the crew of a Village ship which has picked him up. In 'It's Your Funeral' he foils an assassination plot on the outgoing Number 2, and in 'Once Upon A Time' he defeats all the brainwashing attempts of Number 2 in a psychological 'fight to the death'.

It is important to remember that melodrama as such does not necessarily indicate a lack of depth in a dramatic text. The plays of Shakespeare and Jacobean tragedists are extremely melodramatic and use highly conventional narrative structures. In *The Prisoner*, the central character's physical attributes, as demonstrated in the frequent fight or chase scenes, provide a visual counterpoint to the inner strength and incorruptibility that define him. As David Thorburn[9] has pointed out, television melodrama can be:

> ... an encounter with forbidden or deeply disturbing materials: not an escape into blindness or easy reassurance, but an instrument for seeing ... a forum or arena in which traditional ways of thinking and feeling are brought into continuous, strained relation with powerful intuitions of change and contingency.

8 Peter Brooks, quoted in Jane Feur: *Melodrama, Serial Form and TV Today in Television, The Critical View*, p.551.
9 David Thorburn, *Television Melodrama* from *TV: The Critical View*, p.452.

Thorburn also argues that TV melodrama can be likened to that most melodramatic of forms, the opera, where it is not dramatic realism that is important but the expression of emotion by the characters. In the same way that the most successful operas are those in which the composer has created roles which test the vocal capacity of the main actors as performers, the most successful TV series are those which allow the main characters opportunities for frequent emotional display. Thorburn[10] asserts that:

> ... far more decisively than the movie-actor, the TV actor creates and controls the meaning of what we can see on the screen ... in order to assess television we must assess the actor's performance in making truthful or believable the characters ... the medium's reduced scale grants a him a primacy unavailable in the theatre or movies.

The Prisoner is an extreme example of the primacy of the main actor. This is not only because its hero is the only regular recurring character but also because, in a manner that is virtually unique in the history of the television series, Patrick McGoohan is the main creative and controlling force behind the series. Even in the cinema, the existence of actor-director-writers is very rare (perhaps Charlie Chaplin and Woody Allen are the most prominent examples) because, like TV, it is a collaborative artform controlled on an industrial and commercial basis. In terms of television, the position which McGoohan found himself in with *The Prisoner* was unprecedented.

McGoohan's family were Irish-Americans who moved to Sheffield when he was seven. In the 1950s he established himself as a successful theatre actor, playing Starbuck to Orson Welles' Ahab in Welles' production of *Moby Dick* in London in 1952 and later the lead in Ibsen's *Brand* (which was also televised). Both encounters may have been significant for his later career – one may speculate that working with the great cinema auteur Welles may have given him similar ambitions, and the character of Brand is an individualist and a social rebel, in some ways a 'prototype Prisoner'. McGoohan also played a series of roles in low budget British thrillers made by the Rank Organisation such as *High Tide At Noon* (1956), *Hell Drivers* (1957) and *Nor The Moon By Night* (1959); often in action-oriented or romantic roles. In 1960 he accepted the part of John Drake in a new British TV spy series, *Danger Man*.

Danger Man was made by the TV production company ITC, which in the 1950s had specialized in highly melodramatic 'swashbucklers' like the long-running *Adventures Of Robin Hood*. ITC had been set up at the birth of commercial television in Britain by Lew Grade, a colourful, enterprising, cigar-smoking 'TV mogul' whose cheerfully autocratic style of management resembled that of the heads of the major Hollywood studios in the era of the 'studio system' in the 1930s and 1940s. From the beginning, Grade's ambi-

10 David Thorburn, *Television Melodrama*, as above, p. 539.

tion was to break ITC's series into the lucrative American syndication market, and thus these series tended to have what, by the standards of British TV at the time, were very high production values. Whereas BBC series like *Dr Who* (which began in 1963) had to rely largely on studio sets and videotape, the ITC products tended to be filmed dramas with many cinematic qualities and budgets which made location shooting possible. Grade successfully sold *Danger Man* to the US networks, where it was broadcast as *Secret Agent*, and it subsequently became a worldwide hit. Other glamorous, fast-paced ITC series like *The Saint* (1962-68) (starring Roger Moore, a future James Bond), *The Baron* (1965) and *The Champions* (1967-68) followed *Danger Man* into the world market. By the end of the decade, ITC programmes were being shown in every TV-broadcasting nation in the world except Albania and China. In 1969, US stations bought more ITC product than that of any American company except MCA/Universal. Thus, by the time McGoohan proposed the idea of *The Prisoner*, Grade's company had certainly acquired the financial means to stage a high-budget 'prestige' series, even if that meant taking some risks ...

As the star of *Danger Man*, McGoohan was put into a position of power analogous to that of modern Hollywood superstars whose presence alone can make a film 'bankable'. By the third series, McGoohan was earning around £2,000 a week, which made him the highest paid actor on British television. Such stars often have considerable influence over the making of films in which they feature. Because of their drawing power they can often be in a position to exercise their control, as the financial backers of the project cannot afford to lose them. It is clear from all accounts of the making of *Danger Man*[11] that McGoohan decided early on in the production process to exercise as much power as possible. As we saw in the previous chapter, he insisted that his character had no explicit romances, and he also refused to countenance scenes of gratuitous violence. As the series progressed he began to wield an increasing influence over the scripts. He often insisted on approving all sequences himself, and developed a reputation for being a perfectionist, fiercely intolerant of actors who arrived late or who had failed to learn their lines. He also directed several episodes.[12]

By the time McGoohan approached Lew Grade with his ideas for a new series to succeed *Danger Man*, he certainly had ambitions to shape and control his own project. He was in a strong negotiating position as he had effectively 'resigned' from *Danger Man*, which was only two episodes into its fourth series. Grade not only allowed McGoohan to persuade him to go along with the idea that was to become *The Prisoner* but also allocated a

11 Accounts of the production of *Danger Man*, and of *The Prisoner* are given in Dave Rogers, *The Prisoner* and *Danger Man*; Alain Cazzare and Helene Oswald, *The Prisoner, A Televisionary Masterpiece* and Roger Langley: *The Making Of The Prisoner*.

12 McGoohan directed the episodes *Vacation*, *To Our Best Friend* and *The Paper Chase*. Three other Prisoner directors, Don Chaffey, David Tomblin and Peter Graham Scott, also worked extensively on the series.

budget of £75,000 an episode, at that time the highest ever for a British TV series. McGoohan certainly considered himself lucky to be in the right place at the right time. As he later recalled:[13]

> I knew a man who backed hunches, and his decisions were his alone. Lew Grade, now Lord Grade, is such a man. He was behind my previous series. ... He didn't like reading scripts, but preferred to 'hear' the idea, to see it in his mind's eye. After listening to the bizarre concept, he took a few puffs on his cigar, walked around the office a couple of times and said 'It's so crazy it might work. Let's do it. Shake.' ... And we did. And he gave me carte blanche. I was very fortunate.

McGoohan was able to transfer a ready-made production team from *Danger Man* to *The Prisoner*. The series was made under the aegis of McGoohan's company Everyman Films (the name of which was a reference to an allegorical medieval morality play and pointed towards the kind of role McGoohan would play). During the whole production process there was virtually no interference from ITC officials, which meant that McGoohan had the rare chance in TV terms to produce a series that did justice to his vision. Yet his perfectionist approach meant that his production team had to take on an almost impossible workload. The production process in TV is intrinsically a co-operative one, which involves a great number of creative individuals – directors, actors, lighting technicians, script editors, writers and many others – who have to work together to produce a series in what, by cinematic standards, is a very short time. (Often an episode had to be completely produced in a no more than a week.) McGoohan was concerned that the series should display cinematic production values and highly literate standards of dialogue, and he was determined to supervise every aspect of the production.

McGoohan's official title was 'Executive Producer'. In television the Producer or Executive Producer of a series is generally the figure with overall creative control. TV directors tend to be employed to make single episodes of series, and their style usually has to be modified to make their work as indistinguishable as possible from other directors who have worked on the series. McGoohan wrote and directed 'Free For All' (under the pseudonym of 'Paddy Fitz') as well as directing 'Many Happy Returns' and 'A Change Of Mind' (both as 'Josef Serf'), before writing and directing the last two episodes, 'Once Upon A Time' and 'Fall Out'. By working extremely long hours he managed to virtually oversee every aspect of the production of the series, including casting, set and costume design. He frequently rewrote the scripts of the credited writers (and even, supposedly, came up with the main tune for the title theme).

13 Patrick McGoohan quoted from Cazzare and Oswald, *The Prisoner, A Televisionary Masterpiece*, p.7.

The location filming began with an intense four-week shoot in Portmeirion in September 1966, with McGoohan and his crew working a seven-day week and often, a 16-hour day. Studio shooting and editing for the 13 programmes that were intended to make up the first series was completed between October 1966 and March 1967, often at a similarly frenetic pace. But by then the production was well behind schedule. Originally the overall length of the series had been open-ended, and several full 13-episode seasons were hoped for. But McGoohan's perfectionism had taken its inevitable toll on both the production team's stamina and the show's budget. At a meeting between Everyman Films and ITC early in 1967, it was now agreed there would only be four more episodes. One of these, 'Once Upon A Time', had already been filmed but had been held back as the penultimate story. McGoohan now had to come up with an ending to the series. Up till almost the final moment, when he produced the script for 'Fall Out' after a 36-hour uninterrupted writing session, nobody involved in the production (including McGoohan himself) knew how the series was actually going to end. 'Fall Out' was finally completed just two weeks before its transmission date in early February 1968. Lew Grade later commented:[14]

> I kept asking if there would be an ending ... He said, don't worry, there will be an ending.

The final episode of the series was produced under cathartic conditions. McGoohan had to come up with an ending that was true to his conception of the series as an allegory. With Grade's 'carte blanche' behind him, and knowing the series was ending anyway, he was in a position where he could fully concentrate on exploring his philosophical concerns. The result, 'Fall Out', was an audaciously inventive surrealistic extravaganza which still stands virtually alone in television history.

Despite McGoohan's extraordinary feat of authorial control, it is clearly impossible for any one individual to be the only 'author' of a television series on the scale of *The Prisoner*. A certain degree of authorship must be ascribed to the writers of individual episodes, particularly Vincent Tilsley, who wrote 'The Chimes Of Big Ben' and 'Do Not Forsake Me, Oh My Darling'; Anthony Skene, who wrote 'A, B and C', 'Many Happy Returns' and 'Dance Of The Dead' and Terence Feely, who wrote 'The Schizoid Man' and 'The Girl Who Was Death'. Other writers engaged for just one episode were Lewis Grieffer ('The General'), Gerald Kelsey ('Checkmate'). Roger Woddis ('Hammer Into Anvil'), Michael Cramoy ('It's Your Funeral') and Roger Parkes ('A Change Of Mind'). Two directors apart from McGoohan had strong influences on the series' style – experienced film directors Don Chaffey, who directed 'Arrival', 'The Chimes Of Big Ben', 'Dance Of The Dead' and 'Checkmate' and Pat Jackson, who directed 'A, B and C', 'The

14 Lew Grade quoted from *Six Of One: The Prisoner File*.(Channel 4 documentary, 1984).

Schizoid Man', 'Hammer Into Anvil' and 'Do Not Forsake Me, Oh My Darling'. Also, Peter Graham Scott directed 'The General' and Robert Asher 'It's Your Funeral'. There were several other key creative figures in the production process – notably Art Director Jack Shampan and Director of Photography Brendan J. Stafford, both veterans of *Danger Man*. For a series on this scale, this is in fact a surprisingly short list of names, comprised largely of individuals who McGoohan felt he could entrust his vision to.

Only two of the key figures involved have strong claims for a share in of the overall authorship of the series. David Tomblin, the series' Producer, who also directed 'The Girl Who Was Death', wrote and directed 'Living In Harmony' and co-wrote 'Arrival'. In effect he was McGoohan's main creative assistant throughout the whole production, and had considerable input in terms of ideas. His directorial style has considerable similarity to McGoohan's, as both make frequent use of hand-held cameras and other unconventional cinematic devices. The strongest competing claim to 'co-authorship' rests with George Markstein, the Script Editor (who also co-wrote 'Arrival'). A script editor has considerable power over the making of a series, being in charge of supervision of the scripts. Markstein has claimed that the basic idea for the series was his. During World War Two he had been a journalist attached to British Intelligence and had found out about a secret British installation in Scotland used for housing spies who 'knew too much'. The inhabitants were well treated, but were virtual prisoners because of the sensitive nature of their knowledge of national security matters. Other accounts, however, have McGoohan hearing about the place independently. But certainly there was conflict over the direction of the series between Markstein and McGoohan. Markstein, who was a highly successful novelist in the secret agent genre, argued strongly for keeping the series within the parameters of that genre while McGoohan kept pushing the series towards increasingly surreal and allegorical realms. Gradually the question as to whether 'East' or 'West' runs the Village becomes irrelevant. In 'The Chimes Of Big Ben' The Village is said to be in Estonia, whereas in 'Many Happy Returns' it appears to be somewhere on the coast of Morocco. After the first 13 episodes had been produced, Markstein left the series, disillusioned that his 'realistic' concept of the series had been diluted, which put McGoohan in an even more enhanced position of authorship.

Despite all the constraints and limitations of the TV series form, *The Prisoner* represented the expression of a single artistic voice in a way that no other series on such a scale has ever equalled, but this was only achieved by an often literally 'heroic' personal effort by McGoohan himself. As well as controlling the production process, as an actor McGoohan is the focus of the entire series and he is featured in all its major scenes (apart from one episode, 'Do Not Forsake Me, Oh My Darling' when his movie commitments meant that he only made very brief appearances at the beginning and end). With no 'assistants' and no genuine romantic entanglements, the dramatic weight of the series also falls almost entirely upon his head. Such concentration of

drama and production on one individual is extraordinary, but it mirrors the entire theme of the series. Just as the story depicts allegorically the struggles of the Individual against a superficially 'caring' but actually viciously repressive society, so McGoohan's role in the production process pits him as a creative individual against the entire weight of the established corporate production process of series TV.

It can be argued, then, that there are two 'texts' of *The Prisoner* – the series itself and the story of its production and initial reception. In both texts McGoohan is cast as the supreme individualist. His monomaniacal, melodramatic composition and production of the final episode mirrors the wild, iconoclastic surrealism in the programme. Then there are points at which the two texts merge: the Prisoner's birthdate in 'Arrival' is identical to McGoohan's. The photo of the Prisoner which is dropped into the 'Resigned' file in the credit sequence is an old publicity shot of McGoohan. The actor playing the official in the credit sequence who the Prisoner hands his resignation to is none other than George Markstein. And, as we have seen, to make *The Prisoner* McGoohan had to 'resign' from his lucrative job as *Danger Man*. In its breaking down of the barriers of the television series, *The Prisoner* not only symbolises the struggle of the Individual against society but dramatizes the immense difficulties involved in getting one strong creative voice to be heard above the corporate clamour that is the television industry. When the Prisoner declares ... *I am not a number, I am a free man* ... he is rebelling not only against 'society' but against the medium of television itself.

This attitude of 'subversiveness' towards its own medium marks *The Prisoner* as a classic example of a postmodernist text. David Lodge[15] has listed the main principles of postmodernist composition as 'contradiction, permutation, excess and short-circuit'. *The Prisoner* uses contradiction frequently (particularly in its misleading information about the location of the Village). According to Lodge, 'contradiction' is usually accompanied by a feeling of sexual ambivalence and a wealth of trivial detail which makes life appear absurd. *The Prisoner* obviously has both of these elements in plenty. 'Permutation' refers to the frequent use of multiple narrative lines in postmodernist texts. *The Prisoner* continually juggles with several basic narrative lines – the attempt to escape, the efforts of the Village controllers to get the Prisoner to conform and the mystery of the existence of Number 1. At first it seems that the attempt to escape is the crucial narrative line but by the end of the series the revelation of Number 1 becomes more important.

Commenting on the novels of Alain Robbe-Grillet, Lodge defined what he meant by 'excess':[16]

> By presenting the reader with more data than he can synthesize, the discourse affirms the resistance of the world to interpretation.

15 David Lodge, *Working With Structuralism*, p.13.
16 David Lodge, *Working With Structuralism*, p. 14.

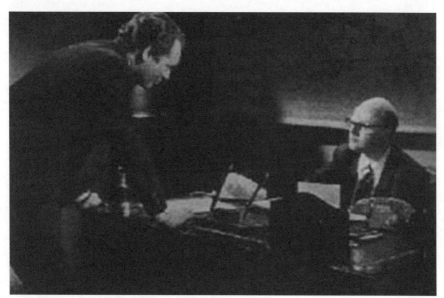

Credit Sequence: McGoohan and Markstein

The Prisoner clearly and deliberately confuses its audience by presenting it with apparently insoluble conundrums such as the issue of who runs the Village, where it is located and exactly what its purpose is. It also barrages the viewer with strange, idiosyncratic imagery (such as the Penny-Farthing, Rover and the Butler), making any single interpretation irrelevant. Lodge also argues that a characteristic of 'excess' is that the main character or narrator's thoughts or actions represent the nature of the social interaction being depicted. This is of course certainly true if one reads *The Prisoner* as an allegory with the Prisoner as an 'Everyman' figure. By 'short-circuit' Lodge was referring to the use of metafictional ploys and the element of self-consciousness about the medium being used. With its constant use of television itself as a narrative device and its frequent depiction of 'screens within screens' *The Prisoner*'s self-referentiality is completely encoded into its structure. It uses the conventions of the television series knowingly, subversively, to undermine those conventions. And it leaves its conclusions wide open to interpretation.

In order to 'decode' *The Prisoner*, the viewer has to enact what Jacques Derrida[17] calls a 'double act'. That is, to maintain a faithfulness to the fictional text's internal logic while making it go 'beyond itself', to look for the unconscious internal (and in this case, mythical) logic of the text. This is what I have attempted to do in this book. Uniquely for a television series, the text (or 'texts') of *The Prisoner* can be ascribed to one over-riding authorial voice.

17 Jacques Derrida, *Positions*, p.198.

Be Seeing You
Theatrical and Cinematic Qualities of The Prisoner

... the television medium presents us with a continuous stream of images, almost all of which are deeply familiar in structure and form ...
 John Fiske and John Hartley, *Reading Television*[1]

All the world's a stage
And the men and women merely players,
They have their exits and their entrances
And one man in his time plays many parts,
His acts being seven ages
 Shakespeare, *As You Like It*, as quoted by Number 2 in 'Once Upon A Time'[2]

Television is by its nature an amalgam of a wide variety of different visual and linguistic discourses. It is capable of combining the visual language of the cinema (as expressed in camera angles and movement, styles of editing and framing) with the dramatic immediacy of theatre. Yet

1 John Fiske and John Hartley, *Reading Television*, p. 17.
2 William Shakespeare, *As You Like It*, Act II, Sc. VII, lines 139-143.

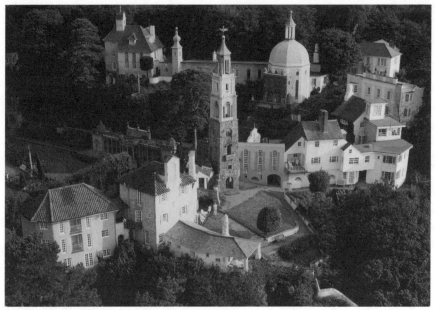

The Hotel Portmeirion, Gwynedd, North Wales

most TV series have to be produced at such a speed, at such low cost, and with such purely commercial intentions in mind, that they fail to take advantage of this potential. As we have seen, McGoohan's attempt to transcend the 'conveyor-belt' mentality of TV production by insisting on high production values throughout *The Prisoner* resulted in the series being curtailed to a 'mere' seventeen episodes – a very short run for a big-budget series of the day. Yet what remains is a series that utilises powerful theatrical and cinematic qualities in its audacious attempt to expand the aesthetic boundaries of the television series as a form. It is an ironic mark of McGoohan's perfectionism in attempting to achieve this that, as White and Ali[3] report, he insisted that the actual word 'television' never be used on the set.

The main physical setting of *The Prisoner*, the exclusive holiday village of Portmeirion in North Wales, provides a particularly 'theatrical' context for the series. The use of a single setting limits most of the action to a specific group of locations – such as the main square, the cafe, Number 6's house, The Green Dome, the beach and the stone boat. The dramatic confrontations which occur in those settings are often highly theatrical ones, in which at least one of the characters is, or appears to be acting out a role – whether it be Number 2 pretending to be the Prisoner's friend to gain his confidence, or the Prisoner turning the tables by reversing the process. Although the high-quality filmed location footage clearly shows the viewer that 'the Village' is

3 Matthew White and Jaffer Ali, *The Official* Prisoner *Companion*, p.142.

a 'real' place rather than an studio set, the strange bricolage of international architecture at Portmeirion gives it a certain 'otherworldly' or fantastical quality. Despite the obviously cinematic 'look' of the series, the use of Portmeirion as a setting encourages the audience, like an audience in a theatre confronted by obviously 'artificial' sets, to suspend disbelief.

The Village looks like – and is – a real 'holiday' location, a fact which adds irony to its real function in the series as 'prison'. As McGoohan was making both an action/adventure series and a moral allegory, its setting needed to look simultaneously 'real' and artificial. The Village was also required to look like it could be anywhere in the world, as its 'true' location in the series was always to remain a mystery. McGoohan, who discovered Portmeirion when filming there for an early episode of Danger Man, later commented:[4]

> This was a setting that could be beautiful enough, mysterious enough and confining enough to be the place for our man … in isolation.

Apart from the Portmeirion shots, most of the rest of the series was filmed in studio-constructed interiors – most prominently Number 2's room, a large circular set equipped with a viewscreen, a whole range of technological 'props' including automatic sliding doors and Number 2's 'bucket chair' which rises up out of a circle in the floor at a press of a button. In front of the chair is a semicircular desk, on which stand yellow, blue and orange portable telephones. The Village Control Room appears to be a large circular room equipped with every kind of surveillance device, in the middle of which two Village operatives continually swivel around on a bizarre electronic 'see-saw' whilst staring into cameras. On the wall is a large map of the world, visually suggesting the 'whole earth as the Village' paradigm from 'The Chimes Of Big Ben'.

Another important setting is the 'Committee Room', to which the Prisoner is first summoned in 'Free For All'. Again the set design is circular, with a series of lecterns placed in a circle around the lectern on a revolving circular dais which the Prisoner stands on whilst being whirled around and 'brainwashed'. Here the design intersects the circles with triangular and pyramidic shapes. Behind Number 2's chair is a purple pyramid with a glowing eye at the top – an ancient symbol of secret societies.[5] The highly expressionistic design of these sets creates a sense of theatrical artificiality which (as has been mentioned in Chapter One) has visual echoes of the work of German expressionist film makers of the 1920s such as Fritz Lang and F W Murnau.

The series' crowd scenes also have a strong air of being 'stage-managed'. The population of the Village is permanently under the mind-control of the

4 Patrick McGoohan quoted from Six Of One: The Prisoner File.
5 Robert Shea and Robert Anton Wilson, in their Illuminatus trilogy of 'psychedelic Science Fiction' novels, identify the symbol as that of the Illuminati, a global conspiracy which controls world governments. As they also point it, it also appears on the dollar bill!

Village 'guardians'. On a number of occasions (such as in the 'carnival' scene in 'Dance Of The Dead') the cast of extras, all dressed in similar costumes, take part in their designated 'fun' activities with blank expressions and rather stiff, mechanical movements. In 'The General', the Prisoner scathingly calls them, 'a row of cabbages'. In 'Arrival', Number 2 demonstrates to the Prisoner his power over them by successfully ordering the entire crowd to stop in its tracks, which it does instantly. Here, as later in 'Free For All', the crowd scenes appear highly artificial and deliberately 'choreographed' – again placing *The Prisoner* outside the naturalistic mode which is conventional for a TV series. The costumes – striped 'holiday' shirts, boaters and slacks, along with colourful umbrellas – and the frequent use of brass band music, resemble the costuming used for a theatrical 'musical' production. The brightly-coloured clothes of the Villagers are in contrast to the top hats, dark coats and dark glasses of the frequently seen Village 'undertakers'. Such theatrical devices work in *The Prisoner* as key defamiliarising elements, maintaining a constant air of slight 'unreality' which seem at odds with many of the other elements of the series, such as its largely conventionally-shot fight and chase scenes.

The Prisoner also contains a number of Shakespearean allusions. As we saw in Chapter 1, the Village as a dramatic setting can be likened to Elsinore in *Hamlet* – a place of confinement from which the protagonist cannot really escape, and a setting for the dramatization of the conflict within his own mind. The connection is made specific in 'The Schizoid Man' where the Prisoner fights a duel with his 'double' and quotes *Hamlet:*[6] 'these foils have all a length ... Aye, my Good Lord' In 'Once Upon A Time' Number 2 declares 'William Shakespeare ... he summed it all up' and the whole (extremely theatrical) episode is structured around, and punctuated by, references to the 'Seven Ages of Man' speech in *As You Like It*. *The Prisoner* is also 'Shakespearean' in its concentration on – and universalisation of – its central character. In many ways, the Prisoner is a tragic figure, who can never really escape from the Village any more than any of us can escape from the essential conflicts within our own minds. In that sense he shares his tragedy with Hamlet, Macbeth, Lear and Othello.

The Prisoner also displays the considerable influence of modern absurdist drama, particularly in those episodes ('Free For All', 'Once Upon A Time' and 'Fall Out') which are scripted by McGoohan himself. The series has many of the qualities of an absurdist drama. On one level, its entire premise – the existence of the Village and its 'social system' – is absurd. Also, the need for 'secrecy' in its dialogue (we must never hear the Prisoner's real name or discover what his real job was or the real reason for his resignation) again places much of its dialogue outside conventional naturalistic boundaries. *The Prisoner* has a particular kinship with Samuel Beckett's *Waiting For Godot* (1955), in which the protagonists (like the Prisoner) wait for a deliv-

6 William Shakespeare, *Hamlet*, Act V, Scene II, lines 279-80.

erance which will never really come. 'Godot' himself is as illusory as *The Prisoner*'s 'Number 1'. Beckett's use of deliberately minimalistic lines – a key feature of modern drama since Godot itself was written – is also echoed in the series, particularly in the penultimate episode 'Once Upon A Time'. Midway through *Godot*,[7] the following conversation takes place:

ESTRAGON: Then adieu.
POZZO: Adieu.
VLADIMIR: Adieu.
POZZO: Adieu.
(Silence. No one moves.)
VLADIMIR: Adieu.
POZZO: Adieu.
VLADIMIR: Adieu.
(Silence)
POZZO: And thank you.
VLADIMIR: Thank you
POZZO: Not at all.
ESTRAGON: Yes yes.
POZZO: No no.
VLADIMIR: Yes yes.
POZZO: No no.
(Silence)
POZZO: I don't seem to be able (long hesitation)
 ... to depart.
ESTRAGON: Such is life.

The absurdity of the dialogue here mirrors the absurdity of life itself as exposed in the play. A similar feeling is generated in one extraordinary exchange in 'Once Upon A Time'. Number 2 confronts a drugged Prisoner, attempting to discover why he has resigned. Dressed as a schoolteacher, he writes 'A, B, C, D, E' on a blackboard.

NO. 2: A, B, C, D, E say them
PRISONER: One, two, three, four, five.
NO.2: Six.
PRISONER: Five.
NO.2: Six.
PRISONER: Five.
NO.2: Six.
PRISONER: Five.
NO.2: Six.
PRISONER: Five.

7 Samuel Beckett, *Waiting for Godot*, Act I.

NO.2:	Six.
PRISONER:	Five.
NO.2:	Six.
PRISONER:	Five.
NO.2:	Six of one ... six of one ...
PRISONER:	Five.
NO.2:	Six of one ... six of one ...
PRISONER:	Five.
NO.2:	Six of one ... six of one ...
PRISONER:	Five.
NO.2:	Six of one ... half dozen of the other..
PRISONER:	Pop goes the weasel.
No.2:	Pop.
PRISONER:	Pop.
NO.2:	Pop.
PRISONER:	Pop.
NO.2:	Pop.
PRISONER:	Pop.
NO.2:	Pop.
PRISONER:	Pop, pop.
NO.2:	Pop.
PRISONER:	Pop, pop.
NO.2:	Pop protect.
PRISONER:	Protect?
NO.2:	Protect pop.
PRISONER:	Pop.
NO.2:	Pop protect.
PRISONER:	Pop.
No.2:	Protect other people.
PRISONER:	Protect other ... pop ...
NO.2:	Protect other people.
PRISONER:	Pop.
NO.2:	Why?
PRISONER:	Pop.
NO.2:	Why?
PRISONER:	Why pop?
NO.2:	Why?
PRISONER:	Pop.
NO.2:	Why why why?
PRISONER:	Pop goes the weasel (sings) ... Half a pound o'tuppenny rice ...
No.2:	Why why why why?
PRISONER:	... Half a pound o'treacle ... that's the way the money goes ...
No.2:	Why why?

PRISONER: ... Pop goes the weasel.
NO.2: Half a pound of ... pop ... pop..
PRISONER: Why?
No.2: Pop? Pop? Pop? Pop?
PRISONER: Pop.

Here, Number 2 fails to make the Prisoner state his Village Number (Six), then pursues the acronym POP (protect other people), hoping this will make the Prisoner reveal why he resigned. But the Prisoner merely taunts him with a nursery rhyme. The symbolic conflict between the two characters is acted out on an absurdist level, and the script here rises to illogical extremes that few television playwrights would dare attempt, never mind the makers of a popular glossy 'action' series. Yet *The Prisoner*, despite or perhaps because of its obvious 'weirdness' by this stage (the penultimate episode), managed to hold a mass audience right up to its final episode.

Dialogue in the series is frequently kept to a minimum, and wherever possible the story is told visually. Minimalistic dialogue is used on other occasions, notably in the final episode 'Fall Out' and the earlier 'Checkmate' where the Prisoner undergoes a 'word association' test. 'Once Upon A Time' itself takes place almost entirely in what Number 2 calls 'The Embryo Room' – a set with moveable and obvious props which visually resemble those in a modern 'studio drama' piece. Most of the action is performed against plain black backcloths, providing a minimalist visual cue for the dialogue.

The scripts of *The Prisoner* also contain a high degree of ironic dialogue, all of which helps to position the series in an allegorical mode. The social interaction within the Village is on the surface pleasant and trivial. Villagers cheerfully say 'Be Seeing You' to each other as they pass. The frequent announcements over the Village tannoys of 'Good Morning, Good Morning ... it's a beautiful day' jokingly link the Village to holiday camps such as Butlin's, which in the 1960s actually had loudspeakers in their chalets to wake up their 'happy campers'. Conversations between members of the Village are frequently held on the level of bourgeois English politeness. An example is in 'The General' where the Villagers test each other on their indoctrinated knowledge of nineteenth-century history as if commenting on the time of day. Most conversations between the Prisoner and Number 2 are conducted with an air of superficial bonhommie. Number 2's frequently call the Prisoner 'old chap' or 'my dear fellow', as if they are old friends. It is made clear that such a form of discourse, despite its apparent pleasantness, does not preclude the existence of a fundamentally vicious totalitarian system. In fact, in the modern world it only eases it. *The Prisoner*'s postulation of 'the whole earth as the Village' depicts a world in which apparently pleasant conversation hides the real 'language' of social control. In 'Free For All' the Prisoner is interrogated by a man in a formal grey suit who speaks in a plummy, concerned way:

MAN: You're honest ... that's good ... Honesty attracts
 confidence ... and confidences are the core of our business
 ... see how honest I'm being with you.
(Cut to Control Room)
NO.2: Very good technique. Where did you get him?
CONTROL
OPERATIVE: The Civil Service. He adapted immediately.

Here the social comment in McGoohan's script is very explicit. It is clear-ly implied that a British civil servant would fit in smoothly with the opera-tion of the Village. Elsewhere, the discourse used is that of the British public school, a prime example of a hierarchical system whose brutality is disguised by language. The blazers, boaters and scarves worn by the Villagers suggest a casual form of 'school uniform'. In 'The Schizoid Man' the Prisoner com-ments, when confronted by an 'angry' Rover, 'Oh dear ... looks like we're in trouble with the headmaster'. *The Prisoner* implicitly satirises such particu-larly British institutions through its use of language, and strongly suggests that British bourgeois gentility is merely a 'front' for rigorous social manip-ulation. *The Prisoner* certainly has a kinship with Lindsay Anderson's con-temporaneous film *If ...* (1968) which satirises the British class system through its depiction of a British public school as a virtual 'prison'. The film's final scenes, which depict a surreal 'fantasy revolution' by the pupils, are similar in tone to the 'revolution' scenes in 'Fall Out'.

There are a number of phrases which, through continual use in the series, grow to have central significance. The Prisoner's retort to Number 2 in 'Arrival' that 'I will not be Pushed, Filed, Stamped, Briefed, Indexed, Debriefed or Numbered' is repeatedly shown onscreen in the final episodes and is used again at the crucial moment in 'Fall Out' when he confronts Number 1. Through repetition, it becomes a central verbal motif of the whole series, a radical declaration of the Prisoner's intent and the balance to the insistent cry of the Number 2's: 'Why did you resign?' The unequivocal 'I Am Not A Number, I Am A Free Man' achieves a similar status through its constant repetition in the second half of the Credit Sequence. Various slo-gans are also seen around the Village, and are sometimes repeated by Villagers. Their tone echoes wartime warnings such as 'Careless Talk Costs Lives' and Orwellian propaganda in 1984 such as 'Ignorance is Strength'. The Village slogan 'A Still Tongue Makes a Happy Life' is particularly Orwellian. More ironic, perhaps is 'Humour is the Essence of a Democratic Society' as the Village permits neither humour nor democracy. In 'Hammer Into Anvil' we are informed that 'Music makes a Quiet Mind' and in 'Dance Of The Dead' that 'Questions are a Burden to Others, Answers a Prison to Oneself'. All the slogans are designed to reinforce the social control of the 'establishment' but they are all couched in essentially reassuring tones. A wall poster slogan in 'It's Your Funeral' even borrows from the American constitution : 'of the People, by the People, for the People'.

The Prisoner is introduced to the Village greeting 'Be Seeing You' early in the first episode. Soon he is using it ironically himself. The slogan, which is accompanied by a curious gesture consisting of a 'salute' formed by making a circle with the fingers around the area of the forehead, becomes ubiquitous throughout the series. It is *The Prisoner*'s quintessional ironic phrase. To the 'guardians' it means that they will continue to maintain their 24-hour a day surveillance. The Prisoner prefers to use it as a 'polite' way of saying goodbye. Characteristically, it is an everyday phrase whose meaning is potentially hidden. On another level, the greeting is perhaps addressed to the viewers of television themselves. As a primarily visual medium, television, of course, is all about 'seeing' ... The Prisoner will 'Be Seeing You' when he returns next week. But in the Village, the main function of television is not for the people to 'see' programmes but for the 'guardians' to 'see' what they are doing. So the phrase takes on more and more ironic resonance as the series progresses.

Another key factor in *The Prisoner*'s use of language is its avoidance of names. Although a few characters, such as Cobb in 'Arrival', Nadia in 'The Chimes Of Big Ben' and Dutton in 'Dance Of The Dead' are named, the inhabitants of the Village are generally known only by their numbers. A slight exception is 'Checkmate', where characters are known by their status as chess pieces, such as 'The Rook' and 'The Queen'. The device helps to underline McGoohan's allegorical intent. The linguist Roger Fowler[8] describes such a technique – where an element in a narrative is presented from an unusual point of view to achieve a defamiliarising effect – as 'undercoding'. The refusal to use 'naming' hits problems in the episodes where the Prisoner makes his 'false escapes' and confronts people from his past life. Here the scripts are shaped so that even his girlfriend in 'Do Not Forsake Me Oh My Darling' does not refer to him by name. His adoption of the moniker 'Peter Smith' in 'Many Happy Returns' does not convince anyone. Yet the 'refusal' makes apparently naturalistic conversations seem somehow slightly 'unreal' and 'dreamlike' in a way that is thoroughly in tune with the series' intent, encouraging the viewer to reflect on the artificiality and constructedness of the script. Such 'undercoding' positions *The Prisoner* in a clearly 'theatrical' light in comparison to other TV series (such as Police or Hospital series) where 'naturalness' of dialogue is valued most of all.

Not only does the series avoid 'naming', it also deliberately avoids the creation of 'rounded' individual characters. Virtually all the characters in the series are defined and motivated exclusively by their relationship to the Prisoner. The only 'recurring' character is Number 2, who is invariably engaged in a mental battle to 'break' the Prisoner. Yet Number 2 is played by a different actor almost every week (Colin Gordon plays Number 2 in both A, B, and C and 'The General' and Leo McKern plays him in 'The Chimes Of Big Ben', 'Once Upon A Time' and 'Fall Out'). Any 'differences' between Number 2's are rarely announced. Sometimes Number 2 is sadistic (as with

8 Roger Fowler, *Linguistic Criticism*. Chapter Ten.

Patrick Cargill in 'Hammer Into Anvil', or Colin Gordon in 'A, B and C'). Occasionally, as with the threatened Andre Van Gyseghem in 'It's Your Funeral', Number 2 is actually a sympathetic, pitiable figure. But usually he is a 'smooth' charmer, convinced he can break Number 6 'his way'. In 'Many Happy Returns' and 'Living In Harmony' the Number 2's appear 'in disguise' for nearly all of the story. Yet it is arguable – especially when considering *The Prisoner* as an allegory – that Number 2 is really one character – the voice of the establishment, that of the politician, the charmer, the tempter (or in the case of Mary Morris in 'Dance Of The Dead', the temptress), the voice of the Devil in the ear of Faust or Jesus, offering the world for the small price of a soul.

As the main 'guest star' in a high-budget series the role of Number 2 was a prestigious one and many well-known TV, film and theatrical leads were employed, perhaps most notably Eric Portman (veteran of many British films) and Leo McKern (later to become a household name for his role in *Rumpole Of The Bailey*). The actors chosen were often associated with parts in which considerable authority is rested, for with the role of Number 2 in its conflict with the Prisoner rests the central dramatic conflict of the series – that of the rebel versus authority. The conflict between the two is almost entirely cerebral and the Prisoner's 'fight scenes' are invariably with Number 2's 'henchmen' rather than Number 2 himself. Sometimes (as in 'Arrival', 'Free For All', or 'Dance of The Dead') Number 2 wins out, leaving the Prisoner mentally battered if not compliant. On other occasions (such as 'A, B and C', 'The General', 'Hammer Into Anvil', 'It's Your Funeral' and 'A Change Of Mind') the Prisoner triumphs. The final conflict between the two is explored in 'Once Upon A Time', where Number 2 plays a series of 'father' and 'authority' roles but fails to break the Prisoner. The confrontations are in general highly theatrical, with both Number 2 and the Prisoner consciously 'playing a part' for a particular effect. In 'Hammer Into Anvil' the Prisoner convinces the paranoid Number 2 that he is a 'plant' who has been sent to test him.

In many ways, Number 2 is a sympathetic character. As the Prisoner points out in 'The Chimes Of Big Ben' he is as much a 'prisoner' as Number 6 himself. He is perpetually in fear of Number 1, who may call at any time on the orange portable telephone on his desk, and whose wrath he will feel when he fails to 'break' the Prisoner. As the first Number 2 only half-jokingly remarks in 'Arrival', 'you'll be the death of me'. In the final 'Fall Out' McKern's Number 2 is revealed as another 'individual in revolt'. The conflict between the Prisoner and Number 2 is an elemental one, which dramatizes the eternal struggle between the Individual and the 'establishment' in personal terms. Such a ritualistic conflict of 'elemental' characters is far more characteristic of theatre than of television or cinema.

The drama of *The Prisoner* is, however, mainly focused around one character – the Prisoner himself. It is a drama revolving around the question of his own identity. Through the series McGoohan portrays the Prisoner

through a series of assumed 'identities'. Most dominant is the 'angry Prisoner' of the 'I Am Not A Number' sequence. This 'Prisoner' is the steely-eyed, determined superspy 'hero' figure who never gives in to the authorities, and whose physical movements – like the way he bangs his fist on the desk in the credit sequence – reflect his mental anguish at being imprisoned. McGoohan had already established himself as an actor with a considerable 'TV presence' and charisma through his role as Danger Man, in which his character generally had to appear in different 'disguises' every week. In *The Prisoner*, McGoohan's character can also be a smooth, ironic, charmer – fighting Number 2 at his 'own game'. If it suits his purposes he can also be romantic (as with the 'Russian agent' Nadia in 'The Chimes Of Big Ben') or whimsical (as when he exhibits his work at the 'art exhibition' in the same episode). But each assumption of such a 'character' is essentially an act – we know this is not the real Prisoner …

The Prisoner is also subjected to constant attempts to make him 'crack' using technological brainwashing 'machines' like the light over his head in his bedroom or the revolving 'ball of light' that hangs in the Village's 'Committee Room'. In many of the episodes he is drugged and subjected to techniques of psychological disorientation. Under the influence of drugs and brainwashing various 'Prisoners' emerge. There is the 'frightened child' unsure of his own identity when presented with his 'doppelganger' in 'The Schizoid Man' or convinced that he has been lobotomised in 'A Change Of Mind'. There is also the 'happy child' in 'Once Upon A Time' who gleefully accepts Number 2's invitation to 'go walkies.' In 'Free For All' the Prisoner becomes a politician, drugged into mouthing official platitudes. Through much of 'Fall Out' he is a passive observer, cold and unemotional. In 'The Girl Who Was Death' he plays it for laughs, twirling a moustache and dressing as Sherlock Holmes. Yet the audience is again always aware that these are 'assumed' roles. The 'Angry Prisoner' will always predominate. Even in cowboy garb in 'Living In Harmony' he is still essentially the anti-establishment rebel hero.

In creating *The Prisoner* McGoohan links his understanding of the theatrical with his vivid sense of the cinematic. He fully uses the visual effects of the medium of television to achieve this. Television, like the cinema, is essentially an image-led medium which tells its stories in a primarily visual way. A big-budget series like *The Prisoner* is shot on film, not videotape and in that sense can be seen (or even shown) as a series of 'movies'. McGoohan's insistence on high production values meant that the series gained an overall cinematic 'look' which was virtually unprecedented in its day. Yet to achieve this within a television budget, however relatively high by the standards of other TV shows, was a remarkable achievement only possible because of the 'impossibly' long hours worked by its makers. There are a few occasions – notably in the very hurriedly made 'Do Not Forsake Me, Oh My Darling' – where the series looks 'cheap' – but these are the exception rather than the rule.

Christian Metz[9] has identified five channels of communication within which cinematic codes are utilised – images, written language, voices, music and sound effects. *The Prisoner* uses each of these categories in the service of the allegory, and to visually counterpose the drama. *The Prisoner* has its own written script, a slight adaptation of the Albertus* typeface, which appears as the series' logo and typescript for its credits. The script is also used by the Village for all official purposes. With its suppression of the capital letter, the script has a certain 'childlike' quality, symbolising the dependence of the Villagers. It also has the effect of making 'Village' products immediately recognisable. The previously- mentioned slogans like 'A Still Tongue makes a Happy Life' are displayed in Albertus in public places like the Village 'Hospital', where the viewer must sometimes be alert to notice them. Yet the Albertus script immediately tells us they are Village slogans.

The Prisoner has many very distinctive visual qualities. Firstly, the various elements of its *mise-en-scène* are presented so as to enhance its allegorical message. Such elements include the settings of Portmeirion itself and the interior sets. Portmeirion is almost always filmed in full sunshine, whereas the interiors are of course artificially lit. The visual contrast between the two main dramatic settings are extreme, with the interior sets representing the protagonist's inner journey. Also important are the elements of costume and crowd movement, which have already been discussed from a theatrical point of view.

One of the features that makes the series particularly distinctive on a visual level is its highly symbolic use of props. Perhaps the most notable is 'Rover', the mysterious giant white balloon which appears in many of the episodes. Rover is the Village's most dangerous weapon, and is its most effective guardian. At the end of each programme, after the end credits, we see Rover bubbling up from its undersea hideaway. At other times, the sight of Rover against the setting of the Village is one of the most surreal of the whole series. Rover has the power to kill, as we see in 'The Schizoid Man', and whenever it takes a victim it appears to cause them severe mental distress. In a visual sense Rover symbolises the whole 'world' that *The Prisoner* depicts, one which 'suffocates' its victims.

Elements like Rover constantly recur through the series, so gaining an iconic quality. The Penny-Farthing bicycle which is wheeled around the Village, usually by the Butler, is particularly mysterious. McGoohan has described it as:[10]

> ... an ironic symbol of progress ... the Penny-Farthing bicycle represents a simpler age. We live in an era where science is advancing so quickly, you don't even have time to learn about the latest innovations

9 Christian Metz, *Film Language: A Semiotics Of The Cinema.*

* Publishers Note: There are a number of versions of the special Albertus script available in the Internet. That which is used for the headings in this book is known as Village and was obtained via the Internet from Mark Heiman (Email: mheiman@carleton.edu).

10 Patrick McGoohan quoted in White and Ali, *The Official Prisoner Companion* p. 171.

before something new arises; making what you've learned obsolete. It's the same with the newspapers. They're so busy cranking out information that before you get a chance to digest it, they're cramming something else down your throat! Everything is moving very fast, possibly too fast ... before its time.

This again demonstrates McGoohan's dark view of technology and the future in contrast to McLuhanite optimism. But in the context of the programme, the 'meaning' of the Penny-Farthing is never explained or commented on, and to viewers it may appear to be a wholly surreal element. *The Prisoner* itself is far too moralistic to be called a 'surrealist' text as such, but it uses strong visual elements of surrealism. One example is that of the 'glowing electronic eyes' of the 'classical' statues at the edge of the Village whose 'heads' turn to survey possible escapees. Another is the figure of ever-faithful Butler, played by the midget Angelo Muscat, who appears in every episode but is entirely mute. Essentially the Butler is another one of *The Prisoner*'s visual metaphors – he is the 'little man' who is always loyal to authority. Many viewers even suspected that the Butler would turn out to be Number 1. In terms of *The Prisoner*'s *mise-en-scène* his size and eternal imperturbability add to the dream-like quality of the images onscreen.

Other distinctive 'props' to be seen in the Portmeirion scenes include the Mini-Moke Village Taxis, the Villagers' multicoloured umbrellas and their 'jolly' striped jerseys and capes. The Portmeirion scenes – such as the 'election rally' in 'Free For All' where the Prisoner is showed in mulitcoloured tickertape – are often riotously colourful. In the series, the bright colours of the costumes and props represent the artificial frivolity of the Village's stage-managed 'fun'. In contrast, the Prisoner himself is always dressed plainly in black, which visually defines his opposition to Village 'gaiety'. Also frequently seen in the Village is the 'lava lamp', a popular decorative item of the late 1960s consisting of a transparent vertical tube within which bubbles of coloured oil continually separate and coalesce. Film of them 'bubbling' often appears on the screen in Number 2's room as a backdrop to his confrontations with Number 6. The image of the 'bubbles' has a close visual symmetry with the image of Rover rising from the ocean, seen when an escape attempt is being foiled and at the end of every episode after the end credits. All through the series, the Village is associated with round or bubble-like shapes, and in association with the terrifying Rover these take on an ominous aspect. As we have seen, the main Village interiors are all circular rooms. In the Control room, the Village operatives endlessly circle round on a raised podium whilst looking into surveillance cameras. Number 2's chair has a circular design and even the 'Be Seeing You' greeting involves making a circle with the fingers. The various indoctrination and brainwashing devices – such as the spiked spinning ball suspended from the roof of the Committee Room – are also invariably circular. The Albertus typescript uses a very circular design for its letters. Finally there is the circular shape of the

Penny-Farthing, the central visual symbol of the series and the official 'Village logo'. The circular designs always stand out within the rectangular shape of the television screen, providing a distinctive form of visual symmetry. Perhaps it could be argued that the circles represent the shape of the globe and thus 'the whole earth as the Village' Their use is certainly a consistent visual feature throughout the whole series.

Another distinctive feature of the 'composition within the frame' of *The Prisoner* is its frequent use of 'screens within screens' (referred to in the last chapter as an example of *The Prisoner*'s postmodern sensibility). The Green Dome and the Control Room contain large viewscreens from where the Villagers are watched. On several occasions the Prisoner is confronted with 'flashbacks' of himself from previous episodes, giving the impression that everything said in the Village is recorded and can be re-run. (And on another level predicting the day when all TV programmes can be recorded and re-run.) In 'A Change Of Mind' 'flashbacks' of the Prisoner are even 'doctored' to give the impression that he has warned successive previous Number 2's of assassination attempts. In 'A, B and C' the screens show the Prisoner's dreams. In terms of *mise-en-scène*, the use of screens-within-screens adds another perspective to the visual play of meaning in the series. Just as the 'guardians' watch the Prisoner on the screens, we as viewers watch the 'guardians' watching the Prisoner. In each case, the medium used is television itself. Thus, the use of screens-within-screens represents a visual commentary on the relationship between the viewer and the TV screen itself, adding to *The Prisoner*'s satirical dissection of the process of television-watching itself.

As Roland Barthes has pointed out,[11] mass media forms like television communicate primarily on the level of connotation – that is, by association with previously established 'meanings' of particular images:

> ... the text directs the reader through the signifieds of the image, causing him to avoid some and receive others – by means of an often subtle dispatching it remote-controls him towards a meaning chosen in advance.

In a television series a whole system of meanings of images is set up which is enhanced by their repetitive use (or lack of it). Just as a cinema film may use certain repeated elements as visual motifs to add visual elements to the meaning being put over, in the process of a TV series continual repetition over a long period establishes certain visual elements as being particularly crucial. The meanings of these elements only become fully recognisable through repeated watching of the series. *The Prisoner* is thus able to create a visual world of its own – its own specific symbolism.

Another important visual element in the series are the shots of London, which we see at the beginning of every programme in the credit sequence.

11 Roland Barthes, *Rhetoric Of The Image in Image/Music/Text*, p.40.

There are also 'London scenes' in 'Many Happy Returns', 'Do Not Forsake Me, Oh My Darling' and 'Fall Out'. The inclusion of Big Ben and the Houses of Parliament, the River Thames, Buckingham Palace and The Mall and Trafalgar Square in these scenes indicates a knowing use of already-established sign-systems. These buildings clearly have connotations in the mind of the British television viewer as representing the seats of authority of the British state itself, and they are a starting point and an end-point for the whole series, connecting the Prisoner to the centres of power and tradition in the 'real world' from which he has come.

Another visual feature of the series, which further places it in the realm of the 'surreal' are the sequences which are obviously meant to represent events in the Prisoner's mind. The uses of hand-held cameras, unusual camera angles, superimposition and other devices to suggest mental disorientation are well-known cinematic conventions for depicting 'interior' states such as dreams. In the case of *The Prisoner*, where so much of the essential action occurs within the protagonist's mind, such sequences are particularly important. An example is the 'memory montage' in 'Free For All', where the Prisoner 'replays' in his mind recent events. The use of super-imposition rather than just 'straight' cutting in these sequences further adds to the 'dream-like' quality of the imagistic chains. Superimposition and special visual effects are again used in 'The General' to depict Number 6 being 'brainwashed' by the 'Speedlearn' process being shown on his TV.

As the series progresses, the surrealistic quality of the images in the series tends to become more and more dominant. As the 'spy thriller' theme recedes and the allegory takes over, the visual distinctiveness of the series increases. This reaches a climax in the final four episodes – 'Living In Harmony' (cowboy story), 'The Girl Who Was Death' (bizarre children's adventure), 'Once Upon A Time' (theatre set) and finally in the surreal dreamscape of 'Fall Out'. Yet all through the series, the Prisoner's story is told primarily in a visual mode. The credit sequence (analysed later in this chapter) is a particularly strong example of the series' cinematic qualities, but there are many other sequences where the story is told through images and sound, without dialogue. A prominent example is the 23-minute opening sequence of 'Many Happy Returns' in which the Prisoner wakes up alone in a deserted Village and then makes his escape. Here, as in a number of other sequences, *The Prisoner* takes on the visual qualities of a silent movie, and tells its story in a purely cinematic way.

The series also contains more conventional visual cinematic codings. Virtually every episode involves the Prisoner in a fight scene (which he usually, but not always, wins). The fight scenes use the conventional technique of fast cutting accompanied by dramatic music. These are easily understood conventions by the audience, being common to television and film action-adventure series. The Prisoner's frequent attempts to escape in the early episodes provide many opportunities for spectacular chase scenes, for which the locations of Portmeirion – particularly its beach – provide an engaging visual backdrop.

The third of Metz's categories – the use of voices – also has an important role to play in the series. As we have seen, much of the dialogue is presented as chatty, ironic, bourgeois. The accents used are almost entirely those of Southern England – 'public school' standard English is the norm. This reinforces McGoohan's implicit critique of the hierarchical structure of British society, within which such accents are privileged over more regional variations. Also worth mentioning are the Village Tannoy announcements, made by the actress Fenella Fielding, famous for her deep, seductive, suggestive tones. Fielding's voice announcing 'Good morning, it's a beautiful day' is delivered with an air of superficial, artificial *joie de vivre* which is most appropriate for the shallow emotions that are all the brainwashed Villagers have left.

The use of music in *The Prisoner* is a particularly important, and sometimes overlooked, element in its overall effect. The music played over the Credit Sequence – the main '*Prisoner* theme' is a particularly dramatic and distinctive piece, which has had success as a 'hit single' in its own right on a number of occasions. The music was written by Ron Grainer, who also composed the equally distinctive *Dr Who* theme tune. According to Dave Rogers,[12] however, Grainer's theme is based on a tune which McGoohan himself made up. Grainer is also responsible for the thematic and incidental music within the series. He uses the conventional techniques of fast, rhythmic music for 'fight' and 'chase' scenes. And as is common with a TV series, *The Prisoner* has a number of musical 'themes' which counterpose particular types of scenes. Yet music in *The Prisoner* is also used as another sign-system, with which McGoohan constructs his allegory. An example of this is in the series' frequent use of well-known nursery rhyme themes, such as *Twinkle, Twinkle, Little Star* and *Pop Goes The Weasel*. In 'Once Upon A Time' Number 2 sings *Humpty Dumpty, Jack and Jill Went Up The Hill* and *The Grand Old Duke Of York* to the Prisoner, who has been drugged into a child-like state. The entire episode 'The Girl Who Was Death' is a children's story. On one level, *The Prisoner* is itself a fairy-story. The use of 'nursery rhyme' themes provide an often ironic counterpoint to its scenes of psychological torture and manipulation.

Other popular song themes are used for ironic effect – *For He's A Jolly Good Fellow* when the Prisoner is praised for his rebellion in 'Fall Out', *My Bonnie Lies Over The Ocean* in 'Do Not Forsake Me, Oh My Darling', (where the Prisoner's mind is set free but his body is literally 'kept prisoner' in another country), *Oh Susanna* in the 'Western' 'Living In Harmony' and the *Eton Boat Song* in the 'school' sequences in 'Once Upon A Time'. In 'Fall Out' The Beatles' *All You Need Is Love* is heard playing on a jukebox at the beginning of the episode and recurs (highly ironically) over the episode's violent scenes on confrontation and 'revolution' as the Prisoner organises revolt and escape from the Village. The young 'hippie' (Number 48) played

12 Dave Rogers, The Prisoner *and* Danger Man, p.220.

by Alexis Kanner in 'Fall Out' continually sings the old spiritual *Dry Bones* as a 'nonsense' answer to any questions he may be asked. In 'Hammer Into Anvil' the Prisoner uses a recording of Bizet's *L'Arlesienne* as part of his plan to disorientate Number 2. Throughout the episode he is seen whistling the main theme of the piece, which also occurs as incidental music, its tragic intensity providing a musical illustration of Number 2's 'tragic' paranoia. Various other themes are also used to signify various emotions. One example, used at whimsical moments, closely resembles Henry Mancini's *Pink Panther* theme.

Rick Altman[13] argues that the soundtrack dominates television, determining when the viewer actually looks at the screen. As television is what McLuhan called a 'cool' medium – one which does not necessarily take up all of our attention – the 'viewer' may be engaged in any number of domestic tasks – such as cooking, cleaning, sewing, ironing – while 'half-watching' the screen. As Altman points out, sounds such as theme music and announcements tend to slightly precede their accompanying images onscreen. Referring to Altman's work, Ellen Seiter[14] comments:

> ... the sound serves a value-laden editing function identifying better than the image itself the parts of the image that are sufficiently spectacular to merit closer attention by the intermittent viewer. Altman asserts that the television soundtrack acts as a lure, continually calling to us 'Hey, you, come out of the kitchen and watch this.' ... the primacy of the soundtrack isolates conventional notions in cinema aesthetics about the necessity of subordinating soundtrack to image.

Metz's final 'channel', that of sound effects, also has considerable importance in *The Prisoner*. Electronic sounds are used to considerable effect whenever technological 'brainwashing' devices are being used. The appearance of Rover is always accompanied by ominous-sounding electronic sound effects which give it much of its power as an image, turning what could appear to be merely ludicrous (a giant white weather balloon) into a potent symbol. Various other sounds, such as the insistent buzzing of the orange 'Number 1' telephone on Number 2's desk, and the bright musical notes that precede the cheery 'good morning' announcements, are sounds which gather more significance through repetition as the series draws to a climax.

It is important to remember that television and cinema use all five 'channels' – image, written language, voice, music and sound effects – simultaneously. Perhaps the most powerfully cinematic sequence in *The Prisoner* is its credit sequence, in which each of these elements is used to considerable effect. The credit sequence is repeated each week at the beginning of the

13 Rick Altman, referred to in Ellen Seiter, Semiotics, Structuralism and Television in Robert Allen (ed.) *Channels of Discourse*, p. 44.
14 Ellen Seiter , as above from *Channels of Discourse*, p. 44.

programme. It fulfils the function for new viewers of 'filling them in' on 'the story so far'. Such a 'storytelling' credit sequence is thus not uncommon in the TV series. The dramatic credit sequence in the American mid-1960s series *The Fugitive*, which explains how Dr Richard Kimble was wrongly convicted of murder and then shows his lucky escape after a train derailment on the way to death row, is one example. Other British series like *The Saint* and *The Avengers* used their title sequences to set a 'tone' for the programme. American series like *The Outer Limits* and *The Untouchables* used a narrator to explain 'the story so far'. Often, great effort and a large proportion of a series' budget may be put into its credit sequence, as it plays a large role in drawing the audience away from domestic distractions.

The credit sequence for *The Prisoner* is an extremely impressively executed example of cinematic storytelling, using all five of Metz's channels to considerable effect. The sequence lasts three minutes – unusually long for a credit sequence but extremely short for the amount of narrative and visual information conveyed. The sequence is constructed in two parts and consists of 61 different shots. In 'Arrival' an extended version of the first section is shown. For the purposes of the rest of the series the second section is used to sum up the action in the first episode. The sequence utilises the full cinematic range of camera angles and types of shot (long shots, mid-shots and close-ups). It is uses both straight cutting and superimposition in its editing, and it links together location and studio shots to give a condensed visual picture of the series.

Probably the most important dramatic element in the sequence is the '*Prisoner* theme' itself, a highly dramatic and expressive piece which creates a considerable suggestion of menace as well as suggesting the 'action-adventure' nature of the series. The theme tune is combined with sound effects in various places to considerable dramatic effect. The editing of the shots is, not surprisingly, very fast, and the types of shot used very varied.

The sequence begins with a loud peal of thunder, followed a second or so later by an image of clouds against a blue, stormy sky. This first image is essentially an elemental one, suggesting the emotion of anger or wrath that will dominate the series. This shot fades and is superimposed with an image in very long shot of a deserted road. A light drumbeat begins, which gets louder as the Prisoner's car – a custom-built Lotus 7 with the numberplate KAR 120C – approaches, getting larger within the frame. This shot lasts only a few seconds but is one of the longest shots in the sequence. The apparently 'empty' panorama which is then filled by an approaching vehicle is particularly cinematic, recalling Hitchcock's famed 'crop-dusting' sequence in *North By Northwest* or the scene in David Lean's *Lawrence of Arabia* where a single horseman emerges in the distance from an apparently empty desert. Meanwhile the title theme goes into its dramatic first few bars, guitars interplaying with a full brass section, and this continues through the next group of shots. Now we see McGoohan's face behind the wheel in close-up. His expression is set, determined, yet somehow with a hint of playfulness. His hair is apparently unruffled by any wind. We cut very quickly to another

shot of the deserted road, followed by a shot of the car from the side. Then we see the car in a mid-shot, crossing what is recognisably Westminster Bridge.

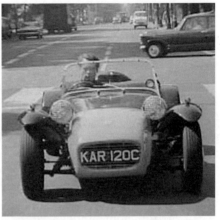

This is the first visual transition in the sequence from the 'unknown' from which the Prisoner emerges to the 'known'. The Prisoner's sudden, 'shock' appearance in London has parallels when he 'escapes' later in the series. The next few shots (again very rapidly cut) show us recognisable London landmarks – first Big Ben, from where the camera pans down to show us the Houses of

Credit Sequence: The Prisoner on his way to resign

Parliament and then the Prisoner's car passing by below. We cut to an overhead shot of him turning right into a street in Westminster. Now the music slows down to a more stately, ominous rhythm. The next shot, seen from the Prisoner's point of view, shows the car heading into what looks at first like an underground car park. Here the Prisoner begins his 'descent' into the 'underworld'. Up till now the images we have seen have been characterised by bright sunshine, but now we cut to a dark corridor. The Prisoner and his shadow appear in the distance and again approach the camera. As the music slows down to the pace of an insistent drumbeat, we hear the Prisoner's footsteps getting louder and louder. We cut to a close-up of the face, now more determined than ever.

The next shot is one of the most dramatic moments in the sequence. The Prisoner opens some doors and stands framed in the doorway in a Christ-like pose – he is, after all, about to 'sacrifice' himself. He is dressed, as he will be throughout the series, entirely in black. As he opens the doors there is another peal of thunder. We now cut to a shot of the room the Prisoner has just entered. Behind the desk sits a bald, bespectacled official who does

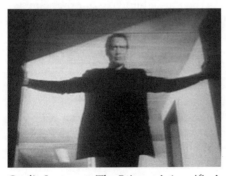

Credit Sequence: The Prisoner's 'sacrifice'

not look up. Above the man's head is a large map of the world. We then cut back to a close-up of the Prisoner's face. He is talking, but we do not hear the words. The music has built up in dramatic intensity again. The next shot is of his hand banging down a letter onto the desk. The letter is marked 'Private and Personal – by Hand'. The man's coffee cup jumps in the air as the Prisoner's fist lands on the table.

Then we cut to a very quick shot of the car leaving, emerging from the underground tunnel. There is a fast montage of images: a sign on a filing cabinet draw which the camera zooms in on, saying 'Resigned' and a shot of a typewriter with keys clicking. Then a sideways photo of the Prisoner (actually a publicity shot for *Danger Man*) is seen having 'xxxx' typed over it. Superimposed over this, we see a mid shot of the Prisoner in his car, now looking rather satisfied. The next shot shows him driving along Pall Mall. In the background we see Buckingham Palace, another highly recognisable London location. Behind him is a black taxi. Then we see a room with what look like endless filing cabinets on each side, suggesting a vast and impersonal bureaucracy. The Prisoner's resignation is conveyed into the relevant draw by an automatic device that slides along a rail above the cabinet and then drops the file into the 'Resigned' draw.

Up to this point, though we have had no dialogue, a clear story has emerged. Our hero, whoever he is, has clearly resigned from some top level government job. The office he has resigned at is obviously in the heart of London. We can easily imagine that he is a top level secret agent. Of course, the television audience of the time associated McGoohan with the figure of John Drake in *Danger Man*. To many viewers, what they were seeing *was* John Drake 'resigning'. This may have been an intertextual expectation that McGoohan was deliberately playing with.

The next shot shows the car pulling up outside the Prisoner's house. The first graphics come up, in Albertus script: 'Patrick McGoohan In'. We cut to the Prisoner getting out of his car, while the camera focuses in on the taxi which has now pulled up behind him. The taxi begins to move forward. Then we see the Prisoner entering his house. On his door is the number '1'. We cut to mid shots of the Prisoner inside his smartly-appointed house, picking up a suitcase. On screen we see the legend *The Prisoner*. The next few shots only take a few seconds and are rapidly intercut. The music slows again. A tall thin man resembling an undertaker in a morning coat and top hat emerges from the taxi and is seen walking up the steps to the Prisoner's house. We cut to the Prisoner packing some photographs of what look like holiday locations into his suitcase. Then a cloud of gas comes into the room through the keyhole in his front door. As the music builds to another climax, we see the suitcase snap shut, then the puzzled expression on the Prisoner's face, then the gas again. From the Prisoner's point of view, we see a view of skyscrapers outside. Then the skyscrapers are superimposed over his face, and the camera tilts and spins. As he falls back on his couch, the main title music ends and the screen fades to black.

As our hero wakes up, the music softens momentarily as he looks around him, confused. The room looks exactly like his own house. He stands up and draws the blinds. Then, from his point of view, we get our first view of the main square in the Village. The title of the individual episode comes up. As we cut to the Prisoner's face, we hear McGoohan's first voiceover. 'Where Am I?' he asks. Suddenly we cut to an interior of Number 2's house, with its

long ramp leading to the raised circular dais in the middle. Number 2's 'bucket chair' revolves towards us, but his face is indistinct. The music is now soft and has faded into the background. A voice (usually that of the current Number 2) replies 'In the Village'. 'What do you want?' asks the Prisoner. 'Information' is the reply.

We then see a long shot of the Prisoner striding across the main square, whilst the names of this week's guest stars are displayed on the screen. The voiceover continues. 'Whose side are you on?' asks the Prisoner. 'That would be telling' replies Number 2, 'We want information'. The next three shots show the Prisoner on the beach, apparently trying to escape, first seen from overhead and then in close up as Number 2 repeats 'information … information'. Now we see the Prisoner running across the beach. 'You won't get it' is his determined answer. Then we catch our first sight of Rover, rising deep beneath the waves to the accompaniment of eerie electronic 'bubbling' noises. As Rover surfaces we hear Number 2 say 'By hook or by crook, we will'.

We then cut to a mid shot of Number 2 in his chair. This shot changes from week to week to show the different actors, and occasionally it is left out. We then get a view of Number 2's room, with its viewscreen and its desk with three portable telephones. On the screen we see 'Script Editor, George Markstein'. The voiceover continues. 'Who Are You?' the Prisoner asks. 'The New Number 2' is the reply.

We cut to a view of the Village Control room. The graphics announce 'Produced by David Tomblin'. 'Who is Number 1?' asks the Prisoner. 'You Are Number 6' replies Number 2. Then we see the Prisoner framed in long shot on the beach, angry clouds like those in the first image of the sequence above his head. He punches the air defiantly and proclaims 'I Am Not A Number, I Am A Free Man'. Number 2 laughs uproariously, and the screen fades to black.

The sequence has been described as a 'prototype music video' and a 'visual poem'. It certainly grips the viewer, telling its story in pure cinematic terms, uniting music, sound effects, onscreen graphics, editing and the various elements of *mise-en-scène* in an exciting and very dramatic way. Not a single moment is wasted.

With *The Prisoner* McGoohan brought together his considerable personal experience of both live theatre and cinema films with his intimate knowledge of the conventions and structures of the TV series acquired during the years of being *Danger Man*. In doing so he successfully brought the narrative and visual strength and depth of the most advanced forms of both the theatre and the cinema into the television medium. His intention was to redefine that medium, stretching it – as it has so rarely been stretched – towards its true potential.

Part Two
The Prisoner as Allegory

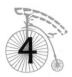

Separation

Episodes 1–7:

'Arrival', 'The Chimes of Big Ben', 'A, B and C', 'Free for All', 'The Schizoid Man', 'The General', 'Many Happy Returns'.

The worlds of allegory are only half familiar and they are rarely safe. Neither protagonist nor readers can predict with any security what phenomena they will encounter or precisely what these phenomena will signify. We have to immerse ourselves in the world of each allegory until we discover its peculiar and persuasive internal logic.

 Gay Clifford: *The Transformations of Allegory*[1]

PRISONER: Free to go ... free to go ... You are free to go ... You are free free free to go ... I am in command ... obey me and be free ... you are free to go ... you are free to go ... you are free to go ... free to go.

 From 'Free For All'

In *The Hero With A Thousand Faces* Joseph Campbell describes the progress of the archetypal hero who, having crossed the 'threshold' into 'dream landscape's his adventures, then has to undergo 'miraculous tests' to prove himself. The first seven episodes of *The Prisoner* present its hero with a series of physical and psychological challenges from which he

1 Gay Clifford, *The Transformations of Allegory*, p.3.

manages to emerge, miraculously, with his personality and his individuality intact. The bizarre setting of the Village, in which virtually all events seem to be arranged for the Prisoner's benefit, is an allegorical dream-landscape within which he fights the contemporary 'dragons' which society uses to control its individuals – the mechanisms of education, politics, science, psychology and, of course, television.

As the series progresses so does its own internal, mythical logic. In the first episode the Prisoner is mysteriously kidnapped and 'magically' transported to the 'fantastical land' of the Village. His captors try a whole range of psychological techniques, brainwashing machines and mind-altering drugs on him, attempting not only to make him 'crack' and reveal the 'priceless' secrets he holds in his head, but also to attempt to 'reconstruct' him as a model 'Villager'. In his role as 'hero', the Prisoner is shown to have almost superhuman powers of mental and physical resistance which enable him – in 'The Chimes Of Big Ben', 'A, B and C', 'Schizoid Man', 'The General', and in most of the later episodes – to outwit his captors' elaborate plans to win him over. His central 'heroic task' is to maintain his integrity as an individual. The surreal setting of the Village and the dream-logic of the narratives of each episode clearly position the series outside the naturalistic mode which most TV series operate within. And the regular weekly time slot of the series creates a 'ritualistic' context within which the Prisoner's heroism can be experienced.

McGoohan himself has described *The Prisoner* as an allegory. Allegory is an essentially didactic narrative form in which all events, settings and characters are symbolic and are created to personify and illustrate a particular moral or religious world view. It is thus intrinsically different to the naturalistic modes of narrative which dominate modern fictional forms. In its attempt to express metaphysical truths in physical terms, it makes considerable use of mythological elements, and its origins can be traced back to such classical works as Ovid's *Metamorphoses*, which was a 'compendium' of classical mythology. During the middle ages the allegory was one of the major popular narrative forms, and was commonly used to express the prevailing established Christian ethos in such works as the 'morality play' *Everyman* and Langland's *Piers Plowman*. Perhaps the best known Christian allegory of all is Bunyan's *Pilgrim's Progress* (1678) in which its hero – 'Christian' – undergoes a symbolic 'journey' to salvation. Traditionally, the allegory is a form for expressing spiritual 'truth'.

Later allegories, however, tend to move away from expressing the established set of social values and towards producing a critique of them. In *Gulliver's Travels* (1726) and *A Tale Of A Tub* (1739), Jonathan Swift utilises the allegorical form to satirise the society of his day. The same technique is used in Orwell's *Animal Farm* (1945). In the twentieth century, many such 'social allegories' have been presented in the form of science fiction. Two examples, which have already been cited as major influences on *The Prisoner*, are Huxley's *Brave New World* (1932) and Orwell's *1984* (1952).

But perhaps the most important allegorical writer of the century is Franz Kafka, whose nightmarish allegorical works *The Trial* (1925) and *The Castle* (1926) were heavily influenced by contemporary developments in psychoanalysis and whose allegorical 'meaning' is always highly ambiguous.

The Prisoner moves through these three distinct allegorical phases. Initially the series appears to be a 'social allegory' using a satirical mode to attack specific elements of modern society such as its political and educational systems, as well as its over-reliance on technology and the threat to individual liberty that its technology poses. Having established this approach as a basis, the series then moves towards a more Kafkaesque 'psychological allegory' as psychological concerns come into prominence. In its bizarre final sequence of episodes it deepens this perspective further by becoming essentially a 'spiritual allegory', concerned with universal human themes.

The first seven episodes establish a number of strong allegorical subtexts, mostly related to social and political issues in contemporary society. Whilst the 'art exhibition' scene in 'The Chimes Of Big Ben' satirises art critics, the whole story of 'The General' is a scathing attack on the education system. Similarly, 'Free For All' attacks political manipulation within supposedly 'free, democratic' societies. Both 'A, B and C' and 'The Schizoid Man' can be read as critiques of behaviourist theories of psychology. The tantalising suggestion of 'the whole earth as the Village' in 'The Chimes Of Big Ben' broadens the allegorical context of the series, positioning the Prisoner as an 'Everyman' figure, symbolic of that part of the modern individual which resists the tendencies of society's instituitions to 'depersonalise' or 'dehumanise' him. The fact that the he (and virtually all the other characters in the series) remain nameless further strengthens their symbolic identity.

Yet, despite these allegorical elements, the Orwellian flavour of Village slogans like 'Questions are a Burden to Others, Answers a Prison to Oneself' and the Kafkaesque nature of the situation itself (one man 'arrested' by unidentified enemies for unknown 'crimes'), *The Prisoner*, for most of the first seven episodes, can still be said to fall within the parameters of the 'secret agent' genre. The influence of script editor George Markstein, with his insistence on keeping 'realistic' elements to the fore, is still prominent, and – as we shall see – many specific references to the Prisoner's former job as a British secret agent are made. The frequent fight and chase scenes identify the series quite clearly as an action-adventure 'thriller', albeit one with far more visual and narrative depth and higher production values than is usual in the genre.

In the opening episodes it is still possible for viewers to discount any allegorical significance the series may have and to 'read' it purely as a 'spy' genre narrative. The Prisoner's main motivation is to escape from the Village without giving away the top-secret information in his head, and his attempts to escape provide the viewer with many 'thrilling' moments. In 'The Chimes Of Big Ben' the Prisoner tells Number 2 that he intends to 'escape and come back and wipe this place off the face of the earth' and any viewer used to the

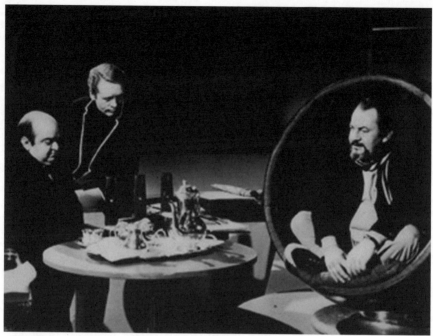

'The Chimes of Big Ben': The Prisoner, Number 2 and the Butler in the Green Dome

narrative conventions of the action-adventure genre can easily imagine that the series is building up to such an 'inevitable' ending. Yet no viewer can fail to perceive that *The Prisoner* contains a number of deepening mysteries. The series of questions which are raised in the first episode remain fundamentally unanswered. So far we have been given few real hints as to the identity of the mysterious 'Number 1', though judging by Number 2's fear of him in 'A, B and C' he clearly does not tolerate failure easily. Although it seems clear that a 'third force' is running the Village, we have little idea of who that 'third force' actually consists of. The question of why the Prisoner resigned is not answered. The viewer is in the dark about this just as much as his interrogators. And the most mysterious question of all – that of whether the events we see unfolding are 'real' or some kind of dream – remains an ambiguous one (see the discussion later of the 'subjective shots' in 'The Chimes Of Big Ben'). The build-up of 'mystery' around the series helps to keep viewers watching as the weeks go by, fascinated in the hope of eventually discovering some 'answers'. Yet when the Prisoner actually manages to 'escape' from the Village and return to London in the seventh episode 'Many Happy Returns', none of these questions are answered and the episode's shocking denouement suggests that his escape attempts are ultimately futile.

The first episode of a TV series is often seen as a 'showcase' for what is to follow. Viewers must be introduced to the main narrative and visual elements of, and characters within, the series. Thus, an opening episode often

has a comparatively larger budget than succeeding segments, and a greater level of care and attention is often put into its production than into the rest of the series. 'Arrival' was originally made as a 90-minute 'movie' before being edited to the standard 50-minute length of all the episodes. It certainly retains a cinematic 'look'. Along with 'The Chimes Of Big Ben', 'Dance Of The Dead' and 'Checkmate' (The first four episodes to be filmed), 'Arrival' was directed by Don Chaffey, who had previously directed such 'big screen' epics as *Jason and The Argonauts*. Like the other three episodes mentioned, a great deal of location footage is used. The attention paid to camerawork, lighting and music gives the episode cinematic intensity. The episode contains a number of powerful, often surreal, visual sequences (particularly those including Rover) and many very distinctive images.

In 'Arrival', the whole visual and narrative world of the Village is created. The 'mystery' of the situation is prominently foregrounded – the questions as to why the Prisoner has been brought to the Village, what his real name is, where the Village is and who runs it, why he resigned and who Number One is are all introduced. Meanwhile, a number of 'sub-themes' – philosophical, psychological and socio-political are suggested. The series' prevailing tone of verbal and visual irony is established. The apparently 'jolly' day-to-day life of the Village (which is also clearly established as a self-contained 'world') is contrasted with dark hints of Village methodologies of brainwashing, torture and murder. We witness the first 'chatty', ironic dialogues between the Prisoner and Number 2. The technological and psychological 'omnipotence' of the Village is revealed, along with its capability for 24-hour surveillance of all its prisoners. We also discover that the aim of the Prisoner's captors is not merely to break him but to win him over to 'their' side. The Prisoner himself is portrayed as a tense and angry rebel-figure, particularly in the definitive 'I will not be pushed, filed' sequence.

'Arrival' begins with a slightly extended version of the first part of the credit sequence described in the last chapter. We see a few extra 'London shots' of the hearse following the Prisoner. The second half of the sequence (which is a kind of impressionistic precis of 'Arrival' itself) does not appear until the next episode. Whereas in the following episodes, the credit sequence functions as a device for narrative recall, here it embodies the narrative itself. As with many other key moments in *The Prisoner*, this is achieved purely by a combination of images and music.

At first sight, the Village appears to be completely deserted. It is a bright summer's morning and there appears at first to be no-one around. The Prisoner runs quickly up the steps of a belltower, fast cutting of shots and a variety of types of shot giving a strong impression of his disorientation. Then the bell begins to ring and the Village, as if by magic, begins to come to life. He sees a woman outside a cafe setting outdoor tables with colourful umbrellas above them, and immediately he runs down to talk to her. 'What's the name of this place?' he asks. 'You're new here, aren't you?' the woman replies cheerfully 'Where?' he persists: 'Do you want breakfast?' she

enquires. The dialogue establishes a certain pattern that will become prominent in the series. Direct questions are rarely answered, and attention is diverted to other matters. This is, of course, a technique that politicians and bureaucrats are particularly adept at using.

The Prisoner's request to use a phone is equally frustrating. He is diverted to the nearest Village phone booth, but on picking up the strange portable device he is asked by the cheerful-sounding operator for his number. Mystified, he replies 'I don't have a number ... No number, no call', the operator replies and hangs up. A Chinese girl in a striped tee shirt appears at the wheel of a colourful mini-moke and asks him where he would like to go, in both English and French. She drives him a short distance, tells him the fare is two units and; as she drops him off; makes the Village's distinctive sign and calls out 'Be Seeing You'. When he enters the Village shop, a conversation is going on in what sounds like Italian, but when he is noticed it abruptly changes into English. The Prisoner's attempts to buy a map which will tell him where he is are also in vain. 'Local maps only sir' the shopkeeper tells him, 'there's no call for any others'. The map he sees is only of the Village and areas within it are referred to anonymously as 'the mountains, the town hall, the beach, the sea'. The shopkeeper, with an air of conspiratorial humour, again repeats 'Be Seeing You' as he departs.

As the Prisoner walks back to his house, a cheerful voice over the Village tannoy system announces 'Good morning all, it's another beautiful day'. The residents of the Village are all dressed in striped shirts, capes and boaters. On arriving back at his house he finds a message on his desk in Albertus script: 'Welcome To Your Home From Home'. The telephone then rings and a voice asks 'Is your number 6?'. The Prisoner, still thinking the 'number' is merely a telephone number, replies that it is. The voice introduces itself as 'Number 2' and invites him to breakfast at the Green Dome, the building at the top of the hill which dominates the Village. As the Prisoner leaves his house we hear on the soundtrack for the first time an arrangement of the nursery rhyme *Pop Goes The Weasel* (an ironic reference that will continue to be used right to the end of the series).

Up to this point, we have been given the impression that the Village is a pleasant place, rather like a decidedly international holiday camp, although it is already clear that our man is a prisoner. The first scene inside the Green Dome changes this ambience radically. It creates a major visual sense of shock, as the 'futuristic' interior is revealed. The scene demonstrates to us just how far-reaching are the Village's powers and influence, and, most importantly, it provides a definitive statement of the Prisoner's resistance to his imprisonment. The incidental music now changes to an eerie electronic wash. Number 2's first words establish the ironically 'chatty' tone that he – and his many successors – will take towards the Prisoner:

At last ... delighted to see you. Come in, come in ... Do sit down ... (presses button and watches a chair come up from a circle in the floor)

I'm I'm sorry, I can never resist that. (Laughs). I hope you don't mind a … working breakfast.

It will indeed be a 'working breakfast'. Number 2 is determined to impress the Prisoner with just how much information his mysterious captors have gathered on him. The Butler wheels in breakfast, revealing that they have already anticipated how many eggs he has with his bacon and how many sugars he has in his tea. He appears only mildly surprised at this, and tolerates the demonstration with apparent amusement. But when Number 2 informs him of his concern about 'a little matter of your resignation' and explains that 'the information in your head is priceless' he becomes visibly angry. He refuses to touch the food, and attempts to leave, but the automatic steel doors of the room slam before him. 'Have you not realised', Number 2 drawls, 'there's no way out'. Number 2 then shows the Prisoner a series of photos of him obviously taken by Village surveillance people in various parts of the world when he was engaged on one secret mission or another. These are somehow projected from the pages of a book onto the Green Dome's huge viewscreen. The shots – and the 'dialogue' attached to them – recall the kind of images and language used within the world of Danger Man. The Prisoner surveys his file and informs Number 2 that the time of his birth is missing. Perhaps surprisingly, he 'fills in' Number 2 on this missing detail. The time he gives, '4.31am; 19 March 1928' is, as we have noted previously, McGoohan's own birthdate.

As the Prisoner declares his refusal to co-operate. Number 2 continues his smooth patter:

Now be reasonable, old boy … it's just a matter of time. Sooner or later you'll tell us what we want to know. Sooner or later you'll want to. Now, let's make a deal. You co-operate, tell us what we want to know, and this could be a very nice place. You may even be given a position of authority.

At this, the Prisoner, his face in close-up against a backdrop of bright red 'lava lamp' bubbles on the viewscreen, delivers his vitriolic riposte:

I will not make any deals with you. I've resigned. I will not be pushed, filed, stamped, indexed, briefed, debriefed or numbered. My life is my own.

These lines will be referred back to on a number of occasions later in the series. It seems that everything that is said in Number 2's house (rather like in Nixon's White House) is recorded and can be instantly played back. The lines clearly define our hero's utter rage at having his life manipulated by others, the bright red of the bubbles behind him providing a visual backdrop with connotations of fiery anger. Number 2's actions in response are all further attempts to demonstrate to the Prisoner the power of the Village over

him. First he accompanies him on a helicopter ride, giving the Prisoner an aerial view of the Village. Speaking in the smooth, polished tones of a professional politician he explains that the Village has its own 'democratically elected' Council, as well as its own newspaper, restaurant, social club and Citizens' Advice Bureau, all of which the Prisoner treats with the ironic contempt it so clearly deserves.

To the accompaniment of another burst of *Pop Goes The Weasel*, Number 2 then takes the Prisoner down to the seashore and shows him the old people's home. The inhabitants, dressed in their Village striped capes and boaters, are mostly engaged in what resemble children's games. Observing the grotesque sight, the Prisoner sarcastically observes 'What are they in for, St. Vitus' Dance?' Number 2 introduces the Prisoner to an 'ex-admiral' who is playing chess. They then take a Village Taxi ride to the main square, which is now filled with 'jolly' Villagers including a brass band, which plays a theme that will recur several times later in the series. The whole scene is apparently a highly festive one, but Number 2's next 'demonstration' is menacingly surreal. When he suddenly cries out 'Wait, wait!' the entire crowd, including the band, stops in its tracks, exactly as if someone has created a 'freeze-frame'. One young man fails to heed Number 2's orders and does not stop. We see a small white ball bubbling at the top of the water fountain. Then Rover appears for the first time above the balcony, emitting a strange electronic buzzing noise. With the rest of the crowd frozen, it bounces down and focuses on the young man, appearing to smother him to death in the process. It is clear that Rover (not referred to by name until 'The Schizoid Man', the fifth episode) has mysterious destructive powers. As soon as Rover has finished its work, the scene jolts out of its 'frozen' state and everyone returns to normal. This event moves *The Prisoner* beyond the basically naturalistic framework it has so far established. The sight of the huge white balloon bouncing menacingly through the Village is a weird and disturbingly dream-like image which shocked and haunted viewers at the time. To many viewers, this image itself defined *The Prisoner*. The way in which Number 2 is able to 'stop/start' the entire population of the Village is very sinister, and further suggests that the entire population of the Village is engaged in 'performing' on behalf of the Prisoner.

As a final part of Number 2's 'tour' he takes the Prisoner to the Village 'Labour Exchange'. The first room we see has some of the main Village slogans on the wall: 'Questions are Burden to Others, Answers a Prison to Oneself, Humour is the Essence of a Democractic Society, A Still Tongue makes a Happy Life and Of the People, By the People, For the People'. The Prisoner is then shown into another large circular room of 'futuristic' design where the 'Manager' of the 'Labour Exchange' stands behind a bizarre wooden contraption comprised of interlocking wheels. The Manager's tone is even more smooth and bureaucratic than that of Number 2: 'And now the questionnaire. If you'd just like to fill in your race, religion, hobbies ... What you like to read, what you like to eat. What you were, what you want to be

... any family illnesses ... any politics?' On hearing the last question, the Prisoner's anger returns. He smashes the contraption and exits the room. From his surveillance position in the Green Dome, Number 2 says 'I think we have a challenge' and the image fades for the first commercial break.

The second two segments of the episode feature a rather more naturalistic presentation of events, which take the form first of an attempt to make the Prisoner confess his secrets, then develop an intrigue whereby the Prisoner is given a lesson in just how far the powers of his captors can extend to. But there are also a number of strangely surreal moments still to come. The Prisoner, still enraged, returns to his new 'home from home' to find a formally dressed maid in his room. He brusquely tells her that her services will not be required. He takes his anger out on the Village radio, which is playing soporific music, by suddenly smashing it and jumping on it. Despite this, the music appears to carry on. The scene, which utilises some fast and rhythmic cutting, is a pure visual expression of McGoohan's character's essential rage at his imprisonment, made particularly powerful by its juxtaposition against the soothing Village muzak..

The maid, who is an attractive young woman, returns and attempts to win the Prisoner over by breaking down in tears and pleading to him that she'd been told that she'd be released 'if only you'd give me some kind of ... information'. But this is a rather obvious device to fool the Prisoner, and he dismisses her summarily. We cut to the imposing Village Control Room, where Number 2 and the Supervisor have been watching the events. For the first time it is established that the Village Controllers can see into the Prisoner's house. Number 2 does not seem surprised that the Prisoner has not fallen for the bait. But Number 2 has seen that, if for a moment or two, his face almost betrayed signs of sympathy for the girl, and the tactic of using his natural protectiveness towards women as a way of 'getting to him' will be utilised again later in this and many other episodes.

Meanwhile, on the arrival of the Village's Electrical Repair Man, the Prisoner announces that he will take a walk. He is about to begin his first serious escape attempt. As soon as he leaves his house he encounters a Village 'gardener', who is a 'double' of the repair man. He makes no comment on this and walks away from the centre of the Village towards its environs. When he reaches some woods, the heads of the statues of a series of classical busts that have been placed between the trees glow with electrical light, and turn to 'watch' him. Guarding the road is the ominous figure of Rover. The chase scene builds up into a sequence of fast cuts as the Prisoner runs to the beach, intercut with shots of the bald, smiling Supervisor calmly running the whole show from his Control Room. The Supervisor dispatches two Village thugs in a mini-moke to apprehend him, but, in the series' first fight scene, the Prisoner knocks the two thugs out and escapes towards the expansive beach with their car. Finally he is apprehended by Rover, who smothers him (though not, of course, fatally) and drags him up the beach, from where he is taken to the Village hospital.

The rest of the story of 'Arrival' centres around the most elaborate attempt yet by his captors to show the Prisoner exactly what he is up against in terms of emotional manipulation. When he wakes up in the hospital bed he realises that the patient in the bed next to him is Cobb, an old colleague of his. But Cobb, who appears to be heavily drugged and apparently in severe distress, can only mumble a few words to him about his abduction before a doctor arrives to insist that the Prisoner must come for a medical check-up. In the corridors the Prisoner sees further warnings of what may await him, and begins to discover the true nature of the Village hospital. Through a circular window into a long corridor, lit by red light, he sees two rows of bound and blindfolded 'patients' sitting on the floor in long white robes, presumably undergoing some form of brainwashing. 'Group therapy' the doctor observes drily 'counteracts obsessional guilt complexes producing neurosis'. Through another window, in a 'pink' room, he sees a young bald man spouting gibberish as a tiny glass ball hovers in front of his eyes. 'Ah', sighs the doctor, 'coming along nicely'. Again, the combination of apparent psychological brutality with polite cheerfulness is highly unsettling. This is exaggerated by the artificial lighting of the 'therapy' rooms and the recurrence of the *Pop Goes The Weasel* theme on the soundtrack.

The Prisoner's checkup is, however, a surprisingly conventional medical procedure in which the doctor reassures him with a practised 'bedside manner'. But then his assistant appears, looking shocked, with the news that Cobb has just committed suicide by jumping out of the window. This brings the second segment of the episode to a dramatic end. That the Prisoner believes that Cobb's suicide has really happened shows his initial naivety about the power of the Village to use psychological manipulation and deception. Later he will be more careful. But as yet he is still unaware that apparently close colleagues like Cobb could actually now be working for the Village.

As he emerges from the hospital, the Prisoner is 'fitted out' as a 'citizen' of the Village. His old clothes having been burnt, he now appears in the black blazer with a white trim that he will wear for the rest of the series. He is also given a straw boater and a 'Number 6' badge, both of which he immediately discards, as well as Village identity, credit, employment and health and welfare cards. He is now officially a 'Number', his details absorbed by the Village bureaucracy. Angered about the 'death' of Cobb, his first action is to go straight to Number 2's house. But to his surprise Number 2 has been replaced. No explanation is given why. The first 'new Number 2' (played by George Baker) is another smooth-talking bureaucrat, but rather more offhand and humourless than his predecessor. He dismisses the Prisoner's concern about Cobb being allowed to commit suicide, then demands his allegiance:

> ... let's be practical. I'm interested in facts. Your only chance to get out of here is to give them to me ... and if you don't give them, I'll take them. It's up to you, think about it. Good day, Number 6.

This is the first time that the Prisoner has been addressed by his Number. He flinches.

PRISONER: Number what?

NEW
NUMBER 2: Six. For official purposes, everyone has a number. Yours is Number 6.

PRISONER: I am not a number, I am a person.

NEW
NUMBER 2: Six of one ... half a dozen of the other ...

The last phrase is another of the recurring phrases in the series, and will be particularly important in the penultimate 'Once Upon A Time'. It is a common phrase indicating that 'the truth' can be told in different ways. However, to the Village guardians, there is no difference between a 'number' and a 'person'. They make the rules about 'the truth', as they are about to demonstrate.

On leaving the Green Dome, the Prisoner sees Cobb's 'funeral cortege' being escorted across the beach by a brass band and blank-faced Villagers. He is surprised to see that a thin, nervous-looking woman (played by Virginia Maskell) is actually showing some signs of real emotion, and he befriends her. She tells him she was a friend of Cobb, and seems genuinely upset. Here we get the first indication that not everybody in the Village is necessarily on 'their side'. Though apparently suspicious at first that the Prisoner might be a 'guardian' trying to trap her, she eventually explains that she planned an escape with Cobb. She arranges to meet him later at the stone boat by the Old People's Home to give him an electropass that will enable him to bypass Rover and steal the Village helicopter.

The woman (whose number is not clearly visible) is then seen in the Green Dome with Number 2. She clearly believes that Cobb is dead, and is told that 'Number 6' is her new assignment as an observer. Whilst he is waiting, the Prisoner plays chess with the old Admiral. He watches the helicopter arrive. He meets the woman (who number is not clearly visible) in the stone boat. He knows that she has been to see Number 2 and is thus suspicious of her, but accepts the electropass anyway. At first it appears to work perfectly. He approaches Rover, accompanied on the soundtrack by tense jazz combo music interposed by snatches of electronic sounds, but the electropass gets him safely into the helicopter.

We cut away to a wide shot of Portmeirion, and the helicopter soaring upwards. We see the Prisoner at its controls. But then he loses control of the joystick. We cut to the Village control room, where a laughing Number 2 is automatically controlling the helicopter. The helicopter changes direction. There is a quick cut across to the Old People's Home, where the woman sits with the old Admiral over the chess board. 'We're all pawns, m'dear' the old man tells her. Then we see the helicopter land back in the Village. Finally,

back in the Control Room we see Cobb (whose suicide had been a ruse) bidding farewell to Number 2, telling him 'I'd better not keep my new masters waiting'.

The Prisoner does not witness this scene, so presumably never knows how the trick was pulled. Naturally he will assume that the woman was another of Number 2's stooges. But he has been successfully manipulated in more ways than one here. As the scene between the woman and Number 2 indicated, her grief over Cobb was genuine, as was her apparent intention to escape. But of course any plan to escape with Cobb would have been impossible if Cobb was working for 'them'. At any rate, the cynical and deliberate raising and then crushing of his hopes appears to have had an effect on the Prisoner's spirit. In the ominous and wordless final few seconds he is 'chased away' from the helicopter by Rover, head bowed. We see the Penny-Farthing bicycle being wheeled past a sign that reads 'Residents Only' as the enigmatic Butler approaches the screen. The symbolism may at this point be somewhat obscure, but the message is clear. The Prisoner has lost a psychological conflict that he apparently had no chance of winning. He must learn the new rules to survive. All the events of the opening episode have been controlled by the Village. Each one has contributed to the successive disorientation of both the Prisoner and the viewer.

'The Chimes Of Big Ben' has a more conventional plot structure than 'Arrival', centred as it is around one carefully planned attempt to force the Prisoner to reveal his secrets, which builds towards a sudden 'twist' ending. It concentrates less on surreal effects than the first episode, although the scene at the Art Exhibition is full of visual irony. There are also one or two 'cheap' looking shots, such as one of the Prisoner and Nadia in a boat, in which the fact that the 'sea' behind them is a filmed backdrop is somewhat obvious; and also a few bad cuts. In contrast to 'Arrival' it looks a little more like 'television'. Much of the dialogue, and McGoohan himself, is more relaxed now and there is a preponderance of ironic dialogue. But 'Chimes', despite its 'spy genre' plot which appears at first to 'explain' many unanswered questions about the Village, ultimately succeeds in enlarging the terms of McGoohan's allegory in several ways. Firstly, it raises the question of 'the whole earth as the Village'. It also confirms that the Individual is truly alone against this totalitarian 'society' and can literally trust no-one. There were hints in 'Arrival' that the Prisoner might be susceptible to emotional manipulation by women and here his captors test this possibility to the limit. In effect they succeed, and it is only the Prisoner's 'heroic' vigilance which prevents him from inadvertently 'spilling the beans'.

The episode begins with the standard credit sequence, which will continue to be used for (nearly all of) the rest of the series. Then there is an announcement from the Village tannoys and radios, beginning with the usual anodyne greeting of 'Good morning, good morning, good morning ... what a lovely day it is. Rise and shine, rise and shine'. The announcer then says that an art competition is being organised for an exhibition in six weeks

time, and encourages all Villagers to participate. We cut to the Green Dome, where Number 2 is watching the Prisoner, who is clearly angry at being woken. The latest Number 2, played by Leo McKern, is a cheery, enthusiastic, avuncular fellow who clearly has considerable respect and admiration for the Prisoner. 'He can make even the act of putting own his dressing gown appear as an act of defiance', he notes to his assistant. When the Prisoner puts his radio, which still plays standard Village 'muzak' into his fridge to silence it, Number 2 laughs his peculiar bellowing laugh. He is determined to win the Prisoner over. 'I want him with a whole heart, body and soul', he says, 'I don't want a man of fragments'.

We next see the Prisoner playing chess at the Old People's Home, this time with a crusty old general (played by the veteran Scottish film actor Finlay Currie) who calls the rebellious Prisoner a fool and expresses the wish to have had him in his regiment. Here the conventional generation-gap discourse often addressed to the 1960s post-conscription generation is punctured by the Prisoner's searching questions: 'Which regiment? Which army?' As the General walks off in a huff, Number 2 appears. In the distance they can see the helicopter landing and a young woman, who Number 2 claims is merely suffering from 'nervous tension', being stretchered out.

Back at the Green Dome, the Prisoner declares his intention to 'escape and come back and wipe this place off the face of the earth'. Number 2 assures him that he will be 'cured' of such 'paranoid delusions of grandeur'. On the viewscreen Number 2 then shows the Prisoner the latest arrival from the helicopter, his new neighbour Nadia (Number 8) waking up in her room, which is again apparently an exact replica of her room at home. Number 2 calls her and summons her to the Green Dome. The Prisoner encounters her on the way. On their first meeting he assumes the air of a Village 'guardian', refusing as ever to give his own name and saying 'Be Seeing You' to her. She tells him that she is Estonian and that, like him, she has resigned from, her job. Naturally, he is suspicious from the beginning that she is a 'plant' and that her appearance is another elaborate ruse to gain his confidence. Yet her actions on the beach the next day convince him otherwise.

Whilst Number 2 and the Prisoner sit by the beach, having their 'little chat' in which Number 2 expounds his projection of 'the whole earth as the Village'. Nadia begins to swim away from the shore. It seems she is engaged in a virtually suicidal escape attempt, despite her being an Olympic swimmer. Back at the Green Dome, Number 2 calls up Rover. 'She's kept in training, I must say ... Oh well, orange alert'. The hint of nonchalance may suggest that Number 2's confidence in Rover's abilities is so complete that he can afford to be casual about its use. Or it may indicate that more is going on than we yet realise ...

Rover rises from the deep and brings back Nadia (on this occasion accompanied by two 'mini-Rovers'. She is taken off to the hospital, to which the Prisoner is later summoned. She is seen there being interrogated in an electronically wired room where, if she makes the wrong move, she will be elec-

trocuted. She looks genuinely under stress, and the demonstration is convincing enough to win the Prisoner over. He offers Number 2 a deal – if she is released he will make some effort to participate in Village life. Again, the dialogue between the Prisoner and Number 2 is highly barbed and ironic. Number 2 continues to 'make notes' for the Prisoner's file 'overweening sense of self-importance ... whilst here, his egomania has, if anything, increased'.

The next morning, we see Number 2 watching Nadia and the Prisoner breakfasting together. 'Charming' he comments. He meets the Prisoner, who informs him that he is planning to create a 'series of abstracts' for the upcoming art competition. Number 2 agrees to turn a blind eye to the use of axes and saws for the project. The 'action sequence' of the Prisoner in the woods that follows, in which he chops down a tree and begins work on some kind of wooden construction, is accompanied by ominous-sounding drum music, whilst Number 2 watches comfortably, and apparently amused, from the Green Dome. Number 2 visits the Prisoner at the scene, and again agrees to 'ignore' the Prisoner's use of illegal tools. The sense of complicity in their conversations is still highly ironic.

The Prisoner and Nadia meet at night outside his house, and indulge in what appears to be a romantic tête-à-tête. This is really a 'cover' for a more practical conversation, but it is the nearest that the Prisoner comes to being involved in a love scene. Nadia claims to have been kidnapped because she had once seen a secret file revealing the location of the Village. She claims that the Village is in Lithuania, on the Baltic coast, thirty miles from the Polish border. She has contact with an 'underground' group not far away. Clearly, the two are planning escape. A genuine 'romance' does appear to be developing between them. Nadia plays the naive ingenue here. 'I want to hear the chimes of Big Bill', she tells him. 'Big Ben', he smiles, almost cutely ...

The next scene, which takes place at the art exhibition, is a parody of the Village's notion of 'artistic free expression', and thus plays jokingly with contemporary notions of art criticism. Every exhibit, except for the Prisoner's, is a figurative image of the current Number 2. The Prisoner has created an 'abstract' piece, which is in fact obviously the pieces of a real boat. He is then questioned by the Village's panel of 'art critics':

FIRST MAN: We're not quite sure what it means,
PRISONER: It means what it is.
NUMBER 2: Brilliant. It means what it is. Brilliant ...
PRISONER: This piece ... what does it represent to you.
SECOND
MAN: A church door?
PRISONER: Right first time.
WOMAN: I think I see what he's getting at.
PRISONER: Now, this other piece here, the same general line,
something more abstract as you'll notice, representing
freedom or a barrier, depending on how you look at it ...

> The barrier's down, the door is open, you're free, free to
> go, free to escape, to escape to this ... symbol of human
> aspirations ... Knowledge, freedom, escape.

It is obvious that the Prisoner is enjoying his tongue-in-cheek participation in the event. On being awarded the prize for best exhibit, he gives a modest and apparently socially conformist speech to the assembled gathering and elects to spend his prize money on a tapestry which has been made by an old lady, Number 38 (naturally depicting an image of Number 2). The tapestry will act as the sail for the boat when, later that night, the Prisoner and Nadia launch themselves out to sea. We cut to the control room where all this, as ever, is being observed. One very significant shot shows the Controller smiling, which hardly suggests he is perturbed by events as they have unfolded. Rover is, however, dispatched and reaches the fleeing couple just as they are about to make contact with the resistance group. Strangely Rover is held back by bullets fired at him by the resistance fighters. The Prisoner and Nadia swim for the shore. They are then nailed into two separate compartments of a long box which is being sent to the Prisoner's old headquarters in London. Just before they get in, the Prisoner borrows a watch from 'resistance' member Karel, as his has become waterlogged.

The next few shots, though apparently quite logical at this point, are in many ways amongst the strangest in the series. We see stock footage of lorries and aeroplanes, and wooden crates being craned off a ship at some docks. This convinces the viewer, used to such conventional TV footage, that a 'real' journey is taking place. Meanwhile, the conversation between Nadia and the Prisoner is playfully 'romantic'. Nadia enquires if he has a wife or girlfriend, and seems pleased when he replies in the negative. She continues to tease him by calling him 'Big Ben'.

The package finally arrives in the London office. Inside the room, the blinds are drawn. We can hear the sound of traffic, apparently from outside, as well as the chimes of Big Ben, indicating that we are in central London. They are met by two officials whom the Prisoner recognises and is pleased to see – Fotheringay (played by Richard Wattis, in countless films the epitome of 'Britishness') and 'The Colonel', who with his 'stiff upper lip' moustache and brusque manner, is something of a 'cartoon' version of a British secret service boss. The Colonel and the Prisoner are left alone, and immediately their conversation becomes as ironically charged as that between Number 2 and the Prisoner. The Colonel is immediately dubious about Nadia: 'And what was her name before she left Peckham Rye to join the Bolshoi Ballet?' and appears not to believe the Prisoner's story, especially when he gives the Village's location as being in Lithuania. The Prisoner explains that the Village is 'a place where people turn up, people who have resigned from a certain kind of job, have defected, or been extracted'.

The Colonel, having reluctantly agreed to the Prisoner's insistence on political asylum for Nadia, then asks him directly about the reasons for his

recent resignation. Just as Big Ben strikes, the Prisoner begins 'it was a matter of conscience'. Then he stops and looks at his watch. Suddenly everything falls into place. He demands to know how it can be that the watch he was supposedly given in Poland still shows the same time as Big Ben is now apparently registering. He quickly discovers that the noises from 'outside' are being produced from a tape recorder in a cupboard. Grimly, he marches out of the room, through a long corridor. He opens the doors at the end of the corridor and steps back into the Village. As usual, it is a sunny day and a brass band is playing.

Nadia is seen in the Control Room with Number 2. ... It was a good idea and you did your best ... she tells him ... I'll stress it in my report ... The episode ends with a shot of the Village, over which is superimposed an image of McGoohan's face. As the face becomes bigger, we see and hear bars slamming down over it. This will now be used at the end of every episode for the remainder of the series.

The unexpected twist at the end of 'The Chimes Of Big Ben' is a shock for the viewer, who has been hoodwinked along with the Prisoner into believing that a genuine escape has taken place. Only the smiling face of the Supervisor when observing the boat trip has suggested that the whole thing has been an elaborate plot. The Prisoner (and the viewer) has been taken in by Nadia. Obviously, Nadia's arrival in the helicopter, her apparent confusion on arrival, her 'suicide' swim and her 'torture' in the hospital were all staged. So was her apparent affection for the Prisoner, who from now on will steadfastly avoid all romantic engagements. Number 2's apparently jocular reaction to the Prisoner's art exhibit and his tacit approval of his 'illegal' work methods are all now revealed as being part of the 'act' that he himself has been stage-managing. With hindsight, it is hard to see how a Number 2 could be so naive. The use of familiar British secret service figures again underlines the apparent power of the Village in the world of espionage and intrigue. Clearly Fotheringay and The Colonel are both employed by the Village (and may have been for some time). The entire art exhibition seems to have been planned in advance, and the 'guardians' seem to have very accurately predicted the Prisoner's reactions.

The shots of aeroplanes, lorries and dockyards are much harder to explain. When they are first shown the audience accepts them as providing visual back-up to the story as it is unfolding. But the only journey the Prisoner has 'really' made is a very short one back to the Village. So, do these shots represent 'flaws' in the narrative, or are they to be interpreted as 'subjective' shots, showing in the Prisoner's mind, what he would have expected to be happening outside the crate? If the latter assumption is true, then other assumptions of 'realism' with regard to what we see on the screen must be called into question. Perhaps the entire Village and all its events are also 'subjective' – maybe the whole thing is some kind of hallucination or dream. The apparent physical 'reality' of the world of the series is merged with 'reality' as experienced by the Prisoner. No easy explanation is given as to which reality is the 'correct' one.

The episode is one of those which engages most with the 'spy' theme. We are left in no doubt that the Prisoner is a British agent. Nadia herself was supposedly a Soviet spy (though perhaps involved in the Estonian resistance movement). In many ways the plot resembles that of the James Bond story *From Russia With Love*, where Bond is hoodwinked by a beautiful Russian Agent into believing that she wishes to defect, and in which he attempts to bring her back to England with him. Whilst the Bond story naturally involves a fully sexual affair, the Prisoner story characteristically avoids such contact. Yet much of the apparently realistic 'spy scenario' which is set up is destroyed by the 'twist' ending. The supposed situation of the Village in Estonia clearly indicates that it is under the control of the Soviet Union. But by the end of the episode the viewer must conclude that this is merely more false information and that the location of the Village remains a mystery. Logically, the Village is much more likely to be run by a 'third force'. Thus, the apparent importance of the cold war scenario is debunked.

The episode contains a great deal of dramatic tension and mass-audience appeal, keeping its viewers guessing until the final minutes. It is far more melodramatic than 'Arrival', though the melodrama is constantly laced with ironic humour. Characters like the Colonel and Nadia are pure stereotypes – stock figures of the 'spy drama'. The escape attempt itself is extremely improbable – firstly in the way that the Prisoner and Nadia manage to evade Village surveillance devices so easily and secondly with its use of the highly melodramatic device of having them 'boxed up' to be 'delivered' to London. It is as if McGoohan, after introducing the menacing world of the Village in 'Arrival', now feels free to begin to play a psychological game with his audience which mirrors and parallels the ongoing battle between the Prisoner and the various Number 2's. In 'Chimes', he 'plays' with melodramatic genre devices only to expose them as cheap tricks. The viewer's recognition of the conventions of the spy genre is engaged, but the conventions are then 'opened out' and questioned. Perhaps the inclusion of the 'subjective shots' discussed earlier is merely McGoohan playfully allowing the viewer some visual wish-fulfilment.

The next episode, 'A , B and C' is dominated by one particular visual image, which is seen both at the beginning and the end of the episode, that of the orange telephone in the Green Dome. This is the telephone on which Number 2 talks to his superior, who (though he never calls him this) we can only assume is Number 1. As the episode begins the phone, which is shot in the foreground to look very large and imposing, rings loudly. In the background, Number 2 looks terrified. This Number 2, played by Colin Gordon, is very different to the 'smooth' Number 2's of 'Arrival' and McKern's 'jolly' type in 'The Chimes Of Big Ben'. He is highly strung and extremely deferential to Number 1. He seems to have a strong masochistic streak, and frequently takes his temper out on his underlings. He constantly drinks milk, presumably for an ulcer. We are left in no doubt that his 'superior' is putting him under pressure to 'break' the Prisoner. Up till now, the Prisoner has been

emotionally manipulated, but has only had glimpses of the more brutal methods being imposed on others. Now Number 2, desperate to achieve results, is quite prepared to use technological mind control and dangerous drugs on him.

Like 'Chimes', 'A, B and C' again foregrounds a conventional 'spy plot' and characters like Madame Engardine, 'A' and 'B' are typical inhabitants of the genre. Yet the reshowing of the credit sequence as a representation of the Prisoner's dream-thoughts indicates a carefully self-conscious use of the series' established imagery, and the final part of the 'party sequence' involves the highly cinematic use of zooms, close ups, a moving camera, unusual camera angles and music in a way that can almost be described as 'psychedelic'. Director Pat Jackson, who later directed 'The Schizoid Man', 'Hammer Into Anvil' and 'Do Not Forsake Me, Oh My Darling', has a somewhat different style to Chaffey's, less 'rich' in tone and with more 'edge'. He also has to work within greater constraints. Whilst Chaffey's episodes use extensive Portmeirion footage, Jackson's episodes are almost entirely shot in the studios, with stock Portmeirion footage linking the scenes.

After Number 2's call from Number 1, he calls the scientist Number 14 and insists that 'the experiment' must go forward, despite her protestations that her methods are untested and that she does not have enough time. We then see the Prisoner being wheeled into a long corridor by two men. He is brought into a laboratory full of electronic equipment and electrodes are attached to his temples. We watch the images in his mind being projected onto the laboratory's screen, which replay the credit sequence. 'It's an anguish pattern' Number 14 comments. The white-coated Number 14 injects the Prisoner with a drug and asks Number 2 for instructions. Images of a party in a grand house appear on the screen, where the Prisoner (dressed

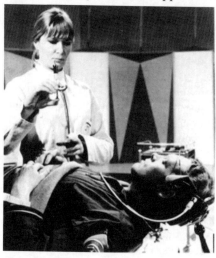

'A, B and C': The Village investigates the Prisoner's dreams

formally in a suit and black tie) is now seen. He meets the host, Madame Engardine, with whom he has an enjoyable, and mutually flirtatious, conversation. Then Number 2 introduces 'A' into the scene. 'A', played by Peter Bowles, is a typical screen villain, suave and moustachioed. He is apparently a former British agent who the Prisoner has not seen since he defected several years ago. He probes the Prisoner with questions about his resignation, but the Prisoner reveals nothing. He then kidnaps him and takes him to a his country house in a white Citroen. A fight scene follows, in which the Prisoner beats up

'A' and his assistant. As he leaves he mutters 'Be Seeing You' indicating that his 'Village' persona is becoming mixed with his drug-induced reversion to his previous existence.

Number 2 is frustrated that the first attempt to use this method to extract secrets from the Prisoner using this method has failed. We see another shot of Number 2 in the background looking worried, while the orange telephone looms over him. We cut to an overhead camera shot of the Village, which zooms in on the Prisoner's house. We then see him emerging from his house, rather confused. He sees Number 14 and challenges her : 'How does one talk to someone that one has met in a dream?'. Number 14 avoids conversation with him, but it is clear that the Prisoner already suspects that something untoward is going on. While the Village's methods in Chimes and 'Arrival' were subtle forms of emotional manipulation, here they are cruder. He next visits Number 2 in the Green Dome to try to find out what is going on, displaying to him a prominent scar on his wrist. Number 2, of course, is careful to reveal nothing and is very arrogant in dismissing the Prisoner's suspicions. After the Prisoner leaves, the 'big phone' rings again, and Number 2 replies 'Sir ... Yes, sir ... Within two days ... You have my word ... Yes sir, I realise my future's at stake ... two days, I guarantee'. We cut to Number 6's house, where he drinks his (obviously drugged) night-time drink and then collapses.

The second 'party dream' sequence features the appearance of 'B', another spy who Number 2 hopes will provoke the Prisoner to reveal his secrets. The Prisoner meets 'B', a sophisticated-looking woman, in the arbour outside the house. After they have exchanged a few reminiscences, they dance together. Number 14 then begins to feed her lines. She tells him that 'A's men are threatening to kill her if she does not tell them why he resigned. Yet the attempt is too contrived, and the Prisoner, who in his waking life has already begun to suspect, asks 'B' 'Have you the feeling that you're being manipulated?' Two of 'A''s thugs appear out of the bushes and another brief fight scene ensues. One man holds a gun to 'B''s head and she pleads for him to 'confess' or she will be killed. ... I don't believe in you ... he tells her, and proceeds to question her about her life and her family. These are questions she cannot answer, and the Prisoner now walks off the screen, clearly having overcome the effects of the drugs and manipulation. Number 2, who has failed again, glances in trepidation at the orange phone.

Next morning, Number 2 watches the Prisoner in his house. By now he clearly knows that he is being watched and he addresses Number 2 directly with an ironic 'Be Seeing You'. 'No, I'll Be Seeing You', Number 2 replies. The double-edged associations of the favourite phrase of the Village are becoming clear. The Prisoner, though still confused, remembers something of last night's events. Suspicious of Number 14, he tails her and discovers the secret laboratory in the woods. When she has left, he breaks into the laboratory through a grid in the heating system (a plot device which is used in countless action/adventure series). He enters the laboratory, discovers the

workings of the 'dream machine' and replaces the contents of tonight's syringe with water. At nighttime he pours his bedtime drink away secretly and then feigns his collapse. We then cut straight into the third 'dream', which now the Prisoner is controlling.

Though the dream begins at Madame Engardine's party again, the quality of the images are very different. The camera wheels around madly, and the earlier sedate waltz music is replaced by loud, almost psychedelic dance music. Taking a mirror from the wall, the Prisoner seizes it and we see a distorted image of his face. As he replaces it on the wall, the images on the screen lose their distortion. Clearly he is in control of the images now. He places a bet on the roulette wheel, pointedly choosing the number '6'. When he wins he is given a key. Number 2 and Number 14 are expecting him to identify 'C' – a key spy whose identity they do not know – from amongst the guests. When she shows the Prisoner an identical key they are shocked to discover that 'C' is Madame Engardine. Of course, the Prisoner now has control of the dream and is deliberately leading them astray. Engardine warns him that there is no turning back. We see them both opening a door with their keys. At this point the screen goes blank. 'He's collapsed', Number 14 tells us, as the second segment of the episode ends.

Number 2 insists that the procedure carry on, despite Number 14's protestations that the Prisoner may be killed in the process. She revives him with oxygen and an image returns to the screen. It shows the Prisoner and Madame Engardine riding in a car along the Champs Elysees. This is shot using a rather obvious filmed backdrop, although in this case this only adds to the 'unreality' of the scene. She is apparently taking him to another, key figure in the 'spy intrigue' who Number 2 decides excitedly 'we'll have to call 'D''. Madame Engardine drops the Prisoner off in front of a set of large doors, which open from apparent daytime into a night scene of a large deserted square. A masked man appears in top hat, black gloves and a long black cloak, fully the theatrical 'villain'. In a scene that anticipates the crucial moment in 'Fall Out' where Number 1 is finally revealed, he rips off the villain's mask and forces him to turn around. It is the face of Number 2 himself. In the final images of the 'dream' the Prisoner opens the doors again to reveal the Village. We see him entering the laboratory and facing another 'double' of Number 2 on the screen, informs him that his resignation was nothing to do with 'selling out'. He then 'rejoins' his body on the operating trolley and the screen goes black, before resuming more 'reruns' of the credit sequence. The final image, of Number 2 staring in terror as the orange phone rings again, re-emphasises the Prisoner's triumph.

There are a few slightly contrived elements in the plot of 'A, B and C'. In the light of the Controllers' complete surveillance of every part of the Village, it seems unlikely that they would have no cameras in the laboratory, not to mention guards protecting it. So the Prisoner's break-in is a little far-fetched. But 'A, B and C' advances McGoohan's allegory in new ways. Here, the figure of the Individual is now shown as capable of successful resistance to the

manipulations of Society. The use of 'onscreen' imagery creates a framework whereby the relationship between 'watcher' and 'watched' is shown, and then cleverly reversed. This mirrors the relationship between the programme itself – with its apparent 'action/adventure' theme – and its subversive attempt to change the parameters of television itself. The Prisoner is now fulfilling his heroic role, successfully beginning to fight off the 'dragons' he is confronted with.

The position of Number 2 is also redefined. It is clear by now that Number 2 really is, as the Prisoner suggested in 'Chimes', just as much a Prisoner as he is. The suggestion seems to be (though this is never confirmed) that each succeeding Number 2 is replaced – and quite possibly 'eliminated' – for their failure to deal successfully with the Prisoner. Most of the future Number 2's will be more careful than Gordon's Number 2 here, and the Village's brainwashing methods will become more subtle. By now the Prisoner's captors seem to have learned that direct questions about his resignation will be unlikely to work in whatever context they are presented. Their efforts will now be concentrated – particularly in the next two episodes – on breaking his spirit by attempting to induce a breakdown of his character.

The process continues in 'Free For All', where the Prisoner is duped into standing as a candidate in the Village 'election'. In 'Arrival' Number 2 had insisted that the Village was a 'democracy'. Now the Prisoner experiences the full force of the Village's powers of social manipulation. With the basic scenario of the series having been established, its wider allegorical themes begin to take shape. The crowd-manipulation techniques used in 'Free For All' can be seen to be an exaggerated version of the contemporary political process, as filtered through the mass media, where candidates' views are expressed in meaningless 'sound bites' and – as our more cynical or paranoid 'citizens' might argue – the results of elections are manipulated by the mass media and other controllers of 'information'. In the Village so-called democracy is merely another form of social control. The main purpose of staging the election seems to be to break the Prisoner's spirit through a continual process of disorientation. In the two previous episodes, he has gained considerable confidence through achieving 'moral victories' over his captors. Here they are determined to prove to him who is 'boss'.

'Free For All' is the only episode before the final two to be both written and directed by McGoohan himself. McGoohan makes extensive use of Portmeirion location shots to create one of the most cinematic episodes in the series, full of highly distinctive visual images and particularly surreal moments. He demonstrates a flamboyant and adventurous directorial style, using hand-held cameras to help create an impression of mob hysteria amongst the Village crowds. The scenes where the Prisoner is being 'brainwashed' use fast, flashing images to suggest hallucinatory states. The bizarre 'truth test' and the use of the Prisoner's silhouette on television provide striking visual illustrations of the theme of the episode. The strange tableaux of the inscrutable Butler radiate an inexplicable sense of menace. Perhaps the

most peculiar and suggestive shot of all is one where a group of Villagers is seen apparently 'worshipping' Rover.

McGoohan further pushes the naturalistic boundaries of the conventions of the TV series by having various 'miraculous' events occur in the episode – such as Number 2's 'instant' appearance at the Prisoner's house – and by showing the door in Number 2's room opening into a different place than usual. Given that the Prisoner is being drugged throughout the episode, it is possible to explain these events as further hallucinations, which may support the theory that the entire narrative of the series happens 'inside' his head. But there is no certainty of this. The viewer is left with a series of disturbing images and messages, often apparently contradictory. McGoohan's script is infused with a twisted sense of irony and there are a number of key speeches which mark the episode out as one of the most thematically central in the series. In terms of visual and verbal style it presages the final episode, 'Fall Out'.

The first image we see after the credit sequence is that of the Prisoner's 'Number 6' telephone ringing. We see the Prisoner putting on his jacket, clearly in a confident, self-assured mood. As Number 2 talks he realises that the voice is being accompanied visually by Number 2's face on the TV screen. The new Number 2, played by the veteran British film star Eric Portman is another smooth-talking 'charmer'. He invites the Prisoner to the Green Dome. The Prisoner curtly tells him that 'the mountain can come to Mahomet'. Just seconds later Number 2 appears at the door. The Prisoner accepts this 'miracle' without comment, and Number 2 introduces him to his new maid, Number 58, an apparently very silly, giggly and childish young woman who talks only in an unidentified Eastern European language and who appears not to understand English.

Number 2 explains that elections are soon going to be held in the Village, and that he feels the lack of opposition to him is 'bad for morale'. The Prisoner compliments him on his 'sense of humour'. Number 2 quotes back the Village adage 'humour is the essence of a democratic society'. However, the events which are about to unfold are far from humorous. Suddenly they hear strident brass band music. Outside a large crowd of Villagers is gathered. They wave large placards featuring the face of Number 2 and chant '... Two, Two, Two, Two! ...' Number 2 tells the Prisoner that if he stands against him and wins he'll be the 'boss' and that 'if you win, Number 1 will no longer be a mystery to you, if you know what I mean'. This is a tantalising suggestion, for by now the Prisoner is fascinated by the mystery of who ·Number 1 may be (as, of course, is the viewer).

Number 2 then takes the Prisoner for a taxi ride to the central square of the Village. The cuts from troubled close up shots of the Prisoner to those of the frenetic crowd suggest the disturbing effect that the generation of this hysterical atmosphere is beginning to have on him. Number 2 then makes a speech to the crowd. The speech is interspersed by pauses, during which the Butler holds up 'cue cards' telling the audience exactly how to react. The crowd respond in a completely pre-programmed way, and the parallels with

TV's use of a 'canned' audience are blatant. Number 2 then introduces the Prisoner as his rival in the election. The Prisoner, pleased to have the chance to address a crowd publicly for the first time, takes the megaphone and attempts to deliver his 'revolutionary' message. He begins 'I am not a number ... I am a person'. This is greeted by instant howling laughter from the crowd. But, encouraged by Number 2, he perseveres:

PRISONER: Unlike me, many of you have accepted the situation of
 your imprisonment and will die here like rotten cabbages.
NUMBER 2: Keep going. They love it.
PRISONER: The rest of you have gone over to the side of our keepers.
 Which is which? How many of each? I intend to discover
 who are the Prisoners and who are the Warders ... I shall
 be running for office in this election.
NUMBER 2: Good people, let us applaud a citizen of character. May the
 better man win and a big hand for Number 6. Be Seeing
 You ...

Despite the apparently 'subversive' sentiments being expressed, the crowd cheers anyway. McGoohan's critique of the democratic process here seems to imply that the content of the message is irrelevant – the crowd would cheer and respond in a preprogrammed way *whatever* he said. In a highly impressionistic sequence featuring the use of very fast cutting and hand-held cameras, the Prisoner is mobbed by the crowd and showered in tickertape. The bright costumes of the Villagers and the colourful surroundings of the Village itself turn the sequence into a riot of colour. As if by magic, large 'Vote for No. 6' placards appear amongst the crowd.

We next see the Prisoner back at his house. Number 2 phones to announce that Number 58 will be his driver for the course of the campaign, and that he will be expected to attend what he calls 'a meeting of the outgoing Council' in the Town Hall. He decides to walk rather than accept her rather unnecessary offer of a lift, but she follows him anyway, still giggling and jabbering away. Eventually he accepts a lift, and he is immediately 'besieged' by a journalist and a photographer, Number 113 and Number 113B, who jump onto the car and begin asking rapid-fire questions, the answers to which they conveniently rewrite themselves:

NUMBER 113: How are you going to handle your campaign?
PRISONER: No comment.
NUMBER 113: (writes) Intends to fight for freedom at all costs.
NUMBER 113B: Smile ... (clicks photo)
NUMBER 113: How about internal policy?
PRISONER: No comment.
NUMBER 113: Will tighten up on Village security.
NUMBER 113B: Smile.

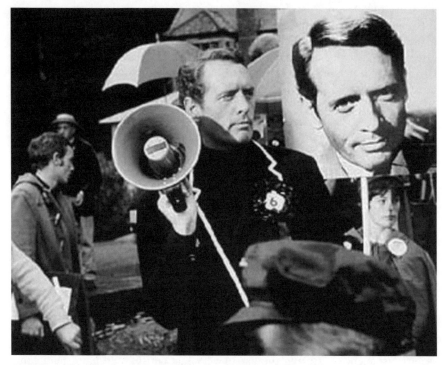

'Free For All': The Prisoner campagins in the Village 'election'

NUMBER 113:	How about your external policy?
PRISONER:	No comment.
NUMBER 113:	Our exports will operate in every corner of the globe.
	How do you feel about life and death?
PRISONER:	Mind your own business.
NUMBER 113:	No comment.

McGoohan's sardonic view of the role of the Press in election campaigns is obvious – they print what they have already decided to print. Again, the content of what the Prisoner says is actually irrelevant. This is confirmed when he picks up the latest edition of the Village newspaper *The Tally Ho*, where his election address – a series of bland, meaningless statements- has already been written for him.

He next appears in the Council Chamber – another very large, imposingly designed circular set dominated by Number 2's chair, atop which is a flashing eye in a pyramid – and is made to stand on a revolving dais in the centre of the room. The identically dressed 'Councillors' (in black and white hooped shirts and top hats) cheer and clap loudly at everything Number 2 says and accede immediately to his every demand, in a way that presages the bizarre 'committee scenes' in 'Fall Out'. When the Prisoner, who refers to them as 'a bunch of

tailor's dummies' asks to question them, the dais is set revolving, whirling him round so he sees each of their lifeless faces in turn. Already knowing that the whole process is a sham, he delivers an eloquent 'political' speech:

> This farce ... this twentieth-century Bastille that pretends to be a pocket democracy ... Why don't you put us all into solitary confinement until you get what you're after and be done with it ... Look at them ... brainwashed imbeciles ... Can you laugh? Can you cry? Can you think? Is this what they did to you? Is this how they tried to break you until they got what they were after? In your heads there must still be the remnants of a brain ... In your hearts must still be the desire to be a human being again.

As he speaks he is spun around faster and faster, to the accompaniment of mesmerising flashing blue lights and disorientating electronic noises. Number 2 bangs on the table in front of him and angrily declares 'This is a most serious breach of etiquette ... I had believed that your desire to stand for office was genuine'. We see the Prisoner's face whirling around as the screen fades to black to signal the first commercial break. After the break, his face is bathed in red light. Suddenly and inexplicably he finds himself in a long, sloping tunnel, again lit in bright red. At the bottom of the tunnel automatic doors slide open into yet another large circular room, lit in a more reassuring soft green colour. The man who greets him is dressed in a highly formal manner, in a grey morning suit, and assures the Prisoner that he 'could be a friend'.

We cut back to the Control Room, where one of the Controllers makes his remark to Number 2 about the man having come from the Civil Service and having 'adapted immediately' Number 2 also converses with Number 1, and using a phrase that will become another key one in the series, promises that the experiments on the Prisoner will not 'damage the tissue' He then rings the man who is conducting the interrogation and tells him to continue. The Prisoner is then subjected to a 'Truth Test'. An image of himself in silhouette is seen on a large viewscreen. Two diagonal lines join at his eyes. On the top line is a circle, representing 'lies' and on the bottom line a square representing 'the truth'. (The contrast between round and square shapes in *The Prisoner* has been commented on earlier.) The Prisoner is asked various questions about why he wanted to run for election, and his thoughts are interpreted by the machine. Finally the effort of trying to control his answers exhausts him and he collapses.

When he recovers his expression has changed from terror and anguish to that of simplistic joy. He thanks the man for his help, asks for his assurance that he will be voting for him, puts on a 'Number 6' rosette (the first time he has ever voluntarily worn his number) and leaves the room, now obviously 'brainwashed'. Out on the street, the crowd is again in a frenzy. The brass band strikes up the instant he steps out of the building. Again hand held cameras and

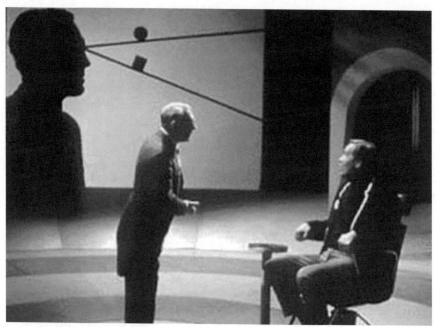

'Free For All': The 'Truth Test'

a plethora of bright colours give us an impression of his mental disorientation. Now he answers press questions in the bland, ambiguous way beloved of real politicians. 'I'll do my best', he tells them 'to give him a run for his money'.

Back at his own house, the television gives an account of the state of play in the election campaign and broadcasts his own speech – which he delivers 'live' to the TV itself. His voice, now devoid of its earlier anger, broadcasts a very different message:

> The Community can rest assured that their interests are very much my own and that anything I can do to maintain the security of the Citizens will be my primary objective. Be Seeing You.

Number 58 is with him as he makes the broadcast. He learns how to say 'Be Seeing You' in her language. This seems to trigger a nervous reaction and he panics, as the effects of the brainwashing begin to wear off. He discards his rosette and drives off towards the beach, through streets lined with crowds chanting 'Six, six, six' and makes a completely futile escape attempt, which involves him stealing a motor boat and indulging in fisticuffs with two Village thugs. As he attempts to reach the open sea, Number 2 hovers above him in a helicopter and warns him to turn back. Rover is summoned, and he is dragged towards the shore. Later, in bed in the hospital, the events of the whole episode flash before his eyes. This is shown by a montage of earlier shots from the episode, linked by superimposition rather than cutting, and

as we hear his voice declaring 'I Am Not A Number, I Am A Free Man' the second segment of the episode ends.

When he wakes up the Prisoner's 'conditioned' state has been restored. From the stone boat next to the Old People's Home he gives a largely meaningless speech ending in 'they say six of one and half a dozen of the other but not here ... it's six for two and two for nothing and six for free for all, for free for all'. He leads the Villagers in a chant of 'Six, six, six, six' then engages in a 'debate' with Number 2 across the main square. The Prisoner, now acting like an assured 'politician', twists Number 2's words around. Number 2 asserts that he has had no spare time recently because he has been working so hard. The Prisoner seizes on this and claims that he is 'working to his limits ... we're all entitled to spare time'. The crowd begins to chant 'six for two, six for two' before the Prisoner delivers the ultimate example of a politician's empty promise:

NUMBER 2: In your spare time ... if you get it ... what will you do?
PRISONER: Less work (smiles) ... And more pay!

The crowd reacts with predictable fervour. The Prisoner has again been thoroughly and successfully brainwashed. But by the time we next see him, at the Village's tame (non-alcoholic) nightclub, *The Cat and Mouse*, his conditioning again seems to be wearing off and he gets suddenly very angry with a waitress. Number 58 steers him towards a supposedly 'secret' drinking den where real alcoholic beverages are served. There he meets Number 2, who, sitting with a towel over his head, is pretending to be drunk. Number 2 maintains that they are in the 'Therapy Zone', an area where there is no Village surveillance. The Prisoner's drink, however, is drugged and he collapses. We are told that the portions of the drug will be enough to take him right through the election campaign. After the 'experiments' of 'A, B and C' his being drugged will be no surprise to the viewer.

Election day comes and, predictably, the Prisoner wins a unanimous victory. Number 2 escorts him to the Green Dome, where, along with Number 58, he is apparently left alone. Still drugged and apparently actually believing that the reins of power have been handed over to him, he calls various Village operatives to check. Number 58, giggling as usual, plays with the controls. Lights flash on and off and chairs rise up and sink back into the floor rapidly. But then her expression suddenly hardens. Repeating the word 'tic' several times she suddenly slaps the Prisoner repeatedly across the face. The Prisoner now snaps out of his delirium. He rushes to the control panel and broadcasts a message over the Village tannoys, telling the Villagers they are all 'free to go, free to go'. A quick cut to an exterior scene shows that the Villagers completely ignore this instruction. Two security guards now rise up out of the floor and chase him towards the steel doors, which open not, as usual, into the Green Dome's foyer but into a room lined with straw in which a group of Villagers in dark glasses sit in apparent 'worship' of Rover. To the

accompaniment of dramatic 'fight scene' music, the two guards grab him, beat him up and then deliver him back into the main room.

Standing above him, the supposedly 'silly' Number 58 now wears the 'Number 2' rosette. She looks witheringly down at him and speaks to him, in perfectly clear English: 'Will you never learn ... this is only the beginning ... We have many ways and means but we don't wish to damage you permanently ... Are you ready to talk?' He makes no reply, and is dragged away. The 'old' Number 2 calls her from his departing helicopter and asks her if everything went well. The new Number 2 tells him not to worry. 'All will be satisfactory in the end ... she says ... give my regards to the homeland'. The bars slam down over the Prisoner's face again.

The final comment about the 'homeland' is a rather enigmatic reference, which tends – rather confusingly – to suggest that the Village is run by one country – but its meaning is never enlarged upon. The outcome of the story, though, is a definite victory for the Village guardians. The Prisoner's sense of self – the core of his being – has been challenged and perhaps weakened. And if the Prisoner has been 'disoriented', so too has the viewer. From here on we also become less and less sure whether what we see on the screen is 'real' or not. There are a number of moments where it is very difficult to tell whether an 'objective' or a 'subjective' reality is being portrayed. 'Free For All''s implicit social commentary can be seen as being directed against the very nature of the political process in modern societies. The scenes where the crowd is being manipulated into hysteria for one candidate or another closely resemble 'manufactured' political events such as American political conventions, with their balloons, ticker-tape and pre-planned enthusiastic cheering. As a candidate in the election, the Prisoner's actual policies are meaningless. The status quo will be maintained no matter who is elected, because unseen hands control the whole political process.

After the 'spy dramas' of 'Chimes' and 'A, B and C', 'Free For All' clearly positions *The Prisoner* as a 'social allegory'. Whilst the totalitarian nature of Village society recalls that of Orwell's *1984*, the heavily ironic tone of the episode has echoes of Swiftian satire. And as the first episode in which McGoohan has complete control (in his role as both director and scriptwriter), 'Free For All' indicates his intention to focus the series on the allegorical form. The next two episodes, 'The Schizoid Man' and 'The General', follow 'Free For All''s burlesque of 'politics' with satirical attacks on behavioural conditioning and the education system.

'The Schizoid Man', provides viewers with their most difficult 'task' yet. Anyone who does not pay full attention to the episode – and television, as we saw in Chapter Two, is a 'cool' medium which many viewers rarely pay full attention to – can easily get extremely confused. Director Pat Jackson imbues the episode with the kind of tense dramatic structure he supplies for 'A, B and C' and the later 'Hammer Into Anvil'. Yet the surreal images of episodes like 'Arrival' and 'Free For All' are avoided. Here the challenge is carried entirely by the narrative.

As in 'Free For All' the Village guardians use tactics which are intended to destabilise the Prisoner's sense of self, this time by producing a doppelganger figure, played by McGoohan himself. The theme of the *doppelganger* is an allegorical literary form which is characteristically used for exploring the depths of human psychology, and usually the 'double' represents the 'evil' side of the hero. A prime establishing example was Edgar Allan Poe's *William Wilson*, in which the main character's life is made a misery by him being continually hounded by his exact double, who bears exactly the same name. The theme has also been commonly utilised in modern films and TV series. It is used on more than one occasion in *Star Trek*, notably in the episode *The Enemy Within* where an 'evil' Captain Kirk is duplicated by the transporter beam. Generally it is a scenario which lends itself naturally to allegorical treatment. 'The Schizoid Man' is no exception. *The Prisoner*'s individuality – his very existence – is challenged. But now, unlike in 'Free For All', the Individual wins a victory (of sorts) over Society. As with 'Chimes' and 'A, B and C' the Prisoner's meticulous attention to detail saves him from his intended fate.

The episode opens with the Prisoner and a girl called Alison rehearsing a 'mind reading' act which she intends to use at a future Village event. There is no hint of romance here, but it is unusual that the girl, who wears a 'Number 24' badge should be referred to throughout by name. Also, for once the Prisoner appears to have formed a genuine relationship with someone. The impression is also given that he has to some degree accepted his imprisonment and is finding ways of whiling away his time.

In the Control Room, we meet this week's Number 2, played by Anton Rogers. Rogers' Number 2 is particularly smooth and self-assured, but lacks the more 'human' qualities of Portman's and McKern's characterisations. He administers a plan which once again involves the Prisoner being drugged and brainwashed. From the Control Room he watches this process begin. The light above the Prisoner's bedside descends, accompanied by electronic buzzing noises on the soundtrack. We then see a montage of superimposed shots in which he is subjected to behaviourist conditioning techniques including electric shock treatment. When he wakes up he first notes the date – February 10th – then notices that he now has a moustache. He is not in his usual house, and the jacket hanging in the cupboard bears the number '12'. The phone rings. It is Number 2, who addresses the Prisoner as 'Number 12' and asks him to come to the Green Dome.

The exchange between Number 2 and the Prisoner in the Green Dome is one which the viewer needs to pay careful attention to in order to follow the plot. The Prisoner tries to demand an explanation for what has happened to him. Number 2 talks to him as if he is Number 12 and explains that his 'assignment' will be to work on their 'prize prisoner', Number 6. With remarkable bravado, Number 2 explains that his job will be to impersonate Number 6 so as to convince him that he is not 'himself', assuring him that 'Once he begins to doubt his own identity, he'll crack'. Whatever the Prisoner says is cleverly twisted around. When he maintains that he is the

'real' Number 6, Number 2 praises him for his thorough dedication to the impersonation. The Prisoner seems to go along with this, perhaps hoping that it will give him some kind of advantage. He is then taken away for 'grooming' In another superimposed montage we see his moustache being removed and his hair restyled, so that he looks once again like 'himself'. Number 2 takes him to his old house, informs him that for future reference the password will be 'Gemini' (meaning, of course 'the twins') and leaves him to meet his double.

The Prisoner's double then appears, dressed in a white jacket. For most of the rest of the episode, it is only the Prisoner's dark jacket and his double's white one that will distinguish them. Even so, there are moments when it is easy for the viewer to become confused as to which is which. There is little doubt that this is intentional. The Prisoner's double has adopted all his essential mannerisms and habits, even his sarcasm: 'Why don't you run away and play somewhere else?' he says scornfully. And it is the double who makes the obvious joke: 'are you one of those double agents we hear so much about these days?' Both play their roles to the full. The double tests the Prisoner out in various ways – the Prisoner finds he is unable to smoke his usual brand of cigars and that the freckle which should be on the right side of his nose now appears on the double's and not his. He has previously discovered that he is now left handed whereas the double is right handed as he used to be. They adjourn to the recreation room to undergo a number of physical 'duels'. Firstly, the Prisoner discovers that he can no longer shoot like he used to, whereas the double scores top marks. The double defeats him in a fencing match, and then wins out at bare knuckle boxing. The Prisoner has apparently lost all his 'superhuman' abilities in these fields. Gradually he is losing confidence and it seems as if Number 2's plan to break him by destroying his sense of identity is succeeding.

At this point Rover appears and ushers them both to the Green Dome. Here the plan reaches its climax, and nearly pushes the Prisoner over the edge. The double is grabbed by Village security men and tortured whilst the Prisoner is welcomed by Number 2 as 'Number 6'. The double is still pretending to be the 'real' Number 6. Number 2, meanwhile, addresses the double as if he were an imposter (which of course he is) and addresses the Prisoner as 'Number 6', but with the tacit understanding between them that the Prisoner is really Number 12 impersonating Number 6 and that the man whose spirit they are trying to break is not in fact himself but his double.

After the double has (apparently) been tortured by the application of a white light beam to his forehead and aggressive questioning by Number 2 (though of course he is acting) he collapses, as if unconscious. The two 'Prisoners' then undergo a fingerprint test. This time the Prisoner wins, which apparently provides scientific proof of who is who. But the double protests in a convincingly 'Prisoneresque' way that 'the trouble with science is that it can be perverted'. Finally, the Prisoner calls for Alison, thinking that her mind-reading act will prove that he is the real Number 6. But Alison, who looks

extremely unsettled, allows the double to win, whilst Number 2 looks on with a self-satisfied expression. The double then pulls a photograph Alison had taken of him from out of his pocket. Alison also points out that the real Number 6 has a mole on his left wrist – and whilst the double has one, the Prisoner does not. The double leaves in triumph with Alison. Number 2 then gets very angry with the Prisoner for his supposed lack of attention to detail, and orders him to report back to him first thing in the morning. The Prisoner fails to respond or argue that he is the 'real' Number 6'.

We cut to a shot of the Prisoner lying in bed at Number 12's house. As with 'Free For All', we now see a subjective montage of superimposed shots taken from earlier in the programme – the faces of Number 2, of Alison and of the double, all crowding in on him, their voices taunting him. His body goes into spasms. We cut to the Green Dome, where Number 2 and the white-jacketed double are watching events on the Viewscreen. 'He's cracking, Number 12', Number 2 comments smugly, 'won't be long now'.

Yet our ever-resourceful hero does not crack. Just as the viewer has finally been reassured that the white-jacketed man is the bogus Number 6, the Prisoner finally begins to regain a sense of self. As in 'A, B and C' and 'Free For All' he struggles to separate dream and reality. Again it his careful attention to detail which pulls him through. He notices that the date on his calendar is still February 10th, yet the bruise on his fingernail has moved upwards, indicating that several days have passed. Standing in the mirror, he stares at his face and relives the whole experience of the conditioning process. This is conveyed by another montage of superimposed shots, some taken from earlier in the episode. We see him mechanically repeating phrases like 'I smoke black cigarettes ... flapjacks are my favourite dish', all of which refer to his newly conditioned habits.

After this visual 'revelation' the Prisoner has now regained his sense of self, but still retains the physical conditioning reflexes. He resolves this problem by giving himself an electric shock from a lamp in his room. Now he goes in search of his double. Number 2, checking on him, discovers that he is not in his room and sends out security men to look for him. He tries the password 'Gemini' on them but they pay no heed and attack him. He beats up both of them in a typically 'staged' fight scene accompanied by dramatic music, then grabs a mini-moke and drives to his old house. He finds his double relaxing on the bed, threatening him with a nerve gas pistol. But he first wins the double's confidence by pretending to be a broken man, which gives the double the chance to ask him why he resigned. He gives only a mumbled reply, and when he has caught the double off guard, attacks him. The fight scene which ensues further demonstrates that our hero is back to the height of his physical powers. He soon has the double whimpering. The double now admits that his real name is Curtis and that the real password is 'Schizoid Man'. The fight continues outside the house, when suddenly Rover appears. The Prisoner shouts out 'Schizoid Man!' and it avoids him, but Curtis' repetition of the words does not work, and Rover smothers him to death.

The Prisoner, now with a key psychological advantage, immediately calls Number 2, claiming to be Curtis, and tells him that Rover has killed Number 6. Number 2 is furious, but appears at first to accept the situation. But in the next scene at the Green Dome the Prisoner already begins to give himself away by suggesting to Number 2 that the whole thing was his idea, which Number 2 calls 'a strange thing to say'. He travels with Number 2 in a Minimoke to the helicopter pad, ill at ease with the casual conversation about the job and his personal life that Number 2 is making. Number 2 makes one reference to 'Susan' saying something to him a month ago, to which the Prisoner does not react.

They pull up at the helicopter pad. Before he gets in he is approached by Alison, who tells him she is ashamed of what she has done to Number 6. Of course, being a 'mind reader' she really knows that it is the 'real' Number 6 who is escaping, but must keep up the 'official illusion'. Here is a very rare example of another inhabitant of the Village communicating in a genuinely 'human' way with the Prisoner, even if that communication has to be virtually 'telepathic'. It must be said that although McGoohan's allegory is basically a bleak one in terms of its view of human society, the existence of characters like Alison implies that he does see glimmers of hope.

Just before the Prisoner is due to depart Number 2 gives a final 'friendly' greeting: 'You won't forget to give Susan my regards, will you?' The helicopter takes off and for a moment it appears that our man may at last be free. But, in exactly the same way as 'Arrival', the helicopter gets only so far before the automatic controls bring it back to the landing pad. Number 2 is waiting. 'Susan', he says wryly 'died a year ago'. The bars slam over the Prisoner's face again.

Despite his final disappointment, the Prisoner has won another important battle in the conflict over his 'soul'. Another exhaustive and elaborate Village plan to break him has failed. He has retained his personal integrity, and his individuality. He has been tested to the very limits and like a true hero has survived. 'The Schizoid Man' is a very carefully structured narrative in which the drama – by being focused entirely on character – does not require 'location' settings. Its investigation into the 'duality of man' further universalises the allegorical strength of the series – allegory itself being a particularly dualistic form. The Prisoner here comes closer than ever before to losing the sense of individuality which defines him.

'The General', which follows, is another 'social allegory'. It is the first episode in which the main focus of the story is not the Prisoner himself but the Village. This time the Prisoner is cast in a new, more subversive role. For once the whole 'drama' that the Village controllers put on does not seem to be 'stage managed' for his benefit. Now he becomes concerned with attempting to take control of the 'drama' itself. Significantly, as with 'The Schizoid Man', there is no hint of any escape attempt being made here. This establishes a pattern that will dominate the next phase of the series, until finally in 'A Change of Mind' (the last episode with a conventional 'Village' setup)

he learns how to manipulate the Villagers so that they turn against their masters. To help him, he constantly looks for allies that can be trusted. Here, in Number 12 (no relation to the Number 12 in 'The Schizoid Man'), he appears to have found one.

The episode, in which Colin Gordon returns as the nervous, milk-drinking Number 2, is an allegorical portrayal of an education system which teaches people 'facts' but not how to think, and in this sense it has an important place in the overall allegorical design of the series. If 'the whole earth' has become the Village, a place where democracy is a sham and we are all being subtly controlled, then 'The General' identifies where that social control begins – in the education system. The metaphor of 'school' – most schools being models of hierarchical systems – had been applied to the Village before, as in 'The Schizoid Man', where Rover is sarcastically referred to as working for the 'headmaster'. Here, the whole 'society' of the Village is 'enrolled' in one class.

We begin with an aerial shot of Portmeirion from a helicopter. Then we see the Prisoner sitting outside the crowded Village cafe. For a moment he catches the eye of a young man who sits at a nearby table. Behind his head is a poster of the man we will come to recognise as the Professor, accompanied by the slogan 'It can be done ... Trust Me'. Then a tannoy announcement, not in the usual cheery 'Village voice' but in a male voice which identifies itself as being from the 'General's department' instructs all students taking the 'Three Part History Course' to return to their houses. The cafe immediately empties, apart from the Prisoner and the young man. We cut to another wall poster, which advertises: 'Speedlearn ... a three year course in three minutes ... Our aim: one hundred per cent entry, one hundred per cent pass'. The young man, Number 12, and the Prisoner have a guarded discussion about 'Speedlearn' which, although conducted in Village 'doublespeak', leaves us with a distinct impression that Number 12 may just be an ally (if, of course, he is not a plant). Number 12 calls himself 'a cog in the machine'.

Their conversation is interrupted by the sound of an ambulance siren. The ambulance and a crowd of Villagers are seen chasing a man down to the edge of the shore. Number 12 identifies the man as 'the Professor'. The Prisoner goes down to the shore to see what is happening, and accidentally stumbles upon a small tape recorder in the sand. He quickly buries it again when two Village 'toughs' appear. He jokingly tells them he is 'playing truant' and they order him back to his house to watch the 'Speedlearn' programme. We then see him sitting down to watch, a tomato juice in hand. The 'show' is compered by a typically slick TV presenter, who introduces the audience first to the Professor's wife. She apologises for the delay. Then the Professor himself appears and explains the basis behind 'Speedlearn':

> ... It is quite simply the most important, most far-reaching, most beneficent development in mass education since the beginning of time. A marriage of Science and Mass Communication which results in the

abolition of tedious and wasteful schooling ... a three year course indelibly impressed on the mind in three minutes.

A picture of the Professor's face appears on the screen. The Prisoner's gaze suddenly becomes fixed, as if he is being hypnotised. We cut quickly between the Prisoner's face and that of the Professor, whose eyes shine with a strange green light. Distorted electronic sounds on the soundtrack add to the effect. As the 'lecture' ends, the Prisoner stumbles and drops his tomato juice onto the floor. He snaps out of the hypnotic state. Number 2 then appears, claiming to be searching for a lost tape recorder, which he even offers the Prisoner his freedom in exchange for. He then asks the Prisoner various questions about European history in the Nineteenth Century. The Prisoner answers them mechanically. Eventually they chant the same answers together, saying the same words at exactly the same time. When Number 2 has gone the Prisoner rings the telephone operator and asks the operator the same questions. The mechanical, word-perfect answers convince him that he, and the rest of the Village have been efficiently brainwashed by the 'Speedlearn' process.

His next move is to return to the beach in search of the tape recorder. He realises that the machine is not where he left it, but then discovers Number 12 hiding behind some bushes. After a conversation in which Number 12 hints that the tape recorder could be a way out of the Village, Number 12 asks him: 'What was the Treaty of Adrianople?' The Prisoner gives his pre-programmed answer 'September 1829'. Number 12 replies 'Wrong. I said what, not when. You need some special coaching'. This enigmatic comment will eventually be the inspiration for the Prisoner's attack on 'The General'. But, as yet, he does not know who the General is. When Number 12 departs he listens to the Professor's message, which refutes his official stance towards Speedlearn entirely: 'You are being tricked. Speedlearn is an abomination. It is slavery. If you wish to be free there is only one way. Destroy the General'.

With this conundrum established, the first segment of the episode ends. The second segment opens on the following morning, where the Villagers at the cafe are excitedly exchanging their new 'knowledge' with each other. Meanwhile, a brass band plays the usual 'cheerful' Village music. We cut to the Committee Room, where Number 2 is talking to Number 1 on the orange phone, reassuring him that all is going well. He calls Speedlearn 'possibly the most important human experiment we've ever had to conduct' Number 12 appears and tries to persuade Number 2 not to trust the Professor, who he labels a 'crank' and a 'troublemaker'. Number 2 gets angry at this and tells Number 12 to keep his opinions to himself. We cut to the Control Room, where Number 2 watches the Professor at work at his typewriter. He is dragged away unwillingly by a white-coated nurse, while the doctor takes his notes and feeds them into a computer, where they are converted into metal strips of digitised information. This is our first clue as to the real identity of the mysterious 'General'.

Number 2's survey continues with a look an Art Class being run by the Professor's wife outside the extremely well-appointed house that she and the Professor have been provided with. He is very surprised to see the Prisoner in attendance. The scene is another satirical attack on artistic pretensions, similar to the 'art exhibition' in 'Chimes'. The Prisoner is told that a man who is ripping up a book is 'creating a fresh concept. Construction arises out of the ashes of destruction'. A woman who is standing on her head is 'developing a new perspective'. The parody of conceptual art suggests that such abstract, apolitical expression can easily be accommodated into a totalitarian society such as the Village.

The Prisoner finally reveals to the Professor's wife the picture he has been drawing. It is a very recognisable study of herself, dressed in the uniform of a General. Angrily, she tears up the picture. Inside the house, he finds a room full of busts covered in white sheets. The Professor's wife follows him and tells him to leave. He ignores her and begins to unveil the statues. One features McKern's Number 2 from 'Chimes', another features himself and a third is of the current Number 2, who now makes an appearance. He takes a mocking attitude to the Prisoner: 'Are you playing truant?' he asks. 'Doing a little homework', the Prisoner replies. He tells the Professor's wife that 'Number 6 and I are old friends' (presumably referring back to 'A, B and C'). The Prisoner enquires about how the Professor is and is told by the doctor he has been sedated. He then does an extraordinary thing. Picking up a heavy walking stick he walks into the bedroom where the Professor lies and smashes the stick into his face. The face, which is only a model, shatters. 'You should take greater care of him, ma'am', the Prisoner jokes 'he's gone to pieces'.

As he leaves the room, an angry Number 2 tells him that his 'offer' about releasing him if he returns the tape recorder is cancelled. The Prisoner takes the tape recorder out of his pocket and gives it to Number 2 with a sarcastic 'best of luck with your exams'. He has now effectively confused Number 2, although he still does not know the identity of 'The General'. He has also exposed the way in which the Village authorities are merciless pushing the Professor to his limits. The screen now fills with a close up of the bust of the Prisoner, then the image dissolves to a scene of yet another manufactured Village 'celebration'. The Villagers, dressed in carnival masks, are waving placards in favour of Speedlearn, apparently gripped by some kind of pre-programmed mania. Amongst the crowd the Prisoner again notices Number 12, who is the only one to appear unaffected by all this.

We cut to the Prisoner's house, where an electrical failure suddenly occurs, knocking all the lights out. Number 12 appears and orders the electrical repair man outside to call for more supplies. With the surveillance systems disabled, Number 12 explains his plan. He gives the Prisoner a small tube which he says contains the Professor's real anti-Speedlearn lecture in minaturised form and explains a plan by which this will be broadcast instead of the next 'history lesson'. The intention is clearly to destabilise and subvert

the entire Village by 'reprogramming' the Villagers. In order to facilitate this, he gives the Prisoner a security pass which will get him into the projection room where he can make the substitution. Here, for the first time, the Prisoner is being given genuinely useful help by another member of the Village, although he and the viewer must naturally hold suspicions that Number 12 is in reality working for the Village controllers.

As the third segment of the episode begins, we see the doctor attending a somewhat recovered Professor at his bedside. Then we cut to a white corridor (obviously somewhere in the Village 'underworld' of control locations) where the 'delegates' to the latest Speedlearn session are assembled. They are all dressed bizarrely, in long formal black coats, top hats and sunglasses. As they slot their security passes into a machine, a tiny mechanical hand jumps out and grabs them. This is accompanied by particularly whimsical music. We then see the Prisoner attempting to negotiate the way in. His first attempt fails and he is informed by the (talking) machine that the second occasion is always fatal. Finally, his pass gives him entrance. We cut to the Committee Room, where the delegates are now gathered, and then back to the corridors, where the Prisoner reaches the projection room. En route he has to dispose of several guards, and in order to gain control of the projection room he also has to disable the projectionist, which he does with typical aplomb.

In previous episodes, the Prisoner's attention to detail has been the vital factor in helping him win considerable moral victories over the Village controllers. But now, in his hurry to set up the Professor's subversive message, he fails to notice that he has cut his wrist in the fight with the projectionist. This will prove to be his undoing. Back in the Committee Room, we see the delegates preparing for the Speedlearn broadcast. Number 12 gives a speech explaining how the process works. Then Number 2 makes his final check of all the operatives. At the very last moment, he notices the blood on the arm of the operative in the projection room. This arouses his suspicion. He orders the camera to zoom in, then he recognises the Prisoner. We cut to a shot of two security guards coshing the Prisoner to the ground. The subversive message is removed and the next phase of the Speedlearn process goes ahead as planned.

The Prisoner and Number 12's sabotage plan has completely failed. But Number 2's arrogance and determination to boast of his victory proves to be his downfall. After a rather perfunctory attempt at 'cross examination', in which the Prisoner's reply as to who heads the 'subversive organisation' which had planned to sabotage the Speedlearn programme is 'Santa Claus' , Number 2 decides that the answer will be obtainable from 'The General'. Of course, he has no reason to reveal to the Prisoner who 'The General' is, but he appears determined to revel in his triumph. When the doors into the relevant room are first opened, we see only The Professor, working away at his desk. Number 2 continues in his boastful manner, making the grandiose claim that 'there is no question, from advanced mathematics to molecular structure, that The General cannot answer'. At this moment a set of curtains

are pulled back to reveal 'The General', which is in fact a huge computer. Number 2 continues to boast about the capacities of the machine, and even reveals that the Village sees 'The General' as a potential device for the mass control of populations.

Number 2 uses 'The General' to help him point the finger of conspiracy at Number 12, whose career as one of the Village authorities is clearly over. Then, at the point when he appears to have everything under control, Number 2 makes one fatal mistake. The Prisoner tells him that he knows one question which 'The General' cannot answer. Number 2 accepts the challenge. The Prisoner types in a very short question, converts it into a metal strip and gives it to the Professor to feed into the computer. 'The General' blows its circuits and explodes, killing the Professor in the process. An aghast Number 2, looking rather ridiculous with his blackened face, asks the Prisoner: 'What was your question?' The Prisoner replies 'W. H. Y. Question mark'. 'In a strange wordless coda to the episode we see the Prisoner passing by the Professor's house and pausing for a moment to acknowledge his grief-stricken wife. Then the familiar bars slam down over his face.

'The General' is certainly a memorable, if highly melodramatic episode. Although the ending fits well with the allegorical subtext of the series, the revelation that 'The General' is a powerful computer is a stock science fiction device. Viewing the episode from the aftermath of the microprocessor revolution, 'The General' itself looks incredibly archaic, and is one of the few visual images that really dates the series. Also, the implied critique of a 'Gradgrind'-type education system consisting entirely of rote-learning is somewhat dubious, particularly in the light of 1960s developments in 'progressive' education methods. It can be argued, however, that the story is less about education than about television. Just as television was used for political propaganda and manipulation in 'Free For All', here it is used to brainwash the population into a state of mindless compliance. Only the Prisoner – the voice of the Individual – can break the impasse by posing the moral question which no-one else dare ask. The episode is a significant triumph for the him, and presages his future victories in the internal politics of the Village.

'Many Happy Returns', which follows, is the culmination of the early phase of the series. It features the last serious 'escape attempt' before the final 'Fall Out', and expands the 'world' of the Village considerably. The script is by Anthony Skene, who had previously written 'A, B and C'. However, the actual amount of dialogue in the episode is relatively small. The episode is directed by McGoohan (under the jokily Kafkaesque pseudonym of 'Josef Serf') and, like the other McGoohan- directed pieces, is highly cinematic in its construction. In fact, the first twenty-three minutes (covering the first two of the programme's three segments) are virtually dialogue-free.

Up to this point, the programme has, despite its thematic adventurousness, settled into something of a 'formula'. Each week the Prisoner has been confronted with some new test or task by the controllers which he has to over-

come. He may win or lose, but his essential spirit is never broken. Each episode has been located entirely in the Village. Even the scene in 'Chimes' where he believes he is in London is another Village mock-up. As we have seen, television series characteristically create their stories in such a repetitious mode. Writing in 1973, TV critic Clive James identified the appeal of *Star Trek* as lying in the '*classic inevitability of its repetitions*'.[2] Such a set pattern is essentially reassuring to an audience, who can enjoy the supposedly perilous exploits of Captain Kirk or the *Mission Impossible* team, knowing that whatever 'terrible' threat may be posed to them this week, they will – no matter how close they seem to death or defeat – inevitably triumph against the odds. 'Many Happy Returns' does much to shake viewers out of this complacent attitude. McGoohan manipulates the pattern of expectancy he has set up, so as to expand his allegory of the 'whole earth as the Village'.

The beginning of the episode is a considerable shock. The Prisoner wakes up to discover that the Village is completely deserted, apart from a solitary black cat that lives by the sea shore. Naturally, he appears to think this is another trick, and thoroughly searches the Village, which is pervaded by an weird silence. No incidental music is used on the soundtrack here. He climbs the belltower and rings the Village bell, but there is no response. He dashes into the Green Dome, but discovers nobody in Number 2's room. Finally convinced that he really is alone, he sets about making his escape. As always he is extremely thorough and methodical. Determined to return home with some 'hard evidence' he takes a series of photographs of the Village. He drives a Village mini-moke as far as he can before realising there is definitely no escape by road. A montage of shots similar to the boat-building sequence in 'Chimes' shows him in action constructing a life raft and taking provisions for the journey from the Village shop. He leaves an IOU for 96 work units, signed 'Number 6?' and then puts out to sea. There is no sign of Rover, and soon the Village is out of sight.

The passage of time is conveyed through superimposed montage shots which show the Prisoner looking successively more bedraggled and exhausted. But his eye for precise detail and his instinct for meticulous planning clearly stay with him. We see him scrupulously keeping a log of his journey, making a compass and carefully protecting the roll of film with pictures of the Village. At first he is even seen shaving. But as we reach 'Day 7' in the logbook, he has given this up and is clearly having trouble staying awake.

Next, we see what looks like a small fishing trawler approaching. A black coated figure appears at the raft, throws the sleeping Prisoner into the sea and steals his provisions. But the Prisoner quickly recovers, swims after the ship and boards it. We cut to the front of the boat, where the two thuggish crewmen are eating their lunch from tins marked 'Village Foods'. Meanwhile, the Prisoner sneaks below decks and discovers a large consign-

2 from *The Observer*, 1973; quoted in *The New Trek Programme Guide* by Paul Cornell, Martin Day and Keith Topping, p.3.

ment of guns in the hold. To create a distraction, he starts a fire. The sailors come to investigate and in true action-hero style he beats them both up, ties them and trusses them. He takes over the steering of the boat. But then one of the crewmen escapes and another fight ensues, before the Prisoner, spotting a shoreline ahead, finally leaps into the water .

The Prisoner has now been washed up onto a beach, above which are towering white cliffs. Checking that his Voyage Log and precious roll of film is undamaged, he climbs upwards. On the clifftop he encounters a swarthy-looking man with a dog leaning on a staff. Eighteen minutes into the episode, he utters his first words (which are practically the same as his first words in 'Arrival'), 'Where is this?' But the man only answers aggressively in a foreign language and walks off. The Prisoner follows him to a gypsy encampment. The gypsies, who converse in the same guttural tongue, are very unfriendly, apart from one young woman who offers him a drink and points him towards a road. At this point he still has absolutely no idea of where he is, and the presence of gypsies only adds to the ambiguity. He then finds the road and looks out on it carefully from behind some bushes.

What he now sees is a considerable shock, for him and the viewer. It is a uniformed British 'bobby', an unmistakable icon of Britishness. Apparently 'by chance' the Prisoner has arrived back in England. He then notices that there are other policemen there and that they appear to be stopping cars and searching for someone. Although he has 'escaped', his paranoia quickly takes over. Making sure he is not seen, he jumps into the back of a lorry where soon he falls asleep. As he wakes up, we hear police sirens apparently pursuing the lorry. We cut to a close up of his fear-stricken face. Quickly, he jumps out of the lorry. The camera then pans back to reveal to us that he is in a crowded street in the middle of London. The shock of recognition of the familiar image is carefully and dramatically timed.

He then walks to his old house – 1 Buckingham Place – which is already very recognisable to us from the weekly credit sequence. A maid answers the door and the first real conversation of the episode occurs. He enquires who owns the house now, but the maid refuses to give him any information and shuts the door in his face. Just then a car pulls up. It is KAR 120C – the Prisoner's own Lotus 7, which features prominently in the credit sequence. A well-coiffured middle aged woman dressed in a trouser suit gets out and makes for the door. The Prisoner rushes up to her and reveals to her that he knows both the registration number and engine number of the car, and that he himself built it by hand. Rather amused by his impertinence, she gives him a quick look up and down an a rather overtly sexual way and invites him in.

The Prisoner is now apparently safely 'home' but every aspect of McGoohan's direction challenges the viewer to compare 'home' to the Village, playing on the familiarity of established visual images as only an episode of a TV series can do. The woman – who introduces herself as 'Mrs. Butterworth' – leaves the room to prepare some refreshments for him. He surveys the room carefully, with his usual eye for detail and carefully checks

the reality of the situation. When he lifts the blinds to look outside, the shot exactly resembles the one in the credit sequence that reveals he is in the Village. But reassuringly, he now sees the view of London outside.

Mrs. Butterworth returns. She fusses over the Prisoner, feeds him sandwiches and fruit cake which he wolfs down, being ravenous with hunger. She asks him his name. He falters and then replies – very unconvincingly – 'Peter Smith'. This is the only time in the series he gives himself a name, but we are given no reason to believe it is anything more than a convenient alias. He tells her that tomorrow (March 19th) is his birthday. She explains that she is a widow, has rented the house out on a ten year lease, and that the car came with the house. She even shows him the documents to prove it. It all seems remarkably convincing, though Mrs. Butterworth asks few really searching questions and seems to take the Prisoner on trust. But after his experience in escaping he seems somewhat dazed, and, unused to any genuine kindness and sincerity, appears to accept the sequence of events. Mrs. Butterworth invites him to take a bath, lends him some of her husband's old clothes, some money and even her car. As he prepares to leave she says 'Don't forget to come back ... I might even bake you a birthday cake ...'.

So the Prisoner drives off, taking exactly the same route as he takes in the credit sequence in exactly the same car. Again McGoohan's direction concentrates on visual parallels depending on the viewer's familiarity with the images being shown. He drives his Lotus into the underground Secret Service centre and walks into the room where he originally resigned. Behind the desk, the official (played again by George Markstein) merely looks up and makes no comment.

We cut to another, larger office, where the Prisoner shows two leading secret service men his photographs of the Village. The two men – 'the Colonel' (not the same 'Colonel' as in 'Chimes') – and 'Thorpe' – are played respectively by Donald Sinden and Patrick Cargill, two extremely recognizable British film and television actors. At first, they mock the Prisoner's story and suggest that he may have in fact defected to the 'other side'. The Prisoner angrily tells them that he is not sure which side runs the Village and that he intends to find out, 'if not here, then elsewhere.' The implied threat of defection seems to demonstrate to his superiors how serious he is. We then see a montage of shots showing how the Prisoner's story is checked – one policeman visits Mrs. Butterworth, another checks the gypsy camp. Finally his superiors appear to believe him. Two military experts – senior Navy and Air Force officers – are called in to help locate the Village. The naval officer, considering the details of his journey, identifies the Village as being somewhere off the coast of Morocco or Southern Spain or Portugal. (A far cry from its apparent location in 'Chimes' of Lithuania). We cut to an airfield, on the next day – the Prisoner's birthday – where a milkman is unloading a crate of bottles. As the Prisoner walks out towards the plane, he announces to the Colonel his determination to find the Village, no matter how long it takes. The Colonel jokes 'you're a stubborn fellow, Number 6'. The Prisoner replies

'James, you call me that once again and you're liable for a bout in hospital'.

The Prisoner, now dressed in a flying suit, climbs up into the plane. The pilot, his face obscured by his helmet and oxygen mask, joins him. As the plane takes off Thorpe and the Colonel stand looking rather wistfully up at the sky, their words are rather ambiguous, and somehow ominous: 'Interesting fellow', Thorpe comments. 'He's an old, old friend', the Colonel says, 'who never gives up'.

The next few minutes of the episode are again shot with virtually no dialogue. We see shots of clouds and various landscapes below. The speed of cutting between shots increases. Finally the Prisoner spots the Village. 'That's it, we've found it!', he shouts, above the noise of the engine. We cut to the grinning face of the pilot, who has pushed up his helmet, revealing his face as that of the 'milkman' seen earlier at the airfield. With a cheery 'Be Seeing You', he pulls a lever. We cut to a shot of the Prisoner floating down to earth in a parachute, and then to a shot of the black cat, apparently looking up. The Prisoner lands on the beach in the Village, which appears at first to be as still, silent and deserted as when he left. We see another shot of the black cat, which appears to be in exactly the same position as when he escaped. He walks across the Village square, which is still deserted, and enters his house. Suddenly, without any explanation, and with a sickening sense of inevitability, a jet of water begins to stream out of his shower, the lights come on and his coffee pot begins to boil. The door opens and 'Mrs. Butterworth' appears, still dressed in her 'London' clothes but now wearing a Village 'Penny-Farthing' badge marked 'Number 2'. She carries a birthday cake with six candles. With an ironic smile she wishes him 'Many Happy Returns'. He goes to the window and looks out at the Village, which is now full of the Villagers going about their 'daily business'. Underneath a large black and white umbrella stands the expressionless Butler. As ever, the Prisoner's face is superimposed over a shot of the Village, and the bars smash down.

'Many Happy Returns' is an episode which transforms the whole 'world' that the series has created. Crucially, the Prisoner must now realise that there is no escape. In their most elaborate plan yet, and apparently without the use of the usual brainwashing devices and mind-altering drugs, the Village controllers have demonstrated to him the futility of the nature of his struggle so far. It is the most crushing blow he has yet received. On his birthday he has been 'reborn' into a new sense of awareness of what the Village really is. Number 2's 'prophecy' in 'Chimes' of 'the whole earth as the Village' seems to have come true. On an allegorical level, it is important for McGoohan to show that the Individual cannot 'escape' from modern society but must fight it from within.

Reviewing the episode, viewers may puzzle over a number of points. If the Controllers planned for the Prisoner to escape, why was he almost murdered by their own operatives on the boat? Why have they apparently allowed the location of the Village to become known to the British authorities? And were the Colonel and/or Thorpe (or even the entire British estab-

lishment) conspiring with the Village authorities to return our hero to his prison? How did the 'milkman' manage to end up as the pilot of the plane? And why, and by what fantastic means, did they arrange for the Village to be deserted? The whole narrative of 'Many Happy Returns' has a nightmarish logic, characterised by nagging repetition. As with a number of the previous episodes, the whole story could be interpreted as being a dream. Or perhaps the Village *had* drugged or brainwashed him ...

By this point in the series, those viewers who clung to the hope that the series would have a conventional, Bond-like, ending were clearly 'misreading' it. 'Many Happy Returns' puts *The Prisoner* well outside the bounds of naturalism. Its 'impossible' circumstances, like the Prisoner's 'accidental' arrival in England, the fact that the lorry he jumps into takes him right into the heart of London, Mrs. Butterworth's sudden appearance in the Village and the sudden 'coming back to life' of the Village place it clearly and specifically in an allegorical vein. From here on, the allegorical focus of the series will shift from social and political concerns towards the psychological battle between the Prisoner and his captors for possession of his 'soul'. The Prisoner will now be much less preoccupied with escaping, and much more concerned with attempting to destabilise the Village itself. His entire 'world' really has become the Village.

Initiation

Episodes 8-12:

'Dance of the Dead', 'Checkmate', 'Hammer into Anvil', 'It's Your Funeral', 'A Change of Mind'

It was late in the evening when K. arrived. The village was deep in snow. The Castle hill was hidden, veiled in mist and darkness, nor was there even a glimmer of light to show that a castle was there. On the wooden bridge leading from the main road to the village K. stood for a long time gazing into the illusory emptiness around him.

 Franz Kafka, *The Castle* (opening lines)[1]

At midnight all the agents
And the super-human crew
Come out and round up everyone
That knows more than they do,
And they bring them to the factory
Where the heart-attack machine
Is strapped across their shoulders
And then the kerosene
Is brought down from the castles
By insurance men who go
Check to see that nobody's escaping
To desolation row.

 Bob Dylan, *Desolation Row*[2]

1 Franz Kafka, *The Castle*, p.9.
2 Bob Dylan, *Desolation Row*, from the album *Highway 61 Revisited*.

PRISONER: Why do both sides look alike?
CHESSPLAYER: You mean, how do I know black from white?
PRISONER: Well?
CHESSPLAYER: By their dispositions. By the moves they make. You
 soon know who's for or against you.
PRISONER: I don't follow you.
CHESSPLAYER: It's simply psychology, the way it is in life. You judge
 By attitude ... people don't need uniforms.
 From 'Checkmate'

After the failure of the Prisoner's 'outer journey' in 'Many Happy Returns', the next five episodes develop his 'inner journey'. While socio-political subtexts are still present in the series, the psychological mode now becomes the dominant one. As the influence of Script Editor Markstein wanes, the 'secret agent' theme becomes less and less pronounced, and the Prisoner's main motivation switches from the need to escape to his attempt to subvert or weaken the social structure of the Village. The crucial 'battleground' of the series is now a psychological one, fought out between the Prisoner and a number of widely different Number 2's. Though defeated by the Village authorities in the first two episodes of this sequence, he learns valuable lessons which allow him to begin to 'play them at their own game' and to use his considerable inner strength to fight back. This results in a series of decisive triumphs for him in 'Hammer Into Anvil', 'It's Your Funeral' and 'A Change of Mind'.

The series thus progresses to deeper allegorical and mythical levels. In terms of his heroic role, the Prisoner now enters the phase of what Joseph Campbell[3] calls 'initiation' during which, by resisting various temptations and by overcoming a series of obstacles, the hero eventually achieves some kind of power. By now he has grasped the basis of the Village's mind-control techniques and has begun to use them to his own advantage. In the last three episodes of this sequence, his actions have a fundamental effect on the power structures of the Village.

The Prisoner's struggle for 'freedom' is increasingly portrayed as an inner struggle. In terms of McGoohan's developing allegory, the primal conflict between the Individual and society becomes an internal battle of wills, with the Prisoner and Number 2 representing individualism and social compliance respectively. Perhaps the fundamental question being asked in these episodes is whether, by taking on and using the Village's methods of mind-control for his own purposes, the Prisoner is to some extent losing his 'soul'. Certainly, the 'soullessness' of Village life, with its entirely artificial 'pageants' peopled by brightly-clothed but blank-faced and spiritually drained prisoners, is now

3 Joseph Campbell, *The Hero With A Thousand Faces*.

emphasized strongly. If the Village represents the destruction of the human spirit in modern society, the Prisoner's role as a 'free individual' is to keep that collective spirit alive.

The idea that *The Prisoner* is purely a manifesto for individualism has been challenged by McGoohan himself:[4]

> ... the series was conceived to make it APPEAR that our hero was striving to be 'completely free', 'utterly himself'. Too much of that and society would be overcome by rampant extremists and there would be anarchy. The intention was satirical. Be as free as possible within our situation, but the war is with Number 1.

Increasingly, the Prisoner is forced to become less concerned purely with his own fate and to take on concerns for the society of the Village. In 'Checkmate' he attempts to organize a mass breakout, and in 'It's Your Funeral' he shows concern for the population of the Village as a whole, fearing that reprisals may be taken against them and acting to prevent this. In 'A Change Of Mind' his being ostracized from Village society seems to cause him genuine pain. *The Prisoner* is decidedly not an 'anarchists' charter'. On an allegorical level, the impossibility of being 'completely free' has been clearly shown to him in 'Many Happy Returns'. Now his concern is to affect and change the society of the Village (which allegorically, of course, represents the society we live in) and thus to save its collective 'soul'.

The identity of 'Number 1' becomes a deepening mystery. The successive Number 2's talk to him each week on the orange telephone, but we are no nearer to finding out his identity, despite the Prisoner's constant efforts. The search for the identity of Number 1 now becomes the main 'spiritual quest' of the series – the 'secret' which the expectations that the narrative sets up increasingly demand an eventual answer to, and a continual 'hook' to keep the mass audience involved with increasingly bizarre turns that the series takes. Yet by the end of 'A Change Of Mind', despite the Prisoner's increasing tendency to 'destroy' successive Number 2's, we are still far from any revelation of Number 1's identity.

The Prisoner continues to operate within many of the visual and narrative conventions and codings of the popular TV series. Fight and chase scenes still feature prominently in most of these episodes, and the Prisoner's status as a conventional hero-figure is continually emphasized. The episodes are still broadly constructed within the dramatic parameters of the TV series, with tension generally rising to climaxes before each commercial break, although the mysterious 'Dance Of The Dead' particularly de-emphasizes conventional methods of raising dramatic tension in a way that presages the partial abandonment of those conventions in the final episodes. The casual

4 Patrick McGoohan, quoted from an interview in Cazzare and Oswald, *The Prisoner: A Televisual Masterpiece*, p.6.

viewer can still enjoy the series on a visceral level without necessarily having followed it from the beginning or without considering the philosophical implications the episodes raise (although such viewers are perhaps likely to find an episode like 'Dance Of The Dead' somewhat confusing or off-putting).

A key theme of these episodes is that of 'justice', which gradually super-sedes the original search for 'freedom'. On several occasions the Prisoner is put 'on trial' and on others he operates as a bringer of social justice. The mock-trial of 'Dance Of The Dead' is succeeded by the Prisoner's determi-nation to gain 'just' revenge in 'Hammer Into Anvil' and to protect the 'inno-cent' population in 'It's Your Funeral'. In 'A Change Of Mind' he is publicly 'tried' for his rebellion against society, and (supposedly) sentenced by mem-bers of that society for his 'social crimes'. The theme of the 'trial' will even-tually culminate in the fantastical trial sequence in the final 'Fall Out'. Here the preponderance of the theme emphasizes the Prisoner's growing involve-ment with the 'society' of the Village as well as McGoohan's avowedly moralistic intentions in creating his allegory.

'Dance of The Dead' is an episode which, as mentioned above, departs from conventional narrative structures. The kind of dramatic tension associ-ated with TV series – generally connected with the eventual revelation of a mystery or the triumph of the hero – is markedly absent. In its place is a form of dramatic tension more reminiscent of modern theatre or 'art cinema' (such as the works of Ingmar Bergman) where the tension is seen in subtle shifts of character. In this way, 'Dance Of The Dead' announces the new direction the series will take, towards complex psychological conflict and spiritual explo-ration. The Prisoner here enters the dark 'underworld' of his soul – a place of fundamental moral ambiguity . The main theme of the episode – as embodied in its title – is that of 'spiritual death', but death appears in a num-ber of forms here – the death of the unknown man the Prisoner finds on the seashore, the 'mental death' of the Prisoner's old friend Dutton, the 'Kangaroo court's death sentence on the Prisoner and the 'official' death of the Prisoner as far as the outside world is concerned.

The episode is particularly notable for its use of women in major roles. As well as a female Number 2, the Prisoner's observer and the Village Supervisor are also here played by women. The talismanic (female) black cat of 'Many Happy Returns' reappears in the apparent guise of Number 2's 'familiar'. Up till now the Village authorities have recognized the Prisoner's sympathy for women as a potential weak point on a number of occasions. But here women are mostly portrayed as far from the 'weaker sex'. Mary Morris' Number 2 is perhaps the cruellest ruler of the Village yet seen, but her cruelty is mental rather than physical. 'Dance Of The Dead' is the first episode of the series so far to completely eschew the fight scenes which have established the Prisoner's 'virility'. In this episode his physical prowess as a (cold) 'warrior' is of no use to him at all. The writer, Anthony Skene, was also responsible for the script of 'Many Happy Returns' where the Prisoner's

apparent saviour 'Mrs. Butterworth' turns out to be the current Number 2. Like Mrs. Butterworth, and many of the other women in the series, Morris' Number 2 has a pleasant exterior which conceals a cold, hard and emotionally barren nature. She is a very formidable foe.

'Dance Of The Dead' is, like the other Don Chaffey-directed episodes,[5] richly cinematic in its textures. It utilises colourful costumes and masks as a visual depiction of its exploration of the theme of identity. Eerie-sounding electronic noises are prominent on the soundtrack. Considerable use is made of the Portmeirion location and there are a number of particularly surreal scenes. The dialogue is, like the episode itself; often allusive and mysterious; and a number of 'theatrical' exchanges of minimalist dialogue are used. Its minor characters, like the town crier, the doctor and Dutton, are a notable gallery of grotesques.

The new Number 2's determination to do things her way is apparent in the first scene, where the Prisoner is being tortured by the sadistic doctor, whose craggy, withered features immediately lend him an air of menace. We see the Prisoner lying on a 'hospital' bed with electrodes attached to his temples. The doctor is administering electric shocks, and one of these makes the Prisoner, whose eyes are glazed, jolt upright. He is cajoled into answering a telephone, on the other end of which is the man we will soon recognize as Roland Walter Dutton. Dutton, who looks mentally and physically drained, asks him to disclose secret information, but the Prisoner's body twitches and writhes as he refuses to talk. At this point Number 2 enters and intervenes, telling the doctor that 'I don't want him broken. He must be won over. It may seem a long process to your practical mind, but this man has a future with us ... There are other ways'.

This is a familiar theme in *The Prisoner*. The importance of not 'damaging the tissue' has been continually stressed since the beginning of the series. But the new Number 2 intends to find more subtle ways of breaking his spirit. Like the Number 2's of 'The Schizoid Man' and 'The Chimes Of Big Ben' she has devised a 'cunning plan' to break his resistance down. But in the earlier episodes, once he had understood the trick they were playing he was able to become stronger and more defiant. Here the effects of the demoralization are more likely to last longer and be more fundamental.

We cut to the Prisoner waking up, rather bleary-eyed and disoriented. Just as he opens the door into bright sunshine the voice of the Village announcer cheerily orders the community to 'rise and shine'. Number 2 addresses him from the TV screen as she sips tea in her swivel chair at the Green Dome and tells him (Ironically using the phrase so beloved of American fast-food waitresses) to 'have a nice day'. Whilst he retires to the bathroom she reassures Number 1 over the phone that her plan is progressing smoothly and that its success is 'only a question of time'. A maid appears

5 The other Chaffey-directed episodes are 'Arrival', 'The Chimes Of Big Ben' and 'Dance Of The Dead'.

to clean his house, dressed in an extravagant eighteenth-century ball gown and the postman brings him some mail, an invitation to tomorrow's Village Carnival. The Prisoner treats them both with his usual withering scorn.

We then see the Prisoner observing the eve-of-Carnival 'celebrations' from a balcony overlooking the central square. Loud brass band music plays and the Villagers march around. As he strokes the black cat Number 2 suddenly appears, as if 'summoned' by her 'familiar'. She encourages him to attend the Carnival, and points to a group of three young women dressed as air hostesses. She suggests he choose one of them to take to the carnival. But he is more interested in a pale, nervous young woman (Number 240), who sits on her own a little way away. When he tries to 'make conversation' with her by asking direct questions about her background, she repeats the standard Village phrase 'Questions are a burden to others, and answers a prison for oneself' and departs abruptly. The Prisoner has clearly detected signs of weakness in her, but when he attempts to follow her he is obstructed by Rover. When he tries to gain access to the Town Hall his way is barred by an invisible 'force field' resembling the kind of device frequently seen in science fiction movies. We cut to the Control room, where Number 240, accompanied by a female Supervisor, who is observing the Prisoner's every move.

Disgusted at all the artificial frivolity, the Prisoner's mood is one of considerable frustration. Back at his house, he furiously cross-examines the maid: 'Where does it all come from? How does it get here? The milk, the ice-cream, the potatoes and the aspirins? At night?' I've never seen a night. I just sleep'. The maid, of course, does not respond. He tries putting a cushion over the television screen, but the only response is a whining electronic noise. When a delivery man brings him flowers for his window he angrily cries 'Supposing I don't want any flowers?' But try as he might, it is clear that he will be involved in the Carnival whether he likes it or not.

We cut to a room in the 'hospital', where Number 2 and the sadistic doctor are discussing the fate of Dutton (who, curiously, is referred to by his 'real' name throughout). Meanwhile, the Prisoner angrily paces up and down his room. It is now night time, and the Village's nightly curfew is 10.30 p.m. He decides to see what the Village is actually like at night, but discovers that his front door has been automatically locked. When an elderly maid brings him his nightly (drugged) 'bedtime drink' he avoids consuming it .When he sits in a chair the light above him descends and a gentle voice tries to lull him into submission: 'sleep ... sleep ... lovely gentle sleep and a lovely tomorrow'. But for once he manages to resist being hypnotised. He jumps from his window and lands outside, unharmed. It is no surprise that this 'escape' is observed in the Control Room by Number 240, who immediately informs Number 2. Number 2, who appears to be 'playing' sadistically with the Prisoner like a cat with a mouse, is unconcerned. She sends Rover to apprehend him, and watches amusedly as Rover pursues him across the wide sands. The scene is accompanied by particularly melodramatic music.

Number 2 assumes that the Prisoner will inevitably return to his room as

'it's the only place he can ever go'. But the next scene shows him waking up, having spent the night in a cave on the beach. He is then confronted with his first encounter with death. A dead body has washed up ashore. He examines the man's wallet, which contains 'family photos' and discovers a miniature working radio. The screen fades to black to signify the end of the episode's first segment.

Back in the Village, the pre-Carnival celebrations are in full swing. Loud brass band music rings out and the Villagers parade with their usual 'soul-less' enthusiasm. From the balcony, the crowd are addressed by a tradition-ally-dressed Town Crier (memorably played by Aubrey Morris) who announces, with true Village irony, that 'there will be music, dancing, hap-piness, all at the Carnival … By order'. We see the Prisoner returning to his house, where his Carnival costume has been delivered. This turns out to be his old suit. 'What does that mean?', his maid asks. 'That I'm still myself', he wryly tells her. When she leaves, he attempts to listen to the radio he has found on the dead man. Number 2 and the doctor are watching. The doctor seems keen to be given free rein to use his 'skills' on him but Number 2 coun-sels caution, asserting that one day 'he will be of great value'. Number 2 seems to have little concern for Dutton, whom she describes as 'expendable' and, though denied access to the Prisoner, the doctor seems to relish the idea of 'experimenting' on Dutton. Never does the Village seem more like a concentration camp.

We next see the Prisoner sitting on a wall on a promontory overlooking the beach. He manages to tune in the radio, but hears only a garbled mes-sage which appears to be in some kind of strange code. Number 2 approach-es, accompanied by Number 240. She confiscates the radio, but does not seem particularly disturbed by him being in possession of it. Still playing 'cat and mouse', she taunts him with veiled threats of what might happen to him if he does not conform. She departs, leaving Number 240 to continue her job as his 'observer'. Again sensing her nervousness, he confronts her with more vicious sarcasm. There follows a very theatrical exchange of minimalistic dialogue, in which the Prisoner's use of language is directly counterposed against the 'official' language of the Village:

NUMBER 240: You have no values.
PRISONER: Different values.
NUMBER 240: You won't be helped.
PRISONER: Destroyed.
NUMBER 240: You want to spoil things.
PRISONER: I won't be a goldfish in a bowl.

Having surreptitiously stolen a rope and lifebelt ring from the stone boat, the Prisoner's next move is to return to the cave, where he writes a message (presumably revealing the truth about the Village) which he places in the dead man's wallet. Back in the Control Room, a worried Number 240 has

'Dance Of The Dead': 'This Is Your World. I Am Your World.'

'lost' the Prisoner again. But Number 2 is still relaxed and unconcerned. We cut back to the beach, where we see the Prisoner drag the body out to sea with his 'message in a bottle'. As he turns back to the shore he is shocked to encounter the dispirited figure of Dutton, dressed in a black and yellow hooped shirt . Dutton tells him he has been in the Village for several months and has completely cracked, telling them 'everything I know'. He realises that he has very little time left before the Village torturers dispose of him: 'soon, Roland Walter Dutton will cease to exist'. The Prisoner has had his second major encounter with 'death'.

The next scene; which opens the third segment of the episode; is one of the most strange and memorable of the entire series, a psychic and elemental confrontation featuring more allusive, minimalistic dialogue and with particularly cinematic qualities. The night of Carnival has finally arrived. The Prisoner, dressed in his old suit, stands on the beach watching the sunset. The whole scene is lit with a weird red light, and ghostly electronic sounds are heard on the soundtrack. Number 2, dressed in green as Peter Pan, approaches him:

NUMBER 2: You're waiting for someone, Mr. Tuxedo? Or expecting someone?
PRISONER: Mr. Peter Pan.
NUMBER 2: So it seems.
PRISONER: With his shadow.
NUMBER 2: You're being hostile again. What are you looking at?
PRISONER: A light.
NUMBER 2: A star.
PRISONER: A boat.
NUMBER 2: An insect.
PRISONER: A plane.
NUMBER 2: A flying fish.
PRISONER: Somebody who belongs to my world.
NUMBER 2: This is your world. I am your world. If you insist on living a dream you may be taken for mad.
PRISONER: I like my dream.
NUMBER 2: Then you are mad.

The lighting and music in the scene tends to suggest that this really all is a dream, and the succeeding scenes grow increasingly surreal. Next we see the Prisoner and Number 2 at the Town Hall, where they supposedly 'spontaneous fun' of the Carnival is in full swing. The Villagers are all dressed in brightly-coloured fancy dress, yet their faces as they dance are listless, lifeless. The Prisoner himself remains at first ironically distanced from it all, and he keeps up a confident, jocular tone. 'Why haven't I a costume?' he enquires. 'Because you don't exist'. Number 2 tells him. The full meaning of this remark will be revealed later. The Prisoner then 'dances' with Number 240, who is dressed as Little Bo-Peep, and continues to attempt to cross-examine her, taunting her just as Number 2 has been taunting him: 'Is he here tonight', he asks her, 'the man behind the big door?'

When the dance ends the Prisoner manages to slip away from the ballroom into a long corridor with a number of doors. He grabs a white coat from a hook to disguise himself as a 'Controller'. A woman comes out of one of the rooms and hands him a piece of paper which she tells him is a 'termination order' for Number 2's urgent attention. She leaves, and he unfolds the paper. It contains only the words 'Roland Walter Dutton'. One of the doors then opens automatically into a darkened room, whose lights come on immediately he enters it. The room appears to be an office full of Village filing cabinets. He finds a key hanging on a hook with which he opens another door, which again is completely dark until he steps inside.

Having penetrated into the 'underworld' of the Village, he suddenly finds himself in a mortuary. Inside one of the draws is the body of the man he found on the beach. At that moment Number 2, accompanied by the cat, appears behind him. Her tone is mocking: 'She's taken to you. I'm jealous. Oh, she's mine. She works here too … she's very efficient … almost ruthless'. The Prisoner's reply is 'Never trust a woman. Even the four-legged variety'.

Number 2 then reveals to him what she meant earlier about him 'not existing'. She tells him that, having disfigured the corpse so its face is unrecognisable, they will dump the body back at sea with his identity papers in the wallet. Thus, to the outside world, he will now be assumed to be dead. '… a small confirmation', she crows 'of a known fact'. Having presented him with his own 'death' she then escorts him back to the ballroom. Still maintaining his cool, he enquires 'I thought there was a cabaret'. Triumphantly she declares 'There is. You are it!'

The 'cabaret' turns out to be an extremely theatrical mock 'trial', in which the Prisoner is accused of 'crimes against the community' – specifically, being in possession of a radio. The trial is a parody of 'justice' in every sense, with Number 2 appointing herself as defender and Number 240 as prosecutor. There is no jury, but there are three judges ('as in the French Revolution' the Prisoner drily observes), all in their 'fancy dress' as notable historical tyrants. The Town Crier, as a Roman emporer, is accompanied by the doctor, as Napoleon and another Villager dressed as Elizabeth 1. The first, and only piece of 'evidence' of the Prisoner's crime is supplied by a

woman in the guise of Cleopatra, who testifies that she saw him listening to the radio. This is backed up by Number 2, despite the Prisoner's protest of 'how can my defender be a prosecution witness?'

Number 240 then begins her summing up. Nervously, still clearly intimidated by the Prisoner, she demands that the court pass the severest possible sentence. Number 2 admits her client's 'guilt' but makes a plea for clemency. The Prisoner responds by demanding to call a 'character witness' – Roland Walter Dutton. But when Dutton appears he has clearly been finally broken once and for all. His appearance in the clothes of a court jester, pathetically holding a stick from which dangles a white balloon, is perhaps the episode's most haunting image of 'spiritual death'.

The Town Crier then dons a black cap and sentences the Prisoner to death and the doctor declares that 'we sentence in the name of the people ... the people carry it out in the name of justice'. For a few moments there is silence, as the Prisoner, now with real fear in his eyes, backs away. Then there is uproar as the screaming crowds pursue him through the corridors of the Town Hall. With his usual resourcefulness he eludes them by discovering a trap door, which he drops down into. He finds himself in another long corridor, then a pair of double doors opens into a large office full of sumptuous antique furniture. Behind an ornate screen he discovers a teleprinter, which he disables by ripping out its wires. Then he notices a long window, on the other side of which the 'angry mob' of Villagers are still in pursuit of him.

Inevitably, Number 2 appears, accompanied by Number 240. Though she mocks him, her words are at first reassuring. She tells him that the crowd is behind a one-way mirror and that they cannot see inside. She sends Number 240 off to 'deal with them' and in answer to his question as to why they are trying to kill him, she retorts 'They don't know you' re already dead' locked up in the long box 'in that little room'. She informs him that Number 240 has been relieved of her post as observer because 'observers of life should never get involved'. His one apparent triumph in the episode is revealed as pointless. The final lines are telling, and torturous 'You'll never win', he tells her. Laughing callously, she says 'Then how very uncomfortable for you, old chap'. At that moment the teleprinter 'magically' begins to type out messages. The bars slam down on the Prisoner's face.

'Dance Of The Dead' is undeniably the strangest episode yet in *The Prisoner*. Its use of locations and costumes is sometimes playfully, sometimes frighteningly, symbolic. It juggles a number of fictional and quasi-historical characters – Peter Pan, Little Bo-Peep, Napoleon, Queen Elizabeth, Cleopatra, the Fool – in various juxtapositions. The Prisoner's descent into the Village 'underworld' recalls *Alice In Wonderland* and *Through The Looking Glass*. The Village 'Carnival', with its deathly overtones, has echoes of the traditional Mexican religious festival 'the day of the dead'. Breaking from conventional television narrative structures, it proceeds from scene to scene with a contorted, dream-like logic. The subtext of sexual threat posed by the female Number 2 is present throughout, summed up in the Prisoner's

paranoid 'trust a woman' and is personified by the apparently harmless but 'really quite ruthless' female cat. Mary Morris' Number 2, with her short hair, androgynous looks and Peter Pan costume, also has a disturbing quality of sexual ambiguity.

Female characters had always been the Prisoner's 'achilles heel', but here he appears to find the scheming tactics of Number 2 to be more of a personal threat than any posed by her male predecessors. Although her 'victory' over him appears to be purely symbolic – turning his 'escape attempt' via the dead man's body into his 'official death' – she has managed to manipulate his emotions more successfully than any previous Number 2. He is certainly 'reduced' by this episode, which represents his personal nadir in the entire saga. Hoping to be rescued by sending a message back to sea with the dead man was always a rather futile attempt to 'escape', and it is cruelly turned against him. In terms of the series' developing allegory, 'Dance Of The Dead' depicts the all-important will of the Individual being dangerously weakened by the inescapable mechanisms of society, embodied here in the form of psycho-sexual 'power games'.

From here on, however, the Prisoner will learn from the manipulation of the 'community' which Morris' Number 2 manages so effortlessly. In the succeeding episodes he concerns himself mainly with finding ways of subverting that community in order to destroy the political system of the Village. Though he fails to do this in the next episode, 'Checkmate', in the following three episodes he scores a series of resounding triumphs over the Village authorities by learning to use their psychological tactics to exploit the situation of paranoia they have set up. He now realises that nobody in the Village really trusts anybody, and that this can even make the highest Village officials vulnerable.

The process begins in 'Checkmate', where the Prisoner attempts to discover 'who are the Prisoners and who are the warders'. Although the episode is structured around an escape attempt (the last of the series before the final episode), there is really very little chance of this succeeding. Far more significant is the Prisoner's 'division' of the community, which up till now has been depicted as entirely in thrall to the manipulation of its controllers. Here we see the Prisoner's first real attempt to organise any resistance against the Village hierarchy. He now begins to turn his familiarity with the Village's methods and its surveillance systems to his advantage.

'Checkmate' is another clearly symbolic story, though its symbolism is far less ambiguous than that of 'Dance Of The Dead'. The motif of the chess game is frequently used throughout the series as an image of social manipulation. Even in 'Arrival' the old Admiral declares 'we're all pawns. m'dear'. The 'human chessboard' scenes in this episode are amongst the series' most enduring images. *The Prisoner* Appreciation Society, Six Of One, has re-enacted the scene in full costume at Portmeirion itself on a number of occasions. In 'Checkmate' the Prisoner plays a 'game of chess' with his captors, in which bluff and counter-bluff are crucial factors. The main supporting

characters , the 'rook' and the 'queen' are referred to throughout by their status as chess pieces rather than by their numbers. After the complex psychosexual 'games' of 'Dance Of The Dead', 'Checkmate''s 'games' are more abstract and intellectual. The tone of the episode is also lighter, and at times almost frivolous. Ironic, jaunty musical themes are used throughout.

Again psychological themes are very prominent. The Village's use of behaviourist techniques to control 'anti-social' individuals is again highlighted. On another level, the episode is a critique of supposedly 'empirical' psychological testing. Though the Prisoner gains the confidence of a number of Villagers in organising his escape attempt by pretending to be a 'guardian', he is finally defeated because his co-conspirator the rook has found his imitation too convincing. One message here appears to be that the results of psychological 'tests' are always open to misinterpretation, as they are fundamentally dependent on the preconceptions of the tester.

'Checkmate' is the last of the Chaffey-directed episodes. Like the others it uses extensive Portmeirion footage and has an expensive, cinematic 'look'. Its images of the Village in bright sunshine are frequently lush and highly evocative. The script, by Gerald Kelsey, is functional and effective but without the strongly ironic and theatrical qualities of episodes like 'Dance of The Dead' and 'Free For All'. The narrative is also far more linear and conventional although, in places, arguably a little contrived.

We begin with an aerial shot of the Village, and then quickly zoom in on the bizarre sight of Rover 'bounding' along one of the Village streets. The Prisoner is seen observing as the entire crowd stands stock still, as if frozen in terror and respect. Yet he notices that one old man continues walking, as if oblivious to the apparent threat. Clearly interested in any sign of nonconformity, the Prisoner follows him to the main square, where a huge chess board has been set up, using humans for its pieces. Each player holds a

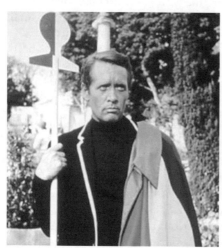

'Checkmate': The Prisoner as 'pawn'

wooden pole, on top of which is the emblem depicting which piece they are representing. The old man (Number 14) and another Villager sit on either side of the board on raised chairs, from where they control the movement of the pieces by megaphone. The Prisoner, with a characteristic air of ironic amusement, accepts the old man's invitation to play. The woman who is enacting the part of the 'Queen' invites him to be her pawn. We cut briefly to the Control Room where the Village Supervisor keeps tabs on the game. The Prisoner strikes up a 'friendly' conversation with the

Queen in which the symbolic significance of the chess game is immediately incorporated;

PRISONER: Why were you brought here?
QUEEN: (watching game) That was a good move, wasn't it?
PRISONER: I know a better one.
QUEEN: Oh?
PRISONER: Away from this place.
QUEEN: That's impossible.
PRISONER: For chessmen ... not for me.

When he is ordered to move the Prisoner at first resists, but eventually complies as the order is repeated over the Village tannoys. Meanwhile, the Supervisor and Number 2 are seen discussing the progress of the game, almost in the manner of TV sports pundits. 'Checkmate''s suave, villainous Number 2 is played by the Peter Wyngarde, later a major TV star in the series *Department S* (1970) and its 'spin off' *Jason King* (1971). He watches the game with detached amusement and his 'commentary' focuses on the Prisoner: 'One false move and he'll be wiped out'. He asserts that the Queen 'will take no risks to protect him'. Already, we are bound to suspect that the whole game may have been set up to trap the Prisoner. Yet events now take a turn that will enable him to devise his own attacking 'gambit'. Suddenly, a plump, balding man who holds the symbol of the 'Rook' in his hand moves independently and defiantly places the opposing King in check. The Supervisor's immediate response is to order the Rook to be removed to the Village 'hospital'. Almost instantaneously, Village guards arrive in a minimoke and stretcher the Rook away. 'Not allowed', the Queen explains to the Prisoner, 'cult of the individual'. Naturally, the game resumes.

Already the Prisoner has spotted two Villagers acting independently – the Chessplayer Number 14 and the Rook. After the game ends he accompanies Number 14 on a stroll around the Village. The Prisoner's suspicions that he has found someone with an independent mind are confirmed, but it is clear that Number 14 feels he is too old to rebel and prefers to 'play safe' behind a mask of conformity. He deflects the Prisoner's more direct questions about the Village by insisting they 'talk about the game'. But the conversation that follows is highly revealing, and gives the Prisoner the inspiration to launch his attempted 'palace coup' The Prisoner wants to know how Number 14 separates 'black from white'. The old man replies: 'By their dispositions. By the moves they make. You soon know who's for and against you ... It's simply psychology ... the way it is in life. You judge by attitude'.

This is one of the first real indications in the series that the society of the Village may not be so compliant as we may previously have thought. The Prisoner now realises that the community is divided into the 'Prisoners' and the 'Guardians' or 'Warders' – or in chess parlance the 'whites' and the 'blacks'. He can now begin to think out his next 'move'. But the Queen is a

constant irritation. As he walks back to his house she accosts him and rather flippantly tells him she could help him escape because she 'likes him'. He clearly does not consider her to be a useful ally, and rejects her offer.

The second segment of the episode begins with the Prisoner's first encounter with the new Number 2. It is the next day, and Number 2 interrupts his morning walk to suggest he accompany him in a mini-moke to the hospital to witness the Rook's rehabilitation. Clearly interested in the fate of the Rook, he accepts. As on other occasions when he is 'protecting other people', the *Pop Goes The Weasel* theme plays on the soundtrack as they drive.

In the hospital, observing the Rook undergoing a particularly brutal example of the Village's techniques of social conditioning, the Prisoner expresses his usual disgust with Village's 'psychological' methods whilst a cool, self-assured Number 2 taunts him. 'The treatment's based on Pavlov's experiments'. 'With dogs?' the Prisoner retorts. A white-coated female psychiatrist describes the progress of the 'experiment' to Number 2, rather in the mode of a lecturer addressing psychology students. She explains that the Rook has been dehydrated. We see him waking up, then discovering that there are two water canisters in front of him, one with a yellow button which proves to be empty and one with a blue button which gives him an electric shock. Finally he is forced to press the blue button and risk the shock in order to satisfy his thirst. The hard-faced psychiatrist assures Number 2 that 'from now on, he'll be fully co-operative'.

Soon afterwards, the Prisoner attempts to approach the Rook. At first the Rook, terrified, runs away. To the accompaniment of a rhythmic 'chase theme' the Prisoner pursues him to the terrace overlooking the seashore. He tells him that he recognised him as a fellow 'Prisoner' by his subservient attitude. The Rook, however, is still unsure which side the Prisoner is on. He proceeds to reveal that before being brought to the Village he had invented a new electronic defence system which he wanted to give to all nations to ensure world peace. The Prisoner quickly appears to win his confidence, and enlists his help in the search for fellow 'Prisoners'.

They conduct a short tour of the Village together to test out Number 14's theory that the 'whites' can be distinguished from the 'blacks' by their 'dispositions'. En route they encounter various Villagers, whom the Prisoner approaches in the confident voice of a 'Guardian' and issues 'orders'. Some, like a gardener, respond arrogantly to this and are classified as 'Guardians' whereas a number of others, including the Village shopkeeper and a house painter, act submissively and are identified as 'Prisoners'. We cut rapidly to various locations in the Village, where the group of Prisoners now begin to meet. It is clear that the Prisoner is now rallying 'the opposition' together.

Such gatherings naturally attract the attention of Number 2, who decides to have the Prisoner brought into the hospital for 'psychiatric tests'. This mostly consists of a word association test, conducted by the psychiatrist (Number 23) – another of the series' minimalistic dialogues – but the

Prisoner's answers are largely meaningless and reveal nothing of his plans. So Number 2 makes his next 'counter-move'. He has the Queen – who stares ahead expressionlessly, obviously drugged or hypnotised – wheeled in to the hospital. She is shown pictures of the Prisoner on a screen whilst the psychiatrist tells her that she is passionately in love with him. They give her a locket containing the Prisoner's picture, which includes electronic microcircuitry that is programmed to send warning signals to the Controllers whenever her heartbeat accelerates in his presence. Again the Village authorities attempt to exploit the Prisoner's 'weakness' for women, this time by means of a technological 'love trap'.

The effectiveness of the device is soon demonstrated as they watch her approaching the Prisoner from the screens in the Control Room. The psychiatrist gives her 'professional opinion' that the best option regarding the Prisoner would be an operation to 'knock out the aggressive centres in the brain', but Number 2 responds with 'No, he's too valuable'. As usual, Number 2 has evidently been warned 'not to damage the tissue'. They continue to observe the unfolding action. The Prisoner drives away from the Village in a mini-moke, followed by the lovestruck Queen in another. They pass out of the range of the Control Room's cameras and he manages to 'lose' her.

The Prisoner's campaign of 'terrorism' against the Village is about to be intensified. He meets with the Rook, who disables and then removes the surveillance camera that the Controllers were about to use to observe them. Now, whilst the screen is darkened, the Rook steals a portable telephone from a kiosk. When an electrics truck arrives he also makes off with more electrical equipment from its toolbox. By the time vision is restored to the Control Room, he has disappeared.

The two conspirators split up, and the Prisoner encounters the Queen, who gives him a lift in her mini-moke and makes a confession of her love for him, which he receives coldly and cynically: 'I'm waterproof ... a slight drizzle won't wash away my doubts. So don't try'. But she is not so easily put off. Later that evening, whilst brushing his teeth before bed, he encounters her being happily domestic in his kitchen, making him hot chocolate. Affronted by this intrusion and convinced that she is another Village 'plant' attempting to gain his confidence, he angrily orders her to leave. When she bursts into floods of tears he humours her by telling her that he likes her. Clearly her outburst of what appears to be genuine emotion – a rare thing in the Village – has moved him.

The next day is again gloriously sunny and the inhabitants of the Village are seen on the sands. The Villagers, dressed in striped 'Edwardian' swimming costumes, are engaged in making sandcastles and harmless-looking ball games. There are a number of red and white striped tents on the beach, and inside one of them we see the Prisoner with the Rook. The Rook has assembled an electrical transmitter, but tells the Prisoner that he needs one more transistor to make it work. The Prisoner sets off but immediately encounters the Queen, who is sunbathing near some rocks. He reluctantly agrees to talk

with her and maintains his usual distance as her protestations of love continue, until she makes reference to the locket around her neck, which she believes he has given her. Feigning interest in her, he asks to see the locket. Inside, behind the miniature photograph of himself, he sees the microcircuitry connected to a tiny transistor. Conveniently, he has already found the missing component that the Rook requires. He tells the crestfallen Queen that he will keep the locket until he finds her a better picture, and quickly departs.

We then see a montage of shots of the conspirators meeting and exchanging a whispered message, coded inevitably in chess terminology, 'Tonight at moonset. Rook to Queen's Pawn Six. Check'. Next, we see the Prisoner and the Rook in the tent at night, transmitting a Mayday message. A ship, the M.S. Polotska, responds and the Prisoner transmits a message in which he claims to be in a crashed aeroplane. We cut quickly to a shot of a small vessel approaching.

But the reaction to this in the Control Room, where the Mayday message is immediately picked up, is decidedly nonchalant. 'We'll let them deal with it', says the Supervisor, who smiles enigmatically. He begins to attempt to locate the source of the message and activates a watchtower to sweep with its searchlights across the beach. Already the Rook has taken to the water on a raft, where he continues to use the transmitter to try to attract the ship. The Prisoner, now gathered with the other conspirators in the stone boat, realises there is a danger that the Rook will be seen, so he leads an assault on the watchtower which comprises the episode's first fight scene. After a short struggle, accompanied by the usual dramatic music, the rebels take control of the tower.

We cut to our first view of the interior of the Green Dome, where. Number 2, sitting in lotus and wearing a white robe, is engaged in deep meditation. When the Supervisor's phone rings he utters a loud cry and smashes the small piece of wood in front of him with a karate chop. But before the Supervisor has the chance to alert him he is confronted by the Prisoner and his band of conspirators, who suddenly burst in. Despite this apparent 'revolution' Number 2 remains detached and sarcastic. 'How very primitive', he comments as they tie him up. But then the Green Dome's audio receivers reveal that the Mayday transmission has stopped.

Announcing that he will investigate this, the Prisoner dashes down to the beach, where he finds that the raft has been abandoned. Out at sea, he sees a boat coming towards the shore. For a moment he glances behind him, almost guiltily, then he takes to the raft alone. Soon he is picked up by the sailors. But the first voice that greets him as he steps into the boat's cabin is that of Number 2, who addresses him from a TV monitor. Sitting back comfortably in his swivel chair, Number 2 announces that 'the Polotska is our ship'. Then the Rook appears on the screen. The dialogue that follows reveals how the Prisoner's game of bluff has backfired. The Rook reveals that he believes that the Prisoner is 'one of them' and that he has deliberately tried

to trap him. Number 2 explains that 'Rook applied to you your own tests ... When you took command of this little venture your air of authority convinced him that you were one of us'. Sneeringly, he reveals that the rest of the conspirators will be back on the chessboard the next day, 'as pawns'.

Angrily, the Prisoner smashes the TV screen and, in another highly choreographed fight scene, beats up the two sailors and takes control of the boat. But the watching Number 2 nonchalantly presses a button and Rover emerges from the deep to steer the boat back towards the shore. The final shot shows the Butler moving a White Queen's Pawn back into position on the chessboard. The bars, as ever, slam down.

Despite this resounding defeat, the episode does establish a glimmer of hope for the Prisoner. He has established that it is possible to fight back against the Village 'system'. In this chess game he has genuinely been a 'player' rather than merely a 'pawn'. However, despite his rare engagement with Village 'society', when the chance of immediate escape presents itself he is quite prepared to abandon his co-conspirators and escape alone. So he remains the supreme individualist. And the experience of fighting back against the Village authorities by use of their own psychological methods will be of great value to him in the next few episodes.

'Checkmate' may lack the depth of the preceding episode, but it continues to foreground the psychological themes that dominate these episodes of the series. The Village's use of various psychological 'control techniques' is again prominently featured, with hypnotism, auto-suggestion, word association tests and brainwashing to the fore. After 'Dance Of The Dead' the episode can almost be called 'light relief'. In places it is very melodramatic, and the 'storming' of the Green Dome seems to succeed rather too easily to be credible in the light of the supposedly 'omniscient' Village technology.

If the game that the Prisoner plays with his captors in 'Checkmate' has a certain rather pointless, even whimsical, quality; in the next episode 'Hammer Into Anvil' there is no doubt that he is in deadly earnest. Now he manages to turn the inherent paranoia of the Village, so often used as a weapon of social control, to his own advantage. If 'Checkmate' was largely a battle of bluff and manoeuvre, 'Hammer Into Anvil' is decidedly a battle of wills in which bluff is used as a deadly weapon.

The totalitarian society of the Village naturally has affinities with fascism, and it is in 'Hammer Into Anvil' more than any other episode that this connection is made explicit. The title of the episode originates from a quotation from a poem by Goethe which Number 2 makes to the Prisoner near the beginning of the story: 'Du musst Ambose oder Hammer sein' (You must be hammer into anvil).[6] Although Goethe was not one of the Nazis' favoured philosophers, the phrase has resonances with elements of Wagner's *Ring* cycle and Nietzsche's *Twilight Of The Idols* (1889) which is subtitled *How To Philosophize With A Hammer*. The work of both Wagner and Nietzsche

6 *Ein Anderes* (An Other) from *Poems Of Goethe – A Selection*, p. 131.

was appropriated by the Nazis and held to support their concept of an Aryan 'super race'. The battle between the Prisoner and Number 2 is also a battle of wills, and notions of the importance of having a superior 'will' were central to the Nazis' philosophy.

Patrick Cargill's Number 2 is the most unlikeable yet – the Prisoner describes him as a ... professional sadist ... and the viewer can have little sympathy for him as he is psychologically 'crushed'.[7] One may even speculate that Cargill's Number 2, who slips almost inadvertently into the Goethe quotation, is actually German. The Village, after all, is frequently described as an 'international community'. Perhaps he is an ex-Nazi who the Village has recruited. Whether this is true is not made specific, but the hint of ambiguity around 'Germanic' themes in the episode helps to suggest a political subtext which further broadens the allegorical nature of the series and the reference to Goethe suggests further connections with the 'Faustian' themes that have been mentioned previously. Certainly, the culture of the Village resembles that of the Nazis in a number of ways, particularly in its emphasis on 'dehumanization'. The extent of this is described by the German psychologist Arno Gruen:[8]

> ... What led to the success of the National Socialists and their power structure was not only their virulent anti-Semitism and open criminality: it was the 'new man' that came into ascendancy with them, a man without personhood, without a self ... The degree to which this was true is dramatically illustrated by a telling detail of Adolf Eichmann's behaviour. In a television interview, one of his abductors reported that when Eichmann had to move his bowels, he sat down on the toilet and then obediently asked his guard, 'May I do it now?'. He gave the other person, the one who now had power over him, control over his most private bodily functions ...

In a similar way the Village attempts to create individuals 'without self' and to control its inhabitants' every thought and function.

In 'Hammer Into Anvil' the Prisoner uses the skills of psychological gameplaying that he has developed in 'Checkmate' to far more successful effect. He concentrates his efforts entirely on a personal battle of wills with Number 2. Whilst his captors have often used the technique of bluff to attempt to ensnare him (notably in 'The Chimes of Big Ben' and 'The Schizoid Man') he now proceeds to successfully bluff Number 2 into submission, so effectively reversing the 'hammer into anvil' metaphor. In order to do so he has to pretend to be a Village 'guardian' himself, a technique which he had practised success-

7 Cargill also appeared briefly in 'Many Happy Returns' as Thorpe, one of the Prisoner's British secret service bosses. But the character he plays here is quite different, and there is no evidence to suggest that the two roles are intended to be the same.

8 Arno Gruen, *The Betrayal Of The Self: The Fear of Autonomy In Men and Women*, p.116/117.

fully in 'Checkmate' – so successfully, on that occasion, that it led to his final defeat. But here he is on firmer ground – beneath Number 2's vicious exterior he recognises the signs of rampant paranoia and exploits them to the full. As a 'psychological' discourse, 'Hammer Into Anvil' can be considered to be an in-depth study of paranoia. On a deeper, more allegorical level, the Prisoner and Number 2 can be seen in this episode as two elemental forces of the human personality forever engaged in mutual conflict.

The Prisoner's eventual triumph in this episode also demonstrates his growing understanding of the mentality of the Village, and shows that he has learned how to exploit the weaknesses of that mentality. He even turns his knowledge of the Village authorities' constant surveillance of him to his advantage. In the succeeding 'It's Your Funeral' and 'A Change Of Mind' he will achieve further victories of a similar kind. He has always been aware that Number 2 is just as much a 'prisoner' as he is, and he comments on this as early as 'The Chimes of Big Ben'. Here (and equally effectively in 'It's Your Funeral') he capitalizes on this knowledge to the full.

'Hammer Into Anvil' is directed, like 'A, B and C' and 'The Schizoid Man', by Pat Jackson, and it shares with those episodes a certain 'tightness' in the structure of its narrative. The story is dramatically very well-paced (whereas the preceding three episodes 'Checkmate', 'Dance Of The Dead' and 'Many Happy Returns', have had relatively meandering narratives). In fact, the story has a very simple and balanced structure. It also contains a number of prominent 'action' sequences. Musical themes are always important in suggesting additional levels of meaning in *The Prisoner* and their use is particularly important here. Bizet's *L'Arlisienne*, which the Prisoner uses as part of his plot against Number 2, appears in various forms throughout the episode, and other musical themes are used to considerable effect.

The first shot we see after the credit sequence is an exterior of the Village 'hospital'. We quickly cut to one of the rooms, where a young woman whose wrists are bandaged (presumably from a suicide attempt) is being interrogated by Number 2. He taunts her mercilessly, implying that her husband has been having an affair. When she still refuses to confess we see a close-up of Number 2's face, and his 'I've wasted enough time' is particularly menacing. As he approaches her she screams in complete terror.

We cut back to an exterior view. The Prisoner happens to be passing and, hearing the screams, immediately dashes into the hospital. We see him run into the room where Number 2 is interrogating the girl. His appearance distracts Number 2 enough for her to escape from Number 2's clutches. She immediately makes for the open window, from where she jumps to her death. As the Prisoner looks down, we see her body spreadeagled on the ground below. He knows that this suicide, like the apparently identical one of Cobb in 'Arrival', has not been faked. Number 2, who seems to have been enjoying playing the role of torturer, is furious. 'You shouldn't have interfered, Number 6', he says. 'You'll pay for this'. The Prisoner's face is set in determined hatred and disgust 'No, you will', he replies, and exits.

Number 2 then summons the Prisoner to the Green Dome, not in the usual 'polite' manner of his predecessors but by sending four Village thugs after him in a mini-moke. The first of the episode's fight scenes ensues, but here the Prisoner's 'superhuman' strength is insufficient against overwhelming odds. He is dragged into the mini-moke and finally deposited in Number 2's office. The conversation which ensues is stripped of the usual ironic 'niceties' which have characterized previous encounters in the Green Dome. When the Prisoner contemptuously calls Number 2 a 'professional sadist'. Number 2 threatens him by placing a sharp blade against his temple. The Prisoner does not flinch and expresses only disgust. Number 2 then does what none of his predecessors has done – he strikes him viciously across his face. As the Prisoner recovers he sheaths the blade, sits down and vows to break him:

NUMBER 2: You think you're strong ... Hmm, we'll see ... Du musst
 Ambose oder Hammer sein.
PRISONER: You must be anvil or hammer.
NUMBER 2: I see you know your Goethe.
PRISONER: And you see me as the anvil.
NUMBER 2: Precisely. I am going to hammer you.

At that moment the orange telephone rings. Number 2's tone suddenly changes to that of extreme obsequiousness as he reassures Number 1 that 'everything's under control, sir'. The Prisoner, already sensing his vulnerability, begins to scorn him: 'You were saying? Something about a hammer'. Number 2 orders him out, shouting 'I'll break you, Number 6!' As the Prisoner leaves, Number 2 picks up the yellow phone and orders the Supervisor to maintain 'special surveillance on Number 6'. The battle of wills has now begun.

The Prisoner, knowing full well that his every move will be watched, wastes no time in opening his campaign to exploit the underlying paranoia that he has sensed in his opponent. Acting coolly and with great self-assurance, he begins a series of manoeuvres that will soon convince Number 2 that he is a 'plant' sent (presumably by Number 1) to spy on him. His first act is to enter the Village music shop, which is adorned with characteristically acquiescent Village slogans 'Music Makes for a Quiet Mind' and 'Music begins where words leave off'. Adopting an authoritative tone, he asks how many copies of Bizet's *L'Arlisienne* are in stock. When the puzzled shop assistant says there are six, he demands to listen to all of them. He takes the records to a listening booth, and then proceeds to play the first few seconds of each one, every time checking his watch. Without buying any of them, he leaves the shop.

We then see the shop assistant in the Green Dome, handing over the records to Number 2 and telling him about the Prisoner's mysterious actions. The Prisoner's judgement that any 'strange' behaviour will immediately be

reported has proved correct. Number 2 is immediately irritated by the Prisoner's actions, and demands an explanation from the hapless shop assistant. None, of course, is forthcoming. Number 2 decides to check personally on what the Prisoner is doing. He watches him from the screen in the Green Dome as he writes a message on his notepad, tears out the page and then leaves his house. This arouses Number 2's suspicion still further and he immediately dispatches his assistant Number 14 to steal the notepad. By using Village technology to read the imprint that the Prisoner's message has left on the sheet below, Number 2 deciphers a clear message, which is projected onto the screen in front of him: 'To XO4 Ref your query via Bizet Record. No.2's instability confirmed. Detailed report follows. D6'. He has fallen straight into the Prisoner's trap. 'Number 6!' he cries, 'a plant!'

The second segment of the episode opens to the strains of *L'Arlisienne* as we see the Prisoner walking through the Village at night, whilst Number 2 and Number 14 follow him at a distance. When he reaches the stone boat he deposits an envelope there. Number 2 takes the envelope back to the Green Dome, and orders one of his scientists to decode the apparently blank piece of paper he finds inside. But when the scientist returns to announce that there really is nothing on the paper, Number 2 accuses the man of 'hiding something' and of 'being in with Number 6'. It is obvious that his paranoia is rapidly accelerating.

The Prisoner's next move is to place a message in the 'personal column' of the Village newspaper the *Tally Ho*. This takes the form of another literary reference, from Cervantes' Don Quixote: 'Hay mass mal en el aldea que se suena' ('There is more harm in the Village than is dreamt of'). He then rings the Director of the Village's Psychiatrics Department and asks him if he has completed the 'report on Number 2'. Although the Director shows only bewilderment at this, he is soon hauled up before Number 2 (who has recorded the conversation) and asked to 'explain himself'. But Number 2's initial rage soon turns to fear. So far he has consistently intimidated all his subordinates, but now he begins to suspect that they may all be conspiring against him. Edgily, he asks the Director 'You aren't preparing a report on my mental health, are you?' Becoming extremely emotional, he ends up angrily ordering the Director to leave.

As each Villager comes to report the Prisoner's abnormal behaviour to him, Number 2's paranoia and cruelty increase. The leader of the Village brass band comes to report that the Prisoner, having requested they perform *L'Arlisienne*, then walked away without listening to their performance. Again Number 2 bawls out the innocent band leader, convinced he is one of the Prisoner's 'fellow-conspirators'. The Prisoner then arranges for 'birthday greetings' to him from Number 113 (who has actually died recently) to be broadcast over the Village tannoys. Number 2, knowing that Number 113 is dead and that today is not the Prisoner's birthday, storms into the Control Room. By now he is hysterical. He dismisses the Supervisor from his job and warns the other Control Room operatives that 'I'll break this conspiracy'.

When he has the *Don Quixote* quote translated, this adds further fuel to his paranoia. The faithful Number 14 suggests that 'an accident' might be arranged whereby the Prisoner could be disposed of (Of course Number 2 is under official orders not to 'damage the tissue'). They discuss how this might be achieved. Suddenly the Prisoner appears, claiming that Number 2 had summoned him. When Number 2 refutes this he darkly suggests that 'someone in the Village must be impersonating you'. As he leaves, Number 14 challenges him to a fight. They agree to meet in combat over a game of Kosho.

The bizarre game of Kosho, which also features in the following 'It's Your Funeral', is a creation of the series and is apparently some form of martial art carried out on two trampolines separated by a water tank. The players wear helmets and long robes. It is never entirely clear what the object of the game is, and it is fairly certain that the game is one of McGoohan's jokes at the expense of the viewer. As the Prisoner and Number 14 play the game, cod 'Japanese' music plays on the soundtrack. The Prisoner, naturally, wins the bout over the caddish Number 14.

The next few scenes show how the Prisoner develops his plan to destabilize Number 2. By now he has adopted a whimsical, mocking approach.

We next see him buying a notebook and a cuckoo clock from the Village shop. He deposits the clock outside the Green Dome. Observing this on the screen, Number 2 immediately calls in a bomb disposal expert. Again the 'bomb' proves to be a hoax. Meanwhile, using the large box the clock was housed in, he traps a pigeon, attaches a message to it, and sets it free. Number 2 has the bird shot down and gets his assistants to decode the message, which translates as 'Vital message tomorrow ... 06.00 hours by visual signal'. At six the next morning (to the accompaniment of *L'Arlisienne* on the soundtrack) the Prisoner is seen on the beach, flashing a Morse code signal. Despite Number 2's demands, none of the Control team can locate a ship, aircraft or submarine that the message might be being sent to. And the message is decoded as a nursery rhyme: 'pat-a-cake, pat-a-cake, baker's man, bake me a cake as fast as you can'. Number 2 has by now been driven to distraction.

The Prisoner's final masterstroke in his campaign is to cast doubt on Number 2's faithful ally Number 14. This he is able to achieve simply by approaching him in the Village cafe and whispering meaningless chit-chat to him. The waiter in the cafe immediately reports the conversation to Number 2. Number 2 summons Number 14 to his office and accuses him of being part of the conspiracy. When Number 14 denies this, Number 2 strikes him violently and banishes him. Number 14, incensed by his unjust dismissal, pays a visit to the Prisoner's house. The Prisoner is seen relaxing in an armchair, listening to some more classical music – this time a piece by Vivaldi. Number 14 threatens to 'kill him' for destroying his career. The rather spectacular fight scene which follows – ending, as usual, in victory for the Prisoner, is accompanied not by the usual 'fight scene themes' but by the Vivaldi music, which continues to play as the fight ensues.

We cut back to the Green Dome, where Number 2 has now been completely overtaken by his paranoia. Having sacked most of his staff, he even dismisses the Butler, who – with no comment as ever – is seen leaving attired with bowler hat and briefcase. He is now truly alone, completely convinced that he is the victim of a conspiracy. As he clings pathetically to the Penny-Farthing, the Prisoner enters through the automatic doors, claiming he has come to 'keep him company'. Number 2 visibly cringes – it is obvious that he is now afraid of the Prisoner. All the Prisoner has to do now is allow Number 2's paranoia to run its course. He treats Number 2's references to him being 'D6' with gentle sarcasm. But then he points out that if, as Number 2 asserts, he is a 'plant', then Number 2's duty would have been to let him do his job. He then moves in for 'the kill':

PRISONER: Who are you working for, Number 2?
NUMBER 2: (Almost in tears) For us ... for us ...
PRISONER: That is not the way it is going to sound to XO4.
NUMBER 2: I swear to you-
PRISONER: You could be working for the enemy. Or you could be a
 blunderer who's lost his head. Either way you've failed.
 And they do not like failures here.
NUMBER 2: You've destroyed me ...
PRISONER: No. You destroyed yourself. A character flaw ... you're
 afraid of your masters. A weak link in the chain of
 command, waiting to be broken.
NUMBER 2: (desperately pleading) Don't tell them ... don't report me ...
PRISONER: I don't intend to. You are going to report yourself ...

Number 2 then picks up the orange telephone and rings Number 1. He reports a 'breakdown in control' as he resigns his post. As the Prisoner leaves he looks back on Number 2, now a completely broken man, slumped in his chair. The Prisoner's triumph here represents his most complete victory so far over the Village authorities. He now clearly understands how to manipulate the social mechanisms of the Village, and he achieves his victory with considerable arrogance and relish, not to mention mocking humour. The victory brings him no closer to the fulfilmentment of his main goals – escaping or discovering the identity of Number 1 – but it is an important psychological boost for him which gives him the confidence to go on to further successes in the next few episodes. In fact, from here on the remaining episodes all end in apparent victory for him. 'Hammer Into Anvil' thus represents another key point in the series, in which the 'tide begins to turn'.

The episode is peppered with references to literature and classical music which reveal the Prisoner as a 'man of culture' in addition to his other qualities. The allusions to *Faust* and *Don Quixote* add further resonance to the series' allegorical subtexts. Perhaps, as has been suggested before, by taking on the Village methodologies to achieve victories over them the Prisoner may

be in danger of 'losing his soul' as Faust does. More pertinently here, it is Number 2 who has lost his soul. Number 2's growing paranoia is a form of 'tilting at windmills' which identifies him with another archetypal fictional character, Don Quixote. The theme of 'duality' echoes the earlier 'Schizoid Man', whereas the structure of a plot – with its 'classical' simplicity in enacting its moral turnaround – could be classified as being similar to that of a 'revenge tragedy', a form often used in the work of Shakespeare and Jacobean dramatists. In a revenge tragedy the protagonist often displays a fatal flaw which destroys him. The Prisoner identifies Number 2's character flaw early on in the episode and proceeds to exploit it mercilessly. Like Macbeth, Number 2 is destroyed by his own paranoia.

In the next episode, 'It's Your Funeral', the Prisoner becomes directly involved in the internal politics of the Village. Again he makes no attempt to escape. The Village Authorities' attempts to manipulate him by involving him in their complicated plot to destroy an outgoing Number 2 fail, again because he now understands the way the Village works enough to turn things to his advantage. As on many other occasions a young woman is used to gain his sympathy, but this does not prevent him scoring another victory.

'It's Your Funeral' is certainly a rather 'lightweight' episode compared to the two which precede and follow it. Minor characters such as the watchmaker are somewhat stereotypical and the plot is very melodramatic. The use of the device of the bomb being planted in the Village 'seal of office' is faintly ridiculous. Also, the notion that certain Villagers practise a technique called 'jamming' which partially subverts Village authority is somewhat dubious. It seems here that the 'jammers' are largely allowed to remain at large, whereas episodes such as 'Checkmate' or the later 'A Change Of Mind' suggest that such rebellious acts would be severely punished, probably with torture or brain surgery. The rather obvious moral of the story – a warning of the futility of terrorist acts – sits somewhat uneasily with the political context of the rest of the series.

In terms of the overall development of the series, however, 'It's Your Funeral' fits well into context as another example of the Prisoner's penetration of the Village's psychological 'defences'. Again he uses his knowledge of the workings of Village 'society' to frustrate the authorities' plans. Here he is able to divide the power of the Village, and so weaken it. In doing so, he strengthens his own psychological position – which had been severely weakened in episodes like 'Many Happy Returns' and 'Dance Of The Dead' – considerably.

We open with an internal shot of the Prisoner's house, into which an earnest-looking young woman dressed in a standard red and white hooped Village shirt and a white cap is seen entering through the automatic doors. We cut back to the Control Room, from which the Supervisor and Number 2, who wears a dressing-gown, are watching. The young woman (Number 50) approaches the sleeping Prisoner, who wakes with a start. He is immediately suspicious of her, telling her: 'Go back and tell them I was not inter-

ested. That I wouldn't even listen … What's the good … They know already'. He orders her to leave, but as she turns away she suddenly collapses. In the Control Room Number 2 explains to the Supervisor that she has been given a drug which will 'remain dormant until triggered by the nervous system'. Darren Nesbit's Number 2 is another smooth, relaxed charmer, far removed from the sadistic Number 2 of 'Hammer Into Anvil'. He confidently tells the Supervisor that she will now become 'lady in distress' and seems sure that she will gain the Prisoner's sympathy.

At this point we may suspect that Number 50 is another 'plant' who is attempting to gain his sympathy so as to coax secret information out of him. But unfolding events will soon prove otherwise. When she revives (at exactly the time predicted by Number 2) he warns her that she has been drugged. He condescendingly says he will listen 'as long as what you're saying doesn't become too obviously phony'. She tells him that she needs his help in trying to stop an assassination attempt in the Village, and that if she fails reprisals will be taken against the population. Still suspicious of her, and knowing full well that the controllers are listening, he turns her down. She also tells him that her name and number are on a Village 'list' for the practice of 'jamming'. But when the Prisoner mocks her she refuses to give him any more information about this and leaves.

As we cut back to the Control Room, we see Number 2 talking on the orange phone, reassuring Number 1 that everything is going smoothly with his plan. 'It's Your Funeral' is an episode in which, like the earlier 'The General', the main focus of the action will be an event in the Village rather than any attempt to 'break' the Prisoner. It soon becomes clear to the viewer that the controllers have selected him for his role in their plot precisely because they have not yet broken him. In order to gain more information on his current movements, an 'Activity Prognosis' on the Prisoner is prepared. This is supervised from the Village's Computer Room by Number 8, a steely-eyed young woman with an almost robotic voice – clearly an efficient and thoroughly brainwashed Village 'guardian'. The Computer has been programmed to predict the Prisoner's movements throughout the day.

The 'Activity Prognosis' is a somewhat comic montage of shots of rather mundane details of the Prisoner's daily routine, accompanied by a deadpan 'scientific' voiceover. The tone of the language used is a deliberately impersonal parody of a psychology experiment: 'Today's activity prognosis for Number 6 … Subject aggressive … exercises daily with a walk around the Village … Daily, subject climbs the belltower … reason unknown … subject eccentric … certainly watching, waiting, constantly … is possible that subject likes the view'.

The second segment of the episode begins with Number 2 discussing a mysterious 'operation' with his henchman Number 100. We then see the Prisoner at the old people's home, where he is sitting for a 'portrait' by a friendly (and somewhat conspiratorial) old man, who supplies him with information about 'jammers', Villagers who deliberately spread false rumours

about non-existent plots and escape attempts to confuse the authorities. Back at the Green Dome, Number 8 presents her continuing Activity Prognosis to Number 2. The Computer seems to be succeeding in predicting the Prisoner's every move, including his visit to the Village gymnasium for his regular kosho practice. Number 2 then sends Number 100 to the gymnasium. Whilst we see the Prisoner engaged in the bizarre game previously featured in the last episode, we intercut with shots of Number 100 replacing the Prisoner's watch with an identical one, which the Prisoner will soon discover is broken.

The Prisoner takes his broken watch to the Village watchmaker's shop, a picturesque place full of clocks of every description. Whilst the watchmaker, a white-haired old man, is off repairing his watch, the Prisoner 'accidentally' sees a mechanism that can be used to denote a bomb. The watchmaker, who appears to be highly nervous, insists that it is 'just a toy', but the Prisoner knows otherwise. Here is the first evidence of the 'assassination plot' that Alison had told him about. When the Prisoner leaves, Number 100 emerges from a hiding place in the shop. It is clear that the old man thinks that Number 100 is a co-conspirator in the assassination plot, but he asks why it was necessary to let the Prisoner see the device. Number 100 tells him that this was done to confuse the authorities. Of course, we know that Number 100 is really Number 2's operative and the nature of the 'official plot' now begins to emerge.

The Prisoner meets Number 50 at the Village cafe, where she reveals that the watchmaker is her father and is planning, along with another conspirator who is unknown to her, to assassinate Number 2, an act which would produce terrible reprisals. Now convinced that she is not a 'plant', he agrees to help her. We cut back to the Green Dome, where the self-assured Number 2 tells his Assistant that the Prisoner will soon be here to tell him that his assassination is being planned. Then we see the Prisoner and Number 50 at the watchmaker's shop, where they unsuccessfully try to persuade him to abandon his plan. The Prisoner's next move is as predictable as the events in his computerized 'Activity Prognosis'. He does indeed go to the Green Dome to warn Number 2 of the planned assassination. But Number 2's tone is gently mocking, suggesting that he believes that the 'plot' the Prisoner has picked up on is merely the product of 'jammers'.

Later that same day, an Announcement is broadcast over the Village tannoys that the day after tomorrow will be the official Village 'Appreciation Day': 'the day when we pay the honour to those brave and noble men who govern us so wisely'. This ceremony will apparently be led by Number 2, who will then unveil the new 'appreciation monument'. The Prisoner and Number 50 are then seen in the watchmaker's shop, where they discover that the watchmaker has planted explosives in the Village's Great Seal of Office, which is due to be presented to him at the 'Appreciation Day' ceremony. This 'dramatic' revelation ends the second segment of the episode.

The final segment begins with the Prisoner making another visit to the Green Dome, this time to warn Number 2 about the exact nature of the

assassination attempt. But the Prisoner is surprised when – as happens earlier in 'Arrival' – he discovers a 'new' Number 2 in the circular chair. This Number 2 is a much older man (played by Andre Von Gyseghem) who looks rather tired and worn-out and lacks Nesbit's Number 2's arrogant self-assurance. He explains that he is in fact the 'real' Number 2 and that all the other Number 2's have been interim replacements (a rather spurious and unnecessary justification of the series' habit of changing the Number 2 every week). He also reveals that he knows that the Prisoner has come to report an assassination attempt, and presents this as an attempt at 'jamming' by the Prisoner: 'My very efficient colleague ... should I say my heir presumptive ... has been collecting evidence that every interim Number 2 who has served here while I have been on leave has been cautioned by you about some improbable conspiracy to murder him'. He then shows the Prisoner an (obviously doctored) film of the Prisoner in the Green Dome warning various Number 2's (none of whom we recognise from previous episodes) of assassination attempts. The Prisoner tells Number 2 that the film is a fake, and Number 2 reveals that the next day – Appreciation Day – is the day he will be handing over power to his successor (Nesbit's 'Number 2'). But after the Prisoner leaves, Number 2 asks his Assistant to reshow the film and he is told that this is 'not possible'. When the request is mysteriously denied, the look on Number 2's face suggests that he now knows that the Prisoner's warning was accurate.

The Prisoner meets Number 50 in the cafe again and he reveals the true nature of the entire plot to her – that the new Number 2 has arranged the assassination of the old Number 2. She explains that her father has been brainwashed into carrying out the assassination and they agree that it must be stopped. We cut quickly to a shot of the new Number 2 on the phone to Number 1, whom he calmly reassures that the plan is preceding smoothly. The Prisoner then returns to the Green Dome. This time the old Number 2 realises that his story is true, and flinches when it is revealed that the Great Seal Of Office will be primed to explode when he makes his 'retirement speech'. But he seems resigned to his fate. We cut back to the new Number 2's phone conversation, in which he reassures Number 1 than 'nothing can go wrong now, I'll stake my future on it'.

We cut to a close-up of a brightly-coloured Village umbrella. The camera pans back to reveal the Villagers engaging in one of their typically staged 'spontaneous' celebrations, marching around the central square whilst cheery brass band music plays. Both Number 2's stand on the balcony awaiting the ceremony. The old Number 2 wears the 'primed' Official Village Seal Of Office. Behind them are several Village 'council members' dressed in the usual 'undertaker' garb of long dark morning suits, top hats and dark glasses. As one of them makes a speech praising the retiring leader, which is somewhat in the tone of a school 'speech day', we see close-ups of both the old Number 2 (who looks, understandably, extremely nervous) and the new Number 2, who we see whispering to his co-conspirator Number 100 into a

miniaturised radio concealed in his large-rimmed glasses. Everything is now set up for the planned assassination.

We see the Prisoner and Number 50 in the crowd. She tells him that her father did not come home last night. They scan the whole area carefully. Suddenly they see a flash of light from the top of the bell-tower. It is the sun reflecting off the watchmaker's binoculars. Immediately they rush to the tower. The Prisoner runs up the steps, and it is no difficult for him to over-power the old man, who holds the detonator for the bomb in his hands. Fast intercutting between both Number 2's, the Prisoner and Number 100 (who is observing from a position in the crowd) build up the tension, which is fur-ther heightened by highly dramatic incidental music. As the bomb has yet failed to go off, Number 2 realises that something has gone wrong and orders Number 100 to investigate. Number 100 rushes to the bell tower, from which the Prisoner is descending with the detonator. A fight between the two follows, in which Number 100 narrowly fails to seize the detonator and let off the bomb. But eventually the Prisoner knocks Number 100 out and the assassination is prevented.

We cut to a close-up of the new Number 2, who is alarmed to hear the Prisoner's voice in his earpiece. The Prisoner rushes to the balcony, which he reaches just as the top-hatted official's tedious speech is ending. Looking highly relieved, the old Number 2 now places the large gold seal around his successor's neck. Whilst the Council members shake the new Number 2's hand, the Prisoner passes the detonator to the old Number 2. He tells him 'it's your passport. No-one will question its authority ... the helicopter's waiting'. The old Number 2 says 'they will get me wherever I am'. The Prisoner replies 'as long as it's not here ... take it and go'. Of course, he is concerned not so much with the fate of the retiring Village official, who after all is his enemy, but with preventing the possibility of the Village taking reprisals against the population. The old Number 2, clutching the detonator, makes his way towards the helicopter, with the new Number 2 making no attempt to stop him.

Just as the younger man is about to remove the seal, the Prisoner grabs him by the hand and begins to shake it energetically. He tells him 'Yes, and so the great day is nearly over ... Came off rather well, I thought ... better than planned. And now you can look forward to your own retirement ... I'm sure they'll arrange something equally suitable for you when the day comes'. As he speaks, we see the helicopter taking off and the old Number 2 flying off to (at least temporary) safety.

This highly melodramatic ending is somewhat difficult to swallow. It is hard to imagine that the retiring Number 2 could really escape the Village's clutches. In many ways 'It's Your Funeral' is a highly conventional piece of television series 'fodder', exploiting typical dramatic conventions by using fast cutting and dramatic music to build up to a 'surprise' ending. Perhaps because it uses a scriptwriter (Michael Cramoy) and a director (Robert Asher) who are not involved in any of the other episodes, The Prisoner's role

here seems to be presented slightly differently to his role in the rest of the series and his motivation – as a 'protector' of the community – is highly questionable given his continued stance of extreme individualism.

'A Change Of Mind' is, however, another key episode in the series. Written by Roger Parkes and directed by McGoohan himself, it is the last of the episodes to be based on the established *Prisoner* format before the widely different explorations of the concluding five episodes. Based around a plot centred on deception which has some similarities to 'The Schizoid Man', 'A Change Of Mind' re-emphasises the importance to the Village of 'breaking' the Prisoner without 'damaging the tissue'. Again, techniques of Pavlovian conditioning are satirised, along with other psychological methodologies such as group therapy. The Village's social control techniques are implicitly linked to those of the totalitarian regime of Mao Tse-Tung's Chinese People's Republic (at that time in the throes of the 'cultural revolution'). The use of language here is amongst the most telling in the whole series, particularly the distinctively Orwellian terms 'unmutual' 'inadequate' 'and' 'disharmonious' which are used as powerful weapons by the Village authorities. There is also a great deal of obviously 'bureaucratic' language in the episode, which strengthens its allegorical depiction of modern methods of social and psychological control.

The picture of social manipulation presented in 'A Change Of Mind' recalls the earlier McGoohan-directed episode 'Free For All'. Whereas 'Checkmate' and 'It's Your Funeral' suggested that the Village was to some extent a divided community, here we see the full force of the Village's social control in action. The episode has very strong allegorical overtones and is one of the series' most eloquent comments on the position of the 'rebel' within society. The morally righteous women's 'public safety' committee suggests the kind of fanaticism practised in the 1960s by Mary Whitehouse and other 'moral protectors' of society. In contrast, the 'stoned' chatter of Number 86 when she is drugged parodies the developing 'hippie' movement. The use of the threat of lobotomy recalls Ken Kesey's allegorical novel *One Flew Over The Cuckoo's Nest* (1962), where a mental hospital ruled by the terrifying 'Big Nurse' was presented as a microcosm of socially-manipulated modern western society. The novel is an important precursor – and quite possibly a direct influence – on *The Prisoner*, and its rebel hero McMurphy fulfils much the same position in the story as the Prisoner does here.

The Prisoner's eventual triumph in the episode reflects the extent to which he now understands Village techniques of crowd manipulation. But whereas in episodes like 'Checkmate' and 'It's Your Funeral' we get the impression that the Village does not entirely consist of brainwashed 'zombies', here the Prisoner has to stand entirely alone. A very bleak view of the 'mob mentality', which particularly recalls the earlier, and also McGoohan-directed, 'Free For All', is featured here. Nowhere is the isolation of McGoohan's allegorical Individual from society made more explicit. Several scenes suggest that the Prisoner's social isolation causes him genuine emotional pain. The very

sparing use of music also suggests a more delicate sense of emotional tension than in any previous episode.

The plot centres around an attempt by the new Number 2 not only to convince the Prisoner that he has been lobotomized but that this 'treatment' has been the result of pressure from the 'community' itself. John Sharp's Number 2 is a superficially 'gentle' but actually very sinister figure. There is absolutely no doubt here that his instructions to 'not damage the tissue' are paramount. As previously, the Prisoner is protected by this order – an order which will take on a new significance when we finally (in 'Fall Out') discover the identity of Number 1.

The episode begins with the Prisoner defiantly engaged in highly individualistic behaviour. In the woods he has built himself a private exercise space where we find him taking his regular morning workout, alone. Suddenly he is menaced by two Village thugs, who emerge from the bushes and begin taunting him by accusing him of being 'anti-social'. In the dramatic fight scene that follows he emerges victorious, despite being outnumbered. As the two dispirited thugs crawl away one shouts: 'You'll face the committee for this'.

We next see the Prisoner in a 'waiting room' attached to the Council Chamber, which is full of other Villagers who are undergoing 'treatment' for 'anti-social behaviour. A large poster on the wall behind him, in the familiar format of the famous world war one recruiting poster with its pointing finger, features the face of the current Number 2 and declares: 'Your Community Needs You!' In the middle of the room is a rostrum where Number 93 is made to 'confess' his 'sins' against the Village orthodoxy. In a quavering voice, he repeats the words provided for him by a voice whose source we do not see, admitting to be 'disharmonious', 'inadequate' and finally 'truly grateful' for what the authorities are doing to him. The man becomes extremely emotional, as he is made to repeat the words faster and faster, until finally he is crying: 'Believe me, believe me' over and over again as the tears run down his face. Another woman, Number 42, sits in the corner, permanently in tears. As Number 93's confession ends, the others in the room stand and applaud.

The Prisoner is summoned into the Council Chamber itself, where he is subjected to yet another 'mock trial'. The Council members, who all have peculiarly blank expressions, wear standard Village hooped shirts and imposing black top hats. Their Chairman is an old man who speaks in a way that suggests a very minor bureaucratic official. As the Prisoner comes in he is asked if he has completed the 'written questionnaire of confession' 'Naturally', he replies, tears the form into a hundred pieces and scatters it across the floor. He tasks his seat on a chair in the middle of the room and – in a similar scene to the one in 'Free For All' – he is spun around extremely fast. The camera takes a subjective position and we see the 'spinning' Council members from his point of view. But he maintains his usual equilibrium, facing the charges of anti-social behaviour being made against him with amused, dry cynicism.

The Chairman then declares – with some relish – that it is time for a 'tea break' and the officials disperse, leaving the Prisoner to follow them out of the Chamber. In the waiting room he pauses to listen to the taped version of Number 93's earlier confession, and claps ironically to the waiting group as he leaves. But he is surprised when, as soon as he begins to circulate in the Village, any attempt he makes to greet passers-by results in their deliberately turning away from him and giving him the 'cold shoulder'. He is handed a copy of the *Tally Ho*, which reports that the hearings against him will be continuing. Now the process of his ostracism from Village society has begun.

Back at his house, he encounters Number 2, who attempts to portray himself as powerless in the situation:

NUMBER 2: I hope that you do not think that I am a member of this committee ...

PRISONER: Oh, of course not ... never ...

NUMBER 2: I assure you, no matter what significance you may hold for me, to the Village and its Committee, you are merely Citizen Number 6, who has to be tolerated and ... if necessary ... shaped to fit.

PRISONER: Public enemy Number 6.

NUMBER 2: If you insist. But public enemies cannot be tolerated indefinitely. Be careful. Do not defy this committee. If the hearings go against you, I am powerless to help.

They are joined by a hard-faced young woman (Number 86) who speaks in an emotionless way very similar to that of Number 8 in 'It's Your Funeral'. She criticizes him for his 'frivolous attitude' towards the committee and warns him that all the hearings are televised, so that the entire Village will be aware of how he acts. She then leads him to a 'group therapy' meeting being held in one of the Village's gardens. Here an earnest group of Villagers are 'helping' Number 42 (the woman who had been in tears earlier in the waiting room) to become 'rehabilitated'. Number 42's crime appears to be that she was composing some poetry and had failed to respond to the greeting of another Villager. When the Prisoner suggests in her defence that 'poetry has a social value' the entire group rounds on him and attacks him verbally. Even Number 42 accuses him of trying to undermine her 'rehabilitation'. 'Strange talk for a poet', he comments. The entire group then turns on him and simultaneously chants 'Rebel! ... Reactionary! ... Disharmonious!' This kind of language, and the presence of a Chinese actor amongst the cast here seems to directly suggest the kind of 'social engineering' being practised at the time in Mao's China during the 'cultural revolution'.

After he leaves the scene of this meeting, the Prisoner is accosted by three men in white coats who insist he accompany them to the hospital for a 'medical'. He has no choice but to comply. The test carried out on him is anoth-

er apparently routine examination, but the other forms of treatment he sees in the hospital appear to be much more of a potential threat. As usual, the Village is subjecting its victims to various forms of behaviourist conditioning. In one room, marked: 'Aversion Therapy.' a man with electrodes attached to his temples is being brutally conditioned by electric shock treatment. He sits in front of a screen, strapped to his chair. When an image of Rover is shown to him he writhes in terror. But when this image is replaced by that of a smiling Number 2, the electric current is obviously switched off and he laughs with relief. When this image is succeeded by the word '... Individualist ...' he begins to suffer again.

Disgusted by this, the Prisoner attempts in vain to wrest the door open. A man sitting on a bench next to him, who wears an apparently permanently fixed inane smile, tells him to 'relax, fellow, relax'. The man has a small scar on his forehead, suggesting that he has recently been lobotomised. The man claims to be 'one of the lucky ones, the happy ones' and we are introduced to the keyword around which the episode will turn. With a guilty look, as if admitting to a dreadful crime, the man confesses: 'I was Unmutual'.

The 'campaign' against the Prisoner now begins to accelerate. His second appearance in the Council Chamber leads to him being declared 'Unmutual' and being told that he will be subjected to 'Instant Social Conversion' if any 'further complaints' are made against him. Again he is spun round but now the scene takes a surreal twist. As the chair begins to spin the room is plunged into blackness and we hear ominous electronic sounds on the soundtrack. When the spinning stops the Committee members have mysteriously disappeared and only the Butler remains in the room. His emotions now roused to anger, the Prisoner pushes his way out of the room.

The Prisoner's walk through the Village is accompanied by a menacing silence. No incidental music is featured. Every Villager who encounters the Prisoner immediately backs away from him. He picks up a copy of the *Tally Ho*, which announces that he has been officially declared 'Unmutual'. Still angry, he tears up the paper and throws it way. But when he reaches his house, he notes a further signs of his social ostracism – his telephone has been disconnected. Then a group of four women bursts in through the automatic doors, led by the strident and matronly Number 48, who claims that the group 'represents the Appeals Sub-Committee' and who, confronted by his sarcastic responses, condescending says that 'it is clearly premature to look for contrition in the poor creature'. Amongst the group is Number 42, now clearly 'socially adjusted', who 'piously' tells him that he has brought his 'misfortunes' on himself.

The next scene is very brief but is virtually unique in the series. Up till now, the Prisoner has apparently stood up to the Village's psychological pressure with his usual stoicism. But now we get a sense that the technique of isolating him socially and threatening him with the kind of brain surgery which he has always been able to avoid has caused him genuine fear. In a very poignant vignette, with no words and no incidental music, we see him

in the woods by the beach, angrily snapping off twigs. He goes down to the beach and we see him staring up at a flight of birds, in a shot which is clearly symbolic of his desire for freedom, but strangely lyrical for so unromantic a series as *The Prisoner*. The cutbacks to his face seem to reveal real emotions of loneliness and desperation, suggesting that he really may be 'cracking' under the strain. Here the first section of the episode ends, but without the usual dramatic 'teaser'.

We next see the Prisoner sitting at the Village cafe. But still he is being ostracised, and the other Villagers are positively hostile. The waiter refuses to serve him. A tannoy announcement reminds Villagers that: 'incidents regarding Unmutuals should be reported to the Appeals Sub-Committee'. Gradually everyone gets up from their seats and, in another menacingly silent scene, he is confronted by a crowd of Villagers who walk slowly towards him. The contrast between their brightly coloured clothes and their 'soulless' expressions adds a disturbing aspect to the scene. The Prisoner retreats to his house, where he again encounters the 'ladies' of the Appeals Sub-Committee. Number 48 tells him that they are 'socially conscious citizens', who have been 'provoked by the loathsome presence of an Unmutual'. The Prisoner no longer has recourse to irony or witticisms. 'They are sheep!' he declares. Number 48 responds by saying that as he has refused their offer of help, there is only one course of action left open. With this barely veiled threat, her group departs.

The telephone – which has apparently been restored – now rings. Number 2 is on the other end, and we intercut between the two as the conversation proceeds:

NUMBER 2 : I warned you … the community will not tolerate you indefinitely.

PRISONER: You need a scapegoat … (Mocking voice) 'Citizens unite to denounce this menace in our presence' …

NUMBER 2: A scapegoat. Is that what you think it is? Allow me to reassure you that after conversion you won't care what it is … you just won't care … you'll soon have lasting piece of mind and adjustment to the social system here …

PRISONER: Drugs?

NUMBER 2: Would drugs be lasting? What would be lasting … is isolation of the aggressive frontal lobes of the brain …

Number 2's words are cold and threatening. The Prisoner is further prepared for his coming 'lobotomy' by an announcement over the tannoys, which indicates that his 'conversion' will take place at the hospital, and will be broadcast on closed-circuit television. As he leaves his house he is quite viciously attacked by a mob wielding umbrellas, led by Number 48. Soon he is being dragged towards the hospital, and we see a white-coated 'doctor' approaching with a syringe. The shots from inside the operating theatre

where the supposed lobotomy is about to take place are all subjectiveness taken from the Prisoner's point of view. At this point he is still half-conscious, and McGoohan's use of hand-held cameras (which recalls their use in 'Free For All') conveys his disorientation.

In charge of the operation is Number 86, who, in her methodical, emotionless voice, gives an account of the process to the cameras in the cold, clinical, language of a medical school lecture: 'the prime concern is to locate the link point of the frontal lobes ... the ultra sonic beam is now focused on the exact link point of the frontal lobes'. As she speaks we see the 'beam' being adjusted in position on the Prisoner's forehead. She gives him another injection, and just before he passes out he hears her saying 'Now to step up the voltage until the ultrasonic bombardment causes permanent dislocation'. The camera then cuts to a close-up of her face. She gives a knowing smile, we see her hands adjusting the dials to 'Maximum' and then the screen fades to black.

It is not difficult for the viewer to realise that the operation is a 'fake' and that the Village Authorities have planned the whole sequence of events to convince the Prisoner that he really has been operated on. But the emotional effect of the whole process on the Prisoner has clearly been shown. As he wakes up in his hospital bed, it seems a clear possibility that the Village's ruse has worked and that the Prisoner will be convinced that he actually has been lobotomized. When he wakes he certainly behaves strangely, and he seems to have a fixed smile on his lips not unlike that of the lobotomized man he met earlier in the hospital. The doctor tells in a friendly 'bedside manner' that he went to sleep 'just at the most interesting point' of the operation. He notices he has a small plaster on his forehead but the doctor tells him to leave it on for a few days, 'just to be on the safe side'.

Number 48, now dressed in a most un-Village-like blue mini-dress, says she will take care of him and leads him off towards his house. As they pass the Aversion Therapy room, his reaction now is a simplistic, childish smile. En route to his house he is greeted by streets lined with cheering Villagers applauding his 'social conversion'. The brass band plays and the normal 'jollity' of the Village is restored. Number 48, whose tone has now changed to a more soothing one, tells him to make himself comfortable. She leads him to a sofa and he lies down whilst she makes a pot of tea.

Despite the fact that he has clearly been drugged, the Prisoner's legendary vigilance serves him well again. Out of the corner of his eye, he notices Number 48 dropping a small pill into his drink. When she is not looking, he pours the drink away into a vase. Giving his hair a gentle stroke, she leaves him to sleep. He is woken by Number 2, who in a soft and invitingly sympathetic voice, immediately begins to probe him:

NUMBER 2: Time for our talk, Number 6 ...
PRISONER: Our talk?
NUMBER 2: Oh yes ... Now that all your aggressive anxieties have

	been expunged, let us say forever, I know you'll feel free to speak ...
PRISONER:	(mumbles) Free to speak ...
NUMBER 2:	(moves closer) ... Particularly about that little incident which has been causing you such absurd distress ... the trivia, the trivia of your resignation ... Yes, you resigned ... Why ? ... Why prematurely? Why did you resign? ...
PRISONER:	(mumbles) It's ... difficult ... need ... time ... to think ...
NUMBER 2:	Oh, time, that was it ... you couldn't stand your job ... You needed time to think ...
PRISONER:	(shouts) No! No!

The Prisoner suddenly lowers his voice back into his 'childlike' tone and implores Number 2 'please don't be angry'. Number 2 coos 'I'm not angry, my dear friend. That's just the way things seem to you', and asserts that they can have their 'little chat' later on. As soon as he has left, the Prisoner goes to a mirror and tears off the plaster. There is a scar on his temple. He begins to pace restlessly around the room, banging his fists on the kitchen table.

We cut to the Green Dome, where Number 2 and Number 86 are watching him from the screen. Observing the Prisoner's aggressive behaviour, Number 2 is clearly worried that things may already be going wrong. Number 86 reassures Number 2 that she gave him 'eight grains of Mytol' a sufficient dosage to sedate him, but he orders her to go back and repeat the dose. She warns him that this could be very dangerous but he insists. Like previous Number 2's, he knows that failure to 'break' the Prisoner is likely to lead to his 'disappearance'. Despite his standard orders not to 'damage the tissue', he is now evidently quite prepared to take risks with the Prisoner's life to ensure that his plan succeeds.

We cut back to the Prisoner's house. He sits at the table, nervously drumming his fingers on the surface. Number 86 tells him she will make some tea to calm him. But, using the excuse that he 'cannot stand girls who don't know how to make a decent cup of tea' he disposes of the drugged drink and insists on making the tea himself. He prepares two cups, and pretends not to notice as she slips another dose into one of them. While she is not looking he manages to switch the cups around. Back at the Green Dome, Number 2 – who has not noticed the switch – seems now confident that his plan will succeed, and orders the Butler to bring him a celebratory cup of tea. But he is furious when, after a few minutes, Number 86 begins to slur her words and smile rather stupidly. Immediately he rings her and orders her to report to him. Rather slowly and reluctantly, and obviously enjoying the effects of the drug, she wanders slowly off.

The Prisoner also goes out for a walk. He knows he has avoided being drugged again, but is still unsure about whether he has really been operated on or not. He meets the lobotomized man he encountered earlier at the hospital, who points at the scar on his forehead and laughs knowingly. This rais-

es more doubts. We cut to the Prisoner's exercise area in the woods, where in another scene which begins without incidental music, he approaches his punchbag tentatively, trying unsuccessfully to summon up some aggression. It may be that some viewers are still uncertain at this point as to whether he really has been lobotomized, but the fight scene which ensues will dispel any doubts. Suddenly the two men who he beat up at the beginning of the episode return, telling him they have 'unfinished business'. One of the men pushes the punchbag into his stomach, and the other punches him on the face. The shock seems to bring him to his senses and he leaps into action. Dramatic incidental music starts up, signifying his return to his normal dynamic self. Soon he has dispatched the two men with even more verve than usual.

As at a similar stage in 'The Schizoid Man', *The Prisoner* was able to exploit the whole situation which has been set up to his own advantage. But this time his plan has a far greater chance of success. In 'Checkmate' and 'Hammer Into Anvil' he had learned that the way to defeat the Village authorities was to turn their own methods against them, particularly by pretending to be 'one of them'. Here he achieves this to devastating effect. Returning to the Village, he meets Number 86, who, still happily 'spaced out', is picking flowers. In the dialogue that follows, which presages that of Alexis Kanner's 'hippie' character in 'Fall Out', it is hard not to detect a sardonic comment on the lifestyle of those who espoused 'flower power':

NUMBER 86: (dreamily) I have to report ...
PRISONER: On plant life?
NUMBER 86: To Number 2 ... I want to make him happy..
PRISONER: The ecstasy of illusion ...
NUMBER 86: I'm higher ...
PRISONER: Really?
NUMBER 86: I'm higher than Number 2 ...

The Prisoner takes full advantage of her drugged state. He pulls out a watch and dangles it before her eyes. She is an easy subject for hypnotism. He tells her that he is her superior and that she must obey his instructions. First he asks her for a complete report on the 'social conversion of Number 6'. Immediately she snaps back into her monotonous 'normal' voice and explains how the whole charade was conducted. He then gives her one final order, which is to executed when the Village clock strikes four, but to maintain suspense the scene cuts before we learn what this is.

His next move is to go to the Green Dome, where he performs a perfect impersonation of his previous drugged state and succeeds in convincing Number 2 that the plan has worked. He declares his full willingness to divulge all his secrets, but persuades Number 2 to allow him to do it publicly, as he would like to 'thank everyone ... the committee ... the ladies' for their help. He also says that he hopes his public confession may inspire others to follow. Number 2 immediately calls a meeting in the Village square,

and soon he and the Prisoner are standing on the balcony in front of a cheering crowd.

The speech begins as expected. The Prisoner thanks Number 2 and gives him all the credit for his 'social conversion'. But then he makes a strange observation: 'to borrow one of Number 2's sayings, the butcher with the sharpest knife has the warmest heart'. Not surprisingly, Number 2 looks disconcerted. Trying to fill in time before the clock strikes four, he rambles: 'Now, thanks to my social conversion, I want to tell you all something ... And I trust that my example will inspire you all to tell, to tell'. At that moment, the clock strikes four and Number 86, who is in the middle of the crowd, suddenly shouts 'Number 2 is Unmutual! Unmutual! Social Conversion for Number 2! Unmutual!' Changing tack entirely, the Prisoner points at Number 2 and tells the crowd: 'Look at him ... an Unmutual who desires to deceive you'. The crowd begins to chant 'Unmutual! Unmutual!' while the Prisoner launches a little polemic of his own: 'Your welfare committee is the tool of those who wish to possess your minds ... you can still salvage your rights as individuals. Your rights to truth and free thought. Reject this false world of Number 2. Reject it ... Now!'

A look of panic crosses Number 2's face. He runs from the balcony to find the crowd advancing on him. He is forced to flee up the hill towards the Green Dome, whilst the angry crowd pursue him, hysterically chanting 'Unmutual! ... Unmutual!' The final shot of the episode shows the Prisoner following the crowd up the hill. Then we see the Butler, in one of his most enigmatic final scenes, unfold his black and white umbrella and – for the first time – follow the Prisoner.

The Prisoner's triumph is again complete and unequivocal. Yet again he has destroyed Number 2 and foiled his plans completely. The episode is The Prisoner's most direct and pointed attack on social conformity. The Prisoner has grasped that the Villagers are so conditioned to respond to Authority that they are prey to anyone who assumes the voice of Authority. In 'Checkmate', he had attempted to divide the 'society' of the Village into 'Prisoners' and 'warders', into 'us' and 'them'. But by now he finds things are not so simple. He has realised that he himself is a powerful factor in the politics of the Village – as their 'prize Prisoner' he is always protected by the express orders that have come down from 'on high' not to 'damage the tissue'. As the focus of the series moves from 'freedom' towards 'justice', he has become the arbiter of Village crises. In 'Living In Harmony' he will even become a 'lawman'. As the final episodes unfold, it becomes clear that the Village Authorities are trying increasingly desperate measures to finally break him.

The Prisoner is above all an extended 'morality play'. By now it has virtually outgrown its origins as a 'spy story' and emerged as both a critique of the political and social cultures of both 'East' and 'West'. At the same time it has begun to confront eternal existential dilemmas. These are essentially moral questions, centering around the relationships between freedom and

justice and between individual conscience and collective responsibility. As the Prisoner's power and stature within the Village grows, he has had to confront such dilemmas head on. 'A Change Of Mind' completes the 'psychological allegory' section of the series by allowing the Prisoner to dispense his own distinctive form of 'moral justice' on Number 2. Similar 'judgements' have already been served on his predecessors in 'It's Your Funeral' and 'Hammer Into Anvil'. Having now understood that he cannot simply 'escape' from the Village, he has engaged in a psychological battle to overcome its 'soulless' control of his 'world'. And, at last, he is beginning to win.

Return

Episodes 13-17:

'Do Not Forsake me, oh my Darling', 'Living in Harmony', 'The Girl Who Was Death', 'Once Upon a Time', 'Fall Out'

The hand of the LORD came upon me, and he carried me out by his spirit and put me down in a plain full of bones … He said to me, 'Man, can these bones live again?' I answered 'Only thou knowest that, Lord GOD'. He said to me 'prophesy over these bones and say to them: O dry bones, hear the word of the LORD. This is the word of the Lord GOD to these bones. I will put breath into you, and you shall live. I will fasten sinews on you, bringing flesh upon you, overlay you with skin, and put breath in you, and you shall live …' I began to prophesy as he had bidden me, and as I prophesised there was a rustling sound and the bones pulled themselves together.
 The Book Of Ezekiel[1]

We are the hollow men,
We are the stuffed men,
Leaning together,
Headpiece filled with straw. Alas!
Our dried voices, when

1 New English Bible, *Ezekiel* 37, lines 1-14.

We whisper together
Are quiet and meaningless
As wind in dry grass
Or rats' feet over broken glass
In our dry cellar.
 T.S Eliot, *The Hollow Men*[2]

Nothing you can do that can't be done,
Nothing you can win that can't be won.
 The Beatles, *All You Need Is Love*[3]

As *The Prisoner* progresses towards its conclusion, its final five episodes present the viewer with a series of radical deconstructions of its own established format. In doing so, its narratives explore a wide range of genres – the spy/science fiction story in 'Do Not Forsake Me, Oh My Darling', the Western in 'Living In Harmony', the comic burlesque/children's story in 'The Girl Who Was Death', modern absurdist drama in 'Once Upon A Time' and surreal fantasy in 'Fall Out'. By expanding the series' generic range, McGoohan deliberately emphasises his allegorical intentions. We see that the Prisoner can exist in a number of historical, mythical and symbolic settings and still retain his essential nature. As a character he is thus universalised, and the narratives move inexorably towards universal themes.

Having realised that he cannot escape without destroying the Village, the Prisoner's energies become focused on the search for his 'holy grail' – Number 1. The final, shocking revelation of the identity of Number 1 in 'Fall Out' confirms that, for viewers to make any kind of overall sense out of the series, it must be approached as a symbolic, allegorical text. Yet the highly ambiguous nature of that revelation daringly invites viewers to 'deconstruct' the entire series in the light of their own individual interpretations. The presentation of such a task to the viewer of a 'cool' medium like television – with its inbuilt 'trash aesthetic' – inevitably made the series extremely controversial at the time it was made, but has also ensured its longevity. As we saw in Chapter Two, the series demonstrates a self-referential quality which identifies it as a classic post-modernist text, and it thus combines one of the most ancient of forms – the moral allegory – with a post-modern sensibility.

The final episodes complete the mythological 'inner journey' of the series, passing through what Joseph Campbell[4] identifies as the final archetypal stage of 'Return', in which the mythical hero triumphs over his 'supernatural' enemies and returns to spiritually 'enlighten' his society. In order to

2 T.S. Eliot, *Collected Poems*, p. 87.
3 The Beatles, *All You Need Is Love* by John Lennon and Paul McCartney – originally released as a single in 1967. Also appears on the album *Magical Mystery Tour*.
4 Joseph Campbell, *The Hero with A Thousand Faces*.

achieve his own 'enlightenment' the Prisoner – having in the earlier episodes been tortured, brainwashed and tricked – experiences the disassociation of his 'soul' from his body in 'Do Not Forsake Me, Oh My Darling', a full-blown hallucinatory 'trip' into an 'alternate' mythical universe in 'Living In Harmony', a fantasy of individual 'indestructibility' in 'The Girl Who Was Death', and a 'return' to childhood and a psychological 'battle to the death' in 'Once Upon A Time'. In 'Fall Out', he is presented with the ultimate 'temptation' – the chance to rule over the Village itself. Like Faust, he is offered the world for the price of his soul. Yet he is also presented with the ultimate 'revelation' about his spiritual existence. The transformations of the series – from social to psychological to spiritual allegory – are complete.

It may be inaccurate, however, to describe *The Prisoner* as a 'religious' allegory. McGoohan is certainly not preaching any 'religious message' or espousing any particular religion. Indeed, one of his satirical targets is the kind of social control used by organized religion. In a 1983 interview he summarized the 'genesis' of the ideas behind the series:[5]

> It was in my mind from ... seven years old ... the Individual against the bureaucracy ... the Individual against so many things that were so confining ... the church, for instance ... it was almost impossible to do anything that wasn't some kind of sin.

It is certainly tempting to cite McGoohan's Catholic background and upbringing as a prime motivating force in his construction of the allegorical world of *The Prisoner*. According to Cazzare and Oswald,[6] as a young boy he intended to take up the vocation of the priesthood. On one level, the entire series can be read as a satire on Catholicism itself. The plethora of iconic visual 'props' (such as Rover, the Penny-Farthing and the Butler) parallels the Catholic church's use of religious icons. The 'Unmutuals' of 'A Change Of Mind' are treated exactly like heretics or sinners, and they have to 'atone' for their 'sins' by publicly denouncing them. The methods of the Village authorities resemble those of the Spanish Inquisition, an organisation dedicated to moulding and conditioning belief towards a Catholic spiritual orthodoxy, in which the accusers also doubled as judges (as in the mock-trial scenes in 'Dance Of The Dead', 'Living In Harmony' and 'Fall Out'). When individuals were brought before the Inquisition, they were often, like the Prisoner, not informed of why they had been abducted from their homes. And, just like the Village authorities, the Inquisition was perfectly prepared to use torture to make its victims 'confess' their heresy and convince them of what it saw as the correct 'spiritual' path.

Catholicism is also characterised by the dogmatic stance that only its priests can have access to the divine, a notion which is epitomised by the

5 Patrick McGoohan quoted in *The Prisoner File*, Channel 4 documentary (1984).
6 Alain Cazzare and Helene Oswald, *The Prisoner*: A Televisual Masterpiece, p. 228.

doctrine of papal infallibility. Spiritual 'exploration' amongst the laity is thus discouraged – the mass of the population cannot have direct contact with 'Number 1' and must rely on the ever-present 'Number 2' (in the form of the priesthood) to 'mediate' for them. As in the Village, regular 'confession' is thought to be essential. However, specifically religious imagery tends to be avoided until the last episode of *The Prisoner* (although the Prisoner strikes a Christ-like pose when making the 'supreme sacrifice' of his resignation in the credit sequence). But 'Fall Out', with its 'resurrection' of Number 2, its Old Testament reference to Ezekiel and its supreme 'temptation' of the Prisoner, contains a number of Biblical allusions.

'Do Not Forsake Me, Oh My Darling' is perhaps the weakest episode of the entire series. It is built around a flimsy spy genre plot and characters, with a somewhat dubious 'science fiction' plot device in the Seltzman 'mindswap' machine. McGoohan was unable to be present for the filming of most of this episode (owing to a commitment to appear in the film *Ice Station Zebra*) and so he only appears at the beginning and end of the story, as well as providing a voiceover in some scenes. Certain scenes, such as those on the supposed journey to Austria, are blatantly 'fake' and look exactly like 'cheap television'. Also, its re-entry into the 'spy' genre gives the Prisoner yet another set of British secret service bosses (his superiors in 'Chimes' and 'Many Happy Returns' were also different). He is also suddenly provided with a fiancee, Janet, with whom he indulges in rather 'soppy' (and highly uncharacteristic) love scenes. Much of the drama is so conventionally handled that the scenes where he cannot be named become somewhat farcical.

Despite these drawbacks, *Do Not Forsake Me* is still effective in the context of the series in that it expands *The Prisoner*'s allegorical scope by having a different actor (Nigel Stock) play the main role. Also, its action takes place largely outside the Village, so widening the possibilities of the series. The experimentation with settings which begins here is a precursor to the range of different settings that will feature in the final four episodes. The use of 'flashbacks' of earlier episodes continues the series' trend towards being self-referential, and the delaying of the credit sequence until a few minutes into the episode is another break with the established format.

'Do Not Forsake Me ...' begins with a mysterious sequence of slides of famous locations such as the Eiffel Tower, the White Cliffs of Dover and Beachy Head, which we soon realise is being examined by members of British intelligence intent on discovering a hidden code that can only be decoded by fitting the slides together in a particular sequence. One of the secret service men asks 'What's number six?' Another replies 'It's Seltzman'. Thunder is heard on the soundtrack, and then the credit sequence begins. However, only the first half of the sequence is used and the second half is replaced by a series of aerial views of the Village.

We then cut to the Green Dome, where this week's Number 2 (Clifford Evans) observes on the screen the Prisoner eating his breakfast. He is then

joined by an agent who has just been flown in to the Village, (Nigel Stock), who is later referred to as 'the Colonel',[7] and who is anxious to discover the nature of his assignment. Number 2 first explains to him that the Village is determined to track down the missing scientist Professor Seltzman, who has invented a machine that can transfer the mind of one person into another. Number 2 claims that Seltzman invented this machine after studying the mind-control techniques of advanced yogis in India, and outlines its potential use to the Village: 'from time to time, diplomatic swaps take place ... imagine the power we would have if the spies we returned had the mind of our own choosing ... we could break the security of any nation'. Number 2 explains that the Village already has a 'Seltzman machine', but that so far they have only able to use it for a 'one-way' mind swap. The Colonel is then shown the Village's 'amnesia room', whose sophisticated 'mind control' technology is capable of selectively erasing an individual's memory. He is told that his mind will be 'swapped' with that of 'Number 6' (the last person known to have been in contact with Seltzman) in order that they can locate the missing scientist. We cut to a shot of a group of Village 'goons'; in their one piece grey uniforms, white hard hats, belts and gloves; who manhandle the Prisoner into a mini-moke. The Prisoner is then seen in the amnesia room, where all his memories of life in the Village are to be 'wiped' in preparation for the 'mind swap'.

The next scene features the Prisoner, whose mind is now housed in the Colonel's body, waking up in his familiar London flat. At first we see only subjective shots, achieved with hand-held cameras, accompanied by McGoohan's voiceover. As if embarking on just another 'normal' day, he checks his appointment book, clearly having 'forgotten' his sojourn in the Village. But then he sees himself in the mirror, and is naturally deeply traumatised. This is emphasised by a 'subjective montage' of shots from previous episodes, including the 'I will not be pushed ...' scene from 'Arrival'. The doorbell rings and a young woman called Janet appears, who is obviously the Prisoner's fiancee. Having seen his Lotus outside, she thinks he may have returned after his year-long disappearance, but of course she does not recognise him in his new body. He tells her that he will attend her birthday party later that same day in order to bring her a message from his 'friend'. After she leaves, we see him smash the mirror in anguish.

The next scene shows Janet entering the office of her father Sir Charles Portland, the Prisoner's former secret service boss, who the viewer may recognise as one of the men seen discussing the coded slides in the Pre-credit sequence. Their conversation is somewhat contrived, as the 'rules' of the series do not allow her to mention the Prisoner by name. Sir Charles denies all knowledge of where her fiancee might be, although Janet seems rather unsure about whether to believe him.

7 Nigel Stock's character is here (rather confusingly) given the same alias as other characters in 'The Chimes Of Big Ben' and 'Many Happy Returns'.

The second segment of the episode begins with a virtual 'rerun' of the credit sequence. The Prisoner gets into his car and, taking the familiar route past the Houses of Parliament, drives into the underground tunnel and strides purposefully down the long, dark corridor. Not surprisingly, he has some trouble convincing the more minor officials that he really is 'himself'. Again his name cannot be used, and he refers to himself as 'ZM73' – showing that the use of numbers is certainly not confined to the Village. When he eventually meets Sir Charles he still does not fully convince him, despite supplying him with many personal details. Sir Charles points out that these could all have been extracted from the 'real' Prisoner under hypnosis, and (in another parallel with Village methods) informs him that he will be keeping him under close surveillance.

To the accompaniment of a twangy guitar theme on the soundtrack, we see the Prisoner driving back to his house, followed by a secret service man who has placed a homing device on his car. When he reaches his house we see in the background the same hearse that featured in the credit sequence, and out of it steps a man dressed in an undertaker's suit and top hat. It becomes obvious that both the British authorities and the Village are keeping a 'tail' on him, and both are waiting for him to lead them to Seltzman. Inside his house, while the sad theme of *My Bonnie Lies Over The Ocean* plays on the soundtrack, he looks wistfully at Janet's picture. He also recovers a large amount of cash that he had hidden in a safe behind his television.

We then cut to Janet's birthday party, which is a very formal, upper-class affair. One indication of the 'cheapness' of the episode is the fact that previously-seen shots of Madame Engardine's party in 'A, B and C' are used. The Prisoner tells Janet that he has a message for her from his 'friend' but that first she should bring him a receipt that the 'friend' left before his mysterious departure. As he waits for her in the arbour McGoohan's voiceover conveys his thoughts: 'Will she come? ... Will she have the receipt?' But his faith in her is justified when she returns with the receipt. When she asks him what the 'message' was he kisses her, at first chastely and then passionately. It is his passion, as much as the explanation that follows, that leads her to believe him when he tells her the truth about his 'mind swap'. Significantly, the Prisoner's only genuinely romantic tryst of the series occurs whilst he inhabits another man's body.

The next day, the Prisoner walks purposefully through the London streets, apparently unaware that he is being followed by both the British secret service man and the Village 'undertaker'. The receipt Janet has brought him turns out to be for a set of slides, which he collects from a camera shop. He is told by the rather obsequious shopkeeper that owing to a 'clerical error' the slides were previously collected by another 'gentleman' who has since returned them. We cut back to Sir Charles' office where the agent informs him that the slides have been collected. When the Prisoner reaches home and begins to display the slides we recognise them as the same pictures the secret service men had failed to decode in the Pre-credit sequence. But he seems to

know how to decode them, and overlays them in the projector in a particular sequence until they finally spell out: 'Kandersfeld, Austria'.

The Prisoner now has the information he needs – the location of Seltzman, the only man who can possibly reverse the 'mind swap' process . Of course, he has been trapped by the British secret service, who know he will lead them to Seltzman. Behind the trap is another one set up by the Village authorities, whose control of the world outside the Village is again emphasised. He immediately drives off in his car, followed by the secret service man. A rapid series of stock location shots establishes his progress first to Dover, then over the channel to France. These are continually intercut with shots of the British secret service man following. The shots depicting them driving through 'Austria' are very obvious backdrops. Finally he arrives in Kandersfeld, where the first (ironic) words the waiter at the local cafe greets him with are 'Welcome to the village'.

It does not take long to locate Seltzman; a frail, white-haired old man who is posing as the village barber. The Prisoner manages to convinces him that not only does he know his real identity, but also that his own appearance is the result of an experiment with the Seltzman machine. He finally proves this by demonstrating that his handwriting is the same as the man who Seltzman knew. But Seltzman, who plays a very stereotyped role as the 'scientist with a conscience', informs him that 'the motive is clear ... you will lead them to me'. He says he has been in hiding to prevent his work being misused, and also tells the Prisoner that he could 'in theory' make the reversal process work. The British secret service man then arrives. Seltzman hides in his basement, and a particularly violent fight scene ensues between the agent and the Prisoner, which the Prisoner wins. But his triumph is short lived. The Village 'undertaker', now dressed as a chauffeur, descends the stairs and sprays them all with 'knockout' gas.

The next scene takes place back in the Village. In the Green Dome, Number 2 shows the Prisoner 'himself' on the screen, still wired up to Seltzman's machine. Seltzman at first refuses to perform the reversal process for them, but finally agrees on condition that he be allowed to work alone. Number 2 accedes, knowing that the Village surveillance cameras will reveal the whole process. The 'mind swap' scene itself is very reminiscent of the scene in Lang's *Metropolis* (1926) where a robot is 'brought to life', which was itself the inspiration for a similar scene in the original Universal studios version of *Frankenstein* (1931). Seltzman wires himself up to the two other men, and electric currents like flashes of lightning appear to connect the three of them. But Seltzman, who is the weakest, goes into spasms and collapses. Number 2 immediately calls for medical assistance. The Prisoner and the Colonel, however, appear to have become their normal selves. Number 2 informs the Colonel that a helicopter is waiting for him and the Colonel takes his leave.

The old man appears to revive for a few seconds, but his dying words: 'You assured me he was in good health ... you must contact Number 1 and

tell him I did my duty', perplex Number 2, who is naturally crestfallen at the scientist's death. He has now lost a valuable 'property' for the Village. But it is only when the Prisoner – now played again by McGoohan – explains that the man who has just flown away from the Village is ... not who you thought it was ... that Number 2 realises that Seltzman has in fact performed a three-way 'mind swap' and has escaped in the much younger and stronger body of the Colonel. 'He's now free', the Prisoner concludes with satisfaction, 'to continue his experiments in peace'. The bars slam down, as ever, on the Prisoner's face.

In its use of the theme of 'split personality', 'Do Not Forsake Me ...' bears some resemblance to 'The Schizoid Man'. The episode marks another defeat for the Village, but this time the victory is Seltzman's, not the Prisoner's. In fact, the Prisoner has been used as a dupe throughout. It has to be admitted, however, that the plot of the episode is full of holes. Seltzman's real prospects of escaping the Village's clutches are surely as unlikely as those of the 'old Number 2' in 'It's Your Funeral'. What happens to the secret service man, or to Janet, is never revealed. The episode has a few touches which align it with the ironic, distanced, stance of the rest of the series, such as the parallels it draws between the British and Village authorities. But the plot; and the characters of Janet, Sir Charles and Seltzman; are stock 'spy fodder' – with a science fiction twist as a rather obvious ploy to allow the makers of the series to film an episode largely without McGoohan. The role of the Village is reduced to that of a SPECTRE-like organisation, competing for 'secrets' with other 'world powers'. This is a reversion to the more limited scope of the series that we were presented with in some of the earliest episodes. Yet it is somehow fitting in terms of *The Prisoner*'s concern with the issue of identity that an episode of the series exists which was made largely without McGoohan, and the use of another actor to play the central role, begins a process of disorientation which will be greatly intensified in the remaining episodes.

The initially unexplained shock transformation of *The Prisoner* in 'Living In Harmony' into a Western is certainly disorienting for the viewer, who may have been lulled by the previous episode into expecting the 'spy' theme to become prominent again. For the first time, the credit sequence (having been 'postponed' in 'Do Not Forsake Me ...') is dropped entirely. Only at the very end of the episode is it made explicit that all the events have actually taken place in the Village. If the format of the series was disturbed in 'Do Not Forsake Me ...' here it is radically altered. Yet the events which take place in the ironically-named Western town of 'Harmony' are soon revealed as being very similar to those in the Village. McGoohan appears as an unnamed man who, having resigned the position of Sheriff, is prevented from leaving the town. The town itself is under the complete control of 'the Judge', who administers his own 'frontier justice', ignoring the normal process of the law. The Prisoner's sympathy towards a young woman – the 'bar girl' Cathy – is again exploited by the authorities. And his repeated attempts to 'escape'

prove futile. 'Living In Harmony' appears to be McGoohan's way of demonstrating to the viewers that *The Prisoner* needs to be 'read' allegorically to be understood, in that its basic situation can be reproduced in a completely different generic setting.

Much of the credit for 'Living In Harmony', however, must go to McGoohan's closest assistant David Tomblin, who both wrote and directed the episode. Tomblin's direction shares with McGoohan's a certain adventurousness, a willingness to take risks, and – crucially – the way that 'Living In Harmony' and the following 'The Girl Who Was Death' (also directed by Tomblin) are constructed reveals an understanding of the series' intent which Tomblin clearly shares with McGoohan. Both episodes have particularly 'hallucinatory' qualities and achieve a cinematic 'look' by treating the camera as an expressive, rather than a merely functional, tool. The episode also uses very pronounced 'fades to black' between scenes, and – most confusingly of all – a number of 'black frames', each of which interrupt the action for several seconds.

'Living In Harmony' pays tribute to the Western genre by using a range of its distinctive narrative and visual conventions, such as the saloon-room brawl, the 'jailhouse' scene, the psychotic young 'Kid' gunfighter and the highly melodramatic 'shootout'. Whereas the Western had originally been a heroic genre depicting the 'taming of the wilderness' by 'frontier man', by the 1950s some filmmakers were using the genre in a more allegorical way. Fred Zinneman's *High Noon* (1952), which 'Living In Harmony' closely resembles in theme, setting and mood, has long been recognised to contain a subtext referring to the anti-Communist 'witch-hunts' led by Senator Joseph McCarthy in the late 1940s and early 1950s. 'Living In Harmony' itself was omitted from the series when it was first transmitted on American TV. The refusal of the Prisoner in the episode to 'pick up his badge and gun' was interpreted as being encouragement to the 'draft dodgers' and the anti-Vietnam war movement which was very active on American campuses at the time. This is particularly ironic because 'Living In Harmony' is the only episode of *The Prisoner* which has an American setting. But it is also a sign that the 'dangerous' allegorical nature of the series was recognised by some at a very early stage.

By the 1960s, the popularity of the old-style Western had declined (partly due to a greater recognition amongst its audience of the reality of the historical 'West', in which genocide against the indigenous peoples was committed on a vast scale). One of the surprise cinema 'hits' of the mid-1960s was Sergio Leone's highly violent and amoral *A Fistful Of Dollars* (1964), the first of the Italian 'Spaghetti Westerns'[8] which made a major international cinematic icon out of Clint Eastwood. In each of the first three 'Spaghetti Westerns' Eastwood plays 'the man with no name', a role which

8 *A Fistful Of Dollars* (1964), *For A Few Dollars More* (1965) and *The Good, The Bad and The Ugly* (1966).

'Living in Harmony': *The Prisoner* as Western

has obvious parallels with McGoohan's in *The Prisoner*. The first person the Prisoner meets in Harmony is a grizzled Mexican who strongly resembles Lee Van Cleef's character in Leone's films.

'Living In Harmony' also contains a performance of extraordinary intensity by the young Canadian actor Alexis Kanner, who also plays a prominent role in 'Fall Out'. Kanner plays the character of the mute, deranged gunslinger the Kid with a range of exaggerated mannerisms that place the performance in the tradition of 'method acting' most commonly epitomised by the performances of Marlon Brando in *The Wild One* (1953) and James Dean in *Rebel Without A Cause* (1956).

The first sequence of shots in the episode parallels the usual credit sequence but with a sudden and shocking generic change. The first image we see on screen (instead of a car) is a mid-shot of a horse in motion, which quickly cuts to a view of the Prisoner in cowboy gear angrily throwing down his Sheriff's badge. We cut between close-ups of the Prisoner's resolute face and the grim face of the Marshall he is 'resigning' to. Then we see the Prisoner removing his gunbelt and his gun, and throwing them contemptuously down on the Marshall's desk. He is seen walking away from the town with his saddlebag, where, as he is set upon by a gang of thugs, the obviously ironic words ... 'Living In Harmony' ... appear on the screen in the usual Village Albertus script. In the manner of a typical Western, the sequence is accompanied by Spanish guitar music.

The Prisoner is dragged back into town and unceremoniously dumped in the middle of the town square, where the Mexican befriends him with the words 'Welcome to Harmony, stranger' and suggests he try the local saloon to relieve his obvious thirst. When asked 'Where is this town?' the Mexican replies 'it's not wise to ask too many questions'. This parallels the Prisoner's initial arrival in the Village, but the Prisoner – as in 'Do Not Forsake Me ...' – appears to have no knowledge of the Village, or in fact, of any other existence except the one in which he now appears.

He enters the saloon, where he is welcomed by the bar girl Cathy, and immediately has his drink shot away from him by the Kid, who is dressed in jeans, braces and a black top hat. Cooly, without reacting, the Prisoner promptly orders another and downs it in one gulp. He then turns and 'flattens' the Kid, who drops to the ground in an exaggeratedly theatrical way. As he does so the screen turns black for several seconds. The Prisoner is then invited to sit with the Judge, who addresses him as 'Sheriff' and begins to cross-examine him about his 'resignation'. The dialogue is, of course, highly reminiscent of conversations between the Prisoner and Number 2 in the Village, and the Prisoner characteristically refuses to give any reasons. Angrily, he gets up to leave. There can be no doubt in the viewers' minds now that, despite the different setting, McGoohan is still playing the same character.

Just as he did in 'Arrival', the Prisoner plans to 'escape'. But when he attempts to buy a horse the horse trader jeeringly tells him that the price of a horse is $5,000. In a scene reminiscent of 'crowd scenes' in 'Dance Of The Dead' and 'A Change Of Mind' he is cajoled by a group of angry locals who take offence to his statement that 'Harmony ... is not my kind of town ...' The outraged 'citizens' soon become an angry mob. The Judge sends his armed men to intervene, informing the crowd that he is taking the Prisoner into protective custody.

The Prisoner is locked up in the jailhouse. The Judge, confronted by the mob at his door, demonstrates his extreme cruelty by 'throwing' them the other inhabitant of the jailhouse, a young man who is promptly lynched. The use of hand-held cameras to depict the confusion of the scene recalls the crowd scenes in 'Free For All'. Just as he is being hung, Cathy rushes towards the scaffold, imploring them to stop. It seems that the young man was her brother. Back in the jailhouse, the Prisoner cooly rolls a cigarette in his cell whilst being 'guarded' by the Kid. In another of *The Prisoner*'s memorable 'silent' scenes, the Kid, who is becoming increasingly drunk, strikes various poses with his gun whilst the Prisoner watches. A close-up of the Kid's face shows his deranged expression, and his eyes look like those of someone who has been drugged. Another 'blackout' interrupts the scene.

Cathy then enters the jailhouse, in a particularly flamboyant red and white feathered headdress. She flirts with the Kid, who is obviously besotted with her, and he grabs her and kisses her roughly. She pushes him away, telling him he must wait 'until later'. Meanwhile she has stolen his keys. The

Kid finally passes out in his chair, and Cathy appears at the Prisoner's window. She slips the keys through the bars and tells him to leave town by the northern road. He lets himself out of the jailhouse and steals a horse. But his attempt to escape is as futile as before. He is again stopped by the Judge's men, who drag him back into town and dump him on the floor of the saloon.

What follows is another of the series' parodies of 'justice'. Sitting at one of the saloon tables, the Judge declares that a court is now in session. Surprisingly, though, it is not the Prisoner who is on trial but Cathy, for stealing the keys. At a 'nod' from the Judge, the jury of this 'kangaroo court' finds her guilty. The Judge then tells the Prisoner that ... when you work for me, I'll let her go ... and the first segment ends with a menacing shot of a deranged Kid on his way to the saloon. Just as in the Village, the authorities are using the Prisoner's sympathy for a young woman to attempt to win him over to their side. In this case, his non-co-operation is symbolised by his refusal to wear the Sheriff's badge and gun which we saw him throwing down on the Marshall's desk in the episode's credit sequence. But now, out of sympathy for Cathy's plight, he makes his first concession – he agrees to wear the badge, but not the gun.

The Kid arrives, now consumed with jealousy over Cathy's affection for the Prisoner. As the second segment begins we see a sequence of close-ups of the bar, the Kid's gun and his top hat. We see another gun slide down the counter. The Kid is attempting to provoke the Prisoner into a gunfight. When the Prisoner does not respond, he shoots at him. The bullet grazes his cheek. The judge intervenes to prevent bloodshed. He tells the Prisoner: 'you won't regret joining my outfit', but warns him that not carrying a gun will be dangerous. This is borne out soon afterwards outside the saloon, when the Prisoner is approached by a 'tough' called Zeke who tells him: 'I don't carry a gun either ... and I don't need one'. A violent fist fight ensues, in which the Prisoner finally manages to knock out both Zeke and his partner, who has joined in the fray. His bruises are tended to by a concerned Cathy, who tries to persuade him to attempt to leave town.

We cut to the saloon. The camera wheels around onto the Kid, who leans up against the bar. A raucous scene is taking place, with a number of the 'cowboys' in a highly jovial mood, whilst a 'Honky Tonk' piano plays in the background. One of them, a little guy called Will, is becoming rather over-familiar with Cathy. The Kid approaches him and stubs a cigarette out on his ear. In the typical manner of a Western, the music immediately stops and everyone else instantly scatters, leaving the Kid to confront Will. It is Will who draws first, but he merely holds his gun and does not shoot, as if not believing that the Kid really wants a shootout. The Kid does not flinch. Without showing any emotion he draws his revolver and fires, and Will is killed instantly. Hearing the shot, the Prisoner comes into the bar. Now wearing his Sheriff's badge, he demands to know what happened, but the men in the bar tell him that Will drew first. He is thus powerless to act, as legally the Kid has acted in self-defence. When the Kid leaves the angry men

urge him to take action against the Kid. As the second segment ends, the camera moves upwards to a balcony overlooking the saloon, where the Judge is smiling in satisfaction. He has succeeded in creating a situation where there is great pressure on the Prisoner to 'pick up the gun'.

The third segment begins with the Prisoner now ensconced in the Sheriff's office. A man called Jim enters and tells him that he and a group of his friends sympathise with him and – using one of the commonest Western clichés – that they wish to help him ... clean up this town ... But the offer is short-lived. In the saloon, we see Jim being attacked by the Judge's men. Shortly afterwards, the Prisoner finds him dead in a chair in the Sheriff's office. But despite this deliberate piece of provocation, the Prisoner still does not take up the gun. He meets with Cathy, and they discuss another escape plan. He tells her to meet him at the edge of town after the saloon closes. We see him waiting for her, and in yet another fight scene he dispatches two of the Judge's men who are guarding the road. But Cathy never makes the rendezvous. Back at the saloon, the Kid comes in and attempts to kiss her, his eyes full of mad lust. Cathy bites him hard on the lip and pushes him away. He approaches her menacingly. In a series of fast cuts we see him strangle her. He walks away, leaving her dead body on the ground.

The Prisoner gives up waiting for Cathy. Instead of escaping on his own, he returns to the town, where he discovers her body. We cut to an elegiac burial scene, shot in the manner of countless Westerns with the Prisoner leaning on his spade as the sun goes down behind him, accompanied by mournful guitar music. The stage is now set for the final confrontation between the Kid and the Prisoner. As the Prisoner strides back into town, the 'Spanish' music fades out briefly, to be replaced by a snatch of a more familiar electronic 'Village'-type theme . He finally picks up the gun, although as he does so he discards his badge. He is determined to meet the Kid as an 'Individual' rather than as a representative of the Judge. As he emerges into the bright sunlight, the Kid is waiting for him.

The 'shootout' scene is another of *The Prisoner*'s impressive wordless cinematic coups. In the traditional Western manner, the two men stand, legs apart, across the deserted square from each other. Each holds a hand to his hip. The camera then concentrates entirely on the Kid. We see him draw, and shoot. For a second, he does not move, and we can only assume that he has won the duel. (He has, after all, already demonstrated the phenomenal accuracy of his shooting). But then he slumps, in a strangely stiff, artificial way, to the ground.

We cut to the saloon, where the Prisoner now sits at a table with a strong drink. The Judge, accompanied by his 'toughs', comes in and congratulates him on his victory. But the Prisoner still refuses to give him his allegiance. The Judge tells him: 'you ain't quitting while I've got Cathy'. The Prisoner informs him that Cathy has been murdered by the Kid. At this, the Judge, who has seemed so self-assured throughout, is shocked. Something has clearly gone wrong with his plan. Suddenly he becomes extremely threatening:

'You work for me whether you like it or not', he tells the Prisoner. 'I'm not letting you join some other outfit. I'll kill you first. You've got five seconds to make up your mind'. Behind him, his men begin to draw their guns.

Despite this final, ultimate threat, the Prisoner prefers to fight against overwhelming odds rather than give in to the Judge's wishes. In the bar-room gunfight (another stock Western convention) that follows he shoots down three of his opponents. But then we see the Judge, his face contorted in anger, firing several shots into him. The Prisoner's face shows incomprehension as he clutches his head where one of the 'bullets' has supposedly penetrated. The screen fades momentarily to black. Then we see an upside-down close-up of the Prisoner's face. As he rises to his feet, we see that he is now dressed in his standard 'Village' outfit, and has some kind of microphone attached around his neck. He runs towards the Judge and attempts to strangle him. But we now see that the 'Judge' is actually a lifesize cardboard cutout figure, which falls over easily. As the Prisoner runs out into the town square, still confused, he sees a cardboard cutout of the Kid lying on the ground. Then he hears the familiar sound of a brass band playing. The next shot shows him looking out over the Village.

We cut to the Green Dome, where the nature of the Village's latest 'cunning plan' is soon revealed. The Judge, the Kid and Cathy are present, all in Village clothing, their lapel badges revealing them as Number 2, Number 8 and Number 22 respectively. Number 8 and Number 22 now speak in English accents. 'Interesting', Number 8 comments, 'that he can separate fact from fantasy so quickly'. Number 2 retorts 'I knew it wouldn't work. Fill him with hallucinatory drugs, put him in a different environment, talk to him through microphones ... give him love, take it away, isolate him ... make him kill, then face him with death ... I should never have listened to you'. Number 8, however, blames Number 2 for his lack of self-control in precipitating the crisis too soon. But Number 2 insists that 'You said yourself that we would get involved and do what we would do in the real situation ... I have to answer for this failure. It seems I'm not the only one who got involved'. At this, Number 22, who has so far displayed the manner of a typical 'emotionless' Village acolyte, breaks down in tears and leaves the room.

Number 22 is then seen approaching the 'mock-up' Western town to revisit the scene of the earlier 'events'. She sits on the steps of the saloon bar which leads up to the balcony, obviously still emotionally traumatised. Then we hear a voice calling out 'Cathy'. It is Number 8, who though still in his Village clothes has again taken on the deranged personality of the Kid. Re-enacting his earlier role, he then begins to strangle her. Hearing the screams, the Prisoner rushes in. He is too late to save her, but proceeds to knock out Number 8 with one blow. When Number 2 appears Number 8 suddenly gets up, and jabbering 'you ain't gonna hit me no more, Judge' proceeds to run up the stairs and throw himself off the balcony to his death. Leaving Number 2 dumbfounded, the Prisoner departs and the familiar bars come down.

This highly melodramatic coda to the episode is, although apparently

taking place in the 'real' world, perhaps the strangest scene of all. Both deaths are extremely theatrical – Number 8 appears to 'finish off' Number 22 with very little effort and it is highly unlikely that a short fall such as the one from the balcony would really be enough to kill him. The final scene reminds us that, although what we have been observing for most of the episode has been given a (somewhat unlikely) quasi-realistic explanation, it is the world of the Village itself which is the real 'nightmare'. 'Living In Harmony' is a dream within a dream.

In some respects, the episode resembles the earlier 'Chimes Of Big Ben', though its treatment of moral themes is far more challenging. As with 'Chimes', the episode is something of a conundrum for the viewer. Again there are a number of sequences in which important events occur (such as the killing of Cathy) despite the Prisoner not being present. If the whole episode is merely the Prisoner's hallucination (abetted by Village microphones and cardboard cutouts) then such events should not occur. Also, the Judge does not know that Cathy has been killed, and clearly sees this as indicating that the plan has taken a wrong turn. Yet, as the conversation in the Green Dome reveals, it was not only the Prisoner who 'got involved' with the situation. This suggests that the hallucinatory drug was also taken by Numbers 2, 8 and 22, and that it broke down their Village conditioning. The final scene suggests that Number 22 really did feel affection for the Prisoner.

The use of the hallucinogenic 'trip' as a narrative device must be seen in the context of its time – 1967, the 'summer of love' when the 'high priest' of LSD Timothy Leary was preaching his message of 'turn on, tune in, drop out', the hippies held sway in San Francisco's Haight Ashbury and psychedelic youth culture was fast spreading across the Western world. But 'Living In Harmony' again indicates McGoohan's caustic view of drug use. Here, as in previous episodes, drugs are used as a means of psychological control. Yet the series' growing fascination with 'psychedelic revolt' will continue to be a subtext for the rest of the series before 'exploding' in the surreal catharsis of 'Fall Out'.

'The Girl Who Was Death' is the most overtly comic episode of the series. It is something of a 'trip' in itself, a fast-moving, logic-defying, action-packed extravaganza. In many ways it parodies the contemporaneous series *The Avengers*, which by the late 1960s had evolved into a largely comic 'spoof' of the spy genre and which is generally preoccupied with a particularly idealized form of 'Englishness'. Here the lampooning of the 'secret agent' theme is taken to great extremes. Several shots of a children's story book indicate to viewers that the episode is actually a 'children's story' and that it is therefore not to be taken 'literally'. But, of course, how can any episode of *The Prisoner* be taken literally? 'The Girl Who Was Death' cocks a snook at those viewers who still imagine that the series is a 'realistic' spy drama. The plot – in which the Prisoner, in a variety of comic disguises, saves London from Dr Schnipps, a mad scientist (who aims to destroy it with a lighthouse that is really a rocket) after escaping a series of elaborate 'death traps' set by his

daughter Sonia – is deliberately ludicrous. When it is finally revealed that the Village authorities have been listening in on a story that the Prisoner is telling to (hitherto unseen) Village children, hoping he will somehow 'let something slip', we sense that he has been playing a game with them, aware as ever that he is being 'observed'. At the same time, McGoohan is 'teases' viewers by again locating *The Prisoner* outside the setting of the Village. The 'transformation' at the end of the main characters in the story into leading members of the Village hierarchy follows the pattern established in 'Living In Harmony'. After the tragic seriousness of that episode he entertains the viewer with a comic diversion, but one which continues to emphasise *The Prisoner* as an allegorical story which can exist in any setting and any genre.

The episode – in which the usual credit sequence is restored – begins with a shot of a children's storybook being opened. A cricket match on a village green is in progress. The batsman, who with his thick beard, moustache and striped cap looks every inch the traditional English 'gentleman', appears to be having a particularly successful innings. But in the background is a beautiful – and rather sinister-looking – young woman, who we will later come to know as Sonia. When the batsman hits another six into some trees, we see her replacing the cricket ball with an apparently identical one. A drum beat builds up on the soundtrack, and a series of still shots of the batsman are intercut with extreme close-ups of the bowler's exaggeratedly contorted features. As bat meets ball, there is a loud explosion. Superimposed over this we see the newspaper headline: 'Colonel Hawke-Englishe Murdered at Cricket Match ... One short of his Century'.

The man we see reading the paper is the Prisoner, who stands in a London street dressed in the white raincoat and cap of a 'gumshoe' detective. His conversation with Potter, another secret agent, whose cover is as a 'shoeshine boy' (albeit one with a radio transmitter hidden in one of his brushes) reveals that Colonel Hawke-Englishe had been on the trail of a 'crazy scientist' called Dr Schnipps, who plans to destroy London with a 'super rocket'. Meanwhile, the girl who delivered the deadly exploding ball at the cricket match is seen in a shop window, disguised as a mannequin. Potter directs the Prisoner to a record shop, where he listens to a record (which, absurdly, he has a 'conversation' with) that tells him to 'take over where the Colonel left off'.

The next scene follows the same pattern as the first one, with the Prisoner, disguised as Colonel Hawke-Englishe, taking his place as a batsman in a cricket match on the same village green. The earlier scene is repeated in exact detail, but this time the Prisoner catches the ball rather than striking it. He then hurls it into some bushes where it explodes. At the scene of the explosion he finds a message written in red lipstick on a handkerchief: 'Let's Meet Again ... At Your Local Pub'. In the pub, having swiftly downed a pint of beer, he reads a message at the bottom of the glass: 'You have just been poisoned'. With an exaggeratedly English 'stiff-upper-lip' composure he then orders, in quick succession, seven different 'shorts' which he knocks back to

make him sick. In the pub's toilet he finds another message, directing him to the Turkish baths around the corner, where he appears dressed as Sherlock Holmes, in Victorian cape and deerstalker, and narrowly avoids being suffocated to death. On each occasion the mysterious Sonia' is seen to be present.

The next message Sonia leaves leads the Prisoner to a fairground, where, still in cape and deerstalker, he takes part in an old-fashioned bare-knuckled boxing match with the champion 'Killer Kaminski', who directs him to the Tunnel of Love. As he goes through the tunnel, he discovers a tape recorder with a message from his mysterious assailant, telling him that 'The tunnel of love is very fitting. I'm beginning to love you in my own way ... All my life I've been looking for a worthy opponent'. He discards the machine just before it explodes. By now he recognises Sonia and, having spotted her on several fairground rides, attempts to catch up with her on the 'big dipper' before making the disconcerting discovering that he is following the wrong girl.

All the fairground scenes are shot using constantly moving and hand-held cameras, giving an impression of hallucinatory disorientation. We constantly cut back to the raucous, mechanical laughter of a 'laughing sailor'. Yet the next scene, where the Prisoner chases Sonia in his car, is even more bizarre. By waving her finger, Sonia makes the world apparently turn on its side. As the Prisoner tries to cope with this, her voice comes his car radio. She continues to tease him mercilessly: 'I love you madly', she tells him, 'you'll make a beautiful corpse'. He follows her to a deserted Village called Witchwood, where – inside a series of deserted shops labelled 'butcher', 'baker' and 'candlestick maker' – she forces him to encounter a series of 'death traps' whilst continually taunting him over a loud speaker system. He manages to survive an automatic machine-gun post, a floor full of exploding mines and candles which burn cyanide gas. Finally he blasts his way out by lining up the candles against a wall and igniting them. Behind the wheel of a bulldozer, he confronts Sonia, who stands above him on a balcony, firing at him with a machine gun. Finally shouting 'bye bye lover!' she blasts the bulldozer with a bazooka, calmly powders her nose and walks away.

The Prisoner, however, has escaped destruction by hiding under a manhole cover. He follows Sonia to a helicopter, and, in a true display of 'superheroics' he clings onto its frame as it rises upwards. The helicopter lands near a deserted seashore, and before Sonia sees him he scurries away into some bushes. He then follows her through a crack in some rocks by the seashore, which leads him to a network of underground tunnels. Eventually he finds his way to a room in the bottom of the lighthouse where Schnipps' 'dastardly plan' is being enacted. All around the room are computers, whilst the walls are decorated with portraits of Napoleon and Josephine. When a soldier appears, dressed in Napoleonic uniform, the Prisoner quickly knocks him out and takes his clothes. Working at tremendous speed, he begins to sabotage the weapons in Schnipps' armoury. We cut to the lighthouse's control room, where Dr Schnipps (dressed as Napoleon) is inspecting his soldiers, to each of whom he promises a section of the country once they have conquered

it. He is accompanied by his daughter Sonia, now in a long white dress in the style of the Empress Josephine.

As Schnipps, the solemn-faced Kenneth Griffith (who later features in one of the major roles in 'Fall Out') plays up the mad scientist's 'Napoleon complex' with great relish. 'In one hour's time', he declares 'London will lie entirely in ruins!' He explains to Sonia that 'there'll be no more Trafalgar Square … it'll be Napoleon Square … and of course Nelson's column will be Napoleon's column'. The lighthouse is in fact a rocket, which is about to be launched. Schnipps announces grandly that 'the countdown has started' but has to be reminded by Sonia to press the button that starts the process. He notices that one of the soldiers is missing and sends the others in search of him. As they trip over each other in the resultant melee, Schnipps sighs 'it's Waterloo all over again'.

As the soldiers descend, the Prisoner knocks them out one by one. The remaining soldiers chase him down to the jetty at the bottom of the lighthouse, where a motor boat waits to take Schnipps and his 'army' to safety. But when they aim their guns at him they all backfire and the soldiers keel rather comically over. Sonia, however, is at hand and is armed. She captures him and he is tied into a chair in the control room, where she informs him that he is about to be given 'the most original death in history'. She explains that 'when the rocket reaches London, you'll be the first to know … Won't that be exciting?'. 'I'll just go to pieces', he tells her. However, Schnipps delays his departure by hurriedly cramming files into his bag, insisting that he must keep them all 'for history'. This gives the Prisoner time to escape. Immediately he changes all the settings in the control room and smoke begins to pour from the panels. With Schnipps and Sonia still delaying, he leaps into the motorboat. Sonia retaliates by throwing grenades at him, but he has already disabled them. As soon as he has reached a safe distance, the lighthouse blows up.

Again we cut to the storybook, which now shows a whaling scene. We see the Prisoner telling a group of attentive children: 'And that is how I saved London from the mad scientist'. In the Green Dome, the actors who we have seen playing Schnipps and Sonia appear in Village costume as Number 2 and his assistant. They have been observing the whole scene, hoping that the Prisoner might 'drop his guard' with children. Number 2 shakes his head ruefully as he says 'he told them a blessed fairytale'. On the screen, the Prisoner, who is clearly quite aware that he has been watched, turns out the light and whispers pointedly 'Goodnight children … everywhere'.

The Prisoner makes considerable use of nursery rhymes and 'fairy stories' throughout, from the first appearance of the *Pop Goes The Weasel* theme in 'Arrival'. To a great extent, the Villagers are often portrayed as if they have regressed to childhood. This is particularly true of the residents of the Village's 'old people's home' who are frequently seen playing children's games. In this sense the series draws on the strongly allegorical nature of children's literature. Many of the 'impossible' events that occur in the series'

more surreal moments are highly reminiscent of *Alice In Wonderland* and (especially) *Through The Looking Glass*. This helps to position the series in its allegorical mode. As the series comes to its climax, McGoohan takes the 'bardic' role of the traditional storyteller, who jests and plays with his audience, continually surprising them with tales that are more and more fantastic. In 'The Girl Who Was Death' the story is being told to the Village children, the watching Number 2 and his assistant and, of course, the TV audience itself. The irony of the story is thus filtered through several levels. The Prisoner's depiction in the 'fairytale' of authority figures as being ridiculous, sadistic and easily duped is clearly subversive in Village terms. To the TV audience, the episode presents a number of very recognisable generic types – the detective, the mad scientist, the seductive siren, the 'gentleman spy' – and throws them all into a frenzied and wildly cinematic dreamworld.

By sending up all the cliches of generic series television, 'The Girl Who Was Death' clears the way for the last two episodes, in which the narrative conventions of series TV are finally abandoned .The two-part climax to *The Prisoner* is first a theatrical and then a cinematic exploration of universal spiritual and psychological themes. In the course of 'Once Upon A Time' and 'Fall Out' (both written and directed by McGoohan), the Prisoner is first regressed to early childhood, then taken through the stages of his life. He experiences authority in all its forms and fights it in a psychic 'duel to the death', which through strength of character he eventually wins. He is then offered the ultimate temptation – of accepting absolute power over the Village – and ultimate knowledge – the 'revelation' of Number 1. Yet, having seen who Number 1 *really* is, he chooses to resist temptation and escapes. But as the series ends, we are left with an inexorable sense that the whole story will soon repeat itself.

'Once Upon A Time' continues the themes of childhood that were present in 'The Girl Who Was Death', but here the emphasis is clearly on tragedy rather than comedy. The entire episode is structured around Shakespeare's 'Seven Ages Of Man' and is mostly set in the sealed 'Embryo Room', which with its moveable props and minimalist backdrops clearly resembles a modern theatre setting. Much use is also made of nursery rhymes and long, apparently nonsensical pieces of minimalist dialogue. The episode also has a very strong Oedipal theme – with Number 2 playing first the Prisoner's 'father' and later various 'father figures' such as judges and teachers. In order to win the deadly serious psychological game being played, the Prisoner is called upon to 'kill' his 'father'.

The episode features the most intense acting performances of the series as the Prisoner and Number 2 work through a series of 'role plays'. Number 2 is played here by Leo McKern, who had previously featured in 'The Chimes Of Big Ben'. His Number 2 is the most complex of all the Village 'rulers' – he can be a smooth, self-assured operative who appears to embrace the entire fascistic philosophy of the Village, but is also fiercely independent and determined to do things 'his way'. At other times he is jovial in a Falstaffian man-

ner, especially when he employs his trademark deep belly laugh. At the same time the Prisoner's process of regression demands that McGoohan play a range of 'Prisoners' – happy, sad, eager, enraged, revengeful ... The drama concentrates on primal emotions, counterposing the values of 'freedom' and 'control'. Like 'Hammer Into Anvil' , 'Once Upon A Time' is concerned with a battle of wills, but McKern's Number 2 is a far more wily and resourceful opponent than Patrick Cargill's Number 2 in the earlier episode.

Number 2's determination to apply the 'Degree Absolute' procedure in 'Once Upon A Time' reflects the state of desperation that the Village authorities have now reached with 'Number 6'. Having had their attempts to 'break' him consistently defeated in the last few episodes, they are now apparently prepared to go to the most extreme lengths. As in earlier episodes like 'Free For All', 'The Schizoid Man', 'A Change Of Mind' and 'Living In Harmony', the Prisoner is 'programmmed' by Village 'mind-control' machines in preparation for Number 2's psychological 'dissection' of his character and his strength of will. Whether he is still under the influence of this 'programming' in 'Fall Out' is never made entirely clear.

A number of universal themes are examined in the final episodes. The theme of 'justice', which has been prominent in the second half of the series, is represented by 'trial' scenes in both 'Once Upon A Time' and 'Fall Out'. In the Village, trials are invariably mock trials, show trials ... always a means to an end. The Prisoner will clearly not find true justice in any Village courtroom. The theme of 'spiritual death' which was explored in 'Dance Of The Dead' and (to a certain extent) in 'A Change Of Mind', is particularly important in terms of the kind of 'death' that the Prisoner and Number 2 are fighting over in 'Once Upon A Time', where the Prisoner goes though a process of 'rebirth'. In 'Fall Out' Number 2 is apparently 'resurrected' from the dead by Village technology. Most importantly, the final episodes focus on *The Prisoner*'s central theme of the role of the Individual within society. The Prisoner plays the role of an allegorical 'Everyman', a universal 'hero' who must forever enact the rebellion of the Individual against the constraints represented by society, the nation state, the mass media, the education system and the church. In 'Once Upon A Time' Number 2 is the mocking, controlling, taunting voice of paternalistic authority, whose entire mission is to make the Prisoner conform.

The kind of language used in 'Once Upon A Time' reflects the linguistic (as well as psychological) game that its main players enact. Number 2 moves the Prisoner through a series of different discourses, reflecting different lifestages, and attempts to gain his compliance by various linguistic tricks, particularly his attempt to force the Prisoner to pronounce the word 'six' and in the bizarre wordplay around the word 'pop'. Large portions of the script consist of single-word or minimalist dialogues, in which the Prisoner and his 'inquisitor' use words like weapons.

The episode begins with usual credit sequence – used here in full for the last time. We open with a shot of the interior of the Green Dome. On the

screen are giant images of lava lamp bubbles. Number 2's circular chair is occupied by none other than the Village 'guardian' Rover. Number 2 brusquely orders the Butler to remove the immaculately presented breakfast tray, picks up the orange phone and actively harangues Number 1, telling him 'You can remove that thing too. I'm not an inmate. You can say what you like. You brought me back here. I told you the last time, you were using the wrong approach. I do it my way or you find somebody else'. Never before have we heard a Number 2 address Number 1 in this manner. However, his first request is complied with, and the chair containing Rover sinks automatically into the floor. It is already clear that the role of this Number 2 will be different to that of previous incumbents of the post.

Number 2 then presses a button on his control panel and the lava bubbles are replaced by a view of the Prisoner in his house. The Prisoner is also having breakfast, but today he seems particularly agitated. Whilst he eats he paces restlessly around the room. Sensing the Prisoner's eternally rebellious spirit, Number 2 says to himself 'Why do you care?' He then rings the Prisoner and asks him exactly the same question. The Prisoner indicates that he recognises Number 2's voice but with an abrupt 'you'll never know' terminates the call. It is clear that both protagonists in the story are already full of anger and repressed tension.

Number 2 then watches a number of past events from the Prisoner's captivity in the Village being reviewed on the screen, including several scenes from 'Arrival', 'Free For All' and 'Dance Of The Dead', and concluding with the classic and by now iconic 'I will not be pushed, filed, stamped' sequence from 'Arrival'. Such the evidence of the Prisoner's rebelliousness seems to lead Number 2 to an irrevocable decision. He phones Number 1 again and demands approval for what he calls 'Degree Absolute' and tells Number 1 in no uncertain terms that 'you must risk either one of us ... there's no other way', but is not pleased when he is told he has been given just one week to complete his 'experiment'. It is agreed that 'Degree Absolute' will begin the same night.

We cut to the Control Room, where Number 2 – who is in deadly earnest – places the control operatives on 'double night time'. He checks all the Village surveillance systems in preparation for the process, then orders the Supervisor to put the Prisoner in a suitably hypnotised condition. In the Prisoner's house, we see the overhead bedroom lamp descend over his head. Slow, dreamy music plays on the soundtrack, in contrast to the urgent, dramatic theme used during Number 2's preparations earlier. Then we see Number 2 by the Prisoner's bedside, singing nursery rhymes to him, particularly *Humpty Dumpty* and the *Grand Old Duke of York*. *Humpty Dumpty*, who was 'broken' and could not be 'put back together again' is an image of the fate of the typical victim of the Village – another 'hollow man'.

When the Prisoner wakes up he appears to have regressed to early childhood. He leaps out of bed, an infantile smile on his face. Number 2 asks him: 'want to go walkies?' and he nods enthusiastically. In the Green Dome we

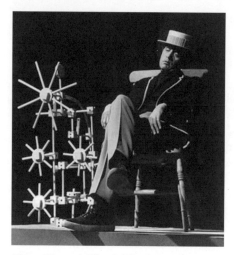

'Once Upon A Time': The Prisoner 'regressed'

see the Prisoner, now eating an ice cream, being brought in by the Butler in a wheel chair. The three then descend into one of the circular holes in the floor and emerge in an underground corridor. At the end of the corridor, heavy steel doors slide open to reveal the 'Embryo Room', the setting for the trial of 'Degree Absolute', in which the Prisoner, Number 2 and the Butler will be locked for a week. The room is decorated by plain black walls. Instead of the usual range of Village technological devices, scattered around the room are what appear to be a number of theatrical 'props', including a blackboard, a desk, a see saw and a rocking horse, all suggesting a children's playroom. As the steel doors close Number 2 reveals that none of them will be able to leave the room for the next week. Summarising the theme of the process that is about to take place, he recites the introduction to the 'Seven Ages of Man' speech from *As You Like It*.[9] He will continue to quote selected lines from the speech as the process develops. Number 2 also devises a 'scientific' formula which he writes on the blackboard: 'A, find missing link ... When I have found it, refine it, tune it and you will play our game. B, put it together, and if I fail ... then C- BANG!' This leaves us in no doubt that Number 2 is risking all in the experiment.

The Prisoner is about to be taken through a regression process in reverse – he begins as an infant and then progresses through various stages of childhood towards maturity. In each one Number 2 assumes the role of a different authority figure, and at each stage the Prisoner's resistance to authority is tested. Firstly, Number 2 declares 'I am your father. Do I ever say anything that makes you want to hate me?' He leads the Prisoner by the hand, telling him he is taking him to a park. Whilst the Butler plays on a swing, still stone-faced, Number 2 and the Prisoner face each other on a see-saw. Number 2 begins to recite 'See-saw, Marjorie Daw, Jackie shall have a new master'. The Prisoner, still in the manner of a small child, repeats the words of the nursery rhyme. Then the first single-word dialogue takes place, building like a word association test as the see-sawing becomes more and more vigorous. Number 2 has begun to try to goad reactions from the Prisoner, who as a 'child' may be vulnerable to suggestion. But as yet he lets nothing slip.

9 William Shakespeare, *As You Like It*, Act II Scene VII, lines 138–142.

As the *Eton Boat Song* plays on the soundtrack, we see a masked Number 2 in black gown and motorboard. He has assumed the role of 'schoolmaster', whilst the Prisoner stands before him, a straw boater in his hand, in the role of a rebellious but honourable child who is refusing to inform on his friends with regard to some unnamed incident. Number 2 tells him that 'society is the place where people exist together ... that is civilisation ... the lone wolf belongs to the wilderness. You must not grow up to be a lone wolf!' He orders the Prisoner to be punished with 'six of the best' and the Butler approaches with a cane. But the Prisoner responds by asking for 'twelve' (which is of course, two times six), implying that he will take even more punishment rather than co-operate. He bends over, and the Butler proceeds to cane him.

We cut to a 'graduation day' ceremony, where the 'schoolmaster' Number 2's speech proudly proclaims the Prisoner's academic achievements. Confronted by the immense stubbornness that has so far refused to allow the Prisoner to conform in any way, Number 2 begins to show signs of desperation. Suddenly he slips out of role and begins to ask directly 'Why did you resign?' The Prisoner, still apparently convinced that he is a schoolboy, appears confused by this. 'Resign from what, sir?' he asks. In another minimalistic exchange of dialogue, Number 2 continues to repeat the question,

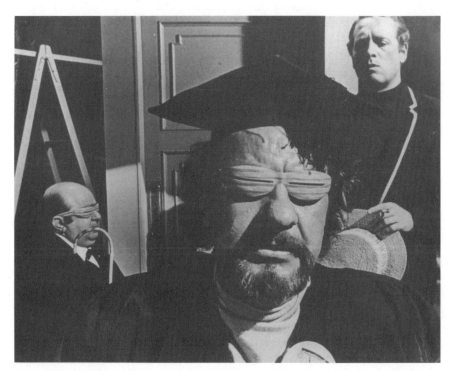

'Once Upon A Time': 'Blind Authority'. The Butler, Number 2 and the Prisoner in the Embryo Room

whilst the Prisoner becomes more and more agitated, repeating the words 'secret … top secret … state secret … confidential'. But Number 2 persists, until finally the Prisoner punches him hard, knocking him over. Silently as ever, the Butler approaches with a cosh and knocks the Prisoner out from behind. As they lay his unconscious body on a table, Number 2 admits 'I'm beginning to like him'.

The exchanges between Number 2 and the Prisoner become increasingly bizarre. As the Prisoner rides back and forth on a rocking horse, his face dazzled by an overhead light, he repeats the numbers one to five at Number 2's prompting, but balks at the number six, continually repeating 'five' instead. This leads into one of the longest stretches of minimal dialogue (quoted in Chapter Three) in which the word 'pop' (a word that in *The Prisoner* stands for 'protect other people', but can also mean 'father' or an explosion, as in Number 2's earlier 'Bang!') features prominently. Number 2 is now becoming increasingly desperate, whilst the Prisoner's replies become more and more self-assured and mocking. Even in his hypnotised, regressed state his basic rebellious nature is in the ascendant.

Shifting the emphasis of their conflict from the merely cerebral, Number 2 then puts the Prisoner through two forms of ritualised physical conflict – first a boxing match, then a fencing match. Of course, the Prisoner's skills in these areas are far superior to his. As they box, Number 2 continues to ask why he resigned. The Prisoner responds with another knockout blow. The fencing match ends with Number 2 pinioned up against a wall, with the Prisoner's blade at his throat. Number 2 urges him to 'kill' and taunts him for not being able to 'step over the threshold' But the Prisoner's sense of humanity has not deserted him and he finds it impossible, even in his current 'altered state', to respond to his adversary's jibes. Again, Number 2 has apparently put his life at risk in an attempt to secure the Prisoner's conformity.

The next 'role-play' places 'bank manager' Number 2 and the Prisoner as interviewer and interviewee. When Number 2 suggests that the Prisoner has 'no respect for tradition' the Prisoner responds with 'I was very good at mathematics'. He is given the job, and before he can walk away, Number 2 calls him back and 'sounds him out' for a 'secret' job, revealing that the bank is a 'cover' for intelligence work. The Prisoner, who is presumably reliving his own experiences as a younger man, seems very pleased to have been selected for 'top-secret, confidential, work'. But his spirits have merely been raised for the particularly strong assault that will follow.

The Prisoner is now summoned before a bewigged 'judge' Number 2, for a supposed traffic offence, and is sentenced (naturally) to six days in jail. 'I was rebelling against the figures, my lord' he protests. Number 2 and the Butler then drag him into an apparently self-contained unit in the corner of the room, which contains a sink and cooking equipment, and down the side of which are full-size metal bars, to which he is handcuffed. Number 2 sparks off another minimalist exchange, demanding that the Prisoner joins

in as they recite alternating even numbers. Again, the Prisoner refuses to acknowledge his number. He begins to become angry, shaking the bars violently as he screams the repeated word 'Five!'.

We cut to Number 2 waking up after taking some rest on the table. The strain of the whole process is clearly taking its toll on him and he looks drawn and exhausted. He walks over to the 'cage', where the Prisoner is still handcuffed, and asks his recurrent question. It is a mark of the Prisoner's growing strength that he actually, for once, answers it:

NUMBER 2:	Why did you resign?
PRISONER:	For peace.
NUMBER 2:	Peace?
PRISONER:	Let me out.
NUMBER 2:	You resigned for peace?
PRISONER:	Sure. Let me out.
NUMBER 2:	You're a fool.
PRISONER:	I resigned for ... (shouts) peace of mind ... Because too many people know too much.
NUMBER 2:	(uncertainly) Never ...
PRISONER:	I know too much.
NUMBER 2:	Tell me..
PRISONER:	I know too much about You!

The Prisoner is beginning to win the psychological battle, and his answer to the question is merely a way of taunting Number 2. Sensing that his opponent is weakening, he wastes no time in turning the tables on him. Grabbing a knife from the kitchen draw, he hands it to Number 2 and tells him to 'kill'. Number 2 has the Butler release him from the cage, and, now under the Prisoner's spell, holds the knifepoint at his throat. The Prisoner drops to the floor and demands 'kill me'. Number 2, now grasping at straws, says 'in the war, you killed'. We cut to the final 'role play', with the Prisoner and Number 2 sitting on a plank which the Prisoner (obviously still under the influence of the Village's mind conditioning) presumably believes is an aeroplane. They are forced to bale out, and the Prisoner is interrogated by Number 2 in the guise of a Nazi officer. This scene begins as a parody of British war movies, and provides one of the episode's few comic moments – Number 2 assumes a cod German accent whilst the Prisoner plays the role of the British 'stiff-upper-lip' P.O.W. to the hilt. But suddenly the Prisoner's mood abruptly changes, as if the effects of the mind conditioning are finally wearing off, and he laughs defiantly at Number 2. Desperately, Number 2 asks again 'why did you resign?' With supreme irony, the Prisoner replies 'Six', giving Number 2 the answer he wanted earlier, but to the wrong question.

The Prisoner is now in control. As the exhausted Number 2 lies on the table, it is the Prisoner who questions him:

PRISONER: You chose this method because you knew the only way to beat me was to gain my respect?
NUMBER 2: That is correct.
PRISONER: This is a recognised method?
NUMBER 2: Used in psychoanalysis. The patient must come to trust his doctor totally.
PRISONER: Sometimes they change places ...

This is doubly ironic because the Prisoner is now acting out the role of 'psychiatrist' to Number 2's 'patient', and it is the Prisoner who has won Number 2's respect, rather than the other way round. Certainly, it is the Prisoner who has assumed the position of the authority figure. Now it is he who introduces the last scene of the drama by quoting the final lines of the 'Seven Ages of Man' speech: 'last scene of all that ends this strange eventful history is second childishness, and mere oblivion'. Number 2, in a strangely elated mood, suddenly becomes the 'jovial host' and shows the Prisoner around the Embryo Room, declaring that 'in it you can relive from the cradle to the grave ... seven ages of man ... William Shakespeare'. He notices that the clock above the sealed metal doors has only five minutes to run. The week of 'Degree Absolute' is almost over. Stepping inside the cage, he explains that it is completely self contained, suggesting that it is some kind of vehicle. Then the Prisoner slams the metal doors shut, locks Number 2 in and hands the keys to the Butler, who bows ceremoniously. From now on, he will serve the Prisoner. Number 2 pleads with the Prisoner to open the door, as the time on the clock ticks away. The Prisoner releases him, and taunts him by reciting *Humpty Dumpty* – which by now aptly describes the rotund but 'hollow' figure of Number 2, who is about to 'have a great fall'. Number 2 goes into a frenzy, and begs at the Prisoner's feet, hopelessly repeating ... why, why, why resign ... This builds into the final exchange of minimalist dialogue, as the Prisoner conducts a 'countdown':

PRISONER: Nine ...
NUMBER 2: ... too late ...
PRISONER: Eight ...
NUMBER 2: Seven ...
PRISONER: Six ...
NUMBER 2: Six ...

A strange disembodied voice, whose origin is not made clear (but which some viewers are bound to assume is the voice of Number 1) suddenly shouts 'Die, Six, Die ... Die! ... Die!' and Number 2 falls to the ground. As the realisation dawns on the Prisoner that his adversary is dead, his triumphant expression turns into one of horror. The heavy steel doors open and the Supervisor appears. 'Congratulations', he says coldly, 'we shall need the body for evidence'. Angrily, the Prisoner smashes a glass down onto the

floor. 'What do you desire?', the Supervisor, now apparently also at his service, asks. The Prisoner declares 'Number 1'. The Supervisor replies simply 'I'll take you'. They exit the room. In a final, almost whimsical, shot the camera pans around the Embryo Room as *Twinkle, Twinkle, Little Star* plays on the soundtrack. Then the symbolic bars come down.

The ending of 'Once Upon A Time' is certainly a teaser for the final episode. The audience has been led to believe that, following the Prisoner's victory in the 'duel to the death' of 'Degree Absolute', the Village has decided to 'concede defeat' to him, and that the identity of Number 1 will finally be revealed. But the Prisoner's grim expression at the end of 'Once Upon A Time' suggests that he is under no illusions. How Number 2 is killed is not revealed, but the shock seems to have jolted the Prisoner back into his usual angry persona. Certainly his inner strength has allowed him to win the psychological duel, but he takes no pleasure in Number 2's death. Despite his apparent triumph, the entire battle he has just taken part in has been set up and defined purely by the Village. His victory is a hollow one, and its prize – to be lauded and approved of by the Village – is of very dubious value.

'Once Upon A Time' is a complex moral allegory, in which the Prisoner and Number 2 represent the voices of 'individuality' and 'society' in conflict with each other. The audience naturally identifies with the Prisoner, but Number 2 reveals himself as a fallible, and perhaps pitiable, figure. The relish with which the Prisoner crushes Number 2 is palpable, but in some ways this may reduce our sympathy for him. The Prisoner may have 'won' the conflict, but the question remains as to what price he may have to pay for doing so. In pursuing his revenge with such enthusiasm, perhaps he has lost something of his humanity – to be pleased about winning a battle by the Village rules may indicate that to some extent he has 'sold his soul', or has been taken in by premises which he supposedly does not recognise. This may be a subtle way of indicating the means by which modern society tends to suppress the individual creative spirit – it is society which has control of the situations in which that individuality can be expressed, and which defines the terms whereby conflicts may be worked out. On a deeper level still, Number 2 and the Prisoner may be seen to represent two eternally conflicting forces within any individual – the pressure to conform and the pressure to rebel. Both forces are, of course, ultimately under the control of a more fundamental, controlling one – here represented by the apparently absent but presumably 'all-seeing' Number 1.

Whereas 'Once Upon A Time' departs from the usual conventions of a TV series by its overt theatricality, 'Fall Out' is an extremely cinematic spectacle. In its setting it makes a deliberate (but ultimately misleading) reference to the endings of James Bond films (see Chapter 1) but the films it most resembles are those of European 'art film' directors such as Fellini, Godard and Bunuel, where the narrative proceeds through a bizarre internal logic with strong elements of surrealism. As with the work of such directors, in 'Fall Out' it is very hard to tell whether what we are seeing is real or a

fantasy in the minds of the characters. This level of ambiguity between subjective and objective realities has been a feature of the series since the first episode, particularly in the McGoohan-directed episodes such as 'Free For All', 'Many Happy Returns' and A Change of Mind. Such ambiguity appears to be deliberate, but is of course most unusual in a popular TV series.

The visual imagery of the episode has a cinematic breadth and scope. Though we see little of Portmeirion (both the final episodes use only stock footage), the setting of the vast cave in which most of the episode takes place creates a background that is constantly full of movement and colour. The image of the massed ranks of white-robed and masked Village delegates reacting in unison is particularly surreal, like an assembly of ghosts. The huge white rocket bearing the inscription '1', under which is a mechanical blinking 'eye' is a potent, threatening presence throughout most of the episode. Number 48's 'musical number' Dry Bones, with which the entire company (excepting the Prisoner and the Butler) joins in, is a bizarre parody of the Hollywood musical. The Prisoner's meeting with Number 1 is a highly expressionistically-edited scene, in which the series' key visual images are featured in a fluid and subjective montage. The final sequence of images on the road and in London suddenly transposes the familiar 'Village' characters into immediately reognisable settings, so visually juxtaposing the 'real world' with the world of the Village, and suggesting that they are in fact one and the same.

As we have seen, the use of music is important throughout the series, and selected themes are often used to provide counterpoints for the action on screen. This is often done through the ironic use of nursery rhymes. In 'Fall Out', two songs in particular are highlighted – The Beatles' All You Need Is Love (1967) and the traditional Negro spiritual Dry Bones. All You Need Is Love had been initially broadcast in a 1967 BBC programme Our World which featured the first global satellite linkup, and featured The Beatles accompanied by a chorus of sundry other kaftanned rock stars bedecked in flowers. It is the first of John Lennon's 'global anthems'[10] and epitomises the spirit of the '67 'summer of love', its lyrics summarising the hope and promise that the emerging 'counterculture' offered to the world. It is also a hymn to what in those days was referred to rather mystically as 'the revolution', which it made explicit by including snatches from the French revolutionary anthem La Marseillaise in its introduction. As we have seen, The Prisoner postulates the Village as a global paradigm, and in 'Fall Out', All You Need Is Love is ironically counterposed against the series' most extreme (though heavily stylized) scenes of violence, which represent the act of revolution itself. To The Prisoner's initial audience, All You Need Is Love (the only well known piece of rock music used in the series) was a very

10 Other Lennon 'global anthems' included Revolution (1968), Across The Universe (1968), Give Peace A Chance (1969), Instant Karma (1970) and Happy Xmas/War Is Over (1972).

contemporary song. And as 'Fall Out' was first broadcast, the near-revolution in Paris of May 1968 was only weeks away. The choice of the song seems to be a deliberate ploy to give *The Prisoner* contemporary allegorical resonance.

On the other hand, the song *Dry Bones*, which Number 48 performs for the assembled Village delegates, is used to mock the Village establishment (and thus, the establishment). It may appear to many viewers that the young 'hippie' is merely responding to his interrogation with scatalogical nonsense, but in fact the song is carefully chosen. Just as in 'Once Upon A Time' the nursery rhyme *Humpty Dumpty* epitomises the inner 'hollowness' of the Village 'soul' in Number 2, so *Dry Bones* portrays what the Village – and thus modern society – does to its citizens. The song is based upon the Biblical vision of the prophet Ezekiel and the 'plain of dry bones' (see note 1). In the vision God appears to Ezekiel and transports him to such a place, where he instructs him to preach 'the word of the Lord' to the bones, in order to bring them to life. Ezekiel complies, and the bones come to life. The image of a whole 'nation' of skeletons – human beings without souls – is an apt one for Village society, with its forced gaiety, its brainwashed population, its techniques of chemical and medical intervention, its rooting out, isolation and destruction of any real humanity. Yet it is also significant that Number 48 continues to sing the song even after the four conspirators have escaped into the 'real world'.

The other notable musical theme in 'Fall Out' is the slow, dreamy piece of instrumental music referred to here as the 'final theme', which we hear prior to Number 2's resuscitation, just before the Prisoner meets Number 1 and later over the final scenes in London. This theme is as distinctive in its own way as the music used over the credit sequence, but conveys a far more world-weary tone, which helps to create the mood of cyclic 'inevitability' that dominates the closing shots. It is important to remember that there are two main meanings of 'revolution': firstly, a political overthrow of those in power, and secondly, the continuous turning of a cycle. The use of the 'final theme' prepares us, with its reassuring tone, for the series' final revelation – or its final 'revolution' ... that occurs in the last shot of all.

Though lacking the intense theatricality of 'Once Upon A Time', 'Fall Out' is a particularly strong episode in terms of characterization. Leo McKern returns again to play a 'reborn' Number 2, who has now shifted from authority figure to rebel. Alexis Kanner (who featured so strongly in 'Living In Harmony') gives another electrifying performance as the young 'hippie' Number 48, and Kenneth Griffith (Schnipps/Number 2 in The Girl Who was Death) plays an important role as 'the President'. The ever-present Angelo Muscat, as the Butler, is now the Prisoner's faithful servant. The allegorical significance of the Prisoner, Number 2 and Number 48 is clearly spelt out in the President's speech to the Village 'assembly'- they are identified as being symbolic of three types of rebellion. Whilst Number 48 represents the 'uncoordinated' rebellion of youth, Number 2 represents the rebellion of a

member of the establishment. The Prisoner is positioned between the two as an 'ideal rebel' who has never compromised his position. It is significant, however, that the three types of rebellion finally have to join forces to triumph over the forces of an oppressive social order (represented, of course, by the Village).

The dialogue in the episode is equally as bizarre as its visual presentation. Again there are a number of minimalist exchanges, particularly involving Number 48, who uses hip 'jive talk'. The speech by the Village's President (who is called this in the programme credits but wears the wig and apparel of a judge) is a polished parody of the tone of a politician, or perhaps a TV presenter. Number 2's dialogue is almost entirely jovial, as the authoritarian side of his personality seems to have been 'killed off' in 'Once Upon A Time'. The Prisoner himself actually has very little meaningful dialogue in the episode, and for a large part of it acts merely as an observer. When he attempts to make a speech he is shouted down. And once he meets Number 1, all dialogue ceases and the story is completed in a purely visual mode.

In 'Fall Out' the Prisoner, having won the battle of 'Degree Absolute' is now treated with great respect (at least on the surface) by the Village authorities. His request to meet Number 1 will be acceded to, but only after he has observed another one of the Village's bizarre 'trial' sequences, in which the very idea of rebellion itself seems to be 'in the dock'. Whether this (very surprising) change of attitude by the Village authorities is 'for real' or merely another trick is never made explicit. Yet the scenes in which Number 1 is revealed and in which the escape itself are made certainly defy any naturalistic logic, so trying to explain the episode in naturalistic terms is ultimately fruitless. McGoohan is quite explicit here in demonstrating that the only really consistent interpretation of the series must be an allegorical one.

The opening shots of 'Fall Out' consist of a montage summarising the plot of 'Once Upon A Time', making it clear that the two episodes are directly connected. The usual credit sequence is replaced by a series of aerial views of the Village, over which the credits reveal that the series was 'filmed in the grounds of the Hotel Portmeirion' a fact which up till this point had been a carefully kept secret. Thus we are promised that this, as the final episode, will be the one to give us 'all the answers'. We cut to a subterranean corridor in the Village, along which the Supervisor escorts the Prisoner (accompanied by the Butler), in a direct continuation of the final scene of the previous episode. They stop at some kind of cloakroom, which contains a mannequin of the Prisoner, dressed in his original dark suit. A disembodied voice announces the whole theme of the episode with the ironic 'We thought you'd feel happier as yourself'. As the Prisoner reaches out to touch 'himself', *All You Need Is Love* suddenly starts up on the soundtrack. We cut to a shot of the three men walking along a corridor carved out of rock, which is lined, bizarrely, with jukeboxes. At the end of the corridor is a heavy wooden door, on which is inscribed 'Well Come'. As the Butler turns the key and they step into a huge cavern, the song fades.

The cavern is full of activity. Groups of Village soldiers march around in lines. 'Doctors' in green coats are engaged in some kind of experiment with futuristic-looking equipment. The 'see-saw' structure from the Control Room, with Village operatives on each end, revolves in one corner. In the centre of it all is a raised podium, on top of which is an ornately carved wooden 'throne'. Behind long desks that resemble those at the United Nations, the Village 'delegates' sit in long white hooded robes rather like those of the Ku Klux Klan, and theatrical black/white face masks. The cards in front of them identify them in a range of symbolic functions 'Welfare, Activists, Pacifists, Defectors, Therapy, Reactionists, Nationalists'. In one corner is the giant rocket-like structure with the winking metal eye bearing the number '1'. Bowing before the President, who stands behind a raised lectern directly across from the podium, the Supervisor then dons a robe and mask and joins the 'faceless ones'. Never before has the 'soullessness' of the members of the Village been so obviously suggested.

The President, who is capable of silencing the entire throng with one bang of his gavel, bids the Prisoner 'Welcome'. In a highly theatrical tone he announces that: 'This session has been called in a matter of democratic crisis … we are gathered here today to resolve the question of revolt … Pointing out the Prisoner to the crowd, he says … I understand he survived the ultimate test. Then he must no longer be referred to as Number 6 or a number of any kind. He has gloriously vindicated the right of the individual to be individual and this assembly rises to you, sir'. To the applause of the delegates, and with a faint, enigmatic, smile the Prisoner ascends the steps of the podium and takes his seat on the 'throne'. The President then announces that the preliminaries for the 'transfer of ultimate power' are about to take place. The notion that the Village would really concede power to the Prisoner may seem hardly believable. Yet from the beginning the Village's aim has been to get the Prisoner on their side. Now, it seems, they are about to offer him their ultimate temptation.

It is important, however, to remember that 'Fall Out' is a direct continuation of 'Once Upon A Time', and that the Prisoner has just spent a week in intense psychological trauma. He is therefore, perhaps, highly open to suggestion … Throughout the 'preliminaries' he remains impassive, a mere observer, reacting to the proceedings only with wry amusement. Such a detached role is highly unusual for him. But as to how much his mind is under the Village influence it is impossible to tell.

The next scene depicts the beginning of Number 2's 'resurrection'. A set of heavy metal doors opens to reveal the moveable cage from 'Once Upon A Time', inside which is Number 2's body. As the body is wheeled across towards the waiting 'doctors', images of Number 2 from the last episode are flashed up on a large viewscreen, whilst we hear for the first time the serene and dreamy 'final theme'. We see steam pouring from the rocket, and its metallic 'eye' begins to flash. The President, as if he has received some wordless communication from Number 1, then gives the order to 'resuscitate!' The doctors place

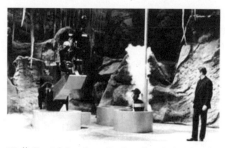

'Fall Out': Number 48 rises from the depths

Number 2's body on what appears to be an operating table. A long automatic 'arm' comes out and covers his face with a thick layer of shaving foam. Then a green metallic hood descends over his head.

The President now begins the 'trial'. 'Revolt', he declares, 'can take many forms ... Here we have three specific instances'. The first example of 'revolt' then appears – Number 48, a young man in an open white frilly shirt and a black braided jacket, with a bell on a string around his neck and a flower in his black top hat. He is held by metal arms against a long pole which ascends up through the floor, steam rising around it. His first words are 'thanks for the trip, dad'. The President replies sternly 'be grateful for the chance of pleading your case before the assembly'. The young man responds by bursting into *Dry Bones*, which sends the delegates into apoplexy. They begin banging their fists on the desks in front of them and gesticulating wildly at each other. The President repeatedly bangs his gavel and calls for order. But when a green light begins flashing in the rocket's eye he gives the order for Number 48's release.

Number 48 immediately runs around the room, pushing buttons at random, with the watching delegates still in uproar. Finally he is tackled by a couple of Village soldiers in front of the podium on which the Prisoner sits. He looks up at the Prisoner and says 'give it to me, dad'. Still giving nothing away, The Prisoner replies sympathetically 'don't knock yourself out'. The President intervenes and tells the Prisoner 'we're obliged, sir'. Now apparently taking the side of the young rebel, the Prisoner replies 'don't mention it, dad'.

The President's 'interrogation' of Number 48, which follows, consists of more minimalist exchanges, this time infused with Number 48's 'hip talk' and snatches of *Dry Bones*. The first exchange, which gets faster and faster, culminates in them shouting 'Take!' at each other. The entire crowd of delegates then joins in, chanting 'Take, Take, Take'. Number 48 kneels with arms outstretched, in a 'crucifixion' pose, before the President silences the throng with his gavel. The President addresses Number 48:

PRESIDENT: Now you're high.
NUMBER 48: I'm low ...
PRESIDENT: Give it to me baby! Confess!
NUMBER 48: Oh dad, I'm your baby ... dad ... you owe your baby
 something daddy ...
PRESIDENT: Confess!
NUMBER 48: The bones is yours, dad! They came from you, my daddy
 ...

PRESIDENT: Confess! Now you're hip ...
NUMBER 48: Hip, dad, hip ...
PRESIDENT: Confess!
NUMBER 48: ... and a hip bone ...
PRESIDENT: Confess!
NUMBER 48: ... and a thigh bone ...
PRESIDENT: Confess!
NUMBER 48: ... shin bone, knee bone ...

In an extraordinary scene of mayhem, Number 48 then runs around the room, still singing 'dem bones, dem bones gonna walk around'. The delegates now rise and begin to sway from side to side as they clap along, as what is obviously a recording of the song is played on the soundtrack. Even the President joins in, finally crying 'hip, hip'. The delegates reply in unison 'hooray!' and the song ends. The President, despite having joined in with the 'fun', declares Number 48 'guilty'. A delegate whose card identifies him highly ironically as 'Anarchist' reads the charge. Number 48's 'crimes' against the Village are then outlined: 'total defiance of the elementary laws which sustain our community, questioning the decisions of those who voted to govern us, unhealthy aspects of speech and dress not in accordance with general practice, and the refusal to observe, wear or respond to his number ...'. Number 48 responds by tinkling his bell and laughing. In a deferential tone, still addressing the Prisoner as 'sir', the President then asks for the Prisoner's approval of the proceedings. The Prisoner, still wearing only a faint smile, merely says that he has 'noted them'. Number 48 is then strapped back into his metal harness and descends back into the floor, still singing *Dry Bones*.

We are then presented with the next example of 'revolt' – Number 2, now beardless and apparently restored to full health, gets up from the 'operating table', declaring 'I feel like a new man'. He greets the Prisoner and the Butler fondly, and then addresses the delegates, explaining to them that he was once in a powerful position in the world of politics before being abducted by the Village. We are left in no doubt, however, that this particular 'new' Number 2 has joined the side of the rebels. 'What is deplorable', he says, 'is that I resisted for such a short time'. Again we see the final images leading to his 'death' in 'Once Upon A Time' on the viewscreen. The Prisoner, who has one clear goal in mind now, then asks him if had ever met Number 1. At this Number 2 bellows with laughter, for reasons that will only become apparent when the actual confrontation takes place.

Number 2 then approaches the rocket, at first a little hesitantly. His face is lit by the green light that emanates from the rocket's 'eye'. Then his resolve is steeled. He talks directly to the eye: 'Look me in the eye ... whoever you are ... whatever you are'. Throwing off his 'Number 2' badge he declares 'you'll hypnotise me no longer'. He then commits the ultimate 'sacrilege' by spitting into the eye itself. He is dragged away by guards and strapped onto

another one of the long poles that will consign him to the same 'cell' as Number 48. As he descends into the floor he delivers a final, mocking 'Be Seeing You'.

The President then begins his 'summing up', explaining the Village's attitude to the revolt of both 'uncoordinated youth' and 'the establishment': *'These attitudes are dangerous, they contribute nothing to our culture and they must be stamped out'*. He then extols the virtues of the Prisoner's form of revolt as being far superior, and calls him *'a man magnificently equipped to lead us ... lead us, or go'*. It seems that the Village has completely conceded defeat to the Prisoner. As we see shots of a *'FOR SALE'* sign being taken down in front of his familiar London flat and a man polishing his car, the President explains that his home is being prepared for him and that they are prepared to present him with the key to his house, his passport and a million pounds in travellers' cheques.

The Prisoner's attitude to this offer is, naturally, very guarded. Whilst the President continues to insist that the offer is completely bona fide, the Prisoner counters every one of the President's justifications with the repeated question 'Why?'. The President insists that he has 'convinced us of our mistakes' and that '... you are pure. You know the way. Show us ... Your revolt is good and honest ... You see all'. In this, the moment of his ultimate temptation, the Village appears to be granting him 'divine' status. The President pleads for him to lead them, and asks him to take the stand and address the delegates. For a moment the Prisoner appears to waver. But then he rises, descends the steps, pockets the keys, cheque book and passport.

His address to the delegates recalls earlier and equally futile speeches made in episodes such as ... 'Free For All' ... He begins the speech with the word 'I', which all the delegates instantly chant back at him. As he attempts to continue his speech it is entirely drowned out by the crowd chanting 'I, I, I' and his mood of calm detachment suddenly turns to anger, as if he has finally realised that the entire set-up may be merely been another example of Village mind-manipulation. It is certainly hard to believe that the Village authorities, with their relentlessly controlling mentality, are really planning to allow the Prisoner to leave. The suggestion seems to be that the 'Degree Absolute' process is some kind of 'sacred' Village ritual in which they are prepared to concede defeat to the victor, and that their reverence for his 'pure revolt' is such that they are prepared to release him. The idea that the Village's ideology is constructed around a set of some kind of 'religious' beliefs may seem hardly credible at first, but we have previously seen the 'worship' of Rover (in 'Free For All') and Number 1 (who on one level is an obvious personification of 'God') is certainly treated by the Villagers with what can only be called a 'religious' sense of awe and fear. Now the Prisoner is about to be given his 'revelation' – his meeting with Number 1.

The Prisoner descends by the same route as Number 48 and Number 2. He finds himself in a long, narrow tunnel, along which are stationed Village soldiers, which leads to the bottom section of the rocket. This is a circular

room in which technicians in white robes are busy at work. It also contains two transparent tubes, marked 'Orbit 2' and 'Orbit 48' in which the two convicted rebels are held. Number 48 is still singing *Dry Bones*, whilst Number 2 continues his distinctive belly laughs. the Butler appears, bows to him, and points to a metal spiral staircase that ascends up into the rocket. The Prisoner climbs the stairs and enters another circular room, in which we see a table covered in various globes of different shapes and sizes. In front of a screen, with his back to the Prisoner, is a figure in a long white robe. On a table sits the orange phone.

This is the moment of truth. From the point at the end of 'Once Upon A Time' when the Prisoner's wish to meet Number 1 was granted, everything has built up what is inevitably the key scene of the entire series, in which the identity of the ruler of the Village (and, thus, if we 'read' the series allegorically, the modern world itself) is finally revealed. The revelation itself confounded many viewers, yet it confirms that for the series to make any logical sense, it *must* be 'read' allegorically. Yet the face of 'Number 1' is only shown to us for fleeting seconds and the scene demands the viewer's entire concentration if the all-important images are not to be missed.

As the Prisoner approaches the white-robed figure, he sees an image on the screen of himself, approaching the same figure, as if the screen is a mirror. Then the screen shows us the famous declaration from 'Arrival', 'I will note be pushed, filed, indexed, stamped, briefed, debriefed or numbered ... My life is my own'. Number 1 turns towards around, his face covered by one of the Village's black and white masks. He holds out a crystal ball into which the Prisoner looks. As the scene progresses the cutting gets faster and faster. In the crystal ball the Prisoner sees the final image of each episode – the bars slamming over his face. As the image is repeated several times in quick succession we hear a voice – McGoohan's voice – repeating 'I, I, I, I, I'. This continues as we see the masked figure, holding up his arms in another 'crucifixion' pose, revealing the large number '1' on his robe. The Prisoner reaches forward and rips off the black and white mask. Underneath it is yet another mask, a rubber 'monkey face'. Angrily, he rips off the monkey mask, and for a couple of seconds only he sees the face of Number 1. The face is twisted into demented laughter. It is his own face.

We cut back to the Prisoner, who gives a strange smile. He chases Number 1, who escapes through a hatch at the top of the room. We see another two-second flash of his evil, grinning face and then the Prisoner locks the hatch. The final secret of the series has apparently been revealed. Number 1 is not some 'criminal mastermind' or 'mad scientist'. He is the evil side of the Prisoner himself – and at the moment of revelation, the letter 'I' and the number '1' are united. This of course puts an entirely new 'spin' on the series and its meaning. It may be tempting to re-examine all the events of the series from this new perspective. Certainly it explains Number 2's laughter when the Prisoner asks if he has actually met Number 1, and the delegates chanting 'I, I, I' not to mention the deferential attitude that the Village

authorities suddenly adopt towards the Prisoner in 'Fall Out'. If, however, we proceed to reinterpret all the events of the previous episodes from this standpoint, we are moving into extremely problematical territory. It is true that the constantly stressed need not to 'damage the tissue' may fit in well with the idea that the Prisoner himself has somehow been 'in charge' of everything that has happened. The fact that we have never seen or heard Number 1 directly before this episode may also support a 'rationalistic' explanation: perhaps the Prisoner has been in charge all along and has merely 'planted' himself in the Village to test its capabilities (in which cause Number 2's paranoia in 'Hammer Into Anvil' was entirely justified). It could even be argued that the idea of the Prisoner as a 'literal' Number 1 explains why the Village was mysteriously deserted in 'Many Happy Returns' or why the Prisoner was unanimously elected leader of the Village in 'Fall Out'.

But, ultimately, attempting to pursue this line of logic, while it may usefully lead the viewer to question the apparent meaning of every episode, must surely be considered futile. From the beginning of the series, as we have seen, The Prisoner has presented us with a series of symbolic scenarios in the areas of politics, education, psychiatry, science, law and ethics. The notion of the 'whole earth as the Village' has been suggested throughout. The elements of political and social satire that dominate the early part of the series, the psychological themes that emerge strongly in its 'middle phase', and the search for ultimate 'spiritual' meaning with which the series climaxes all place The Prisoner in a clearly allegorical mode. To read the series as a completely consistent and developing 'story' is also surely to misread it (and to reduce its ambiguous, challenging qualities). The series is, despite McGoohan's clear authorial domination, partly the product of a number of writers, directors and other creative contributors. It would be hard to argue that the writers of episodes such as 'The General', 'The Schizoid Man' or 'Do Not Forsake Me, Oh My Darling' are aware of the idea of 'the Prisoner as Number 1'. Indeed, all accounts of the series' production agree that even McGoohan himself did not know Number 1 would turn out to be until he had actually written the final script, which he did at virtually the last possible moment. Thus, in what was referred to in Chapter Two as the 'parallel text' of the making of The Prisoner, Number 1's identity remained a mystery to the entire production crew – including McGoohan himself – until the making of the final episode.

In order to 'decode' The Prisoner in the most fruitful way, it is most useful to see it as carrying meaning on a number of different levels. On a political level, it is an allegory of the Individual versus Society with the Village as an extreme representation of the tendencies of the modern world towards social control. On this level, the revelation of the Prisoner as Number 1 represents the idea that society is finally controlled by Individuals and that therefore those Individuals can take control rather than be controlled. In this sense The Prisoner is ultimately more hopeful and positive than the similar distopian fantasies of Huxley in Brave New World or Orwell in 1984. On a

psychological level, the revelation of the 'identity' of Number 1 focuses the whole series' concentration on the theme of 'identity' and of the struggles of individuals to truly come to 'know themselves' in a world full of conflicting images. The revelation may also suggest that any individual constructs his or her own psychological reality, and that the Village is a mental prison of his own making. On a spiritual level, the revelation of Number 1 (and, some would argue, the entire series) may be seen as a 'vision' of the 'duality of man' – with the Prisoner and Number 1 representing the good and evil sides of human nature. Certainly, as with all great mythical stories, it is suggested that real change will only occur if the Hero looks *within* ...

However, the Prisoner's encounter does not close the episode, and the events which now unfold take us from the 'revelation' to a 'revolution' to a final return to the 'genesis' of the whole series. As Number 1 escapes through the hatch, smoke begins to rise around the rocket. Momentarily, we cut back to the cavern, where the 'eye' of the rocket closes. The President looks worried. Back inside the rocket, the Prisoner descends down the staircase. With the aid of the Butler and a fire extinguisher, he manages to disable all the technicians and the soldiers in the corridor. He then rushes up to the rocket's control room and with a look of grim pleasure resets the controls for the rocket to take off. On the viewscreen he sees the President vainly trying to establish control as the white-robed delegates rush around madly in complete panic.

The Prisoner and the freed Number 2 and Number 48 now rise up through the floor of the cavern in white robes and masks, carrying machine guns. They cast aside the masks and begin firing indiscriminately into the crowd. It is a potent image of violent 'revolution'. In a highly ironic piece of juxtapositioning, as the carnage ensues *All You Need Is Love* is faded up on the soundtrack. The Village personnel, led by the President, retreat into a long corridor. In a fast montage of shots we see Villagers frantically running through the streets of the Village as the tannoys announce: 'Evacuate! Evacuate!'. Several helicopters are seen taking off. Back in the cavern, more and more smoke pours out of the rocket. The Prisoner, Number 48 and Number 2 install themselves in the moveable cage from 'Once Upon A Time', which we now see is attached to a lorry, with the Butler at the wheel. They drive into a long, dark tunnel, at the far end of which are metal gates.

Shots of the approach to the gates are intercut with more scenes in the Village. We see the Villagers running away in all directions, on foot and in mini-mokes, and more helicopters rising behind the Green Dome. Then the lorry bursts through the gates and out of the Village. At that same moment, the rocket ignites. We see a shot of its ignition process, presumably taken from genuine NASA stock footage, followed by an impressive special effects shot depicting the rocket rising from its underground location in the Village. We cut to Rover, who rises from the water only to shrivel up and disappear, making its final bow to a comic tune: 'I, I ,I, I, I, I, like you very much'. As the song continues on the soundtrack, we see the final aerial views of the Village.

The lorry containing the Butler and the three rebels is seen driving along a country lane, and then emerging onto a dual carriageway. In another one of *The Prisoner*'s 'magical transformations', it is clear that we are in England. We see the Prisoner, Number 48 and Number 2 gleefully throwing equipment out of the door of the cage. We cut to the interior of a car, driven by a respectable-looking representative of 'the establishment' in bowler and pinstripes, which is overtaking the lorry. The 'city gent' looks astonished as the *Dry Bones* song booms out over his car radio and he sees the three escapees dancing wildly to the tune inside the cage. The lorry then stops and drops Number 48 off. He stands by a sign which reads 'London 27 miles' and begins hitch-hiking.

As the 'final theme' plays on the soundtrack we cut to a shot of Trafalgar Square, and we follow the progress of the lorry until it is stopped on the Embankment by a policeman. Number 2 looks up at Big Ben, then crosses the road to the Houses Of Parliament, from where he waves farewell. We see the Prisoner at a distance, apparently explaining something to the policemen. From the way he touches his elbows and knees he appears to be miming the story of *Dry Bones*. As he does so we hear another brief snatch of the song itself, before the 'final theme' fades in again. We then see the Prisoner, hand in hand with the Butler, running for a bus on Westminster bridge. We cut back briefly to the dual carriageway where Number 48, apparently unconcerned about which direction he is travelling in, crosses the road and begins hitching in the opposite direction. The first credit reads: ... *Alexis Kanner* ...

As the final theme reaches its climax, the Prisoner and the Butler approach his London flat, outside which sits his car. But now the mood of gleeful liberation shifts. As the Prisoner gets into the car, an ominous-looking black hearse drives by. The Butler walks up the steps to the Prisoner's flat and the second credit reads ... *Angelo Muscat* ... The door to the flat, which quite clearly is number '1', opens automatically in front of him in the manner of doors in the Village, and he steps in. This is the first suggestion that the 'escape' may not be all that it seems.

Just as the opening credit sequence of 'Arrival' tells the beginning of the story in purely visual terms, so the final credit sequence ends the series in a similar way. We see an overhead shot of the Prisoner driving his car through Westminster, which looks disturbingly similar to a shot from the original credit sequence. The next credit, not for 'Patrick McGoohan', but merely, in lower-case Albertus script, ... *prisoner* ... appears on the screen. We then get a final glimpse of Number 2, now dressed in pinstripes and bowler, entering the Houses of Parliament. As the final credit reads ... *Leo McKern* ... there is a very familiar crack of thunder – very familiar because it is the first sound we ever hear in the series. The final two shots are the same as the first two shots of the series – the Prisoner driving towards us along an open road, followed by a close-up of his face. Then, for the last time, despite the Prisoner's supposed 'escape', the bars come down.

'Fall Out' can only be described as an extraordinary piece of television,

which crams into its fifty-minute span a bewildering multiplicity of bizarre images. It is virtually without precedent in its medium, not only for its highly cinematic intensity but for its sustained use of symbolism in character, costume, plot and setting. Whilst making use of many of the dramatic conventions of 'action adventure' series – in particular the 'fight scenes' and the rocket's 'countdown' coupled with the Prisoner's dramatic 'escape' – 'Fall Out' subverts those conventions entirely by refusing to let them reach their usual conclusion. As a result, the viewer is given no easy answers to the questions that the series has raised. Even the revelation of Number 1 is shown so quickly that a casual viewer could easily miss it.

The title is as ambiguous as the episode itself – 'Fall Out' implies a conflict or a 'falling out' between individuals. It may suggest that the Prisoner 'falls out' of the Village by escaping. It also can refer to nuclear 'fallout', which may put terrifying implications onto the contents of Number 1's rocket. In a more general sense, 'fallout' has now come to be a metaphorical way of expressing the idea of any kind of 'repercussions' of a cataclysmic event. In the context of the Prisoner's 'parallel text', the episode certainly created a great deal of 'fallout', firstly with angry viewers jamming switchboards by demanding to know what on earth it was all about, and secondly by provoking an endless debate amongst fans of the series.

'Fall Out' is also, in its use of 'hallucinatory' imagery, music and dialogue, clearly influenced by the 'psychedelic' era which was still virtually current whilst it was being made. As a reflection of that era it stands comparison with albums like The Beatles' *Sergeant Pepper* (1967) or Jimi Hendrix's *Electric Ladyland* (1968), or films such as Dennis Hopper's *Easy Rider* (1968). On one level it celebrates 'revolution', first violent, then joyous … The revolution which destroys the Village is achieved by the combination of what the President defined as 'three types of revolt', implying perhaps that any 'revolution' that might overthrow the 'whole earth as the Village' would need to be balanced and be effectively led.

Yet, if in its initial London scenes 'Fall Out' threatens to conclude as a comic, 'anti-establishment' text, this is confounded by the concluding shots, which complete the 'circular' shape of the series (symbolised in the use of so many circular-shaped rooms and objects) as the Prisoner completes the process of Campbell's mythical 'return'. The clear suggestion in the final shots is that the Prisoner's inevitable destination will be that familiar London office, where he is heading to begin the entire process again. Back at his house, the Village hearse is waiting. *The Prisoner* is thus concluded as a 'cyclic' text, implying that the allegorical process it describes is an eternal, universal one. The Prisoner's struggle – that is, the struggle of every one of us to maintain our individuality within society – will always continue.

Part Three
The Prisoner Today

The People Who are Watching
The Prisoner in the Video Age

I wanted to have controversy, arguments, fights, discussions; people in anger waving fists in my face ... has one the right to be an individual? ... I wanted to make people talk about the series. I wanted to make them ask questions, argue and think. More than anything, I believe in the freedom of the individual. The loss of one's individuality is a nightmare. Just watch and you'll find out.
 Patrick McGoohan[1]

PRISONER: We mustn't disappoint them ... the people who are watching.
 From 'A, B and C'.

T he scene in 'Fall Out' where Number 1 is finally revealed is the answer to *The Prisoner*'s 'big question', the moment in which viewers were finally supposed to 'make sense' of the entire story. Yet the revelation is presented in a couple of quick 'flashes' adding up to no more than three seconds. Today, with the benefit of the VCR, it is possible to rewind the episode, 'freeze' the grinning face of McGoohan in the white hooded robe and 'prove' without doubt that Number 1 and the Prisoner really are 'one and the same'. But in 1968 the age of the video recorder was well over a decade into the future. And it is fairly certain that much of the 'outrage'

1 Patrick McGoohan quoted in Max Hora, *The Prisoner of Portmeirion*, 1985, p. 57.

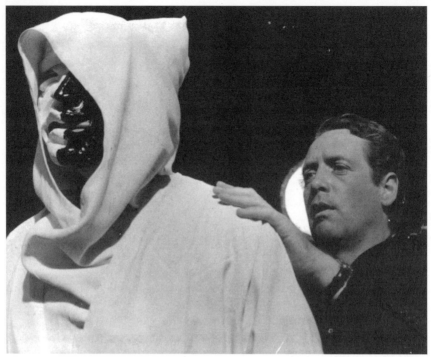

The Prisoner confronts Number 1 in 'Fall Out'

caused by 'Fall Out''s initial screening was stimulated by McGoohan's extreme 'cheek' in making his revelation so difficult to spot. The Daily Telegraph's contemporary review of 'Fall Out' summed up the disillusioned mood of much of the public:

> ... as baffling as its predecessors with no solutions given to any of the problems ... the lasting impression was of a heap of hokum carried off with the smoothness of a confidence trick.[2]

However, the symbolic nature of the revelation itself is such that an 'obvious' presentation could only oversimplify the issues that the revelation is bound to raise. The allegorical notion that Number 1 and the Prisoner are the same is not an easy one to grasp, and its visual presentation forces the viewer into participating in a sudden, fleeting glimpse into the 'Everyman' figure's inner world. In 'Fall Out' McGoohan defies television's status as a 'cool' medium and *forces* the viewer to concentrate. The revelation is inevitably disturbing to viewers attuned to the conventional ritualised melodrama of the TV series. The message it conveys – that we must look inside our own psyches to find the evil in the world – is also profoundly uncom-

2 Review by Peter Knight in *The Daily Telegraph*, February 1968.

fortable for many people. In a 1977 interview McGoohan explained his rationale for making viewers 'work' in what is normally constituted as a 'leisure'-oriented medium:

> That was deliberate. I forgot how many frames; I think there were 52 frames, or something, of the shot when they pulled off the monkey mask. And No. 1's a monkey and then No. 1's himself ... I mean, I could have held it there for a good two minutes and put a subtitle on it saying, 'It's him,' you know ... But I thought I wasn't going to pander to a mentality so low that it couldn't perceive what I was trying to say, so you had to be a little quick to pick it up.[3]

In 1968 the showing of a programme like *The Prisoner* was far more of an 'event' than it ever could be today. Great Britain still only had three television channels, one of which (BBC 2) was firmly dedicated to programmes aimed at (largely elite) cultural minorities. Any programme shown on one of the major channels could thus attract such a large audience as to become a cultural focus for discussion over the nation's breakfast tables and lunch breaks. In launching 'Once Upon A Time' and 'Fall Out' on this truly mass audience, McGoohan found himself in a position to communicate complex, challenging ideas to a wide population. The conditions under which this could be achieved only existed for a relatively brief time before satellites, video and the expansion of channels destroyed the homogeneity of the mass audience. And, as we have seen, McGoohan had managed to gain such a degree of authorial control over his series that almost *anything* he wrote would inevitably be produced and shown – even the surreal, absurdist melodrama of *The Prisoner*'s concluding episodes. The transmission of 'Fall Out' was thus the product of a particular moment in television history, and almost certainly an unrepeatable one.

Despite the complexity of its themes, *The Prisoner* was made as 'instant television'. Though it may anticipate the video age, the differences between how viewers of today comprehend the 'revelation scene' in 'Fall Out' and the way it was perceived when first transmitted are an indication of the whole shift into a 'post-modern' culture brought about by the expansion of electronic forms of communication in the last three decades. The sophistication or 'visual literacy' of viewers has grown considerably since the 1960s. This can clearly be demonstrated by comparing TV adverts of the 1960s, with their largely straightforward messages, to their sophisticated, self-referential equivalents of today. Similarly, the modes of address of TV chat show hosts have been transformed, from the more straightforward approach of presenters like David Frost or Johnny Carson in the 1960s to the 'personal counselling' role of figures like Oprah Whinfrey or Mike Donahue in the 1990s.

3 Transcript of interview with Warner Troyer of Ontario Educational Communications Authority, March 1977.

Perhaps it is in children's TV where the change is most noticeable of all. The patronizing tone of 1950s and 1960s children's TV has been replaced by an attitude which views children as privileged and important consumers. The viewer of the 1960s did not live in the cool, detached age that the children of the 'video age' inhabit. Whilst 1960s series like *The Avengers* are enjoyed by the modern audience largely for their 'camp' value, viewers at the time certainly took Steed and Mrs. Peel's antics far more seriously. Similarly, despite the many surreal sequences, twists of logic and 'unreal' elements throughout *The Prisoner*, many viewers still expected Number 1 to be a conventional villain.

The rapid spread of the VCR in the last two decades has played a key role in changing audience perceptions not only of television but of notions of the time and space surrounding it. The generation that has grown up in the 'video age' has become accustomed to moving images which are no longer tied in the old way to the notion of 'immediacy' that dominated television in its first era. In such a context, *The Prisoner* appears to be an ideal 'video text', as repeated viewings reveal more and more depth in each episode. With a VCR the sequencing of shots and the use of costume, props and lighting can easily be studied. The series can be watched, discussed, reassessed and 'deconstructed' in the viewer's 'own time'.

The coming of the video age has inevitably been accompanied by changes in the kind of value that audiences and critics attach to TV programmes. Once TV programmes can be reviewed they become more easily analysed and attain a value-status more on a par with books. And many television series, of course, are now made with the future prospect of video sales (and thus posterity) in mind. The evolution of a critical canon of 'great works' of television is an inevitable result of this process, and the notion that series like *The Prisoner* can be seen as television 'classics' is already well-advanced. This book is undoubtedly a conscious contribution to such a process, but could never have been written in this form without the use of a VCR.

When examining *The Prisoner* today, it is important to bear in mind the ways in which three decades of the development and expansion of television and global communications have 'reconstituted' television audiences. If, as Marshall McLuhan suggested in the 1960s, television brought about one 'revolution' of consciousness, then the expansion of electronic forms in the years that have followed can certainly be said to have brought about another. A kind of 'Global Village' has undoubtedly taken shape. Communications satellites now beam hundreds of channels across the world, arguably creating a global 'media culture'. Yet that culture is hardly the unitary culture which McLuhan's optimism implied and predicted. A plethora of channels now presents the viewer with a vast choice of entertainment, and as a result audiences – and thus modes of consciousness – have become 'segmented'.

In the multi-channel 'universe' of modern TV, programmes which attract identifiable (and therefore targetable) audiences are bound to be regarded positively by programmers. *The Prisoner* is one series which is likely to find

a perennial audience in constant reruns on satellite stations. This and its wide availability on video have combined to make it a 'product' with a potentially limitless 'shelf life'. The assimilation into 'endless syndication' is part of the process by which a series achieves the accolade of being regarded as 'classic' TV, and the way in which its imagery and themes become absorbed into the discourses of TV is an indication of the self-referential nature of post-modern media culture. As a 'classic' series *The Prisoner* is often referred to in other TV shows, particularly 'TV Quizzes' and retrospective documentaries of the 1960s. It is sometimes alluded to in music programmes, adverts (see Note, Chapter Ten) and even comedies such as a 1995 episode of the British sitcom *Two Point Four Children*, in which the leading male character is seen visiting Portmeirion and being chased by Rover. The makers of such a programme clearly expect their audience to be familiar with *The Prisoner*.

Because of the extraordinary nature of the conditions of its production, it can be argued that the 'influence' of *The Prisoner* on subsequent programmes is questionable. *The Prisoner* was one of the first popular series to challenge the rather simplistic values that had dominated TV series since their inception in the 1950s, and its showing certainly helped to broaden the possibilities of the series as a form. Yet few TV series have attempted to approach the metaphysical and symbolic themes that *The Prisoner* propounded, or have possessed *The Prisoner*'s theatrical and cinematic 'edge'. And very few series have been subject to the kind of 'authorship' that McGoohan imposed. In Britain, the conditions of production have tended to mediate against the creation of long-running series (except for the far cheaper form of the 'soap opera') and the 'mini-series' has become a preferred mode. British series have always had to run on far lower budgets than their US equivalents. With the strong literary bias of British culture, television 'auteurs' such as Dennis Potter, writer of series like *Pennies From Heaven* (1978) and *The Singing Detective* (1986) and Alan Bleasdale, writer of *Boys From The Blackstuff* (1983) and *G.B.H.* (1990), have been given great prominence. Yet the directors of the series – who may in reality have as much creative input as the writers – tend to be have a relatively low public profile. The notion of the writer as 'auteur' of a whole series is one which was unknown until *The Prisoner* was made.

Perhaps the nearest comparison would be with the American series *Twin Peaks* (1990) which was 'co-authored' by the prominent 'surrealist' director David Lynch and leading TV scriptwriter Mark Frost, although in the public mind it was seen very much as Lynch's creation. Certainly the series (several episodes of which were directed by Lynch itself) has the visual stamp and much of the surreal narrative style of Lynch's films like *Blue Velvet* (1986) and *Wild At Heart* (1990). Like McGoohan, Lynch was attempting to subvert the conventions of the major forms of prime-time television, in this case the soap opera and the detective story. Behind the banal surface of life in Lynch's 'typical' American small town lie subtexts of murder, perversion,

corruption, madness and conspiracy. Just as in *The Prisoner* the fans of spy and science fiction series are 'lured' into a symbolic 'dream-landscape', so *Twin Peaks* uses the form of the soap opera to similar effect.

Both series involve their viewers through the continual creations of enigmas and through posing a central question which viewers must wait a long time to find out the answer to. The way the bizarre 'detective' FBI Agent Cooper continually talks to the unknown 'Diane' on his dictaphone recalls similarly enigmatic conversations with *The Prisoner*'s Number 1. Cooper himself – who uses 'Tibetan Buddhist' principles in his detection process – is a thoroughly enigmatic figure, who seems to be naturally drawn to the strange world of *Twin Peaks*. Like the Prisoner, he is taciturn by nature and often appears to be 'keeping secrets' from the viewer. Whilst *The Prisoner* revolves around the question 'Who is Number 1?'. Twin Peaks continually asks 'Who killed Laura Palmer?'. And whilst both questions are answered, the answers themselves beg further questions. We eventually learn that Laura Palmer has been killed by her father, but he has been 'possessed' by a mysterious and quite possibly 'alien' force which is never fully explained.

Twin Peaks can also be compared to *The Prisoner* in its use of surrealism. 'Real life' sequences in the series are intercut with sequences which are clearly stated to be Cooper's dreams. Cooper himself relies on his dreams as part of the detection process. It is possible (as with *The Prisoner*) to postulate that the entire series is its central character's 'dream'. But McGoohan's use of 'dream-images' differs radically from Lynch in that while Lynch, as a true surrealist, produces a narrative which ultimately (and quite deliberately) defies or transcends any identifiable symbolic or moral explanation, McGoohan's surrealism is always used in the service of his allegorical or symbolic structure. And whilst Lynch is ultimately somewhat amoral in his attitudes, McGoohan is, as we have seen, decidedly a moralist, and *The Prisoner* is a profoundly moral work.

The presence of series like *Twin Peaks* and its imitators like *Northern Exposure, American Gothic* and *Eerie, Indiana* certainly indicates the tremendous changes that the TV series has undergone in the years since *The Prisoner* was first shown. In The USA, such long-running shows as *Hill Street Blues, NYPD Blue, Star Trek: The Next Generation* and *Deep Space Nine, Roseanne* and *The Simpsons* have prospered, although the kinds of social issues and thematic concerns which such series raise are far more problematical and complex than those dealt with by mass-audience TV series of the 1960s.

As time passes and *The Prisoner* continues to accrue 'classic' status, it becomes harder and harder for contemporary viewers to comprehend the nature of its impact on its original audience. TV has moved a long way from the immediacy and 'trash culture' of the 1960s which led the BBC to 'wipe' what would now be regarded as priceless footage of The Beatles, Bob Dylan

and the Rolling Stones, little imagining that anything as 'trivial' as pop music could be of interest to future generations. Similarly, at this time the BBC also destroyed many episodes of the cult series *Dr Who* (which has now become a highly popular product on video) due merely to a lack of storage space. The commonest complaint amongst TV viewers at the time was that there were 'too many repeats', implying that all television should be original and immediate. Today we live in a different age, in which popular culture is no longer so undervalued and in which those who grew up with television culture are now coming to dominate the media itself. But it is important when considering such artifacts of that earlier 'era' to bear in mind that, whilst we as modern viewers may be viewing what we perceive as 'art', the great majority of the original audience regarded what they saw seen purely as 'entertainment'. The same might be said for Elizabethan drama or the Victorian novel. Yet if a series like *The Prisoner* were to be made today, it would have a ready-made, segmented 'educated' audience which researchers would have profiled in detail. It would be unlikely to be a mass audience phenomenon and would be immediately classified as a 'cult' show. It would therefore make much less of a *difference* ...

Many Happy Returns
The Prisoner as Cult

In a highly complex society, television has begun to perform one of the oldest, most traditional functions of images: to visualise common myths and to integrate the individual into a social whole.

 Gregor T. Goethals, *The TV Ritual: Worship At The Video Altar*[1]

... the Prisoner has been charged with the most serious breach of social etiquette – total defiance of the elementary laws which sustain our community, questioning the decisions of those who voted to govern us, unhealthy aspects of speech and dress not in accordance with general practice, and the refusal to observe, wear or respond to his number.

 From 'Fall Out'

QUEEN: Not allowed ... the cult of the individual.
 From 'Checkmate'

Over the last thirty years, whilst the apparently 'materialistic' culture of the mass media, as expressed through television, film, pop music and advertising has expanded into ever more profitable markets, the monoliths of organised religion have continued to decline and splinter. Yet the 'market' for religious belief has remained a strong one. The desire to

1 Gregor T. Goethals, *The TV Ritual: Worship At The Video Altar*, p.2.

belong to a group with a shared 'spiritual' outlook remains a very powerful focus for many people. Thus, a wide variety of new religious cults continues to appear, both inside and outside the major faiths. The phenomenon of the 'cult' is hardly a new one, but is one which has gained considerable prominence (and publicity) in recent times.

Modern religious 'cults' may vary tremendously in beliefs and intentions but most coalesce around a charismatic leader (or, as we might say, a 'Number 1') figure such as Bhagwan Shree Rashneesh (Sanyassins), L. Ron Hubbard (Scientologists) or Maharishi Mahesh Yogi (Transcendental Meditation). The beliefs of many of these groups are centred around the ancient teachings of Eastern religions, which are characteristically offered in more palatable forms to 'Westerners'. One of the most common motivations which leads spiritually 'alienated' members of our society join such cults lies in a search for meaningful rituals appropriate to life in a global culture. In a world dominated by the mass media, the socializing function of the major religions has been greatly diminished. And the 'New Age gurus' are well known for their use of mass media forms to spread their messages.

Given that the mass media has appropriated many of the functions that were formerly held by religions, it is perhaps not surprising that the most well known media personalities are referred to as 'icons' and are regarded by their fans as virtually 'divine'. The twentieth-century phenomenon of Stardom has positioned a series of film, television and pop stars as otherwordly, often 'saintly' figures. The way in which the theme of 'martyrdom' has been expounded on by the media in the wake of the premature deaths of stars like Rudolph Valentino, James Dean, Marilyn Monroe, Jimi Hendrix, Elvis Presley and John Lennon (not to mention those of 'TV star' politicians like John and Robert Kennedy and Martin Luther King) exposes the clear survival of the explicitly Christian ethos of the martyr as 'saviour'. Thus the 'cult of Elvis' (which has become so widespread it could almost be termed a 'religion') insists that Presley is still alive somewhere, having, like Jesus, apparently 'risen again'. By presenting its 'heroes' in a way which positions the audience to 'worship' their iconic images, the mass media creates figures who are held in fervent awe by millions of fans. When John Lennon made his infamous comment (which caused a considerable reaction from the fundamentalist right wing in the USA) about The Beatles being 'bigger than Jesus' he was touching on the same theme.

Rogan Taylor, in *The Death and Resurrection Show* (1985)[2] puts forward the view that 'showbusiness' itself is basically a 'religious' ritual and has its origins in the traditions of shamanism that are the oldest known religious structures. He describes the traditional 'path' of the shaman, which involves a descent into the 'underworld', a symbolic 'death', dismemberment and eventual 'resurrection' as the shaman returns to earth with new powers. Such a process is naturally close to Joseph Campbell's 'heroic pattern' as expressed

2 Rogan Taylor, *The Death and Resurrection Show*.

in *The Hero With A Thousand Faces,* and the character of the Prisoner could certainly be said to fulfil many of these 'shamanic functions'. Taylor identifies a number of leading twentieth-century entertainers like Charlie Chaplin, Louis Armstrong, Little Richard, Elvis Presley, Bob Dylan, Jimi Hendrix and John Lennon as modern 'shamans' and the kind of 'devotion' such figures have inspired in their fans gives much support to this idea.

Gregor T. Goethals, in *The T.V. Ritual: Worship At The Video Altar* argues that television communicates on two levels – firstly, that of 'information' and secondly on a deeper level of ritual, or myth – and that television watching is a ritual activity. Despite the coming of the VCR , the 'observance' of regular time slots is one which persists in the video age (which may be why the sense of 'time-shift' in watching 'yesterday's television' is so distinct), perhaps because its ritual nature is so attractive to viewers, who come to assimilate the viewing of particular programmes as part of their daily routine. Goethals cites the presentation of large-scale sporting events as particularly ritualistic and identifies them as modern substitutes for religious sacraments of the past. He states that:[3]

> ... TV has woven a web of myths, furnishing the rhythms, the visual extravaganzas, the pseudo-liturgical seasons that break up the ordinariness of our lives ... its environment of symbols surrounds us all ...

Any assessment of the value of a 'cult' television series must therefore reflect on its 'mythical' status as a feature of its popularity. It must take into account the intensely ritual nature of the experience of TV watching. *The Prisoner* utilises all the key psychological modes of the ritual process. It locates a mystery, or several mysteries, and keeps its audience involved in a continued search for meaning. It frames its mythical world between the iconic imagery of the credit sequence and the Final Bars, and builds to a ritual climax in the final episode where the search for meaning *itself* is questioned. In doing so it excites, puzzles, amuses, frustrates, confuses and ultimately staggers its audience with the ritual power of its discourse.

The phenomenon of the 'cult' TV series is very much a product of the 'video age'. 'Cult' series are distinguished not by having the highest viewing figures but by having the most 'faithful' and 'devoted' fans. With the segmentation of audiences in the modern era, the advertisers who fund commercial TV respond positively to such groups. Though their audiences may be smaller than those for certain soap operas or chat shows, the 'guarantee' of an audience is increasingly valuable. Many 'cult' series have an audience profile which includes a disproportionate number of high earners, and this allows successful 'product placement' to occur in advertising slots. Thus the creation of 'cult shows' is a prominent feature of modern television culture,

3 Gregor T. Goethals, *The T.V. Ritual: Worship At The Video Altar,* p. 142.

and the current conditions of production will encourage further 'cult' series to be made.

The role of the VCR in the creation of 'cult' series has been crucial. Many fans of such series devotedly record each week's episode or buy pre-recorded video tapes. Dedicated fans are also prime consumers for the ever-expanding 'merchandise' related to such series, which range from books and magazines to clothes, games and models of key objects. The use of video means that the episodes can be viewed at any time, and especially at the pre-arranged gatherings, or 'conventions' of fans that are a central unifying factor in such cults. Many 'cult' series are series from the 1950s (such as *Bilko* or *Hancock's Half Hour*) or the 1960s (such as *Dr Who, The Avengers, Star Trek* or *The Twilight Zone*) which had been constantly repeated up to the worldwide spread of the VCR in the 1980s. Others, such as *Twin Peaks, The X-Files* or *Babylon 5* are products of the modern era.

It may be significant that most modern cult series are science fiction series. Science fiction has become the main popular genre through which mythological stories are told. As noted in earlier chapters, the TV series as a form has many qualities, such as its insistent patterns of repetition, which are elements that hark back to traditional, mythical, orally-communicated modes of storytelling. Like the cinema, its need to communicate with the mass audience often involves it in the creation of representative figures which often resemble what Jung called 'archetypes of the collective unconscious'[4] but unlike in the cinema those figures communicate with us more intimately because they appear in our homes on a regular weekly basis; just as, in an earlier era, worshippers in church were regularly presented with familiar religious icons. Mr. Spock in the original *Star Trek*, for example, is an archetypal representation of 'logic', just as the Prisoner is an archetypal representation of 'rebellion'.

'Six Of One', the *Prisoner* 'Appreciation Society' was formed in 1977, initially by three fans in response to a rescreening of the series by ATV Midlands. McGoohan agreed to become honorary 'President' of the society (ironically, perhaps, in view of the key role of 'the President' which features in 'Fall Out'), but he has had no personal involvement. It now has around 2000 members and branches have been founded in France and North America. It produces a range of publications under various names such *Number 6, Alert, Escape* and *The Tally-Ho*, which regularly update members on the latest Prisoner-related news, as well as providing analyses of particular episodes and of specific elements and themes in the series. Members also send in original short stories based on *The Prisoner* or on Prisoner-related themes. The magazines also focus on every conceivable aspect of trivia related to the series, such as exactly where each outside location for the series was situated and how one can obtain a 'lava lamp'. Interviews with various cast members – even those who were in one episode or less – appear.

4 Carl Jung, *The Portable Jung*, p.59.

Humorous cartoons such as the Pnuts series by Tony Reeve are published, which assume considerable knowledge of the series amongst the magazines' readership.

Articles and letters also appear concerned with the series' 'great debates'. Perhaps the most prominent of these is the debate over series order. (See Note 2 to Chapter Two). In his booklet *Prisoner Portmeirion Production*, Six of One's Max Hora includes 30 closely-typed pages of arguments on this topic. Many of these arguments, which focus around identification of dates mentioned in the series and which often rely for 'evidence' on single statements made by characters, represent extremely 'literal' readings of the series by its fans. Hora and many others insist, for example, that 'Dance Of The Dead' should be placed 2nd in the series rather than 8th, mainly because at one point in the episode the Prisoner remarks that 'I'm new here'. The fascination with the issue of series order is an interesting one, however, in that it represents continual attempts by *Prisoner* 'devotees' to 'reconstruct' the text of the series into the shape of a completely consistent and logical continuous story – to force it into the mould, in fact, of a serial rather than a series. Yet, as was argued in Chapter Two, whilst *The Prisoner* may contain elements of the serial form it is basically a series which, apart from its one opening and two concluding episodes, does not have to be watched in a particular order to be followed and understood. And the chaotic conditions of production of the series inevitably meant that there were a number of inconsistencies in the series regarding matters like dates and the time each episode was supposed to take up. But the tendency of 'cult' members to attempt to recreate the series as a logically planned serial parallels the ways in which religious cult members endlessly reinterpret the works of their gurus in a more literalistic way. 'Cult' shows like *The Prisoner* thus come to be regarded as 'sacred texts', with certain 'experts' on the series constituted as their 'priests'.

In its unique location, *The Prisoner* has a distinct advantage over other cult series – fans can actually visit 'the Village' itself . Even though (as we have seen throughout our analysis of the series in Part Two) the greater part of the series is actually filmed in studio sets, the action of the series is always enclosed in its location. Portmeirion is a privately-owned 'Hotel Village' in North Wales which with its unique mixture of global architectural styles is a large tourist attraction in its own right, bringing in more than 100,000 tourists every year, though at the time *The Prisoner* was made, it was considerably less well-known. It has been used as a location for many TV series including *Dr Who* and *Brideshead Revisited*. By visiting Portmeirion, Prisoner fans can truly feel they are in 'the Village'. Portmeirion is thus a natural 'world centre' for the 'cult' of *The Prisoner* and for the Prisoner fan the visit to Portmeirion is certainly a 'pilgrimage'.

Six Of One runs a shop selling Prisoner-related items in 'Number 6's house' at Portmeirion, where budding social rebels can buy a sweatshirt with an image of McGoohan, underneath which they can proudly display the legend: 'I will not be pushed, filed, stamped, indexed, briefed, debriefed or

The Chess Game from *Checkmate* reenacted by Six Of One

numbered'. The society, which enjoys the official support of ITC, produces and distributes many items of Prisoner merchandise such as posters, leaflets, tee shirts, badges, key rings, postcards and maps of 'the Village' – the usual kind of paraphernalia distributed in 'fan networks' by followers of TV shows or pop groups. As well as the Village slogans, the visual elements of the paraphernalia naturally centre around the distinctive Village icons such as Rover, the Butler and the Penny-Farthing. The society also holds an annual convention at Portmeirion, which regularly attracts around 400 people, although McGoohan himself (like Number 1 in the series) is invariably absent from the proceedings. The convention includes discussion groups, tours of 'the Village', special screenings of *Prisoner* and *Danger Man* episodes in cinematic formats, the performance of original *Prisoner*-related plays written by Six Of One members and quiz competitions on *Prisoner* trivia. In 1983 *By Public Demand*, a film in which members acted out a new *Prisoner* story, was shown.

Perhaps the most spectacular features of the conventions – which have given the society much of its reputation for eccentricity – are the regular 're-enactments' of scenes from the series such as the 'human chess game' in 'Checkmate' and the 'election parade' from 'Free For All'. Such re-enactments, which are carried out by fans dressed in *Prisoner* clothes and who carry brightly-coloured 'Village' umbrellas, are undeniably 'ritual' activities; ways in which Prisoner 'followers' can 'testify' to their 'faith' in the series, very much like medieval 'morality plays' in which ordinary people took part in re-enacting the gospel stories. As many authentic objects from the series as possible are assembled – a 'Village' mini-moke gives taxi rides and various weather balloons are set loose in imitation of Rover.

Six Of One has also held 're-enactments' of scenes from the series in other locations. Meetings have been held at the Thatched Barn Hotel in Hertfordshire, which is featured in 'The Girl Who Was Death'; at a disused railway tunnel in Mayfield, Sussex where the 'escape' shots from 'Fall Out' were filmed and at Beachy Head, Sussex, which was featured in 'Many Happy Returns' . In the TV Documentary *The Prisoner* File (1984), members of Six Of One in 'Village' costumes are seen running for a bus on Waterloo Bridge in imitation of the Prisoner and the Butler in the closing montage from 'Fall Out'. The desire to vicariously 'play a part' in cult series is another ritual impulse which can also be seen at *Dr Who* and *Star Trek* conventions, where 'delegates' often appear in costume as characters from the shows. Similarly, at Presley conventions many fans arrive in 'disguise' as a 'fifties' or 'seventies' Elvis and at Dylan conventions fans dress as characters from his songs. Again 'cult' members are engaged in the activity of 'replaying' the 'sacred text'.

As is the case with other 'cult' series like *Star Trek, Dr Who* and *The X-Files*, a number of further 'parallel texts' have been created around the series. A number of novels have been published which attempt to extend the story. The first batch of these were released by New English Library fairly soon after the series was made, to 'cash in' on its initial popularity. In the first, *The Prisoner*, by the internationally known science fiction writer Thomas M. Disch, a 'mystery man' suffering from amnesia wakes up in the Village, where he finds seventeen film canisters, each one containing an episode of the original series. The protagonist gradually recovers his memory and eventually escapes. In *Who Is Number 2?* by David McDaniel (1969) the Prisoner is recaptured and returns to the Village, where he eventually smashes its bureaucratic system. The novel features a sequence in which the Prisoner races his Lotus 7 around a special race track which has now been built in the Village. Hank Stine's *A Day In The Life* (1970) clearly identifies the Prisoner with the figure of John Drake, who is sent on a mission to kill Number 1. All three novels tend to reduce *The Prisoner* to a level of 'pulp fiction' in which the subtleties of the series, not to mention its 'deeper meanings', are avoided.

A more 'authentic' attempt at a Prisoner novel was made by former Six Of One president Roger Langley with his *Think Tank* (1984). Here, the Prisoner, now 67 years old, is recaptured by a 1980s Village and put through considerable mental torture. More recently, a four-part graphic novel, *Shattered Visage* by Dean Motter (1986), is another 'sequel' to the series' events, and features a female heroine who resigns her job to make a solo sea voyage. She is shipwrecked on the shores of the Village where she meets the Prisoner, now an old man and the Village's only inhabitant. The novel concludes in an attack on the Village by paratroopers and the escape of the protagonists. Perhaps in order to justify its more 'literal' presentation of events, it is revealed that the events of 'Fall Out' were the Prisoner's hallucination. *The Prisoner* has also been adapted as the basis of several video games and

a fantasy role-playing text. And in July 1989 the Post Mortem Theatre Company staged a production of 'Once Upon A Time' at the Edinburgh Festival. Significantly, this was produced 'back to back' with a production of Samuel Beckett's *Endgame*, and the two pieces were deliberately linked through elements of text, performance and design.

All such 'parallel texts' are highly controversial amongst the series' followers as they threaten to violate the 'sacredness' of the original text of *The Prisoner*. Yet their existence indicates considerable public hunger for further development of that text. Any 'parallel text' of *The Prisoner* has to maintain extremely high standards of consistency with the original text to achieve any credibility with Prisoner fans. The series itself is so 'complete' as a 'circular text' whose final image is identical to its first one, that the problems of creating a viable 'modern Prisoner' are particularly complex. And the 'secret' of the identity of Number 1 is, of course, already out ...

Since the 1980s various possibilities have been floated of an 'updated' *Prisoner* as a new film or TV series. In January 1995, following the takeover of ITC by Polygram, the possibility of making a cinema film of *The Prisoner* was mooted by Lord Grade. Since then, rumours have persisted of various 'deals' having been made regarding the project, and of McGoohan writing a script for it. Many TV series of the 1960s and 1970s have been remade by Hollywood in recent years, and in many cases these have been 'cult' series such as *Batman, The Fugitive, Star Trek* and *The Twilight Zone*. The presence of the 'cult' audience gives any film a ready-made financial boost, so it is not surprising that such a proposal should be put forward. It will be interesting to see, if such a film is made, what effect this will have on the cult of *The Prisoner*.

There is thus a possibility that *The Prisoner* may gradually evolve from the position of a 'fixed text' of a 17-episode TV series into what John Tulloch and Manuel Alvarado[5] (in a study of *Dr Who*) refer to as an 'unfolding text'- that is, one which continues to expand under the aegis of new authors and directors. *Star Trek* is the most prominent example of such an 'unfolding text'. Like *The Prisoner*, it originally consisted of one 1960s TV series, but has now 'unfolded' into five TV series, seven films and an ever-growing number of novels. To a certain extent the existence of the *Prisoner* novels has already begun this process. It is hardly surprising that 'cult' fans will demand more of their favourite series, yet whether *The Prisoner* is really adaptable as an 'unfolding text' remains to be seen. 'Unfolding texts' naturally have a multiplicity of authors, but such is Patrick McGoohan's identification with *The Prisoner* that any film made without his input would be unlikely to be regarded as 'authentic' by *Prisoner* 'devotees'.

The Prisoner is recognised by many viewers as a landmark in TV history, and its visual icons, such as Rover and the Penny-Farthing, have been parodied on many occasions on television itself, such as in Channel 4's *The*

5 John Tulloch and Manuel Alvarado, *Dr Who: The Unfolding Text*.

Laughing Prisoner (1987) featuring Jools Holland and Stephen Fry. A number of TV adverts have also been inspired by the visual style of the series. Various rock bands have paid tribute over the years, including Iron Maiden, whose album *Powerslave* (1984) includes two songs called *The Prisoner* and *Back In The Village* which feature 'samples' from the Prisoner soundtrack and The Rumor, with their album *Be Seeing You* (1979). In November 1980 the Teenage Filmstars achieved a minor 'indie' hit with their song *I Helped Patrick McGoohan Escape* and in 1988 a dance-track by Taboo called *Number 6* was issued. Video clips for the Siouxsie and the Banshees single *The Passenger* (1986) and Altered Images' *See Those Eyes* (1984) were filmed at Portmeirion, using specifically Prisoner-related imagery. There are also an expanding number of Prisoner information sites on the Internet, providing facts, interviews, statistics, pictures and assorted trivia to *Prisoner* fans.

The cult of *The Prisoner* is inevitably also a 'cult of McGoohan', which positions its creator as a transcendent artistic 'genius'. Yet in the years since the series was made, McGoohan has not featured in an 'authorial' role in any TV series or films, apart from one episode of the American detective series *Columbo* which he directed in the early 1970s. In 1977 he played the role of an eccentric doctor in the short-lived American series *Rafferty*. He has appeared in a few major films in the intervening years, such as Don Siegel's *Escape From Alcatraz* (1979) (where, ironically, he played the role of the Chief Prison Warden) and David Cronenberg's *Scanners* (1981). In 1977 he appeared in the *Prisoner*-influenced *Kings and Desperate Men*, directed by Alexis Kanner (The Kid in 'Living In Harmony' and Number 58 in 'Fall Out'), and in 1996 he received considerable critical acclaim for his Edward I in Mel Gibson's medieval epic *Braveheart*. Almost all of these roles, however, have been supporting roles and only *Braveheart* has been a box-office success. McGoohan has never achieved the major star status in films that he reached in television in the 1960s. The only film he has directed is a now largely forgotten rock and roll musical version of *Othello, Catch My Soul* (1974). It is perhaps one of the strangest enigmas surrounding *The Prisoner* that its creator's reputation as an 'author' rests with *The Prisoner* alone.

In examining *The Prisoner* as a 'cult', it is important to identify the features of the series which make it a focus for such ritualistic activity and have preserved its relevance to contemporary viewers. The increasing resemblance of the 'world' to the 'Village' in terms of the modern prevalence of surveillance and technological 'mind control' (which will be examined in more detail in Chapter Ten) is certainly one stimulus. There is no doubt that many *Prisoner* fans are attracted to the series mainly because of the social messages it contains. Also, as the popularity among fans of Six Of One's re-enactment of the chess game in 'Checkmate' demonstrates, its costumes and imagery are undeniably attractive.

Yet there is inevitably an irony in the notion of any 'cult of *The Prisoner*'. The main message of the series – that individuals must take 'spiritual'

responsibility for themselves – seems to run counter to the very idea of a 'cult' of any kind. In one of the series' most bizarre moments, when the Prisoner attempts to escape from Village guards after (supposedly) winning the 'election' in 'Free For All', he suddenly discovers a group of Villagers in sunglasses, staring devotedly in apparent 'worship' of Rover, the evil 'beast' of the Village.[6] As the Villagers see the Prisoner approach, they turn their heads towards him almost mechanically, as if disturbed whilst entranced by their favourite TV programme. Throughout its 17-week span, *The Prisoner* continues to refer to and parody the 'religious' ritual of TV watching itself. This image in 'Free For All' of the 'brainwashed viewer' is a challenge to whoever watches the series and, in the modern context, a warning to those who might seek to make *The Prisoner* itself an object of 'worship'.

6 In the light of the discussion in this chapter, it is interesting that this brief sequence was not shown in original transmissions of the series but was added for the 1984 broadcast in Britain on Channel 4.

Never Trust a Woman

Sexuality and Gender Relations in The prisoner

> ... each reader, male or female, is constrained and defined within the two positions of sexual difference thus conceived: male hero-human, on the side of the subject; and female-obstacle-boundary-space, on the side of the object.
> Teresa De Lauretis, *Alice Doesn't ... Feminism, Semiotics and Cinema*[1]

> Men look at women. Women watch themselves being looked at. This determines not only relations between men and women but also the relation of women to themselves. The surveyor of woman in herself is male: the surveyed female. Thus she turns herself into an object- and most particularly an object of vision, a 'sight'.
> John Berger, *Ways Of Seeing*[2]

> PRISONER: Never trust a woman, even the four-legged variety.
> From 'Dance Of The Dead'

D uring the last three decades the ever-expanding discourses of modern feminism have been used to 'deconstruct' many literary and filmic texts from the point of view of gender relations. Given the mixture of fear and suspicion with which women in *The Prisoner* appear to be

1 Teresa De Lauretis (1984), *Alice Doesn't: Feminism, Semiotics, Cinema*, p.120.
2 John Berger, *Ways Of Seeing*, p.47.

regarded and the unusual way in which sexuality as a theme is apparently avoided in the series, it may be useful here to add some of those discourses to our overall perspective. Feminist film and media theorists have constructed their critique of the presentation of women and gender relations in popular films from a standpoint first defined in Simone de Beauvoir's pioneering *The Second Sex* (1949).[3] De Beauvoir argued that in a society in which the production of images is male-dominated, man is seen as the embodiment of the 'self' (capable of defining the meaning of his own existence) whilst woman is seen as the 'other' (whose 'meaning' is defined for her by man). Certainly, any examination of major popular 1960s TV series and films would support such an assertion. Even in *The Avengers*, where the leather-clad female co-protagonists Cathy Gale (Honor Blackman) and Emma Peel (Diana Rigg) play aggressively 'male' roles, frequently dispatching villains with their advanced fighting skills, the camera lingers on their lithe bodies in such a way as to provide plentiful erotic stimulation for male viewers. An extreme, but very pertinent example occurs in the episode *A Touch of Brimstone* where Emma Peel, in order to infiltrate a group of political dissidents who have recreated the eighteenth century 'Hellfire Club', appears in one scene in full sado-masochistic leatherwear (including a spiked 'necklace') and fights off her adversaries with a whip.

The feminist perspective on cinematic and televisual texts is largely constructed from the point of view of the audience, and it seeks to identify the differences in ways in which popular films and TV programmes appeal to audiences. In doing so it frequently draws on psychoanalytic theories which focus on the various forms of pleasure which audiences experience through their viewing. Laura Mulvey, in her groundbreaking essay *Visual Pleasure and Narrative Cinema* (1974)[4] states that:

> In a world ordered by sexual imbalance, pleasure in looking has been split between active/male and passive/female ... The determining male gaze projects its fantasy onto the female figure, which is styled accordingly. In their traditional exhibitionist role women are simultaneously looked at and displayed, with their appearance coded for strong visual and erotic impact so that they can be said to connote 'to-be-looked-at-ness'.

Drawing on the work of the Freudian psychoanalyst Jacques Lacan, Mulvey identifies three key psychological features which determine the pleasure of the viewer of mainstream film – 'Identification', Voyeurism' and 'Fetishism'. She points out that the degree and intensity of such pleasure depends on the relative strength of pre-existing psychological patterns that are already at work within viewers, which themselves are the result of the

3 Simone De Beauvoir, *The Second Sex*.
4 Laura Mulvey, *Visual Pleasure and The Narrative Cinema* in *Screen* 16, No. 3 (Autumn 1975) p.11.

dominant male-orientated nature of the form. Viewers identify narcissistically with an idealized figure on screen, and draw pleasure both from a voyeuristic fascination which allows them access to the characters' intimate moments and a fetishistic impulse which emphasises sado-masochistic tendencies. In this context women on screen become idealized 'fantasy objects' and certain parts of their bodies (such as Marilyn Monroe's breasts or Betty Grable's legs) become the object of the camera's fetishism.

According to Mulvey, the pleasure of fetishism is linked to what Lacan identifies as the replacement of a psychological 'lack' in the viewer. Such a 'lack' has been associated with basic psychosexual elements such as castration fear in men and the 'penis-envy' which a 'phallocentric' society installs in women. Thus, fetishistic pleasure in the viewer is often associated with sexual images. However, in our discussion of the relationship between popular genre forms and *The Prisoner* in Chapter One, we have already seen how McGoohan deliberately distanced himself from the fetishistic portrayal of women as 'sex objects' that was so prevalent in the 1960s spy genre by insisting that his character John Drake in *Danger Man* avoid romantic involvements with women and ... *sex and all that rubbish*.[5] This tendency was certainly carried through into *The Prisoner*, where, despite the frequent presence of a female 'lead', the Prisoner himself very rarely appears to have any sexual motivation. Female characters in the series are mostly attired in the standard de-sexualized Village costumes and cinematic and televisual conventions such as 'backlighting', which place artificial emphasis on the beauty of the female 'object', are generally avoided. Though female characters are frequently sent to 'ensnare' the Prisoner, they are used by the Village authorities in attempts to gain his sympathy rather than to get him into bed. Only in 'The Girl Who Was Death' do we encounter a conventionally 'sexy' woman. But the episode is partly a parody of series like *The Avengers*, and Sonia's sadistic streak has deliberate resonances with the character of Emma Peel in episodes like *A Touch of Brimstone*.

In the Village sexuality appears to be almost completely repressed. There is, of course, no privacy in which sexuality might be expressed, as constant surveillance is maintained on everyone. The lack of any 'passion' in the Village is indicative of the general lack of 'permitted' emotions. Only in 'Do Not Forsake Me, Oh My Darling', where the Prisoner's mind is inside another man's body (and he is well away from the Village), does he indulge in a passionate kiss. Given McGoohan's previous strictures on his Danger Man character, it is perhaps significant that the kiss occurs when the Prisoner is being played by another actor. This almost complete 'denial' of sexuality in *The Prisoner* appears to emanate directly from McGoohan himself, indicating an attitude which can almost be described as 'puritanical'. McGoohan himself has stated:[6]

5 Patrick McGoohan quoted in *The Official Prisoner Companion* by Matthew White and Jaffer Ali, p.179 (see Chapter One, note 11).
6 Patrick McGoohan quoted in Six Of One's *Danger Man* magazine (No. 4. 1976), p.9.

I abhor violence and cheap sex we need moral heroes. Every real hero since Jesus Christ has been moral.

As we saw in Chapter 1, the general avoidance of sexuality in the series can be (at least partially) explained by McGoohan's concern that his character be distanced as far as possible from the ultra-misogynist stance of the James Bond-type spy hero. However, it can be argued that the viewer of the series does derive consistent fetishistic pleasure from the series' repetitive use of 'objects' like Rover, the Penny-Farthing or the Butler, the pleasurable recognition of which could be said to compensate for the 'lack' of 'real emotions' in the series.

The Prisoner also deliberately plays with notions of 'voyeurism', although again this is achieved in a strikingly asexual way. All the Prisoner's intimate actions are observed by his captors on their omnipresent screens. In a sense they are watching him 'on television'. And the viewer, of course, is watching them. Stephen Heath[7] has called this the 'totalising security of looking at looking'. The fascination of such a 'double gaze' (memorably explored in Hitchcock's *Rear Window* (1956)) reflects on and questions the entire notion of viewing pleasure, suggesting the viewer's implication in the whole voyeuristic process. But unlike the lascivious hero of *Rear Window*, the viewer of *The Prisoner* receives no sexual gratification. As a mythical hero-figure, the Prisoner himself is certainly idealized. He is portrayed as being brave, resourceful, compassionate, highly intelligent and accomplished in every field of athletic and academic endeavour. As such he is a figure of fantasy identification for the viewer (or, at least, for the male viewer) and although his very 'unreachability' created a certain fascination amongst many female viewers, he is rarely presented as a sexually appealing 'object' His rebellion, unlike that of Winston Smith in *1984*, is never a sexual one.

It is noticeable that in all the three areas Mulvey identifies as being sources of pleasure for viewers, *The Prisoner* steadfastly avoids conventional sexualized codings. It would certainly be inaccurate to accuse the series of any form of objectification of its female characters, who are cast in strong dramatic roles, and are depicted as active rather than passive participants. Several female Number 2's are featured, and the female leads often win key psychological battles against him. As an example, the apparently 'silly girl' Number 58 who is the Prisoner's 'guide' in 'Free For All' is finally revealed as the harsh, mocking figure of the new Number 2. Yet there is no identifiable discourse in *The Prisoner* which suggests that the oppression of women as a group is a particular feature of the Village. In the Village (and by implication, in the modern world) everyone, male or female, is oppressed.

From the first episodes the Village authorities identify the Prisoner's sympathy towards women as an important weakness. *The Prisoner* can certainly be said to have an inbuilt 'gentlemanly' code which often positions him as

7 Stephen Heath, *Questions Of Cinema*, p.120.

being a 'protector' of women or succeeds in engaging his sympathy (if not his desire) for them. The first attempt by the authorities in 'Arrival' to exploit these characteristics, in which his 'maid' breaks down and cries in order to try to inveigle some 'secrets' from him, is relatively crude. Yet later in the same episode his sympathies for, and resultant trust of, the woman he sees in tears at Cobb's funeral is exploited mercilessly. The electropass for the helicopter which the woman supplies him with turns out to be useless. Although she is not a Village 'plant' as such she is successfully manipulated by the authorities. Here, as in later episodes, the Village uses women in attempts to crush the Prisoner's spirit. And although he has tremendous resistance against the various forms of psychological pressure that are put on him by male authority figures, it seems that he has more difficulty in accepting such pressure when it is being applied by women.

In a number of episodes female characters are used to gain the Prisoner's sympathy as part of Village plots to make him 'crack'. He is hoodwinked into a near-romantic affair with the Village 'plant' Nadia in 'The Chimes Of Big Ben', who gives a very convincing display (which we suspect may be more real than she or the authorities intended) of being attracted to him. After this, he naturally regards all women with suspicion. Yet he is still capable of being fooled. In 'Free For All', as in many of the early episodes, the main purpose of the authorities seems to be to break down his psychological resistance. His relationship with Number 58, the young woman who pretends not to speak English and who constantly giggles at everything he says, is particularly strange. The moment at which he learns to say 'Be Seeing You'

A rare ally: Alison in 'The Schizoid Man'

in her language sets off a panic reaction in him. When she is finally revealed as a highly authoritarian Number 2, the positions are reversed – it is the Prisoner who has been 'silly' in accepting her 'act'.

It can certainly be argued that the Village authorities – who have of course prepared a thorough psychological profile in the Prisoner – have correctly identified his 'gentlemanly' attitude towards women as the source of his psychological weakness around them. Such an attitude tends to predispose him to underestimate their capacity for deceiving him. In 'The Schizoid Man' he is betrayed by his 'friend' Alison in a mind-reading' test which has been set up by the Village authorities. Yet Alison is the first really sympathetic

female character we have seen, and she later apologises to him for her deception.

'Dance Of The Dead' is the episode which confronts the issue of gender relations most fully. Here the Village has a female Number 2, a (very harsh and unsympathetic) female Supervisor and the Prisoner is given a female observer. The 'matriarchal' Village authorities then proceed to subject him to perhaps his most harrowing psychological 'torture', which culminates in his 'official death'. No attempt is made in this episode to make him confess his secrets, but the women conspire very successfully to break down his inner strength. The psychologically 'castrated' figure of the Prisoner's friend Roland Walter Dutton is presented to him as the episode's most terrifying symbolic manifestation of spiritual 'death'. Number 2 herself appears at the Village carnival as Peter Pan (traditionally a role played by a woman) and in the scene in which they confront each other on the beach at night her air of sexual ambivalence seems to be particularly threatening to him. It may be that the Prisoner, as a representative of a very male-oriented world, has difficulty accepting the authority of a woman.

In 'Dance Of The Dead' the Prisoner 'adopts' the black female cat – traditionally a symbol of male guilt over feminine sexual power, as in Edgar Allan Poe's story *The Black Cat*, where the cat represents the wife that the protagonist has murdered[8] – and feeds her, which his maid points out is against the rules. Finally, after the mock-trial sequence has resulted in him escaping from a 'lynch mob' Number 2 confronts him and explains that the cat has been hers all along. This sets up associations of witchcraft, with the cat as Number 2's 'familiar'. *The Prisoner*'s use of the misogynist statement that one should 'never trust a woman, even the four-legged variety' is the most evocative indication in the series of how effective the Village women can be in breaking down his spirit. This statement must be seen in the context of the series. In the Village one does not trust anybody – male or female. If women are generally unsympathetically portrayed, then so are men. Yet the apparently 'sexual' nature of the threat he feels in 'Dance Of The Dead' seems to suggest a basic, even irrational, fear of women; and the implied discourse engaged in with the viewer appears to predispose that viewer to be male.

The woman who plays the part of 'the Queen' on the 'human chessboard' in 'Checkmate' is brainwashed and hypnotised by the Village authorities into being 'in love' with the Prisoner. This artificial 'love' is the only kind of emotional attachment we see in the Village. By now, the Prisoner is extremely wary of such tactics, and is very dismissive of her obsession with him. Yet in one scene, when his rejection causes her to break down in tears, he is clearly moved by her plight and concedes to 'liking' her. Later on, however, he is quite prepared to cynically exploit her trust in him by taking away the locket she wears with his picture in because it contains a micro-transmitter. In

8 Edgar Allan Poe, *The Black Cat* in *The Complete Illustrated Stories and Poems*, p. 235.

'Hammer Into Anvil' his adoption of the role of 'avenger' is stimulated by his anger at Number 2's sadistic 'destruction' of a young woman who would rather commit suicide than face the Villager official's torture. What results is a very male battle of wills in which the Prisoner triumphs.

The watchmaker's daughter in 'It's Your Funeral' is another sympathetic female character, yet also one who has been manipulated by the Village into playing their 'game'. At first the Prisoner rejects her approaches when she attempts to obtain his assistance in preventing an assassination plot which she is convinced will result in general reprisals against the population of the Village, but her forthright denunciation of his attitude in doing so helps to convince him that she can be trusted. In 'A Change Of Mind', the Prisoner is attacked both verbally and physically by the 'upstanding ladies' of the Village 'committee'. Later, by reversing a drug dose intended for him, he succeeds in manipulating his female 'observer' Number 86 into actions which help him secure another victory over Number 2. The Village's use of gender relations as one of the 'tools' in its armoury of techniques of mental manipulation suggests on an allegorical level that relations between the sexes is another area which a controlling society uses to dominate and isolate individuals.

The majority of women in the series can be divided into a distinct 'types'. The female authority figures or 'bosses' such as Number 2 and the Supervisor in 'Dance Of The Dead', the steely-voiced technocrat Number 8 who presents the Prisoner's 'activity prognosis' in 'It's Your Funeral' and the leader of the fearsome 'women's committee' in 'A Change Of Mind' clearly represent the authority of the Village and though heavily outnumbered by male authority figures (the Village is quite obviously a 'patriarchy') they all dispense their authority at least as callously and ruthlessly as the men.

Other prominent women in the series, who also work for the Village but disguise themselves in various ways in attempts to gain the Prisoner's sympathy, figure as 'temptresses' who the Village deploys in attempts to exploit what they have identified as his key psychological weakness. The Village 'double agent' Nadia in Chimes, the 'motherly' Mrs. Butterworth in 'Many Happy Returns' and the 'whore with a heart of gold' Cathy in 'Living In Harmony' all exude a certain degree of (somewhat measured) sexuality. Although the Prisoner never responds directly to this, sexual subtexts are certainly present in the ways his relationships with them are depicted. He appears to show genuine affection for Nadia and although his 'romantic tête-à-têtes' with her are really 'covers' for an escape plan, at the end of the episode he seems outraged and hurt by her deception. In 'Many Happy Returns' he appears to place a completely naive trust in Mrs. Butterworth, who although she takes very much a maternal role in looking after and feeding him after the ordeal of his journey on the raft, is clearly seen to 'eye him up' in a rather sexual way. She also insists, in a mildly fetishistic way, on dressing him in her dead husband's clothes. In 'Living In Harmony' Cathy's apparent 'love' for him leads to her 'murder' by the jealous Kid, and

although he barely reciprocates this he chooses to return to Harmony to avenge her death rather than leave town. Cathy's 'temptation' is thus successful (as is that of Mrs. Butterworth) in that by allowing her his sympathy he has weakened his resolve against the Village and has allowed the Village to manipulate his mind.

A number of the women are naive 'dupes', who though they are 'prisoners' rather than 'guardians', are manipulated by the Village controllers into gaining his confidence. In many ways they are more effective agents for the Village than the 'temptresses' because in their own minds they are genuinely on the Prisoner's side. The woman who provides the Prisoner with the electropass for the helicopter in 'Arrival', the 'mind reader' Alison in 'The Schizoid Man', the 'lovestruck' Queen in 'Checkmate' and the watchmaker's daughter in 'It's Your Funeral' are basically sympathetic characters (which is signalled by the fact that none of them are referred to by their numbers). In 'Arrival' the woman has been doubly duped because she has also been convinced of the death of her 'friend' Cobb (in reality another Village 'double agent'). Alison provides a subtly coded 'apology' to the Prisoner for allowing herself to be drawn into the plot against him. The Queen is a rather pathetic, pitiable figure. The watchmaker's daughter finds herself unwittingly drawn into the Village's internal power struggle but earnestly strives to protect the population against reprisals.

Finally, there are the 'innocents' like the maid in 'Arrival', the 'observer' Number 240 in 'Dance Of The Dead' and the woman who commits suicide rather than face the sadistic Number 2 in 'Hammer Into Anvil'. These women are brainwashed victims of the (patriarchal) power of the Village and as such they also gain our sympathy. Number 240 appears very nervous throughout 'Dance Of The Dead' and the Prisoner taunts her cruelly. In 'Hammer Into Anvil' his 'heroic' quest is to avenge the woman's death by destroying her tormentor Number 2. The Prisoner is often protective to women in this way, and in 'Hammer Into Anvil' his revenge transforms him into a male authority figure.

There are few women in the series who are not 'bosses', 'temptresses' 'dupes' or 'innocents'. Yet there are some who undergo transformations from one category to another. Number 86 in 'A Change Of Mind' begins as hard-faced Village technocrat, and thus one of the 'bosses'. But when the Prisoner doses her with the drug intended for him she becomes an innocent 'flower-child'. Finally she plays the role of 'dupe' in reverse when the Prisoner hypnotizes her for her role in his plan to manipulate the Village 'mob'. In 'Free For All' the apparently innocent 'silly girl' Number 58 finally reveals herself as the new Number 2, as does Mrs. Butterworth in 'Many Happy Returns'. In 'Living In Harmony' Cathy is also eventually unveiled as a Village 'boss'. Yet all these transformations remain firmly within established categories.

The Prisoner's avoidance of the conventional, casual sexism of its 1960s TV series counterparts is one of the elements which ensures its continuing relevance to a present day audience. Yet the positioning of women in the

series raises questions which may have been much less obvious at the time of its production. It is significant that in the final two episodes, 'Once Upon A Time' and 'Fall Out', where the allegorical nature of the series is made explicit, no women at all appear. Women do not participate in the 'revolution' in 'Fall Out' and although the Prisoner is taken through all the stages of his life in 'Once Upon A Time', women do not seem to play any of the major roles in his life. It would certainly be accurate to classify women in *The Prisoner* as various forms of 'the other'. That the series is presented as a male-orientated discourse is hardly surprising, in that its main 'auteur' (McGoohan) and its entire team of writers, directors, producers and camera staff are entirely male. Women are portrayed as oppressors ('bosses' or 'temptresses') to be feared , or victims ('dupes' or 'innocents') to be pitied. In their various ways they all represent threats to the Prisoner, and their sexuality is the most unspoken and dangerous threat of all. Any emotional involvement will necessarily compromise the Prisoner's struggle, so he strives to maintain an aloof, detached manner towards them.

From today's standpoint it is certainly possible to challenge the idea that a male hero such as the Prisoner can stand as an allegorical figure representing both males and females. However, *The Prisoner* trades upon allegorical and mythical traditions in which exactly the same assumptions are made; and these traditions embrace the Bible, Shakespeare and the great majority of the literature and culture of western society. Thus, if one questions the Prisoner's 'Everyman' status, one must do the same with Hamlet and Faust. And it is also possible to argue that, as everything in the series is viewed through the Prisoner's perspective, all the characters apart from him, including the males, can be seen as forms of 'the other'. If the females can be classified as 'controllers', 'temptresses', 'dupes' and 'innocents', the male characters can be similarly categorized. As *The Prisoner* is an allegory it is not concerned with the creation of 'character' in the modern, naturalistic sense. In an allegory all characters have representative functions, and therefore tend to fall into stereotyped categories. This is certainly as much true of males as it is of females. Although the avoidance of sexuality itself in the series is one of its most puzzling qualities, its result is to compensate for its undeniably male perspective by making its hero, in an allegorical sense, virtually asexual, and thus – arguably – an 'Everyman' figure who can be identified with by both sexes.

On another level, *The Prisoner* can be seen to be a critique of patriarchal forms of social control. As we have seen, the Village features elements of fascistic and totalitarian methods of manipulating its citizens' minds as well as other means – particularly the all-important stress on the need to 'confess' – which have resonances with the methodologies of the Catholic church. In *The Mass Psychology of Fascism*,[9] Wilhelm Reich states that both Catholicism and fascism considered the suppression of sexuality and of

9 Wilhelm Reich, *The Mass Psychology Of Fascism*.

open, equal relationships to be essential in maintaining their power. Under fascism, deliberately repressed sexual impulses were channeled into 'healthy' athletic and military activities. Such repression is a feature of extreme patriarchal societies. In the Village, there is no possibility whatsoever of equal, open relationships. Every person is 'numbered' to remove their individuality, and all the citizens (except the Prisoner) take part in the 'stage-managed' Village marches and carnivals. The desexualised nature of Village society is made clear in 'Dance Of The Dead', where the carnival dance is thoroughly lifeless and completely sexless. Thus McGoohan's 'avoidance' of sexuality in *The Prisoner* can be seen as a deliberate comment on the psychology of male social control.

The Whole Earth as
The Village
The Prisoner as Prophecy

... hierarchised, continuous and functional surveillance ... enables the disciplinary power to be both absolutely indiscreet, since it is everywhere and always alert, since by its very principle it leaves no zone of shade and constantly supervises the very individuals who are entrusted with the task of supervising; and absolutely 'discreet'; for it functions permanently and largely in silence.
 Michel Foucault[1]

Advertising signs they con
You into thinking you're the one
That can do what's never been done,
That can win what's never been won,
Meantime life outside goes on all around you.
 Bob Dylan, *It's Alright Ma, I'm Only Bleeding*[2]

Hear The Word Of the Lord!
 No 48 in 'Fall Out'

1 Michel Foucault (1975). *Discipline and Punish*, p.176-177.
2 Bob Dylan (1965) from the album *Bringing It All Back Home*. Lyrics quoted from Bob Dylan: Lyrics 1962-85.

The continuing interest in *The Prisoner* some 30 years after it was made owes much to the enduring relevance of its themes. Its depiction of a 'world' in which surveillance is universal, more and more information is held on individuals and ever more subtle forms of social control are practised is even more relevant today than at the time the series was made. *The Prisoner* can thus be seen as a 'prophecy' – an 'inspired' warning of the future. As we saw in Chapter One, the science fiction element of the series is one of its main generic elements. The Village's technology is deliberately portrayed as being futuristic, and the depiction of Village society itself is certainly a warning for the future. Although the series contains many prominent 'sixties' elements, particularly in terms of costume design and visual imagery, direct references to any contemporary events are entirely avoided. The resultant 'timelessness' of the action in the series is an important feature of McGoohan's allegorical design.

Number 2's prediction of the 'whole earth as the Village' in 'The Chimes Of Big Ben' is a key prophetic phrase in *The Prisoner*, which points the viewer towards its allegorical themes. Anyone who has 'grown up' with *The Prisoner* as a constant reference point will have noticed that many of its technologies – such as portable phones, credit cards for money and video surveillance cameras have now become commonplace. As in the Village, the whole of many modern city centres and motorway systems are now constantly surveyed by cameras which record every movement of every individual. This is frequently justified by the authorities as a 'vital' weapon in the 'war' against crime and terrorism.

Surveillance technology is no longer merely the province of the police and secret agents. Like so much else in modern society, it is being 'privatised'. Equipment such as bugging devices which can be placed in telephones or wall sockets is available through mail order. In London's Kensington, a 'Spy Shop' exists where such devices can be purchased quite openly. Industrial 'espionage' is, not surprisingly, big business. The ubiquitous 'all-seeing eye' of the video camera appears not only in public streets but even in small independent shops outside of city centres. Surveillance may no longer be controlled by 'Big Brother', but wherever you go, someone somewhere may 'Be Seeing You'.

'Futuristic' technology: The Prisoner uses a portable phone

Meanwhile, the trend towards ever more complex bureaucratization of administrative and financial institutions continues, and this has been intensified by the computer revolution of the last thirty years. Today, everyone has a 'number' – be it a National Insurance Number or a computerized bank 'pin number' or

Payroll number. The key 'commodity' in the modern world is frequently said to be 'information', which is exactly what the Prisoner is referring to in his most iconic scene of rebellion in the credit sequence as he roars 'You won't get it'. The Village is a society which produces no material goods or food – everything is imported and its main industry is 'information' itself. In that sense the Village resembles countries like Britain today, whose manufacturing base has crumbled – to be replaced by 'service' and 'information' industries – and in which the majority of manufactured products are supplied from cheaper or more efficient overseas markets. The Village also experiments (in 'The General'), with computer technology as a device for the 'mind control' of large populations.

In many ways the Village resembles a modern international corporation. It has its own 'corporate logo' in the Penny-Farthing badge, which appears on all its 'products' (such as the *Village Foods* in 'Many Happy Returns'). Its 'workers' are dressed in costumes which enhance its 'corporate image'. In worldwide corporate chains like MacDonalds and Burger King, fast-food assistants are taught specific 'cheerful' phrases which have been calculated to put the customer in a receptive mood and thus increase profits. Just like the Villagers, their very thought processes have been manipulated by their unknown masters. Dressed in brightly-coloured uniforms, they dispense platitudes which have no real emotional substance. The 'have a good day' language they are taught to use is as soulless and ultimately meaningless as the hollow cliches which the 'Villagers' use as communication or the sickeningly false tones of the Village announcer as she cheerfully rouses the population with her usual 'Good morning everyone … it's a beautiful day'.

In the years since *The Prisoner* was made, consumerism has advanced to the status of an ideology, even a 'religion'. The prevalence of surveillance is largely a response to the need to protect consumer products. The ideology of consumerism, and of the 'consumer society', is expressed most obviously in advertising. In a 1977 interview McGoohan (although undoubtedly indulging in some mischievous humour) makes specific his identification of advertising as one of the major forms of social manipulation used in modern society:[3]

QUESTIONER: Would you say that there is a distinct lack in the rest of the Villagers? Are they soul-less beings?

McGOOHAN: Ah, the majority of them have been sort of brainwashed. Their souls have been brainwashed out of them. Watching too many commercials is what happened to them.

TROYER: I used to think that television commercials were spiritually healthy because they made us sceptical and

3 Patrick McGoohan, interviewed by Warner Troyer for the Ontario Educational Communications Authority, Toronto March 1977.

that that was probably a very good thing to learn early on.

McGOOHAN: Well, they don't make enough people sceptical because if they made enough people sceptical, the people who were made sceptical wouldn't be buying all the junk that they're advertising and then they'd be out of business ...

Ironically, the episodes themselves are constructed in the conventional TV series three-segment mode to fit around the all-important advertising slots, and *The Prisoner*'s imagery has since been used in TV advertisements.[4] Yet perhaps the origin and location on the series in commercial television is quite apt – as the 'world' of the series and the 'world' of advertising culture interact at regular intervals, constantly reminding the viewer of the relationship between the two. In the last 30 years, as corporate culture has encircled the world, advertising has become ever-more prevalent in the mass media and on the streets. Today it is literally inescapable, and its effect is undoubtedly often completely subliminal – when walking down a street, for instance, we may catch a glimpse of an advertisement out of the corner of an eye on a billboard, a bus or a passing car and the image may enter our subconscious. In the field of broadcasting, only the BBC tentatively holds on to its resistance to advertising (although it is particularly adept at advertising its own products). In 'Third World' countries advertising is an even more powerful force, and the possession of certain 'brand name' products often indicates the higher social status of more well-off consumers.

The 'imprisonment' of the soul in the modern world is, in the terms of McGoohan's allegory, an imprisonment in the kind of shallow materialism advocated by advertising and its related discourses. The 'soulless' Villagers of *The Prisoner* are like the 'happy consumers' in the most inane adverts for domestic products such as soap and margarine. who blandly 'testify' to the efficacy of a particular product. The ubiquitous Village slogans such as 'Questions are a Burden to Others, Answers a Prison for Oneself' and 'Humour is the Essence of Democratic Society' are themselves very much like advertising slogans. They are displayed prominently throughout the Village and clearly represent the ideology of the Village's 'corporate culture'. They exhort the Villagers to 'conform' in much the same way as advertising slogans encourage consumers to 'conform' to the lifestyle or image they are selling. If consumerism is the most powerful modern 'religion' and the vast

4 In 1989 Renault produced an advert for their new Renault 21 which was filmed in Portmeirion and based on *The Prisoner*. The slogan used was 'Escape to the Totally New Renault 21'. The 'hero' of the ad, 'Number 21' is seen escaping from the Village in a Rover 21, which Rover fails (naturally) to catch up with. The advertisers claimed that the ad was aimed at 'successful, upwardly mobile 30-somethings', who could remember *The Prisoner* from their student days and that the image being presented was of a car for 'someone doing their own thing'. (Source *Today*, September 18 1989.) The advert cost £250,000 to make (more than three times the budget for individual episodes of *The Prisoner*).

shopping malls which have sprung up in our major cities in the last thirty years are its 'temples', then it is a particularly hollow and 'soulless' religion, whose 'hymns' are the seamless pieces of muzak that fill the air in shopping arcades and supermarkets.

In the last thirty years, economic power in the world has swung away from the state and towards huge international corporations which provide the funding – and therefore dictate the ideological inclinations – of the major political parties. The attaining of political power has become dependent on the creation of a saleable 'image' in precisely the same way as advertisers sell products. Political parties have increasingly turned to advertising agencies to help define their 'corporate' image. They have appointed their own image-makers or 'spin doctors' who define party policy through a strategy of 'image creation'. The increasing reliance of media coverage of politics on the 'soundbite' exactly mimics the use of key slogans to sell products through advertising. So the advertising process has become the central paradigm for the presentation of political issues and personalities. Thus, the allegorical force of an episode like 'Free For All', where the entire election process is manipulated by the 'image makers' of the Village, has only been intensified by the passing of time. Politics in the 'world' has become more and more like politics in the 'Village'.

The entire spectrum of 'right-left' politics has been transformed in the years since the series was made. The 'east-west' confrontation which dominated world politics from 1945 until 1990 has been superseded by a complex set of power struggles often based on ancient nationalistic rivalries, and the political consensus in countries like Britain has shifted dramatically to the right. None of this makes *The Prisoner* any less relevant to the modern viewer, despite the series' apparent grounding in the 'east-west' spy scenario. Although the Village uses forms of social control resembling those which were characteristic of communist countries (such as the 'Maoist' self-criticism' sessions in 'A Change Of Mind') it is far more likely to use the 'western' techniques of behaviourist psychology, chemical therapy, and (in 'The General'), television itself. As we saw in Part Two, the issue of which side of the 'iron curtain' the Village is in becomes increasingly irrelevant as the series develops. While Orwell's vision of a 'Stalinist' world order in *1984* has been outmoded by the rise of modern technology and the mass media, *The Prisoner* continues to grow in relevance. Politicians themselves seem increasingly to resemble the Number 2's of the series – often casually dressed, 'chatty' and apparently 'reasonable' in every way. And like the Number 2's, politicians themselves appear to be increasingly powerless, 'prisoners' themselves, always dependent on the approval of an unknown voice on the end of some portable telephone. It is no co-incidence that the Leo McKern's freed Number 2 in 'Fall Out' heads straight for the Houses of Parliament, where he is obviously accepted as a man of importance.

Yet, like all great works of 'prophecy', *The Prisoner* has a universal dimension which places it outside of chronological time. Its basic message is one which reflects upon the whole of human experience. The forms of social

control it depicts are characteristic not only of the modern age but of the ecclesiastical forms of mental manipulation prevalent in the medieval era and before. In its purest allegorical form, the series reflects a timeless struggle between the Individual and society, and between eternally warring dualistic forces within the Individual. As a prophetic text, *The Prisoner* delivers a warning to modern humanity of the fate that awaits it unless the individuals within it make fundamental inner changes.

The Prisoner's themes focus our attention on the danger that modern mass-media culture will produce a 'soulless' society like the one in the Village, a whole world full of 'dry bones'. Like Ezekiel, McGoohan brings the 'dry bones' to 'life' by showing us the full psychological horror of a society dedicated to the elimination of the 'free spirit'. His warning is essentially the same as that delivered by many other widely misunderstood prophets throughout the ages – that humanity is in constant danger of sacrificing its vitality, of destroying its identity, of losing its soul ...

Be Seeing You ...

Appendix A
The Prisoner episodes

Main Credits

Overall Credits:
Executive Producer: Patrick McGoohan
Producer: David Tomblin
Script Editor (episodes 1 to 12 and episode 16): George Markstein
Theme Music: Ron Grainer
Artistic Director: Jack Shampan
Director Of Photography: Brendan J. Stafford
Made for ITC Productions by Everyman Films Ltd.
Recurring Characters:
The Prisoner (Number 6): Patrick McGoohan
The Butler: Angelo Muscat
The Supervisor: (in episodes 1, 2, 4, 6, 10, 12, 16, 17) Peter Swanwick

The Episodes:

1 – 'Arrival'
Initial UK Transmission Date:
Screenplay: George Markstein and
David Tomblin 1 October 1967
Director: Don Chaffey
Guest Stars:
Guy Doleman: Number 2
George Baker: New Number 2
Paul Eddington: Cobb
Virginia Maskell: Woman

2 – 'The Chimes of Big Ben'
Initial UK Transmission Date:
8 October 1967
Screenplay: Vincent Tilsley
Director: Don Chaffey
Guest Stars:
Leo McKern: Number 2
Nadia Gray: Nadia
Richard Wattis: Fotheringay
Finlay Currie: Old General
Kevin Stoney: The Colonel

3 – 'A, B and C'
Initial UK Transmission Date:
15 October 1967
Screenplay: Anthony Skene
Director: Pat Jackson
Guest Stars:
Colin Gordon: Number 2
Sheila Allen: Number 14
Katherine Kath: Madame Engadine
Peter Bowles: 'A'
Annette Carrell: 'B'

4 – 'Free For All'
Initial UK Transmission Date:
22 October 1967
Screenplay: Patrick McGoohan (as
'Paddy Fitz')
Director: Patrick McGoohan
Guest Stars:
Eric Portman: Number 2
Rachel Herbert: Number 58

5 – 'The Schizoid Man'
Initial UK Transmission Date:
29 October 1967
Screenplay: Terence Feely
Director: Pat Jackson
Guest Stars:
Anton Rodgers: Number 2
Jane Merrow: Alison

6 – 'The General'
Initial UK Transmission Date:
5 November 1967
Screenplay: Lewis Grieffer (as
'Joshua Adam')
Director: Peter Graham Scott
Guest Stars:
Colin Gordon: Number 2
John Castle: Number 12
Peter Howell: The Professor
Betty McDowall: Professor's wife

7 – 'Many Happy Returns'
Initial UK Transmission Date:
12 November 1967
Screenplay: Anthony Skene
Director: Patrick McGoohan (as
'Josef Serf')
Guest Stars:
Georgina Cookson: Mrs.
Butterworth
Donald Sinden: The Colonel
Patrick Cargill: Thorpe

8 – 'Dance of the Dead'
Initial UK Transmission Date:
19 November 1967
Screenplay: Anthony Skene
Director: Don Chaffey
Guest Stars:
Mary Morris: Number 2
Norma West: Number 240
Duncan MacRay: The Doctor
Aubrey Morris: Town Crier

9 – 'Checkmate'
Initial UK Transmission Date:
26 November 1967
Screenplay: Gerald Kelsey
Director: Don Chaffey
Guest Stars:
Peter Wyngarde: Number 2
Ronald Radd: The Rook
Rosalie Crutchley: The Queen
Patricia Jessel: Psychiatrist
George Coulouris: Chessplayer

10 – 'Hammer into Anvil'
Initial UK Transmission Date:
3 December 1967
Screenplay: Vincent Tilsley
Director: Pat Jackson
Guest Stars:
Patrick Cargill: Number 2
Basil Hoskins: Number 14

11 – 'It's Your Funeral'
Initial UK Transmission Date:
10 December 1967
Screenplay: Michael Cramoy
Director: Robert Asher
Guest Stars:
Darren Nesbit: 'new' Number 2
Annette Andre: Watchmaker's
daughter
Martin Miller: Watchmaker
Mark Eden: Number 100
Andre Van Gysengham: 'old'
Number 2

12 – 'A Change of Mind'
Initial UK Transmission Date:
17 December 1967
Screenplay: Roger Parks
Director: Patrick McGoohan (as
'Josef Serf')
Guest Stars:
John Sharp: Number 2
Angela Browne: Number 86

13 – 'Do Not Forsake Me, Oh My
Darling'
Initial UK Transmission Date:
24 December 1967
Screenplay: Vincent Tilsley
Director: Pat Jackson
Guest Stars:
Nigel Stock: The Colonel/The
Prisoner
Clifford Evans: Number 2
Zena Walker: Janet
Hugo Schuster: Seltzman
John Wentworth: Sir Charles

14 – 'Living in Harmony'
Initial UK Transmission Date:
31 December 1967
Screenplay: David Tomblin
Director: David Tomblin
Guest Stars:
Alexis Kanner: The Kid
David Bauer: The Judge
Valerie French: Cathy

15 – 'The Girl who was Death'
Initial UK Transmission Date:
7 January 1968
Screenplay: Terence Feely
Director: David Tomblin
Guest Stars:
Justine Lord: Sonia
Kenneth Griffith: Schnipps

16 – 'Once Upon a Time'
Initial UK Transmission Date:
28 January 1968
Screenplay: Patrick McGoohan
Director: Patrick McGoohan
Guest Stars:
Leo McKern: Number 2

17 – 'Fall Out'
Initial UK Transmission Date:
4 February 1968
Screenplay: Patrick McGoohan
Director: Patrick McGoohan
Guest Stars:
Alexis Kanner: Number 48
Leo McKern: Number 2
Kenneth Griffith: The President

Appendix B
Bibliography and Filmography

The Prisoner on video
The Prisoner (9 vols.) Channel 5 Video.

Books on *The Prisoner*
Carraze, Alain and Oswald, Helene (1990). *The Prisoner: A Televisionary Masterpiece.*
 (Christine Donougher, transl.) London: W.H. Allen & Co.
Rogers, Dave (1989). *The Prisoner and Danger Man.* London: Boxtree.
White, Matthew and Ali, Jaffer (1988). *The Official Prisoner Companion.* London: Sidgwick
 and Jackson.

The Prisoner fiction
Disch, Thomas M (1970). *The Prisoner.* New York: Ace Publishing.
Langley, Roger (1984). *Think Tank.* Colchester: Escape Productions.
Langley, Roger (1986). *When In Rome.* Colchester: Escape Productions.
McDaniel, David (1969). *Who Is Number Two?* New York: Ace Publishing.
Motter, Dean (1988–89). *Shattered Visage.* (graphic novel) D.C. Comics.
Stine, Hank (1970). *The Prisoner: A Day In The Life.* New York: Ace Publishing.

Six Of One publications (short books and pamphlets)
Hora, Max (1987). *Village World.*
Hora, Max (1987). *Portmeirion Prisoner Production.*
Hora, Max (1987). *The Prisoner Of Portmeirion.*
Philibert, Jean-Michel and Cottare, Phillippe (1988). *The Prisoner* (cartoon book).

TV productions on *The Prisoner*
The Prisoner File – Channel 4, 1984 (documentary).
The Laughing Prisoner – Channel 4, 1987 (comedy/music).

Films starring Patrick McGoohan
The Dam Busters (dir. Michael Anderson 1954) GB.
Passage Home (dir. Roy Baker 1955) GB.
The Warriors (dir. Henry Levin 1955) GB.
I Am a Camera (dir. Henry Cornelius 1955) GB.
Zarak (dir. Terence Young 1956) GB.

Hell Drivers (dir. Cy Endfield 1957) GB.
The Gypsy and the Gentleman (dir. Joseph Losey 1958) GB.
Nor the Moon by Night (aka *Elephant Gun*) (dir. Ken Annakin 1958) GB.
All Night Long (dir. Basil Dearden 1961) GB.
Two Living, One Dead (dir. Anthony Asquith 1961) Sweden.
Life for Ruth (aka Walk in the Shadow) (dir. Basil Dearden 1962) GB.
The Quare Fellow (dir. Arthur Dreyfuss 1962) Ireland.
The Three Lives of Thomasina (dir. Don Chaffey 1963) USA.
Dr Syn, Alias the Scarecrow (dir. James Neilson 1963) GB.
Ice Station Zebra (dir. John Sturges 1967) USA.
The Moonshine War (dir. Richard Quine 1970) USA.
Mary Queen of Scots (dir. Charles Jarrott 1971) GB.
Silver Streak (dir. Arthur Hiller 1976) USA.
Kings and Desperate Men (dir. Alexis Kanner 1978) Canada.
Brass Target (dir. John Hough 1978) USA.
Escape from Alcatraz (dir. Don Siegel 1979) USA.
Scanners (dir. David Cronenberg 1980) Canada.
Baby: Secret of the Lost Legend (dir. B.W.L. Norton 1985) USA.
Braveheart (dir. Mel Gibson 1995) USA.

Films directed by Patrick McGoohan
Catch My Soul (1974) USA.

TV movies starring Patrick McGoohan
Koroshi 1966.
The Man in the Iron Mask 1976.
The Hard Way 1980.
Three Sovereigns for Sarah 1985.
Jamaica Inn 1982.
Of Pure Blood 1986.

TV series starring Patrick McGoohan
Danger Man (aka Secret Agent) (ITC 1960–68) GB.
The Prisoner (Everyman/ITC 1967–68) GB.
Rafferty (Warners 1977) USA.

Appearances in other TV series:
The Vise (1953). GB – episode *Gift from Heaven*.
You are There (1954). GB – episode *The Fall of Parnell*.
The Makepeace Sage (1956). GB – episode *Ruthless Destiny*.
Columbo. USA – episodes: By *Dawn's Early Light* (1974),
Identity Crisis (1975), *Agenda for Murder* (1989–1990).

TV plays starring Patrick McGoohan (all GB)
All My Sons 1955.
Disturbance 1957.
The Little World 1957.
The Third Miracle 1957.
Rest in Violence 1958.
This Day in Fear 1958.
The Iron Harp 1959.
Terminus Number One 1959.
Brand 1959.
The Greatest Man in the World 1959.
The Big Knife 1959.
A Dead Secret 1961.
The Prisoner 1962 (not related to the later series).
Shadow of a Pale Horse 1962.

The Man Out There 1964.
Sergeant Musgrave's Dance 1964.

Other works cited

Allen, Robert C. (ed.) (1992) *Channels of Discourse Reassembled: Television And Contemporary Criticism.* (2nd edition) London: Routledge.

Alvarado, Manuel; Buscombe, Edward and Collins, Richard (eds) (1993). *The 'Screen Education' Reader: Cinema, TV, Culture.* London: Macmillan.

Andrew, J. Dudley (1976). *The Major Film Theories: An Introduction.* London: Oxford University Press.

Barthes, Roland (1957). *Mythologies.* Paris: Editions Seuil.

Barthes, Roland (1977 ed.). *Image/Music/Text* (transl. Stephen Heath) London: Fontana.

Beckett, Samuel (1952). *Waiting For Godot.* Paris: Minuit.

Beckett, Samuel (1958). *Endgame.* London: Faber.

Berger, John (1972). *Ways Of Seeing.* Harmondsworth: Penguin.

Bunyan, John (1678). *The Pilgrim's Progress.* London: Cassell.

Campbell, Joseph (1949). *The Hero With A Thousand Faces.* New Jersey: Princeton University Press.

Cervantes, Miguel de (1906 edition). *Don Quixote.* London: Dent.

Clifford, Gay (1974). *The Transformations Of Allegory.* London and Boston: Routledge.

Cornell, Paul; Day, Martin and Topping, Keith (1995). *The New Trek Programme Guide.* London: Virgin.

De Beauvoir, Simone (1949). *The Second Sex.* Paris: Gallimard.

De Lauretis, Teresa (1984). *Alice Doesn't ... Feminism, Semiotics, Cinema.* Bloomington: Indiana University Press.

Derrida, Jacques (1972). *Positions.* Paris: Minuit.

Dylan, Bob (1987). *Lyrics 1962–1985.* London: Jonathan Cape.

Eco, Umberto (1979). *The Role Of The Reader: Explorations In The Semiotics Of Texts.* Bloomington: Indiana University Press.

Eco, Umberto (1990). *The Limits Of Interpretation.* Bloomington: Indiana University Press.

Eliot, T.S. (1925). *The Hollow Men* in *The Complete Poems and Plays of T. S. Eliot.* (1969 edition). London: Faber and Faber.

Erens, Patricia (ed.) (1990). *Issues In Feminist Film Criticism.* Bloomington: Indiana: University Press.

Fiske, John and Hartley, John (1978). *Reading Television.* London: Methuen.

Foucault, Michel (1975). *Surveiller et Punir: Naissance de la Prison.* Gallimard: Paris. (*Discipline and Punish* transl. A. Sheridan (1977), New York: Pantheon).

Foucault, Michel (1976). *Histoire de la Sexualite: Vol. 1.* Paris: Gallimard. (*The History Of Sexuality, Vol. 1: An Introduction,* transl. R. Hurley (1980), New York: Vintage/Random House.

Fowler, Roger (1986). *Linguistic Criticism.* London: Oxford University Press.

Goethe, Johann Wolfgang von (1966). *Poems Of Goethe: A Selection.* London/New York: Cambridge University Press.

Goethals, Gregor T (1981). *The TV Ritual: Worship At The Video Altar.* Boston: Beacon.

Gruen, Arno (1988). *The Betrayal Of The Self: The Fear Of Autonomy In Men and Women* (transl. Hildegarde and Hunter Hannum) New York: Grove Press

Hartley, John (1992). *Tele-ology: Studies In Television.* London: Routledge

Heath, Stephen (1981). *Questions Of Cinema.* London: Macmillan

Huxley, Aldous (1932). *Brave New World.* London: Chatto and Windus

Ibsen, Henrik (1915). *Brand.* (transl. F. E. Garrett) London: Dent.

Jung, Carl (1936). *The Portable Jung.* Harmondsworth: Penguin. (1972 edition).

Kafka, Franz (1925). *Der Prozess (The Trial)* Munich: Kurt Wolff Verlag. (Willa and Edwin Muir, transl 1930) London: Martin Secker and Warburg.

Kafka, Franz (1926). *Das Schloss (The Castle)* Munich: Kurt Wolff Verlag. (Transl.. as above)

Kaplan, E. Ann (ed.) (1990). *Psychoanalysis and Cinema.* New York/London: Routledge.

Kesey, Ken (1962). *One Flew Over The Cuckoo's Nest.* New York/London: Methuen

Lapsley, Robert and Westlake, Michael (1988). *Film Theory: An Introduction.* Manchester: Manchester University Press.

Le Carré, John (1990 edition). *The Spy Who Came In From The Cold.* London: Hodder and Stoughton.

Langland (1967 edition.) *Piers Plowman*. London: Arnold.

Lodge, David (1981). *Working With Structuralism: Essays and Reviews on Nineteenth and Twentieth Century Literature*. London/ New York: Routledge

McLuhan, Marshall (1964). *Understanding Media*. London/ New York: Routledge.

McLuhan, Marshall and Fiore, Quentin (1967). *The Medium Is The Massage*. New York: Bantam

Melville, Herman (1992 edition). *Moby-Dick*. Ware, Herts: Wordsworth Classics.

Metz, Christian (1974) *Film Language: A Semiotics of The Cinema*. (transl. Michael Taylor). New York: Oxford University Press.

Mulvey, Laura (1975). *Visual Pleasure And The Narrative Cinema* in *Screen* 16, No. 3. (Autumn 1975).

Newcomb, Horace (ed.) (1994). *Television: The Critical View*. London: Oxford University Press.

The New English Bible (1970 edition). London: Collins.

Nietzsche, Friedrich (1889).*Gotzen-Dammerung* (*Twilight of The Idols*). (R.J. Hollingdale, transl. 1968) Harmondsworth: Penguin.

Orwell, George (1945). *Animal Farm: A Fairy Story*. Harmondsworth: Penguin.

Orwell, George (1949). *1984*. London: Secker and Warburg.

Ovid (1984 edition). *Metamorphoses*. London: Heinemann.

Pearce, Lynne (1991). *Woman/Image/Text: Readings In Pre-Raphaelite Art and Culture*. Hemel Hempstead: Harvester Wheatsheaf.

Poe, Edgar Allan (1988 edition). *Collected Stories and Poems*. London: Octopus.

Propp, Vladimir (1968 edition). *Morphology Of The Russian Folktale*. Texas: University of Texas Press.

Shakespeare, William (1947 edition).*The Complete Works*. London: Oxford University Press.

Shea, Robert and Wilson, Robert Anton (1975). *The 'Illuminatus' Trilogy: The Eye In The Pyramid*, The Golden Apple, *Leviathan*. New York: Dell.

Swift, Jonathan (1726). *Gulliver's Travels*. Harmondsworth: Penguin.(1967 edition).

Swift, Jonathan (1739). *The Tale Of A Tub*. London: Bathhurst.

Taylor, Rogan (1985). *The Death And Resurrection Show: From Shaman To Superstar*. London: Blond.

Tulloch, John and Alvarado, Manuel (1983). *Doctor Who: The Unfolding Text*. London: Macmillan.

Williams, Raymond (1974). *Television: Technology and Cultural Form*. London: Fontana/Collins.

Films referred to in the text

Aladdin (dir. John Musker/Ron Clements 1992) USA.

Batman (dir. Tim Burton 1989) USA.

Blade Runner (dir. Ridley Scott 1982) USA.

Blue Velvet (dir. David Lynch 1986) USA.

Brazil (dir. Terry Gilliam 1985) GB.

Dr No (dir. Terence Young 1962) GB.

Easy Rider (dir. Dennis Hopper 1969) USA.

A Fistful Of Dollars (dir. Sergio Leone 1964) Italy/Germany/Spain.

For A Few Dollars More (dir. Sergio Leone 1965) Italy.

Frankenstein (dir. James Whale 1931) USA.

From Russia With Love (dir. Terence Young 1963).GB.

The Good, The Bad And The Ugly (dir. Sergio Leone 1966) Italy.

High Noon (dir. Fred Zinneman 1952) USA.

Home Alone (dir. Chris Columbus 1990) USA.

If... (dir. Lindsay Anderson 1968) GB.

Jason And The Argonauts (dir. Don Chaffey 1963) GB.

Jaws (dir. Steven Spielberg 1975) USA.

Jurassic Park (dir. Steven Spielberg 1993) USA.

Lawrence Of Arabia (dir. David Lean 1962) GB.

Metropolis (dir. Fritz Lang 1926) Germany.

North By Northwest (dir. Alfred Hitchcock 1959) USA.

Raiders Of The Lost Ark (dir. Steven Spielberg 1982) USA.

Rebel Without A Cause (dir. Nicholas Ray 1956) USA.

Rear Window (dir. Alfred Hitchcock 1956) USA.
Snow White and The Seven Dwarfs (dir. Walt Disney 1937) USA.
Star Wars (dir. George Lucas 1977) USA.
The Terminator (dir. James Cameron 1984) USA.
Thunderball (dir. Terence Young 1965) GB.
Wild At Heart (dir. David Lynch 1990) USA.
The Wild One (dir. Laslo Benedek 1953) USA.
You Only Live Twice (dir. Lewis Gilbert 1967) GB.

TV programmes referred to in the text
The Adventures of Robin Hood (ITC/Sapphire 1955–59) GB.
American Gothic (CBS/Gothic Renaissance from 1995).
The Avengers (ATV 1960–69) GB.
Babylon 5 (Warner Bros./Prime Time from 1994) USA.
The Baron (ITC 1965) GB.
Bilko (aka *The Phil Silvers Show, You'll Never Get Rich*) (CBS 1955–59) USA.
Bonanza (NBC 1969–61) USA.
Boys From The Blackstuff (BBC 1983) GB.
The Champions (ITC 1967–68) GB.
Department S (ATV 1970) GB.
Dr Who (BBC from 1963) GB.
Eerie, Indiana (ABC 1991–93) USA.
The Fugitive (ABC 1963–66) USA.
G.B.H. (BBC 1991) GB.
Gunsmoke (CBS 1955–75) USA.
Hancock's Half Hour (aka Hancock) (BBC 1956–62) GB.
Hill Street Blues (NBC/MTM 1980–87) USA.
Jason King (ATV 1971) GB.
The Man From UNCLE (NBC/MGM 1964–67) USA.
Mission Impossible (CBS/Paramount 1966–72) USA.
Northern Exposure (CBS/Universal 1990–95) USA.
NYPD Blue (ABC, from 1993) USA.
The Outer Limits (ABC/UA/Daystar 1963–63) USA.
Pennies From Heaven (BBC 1978) GB.
Perry Mason (CBS/Paisano 1957–65) USA.
Roseanne (ABC/Casey Werner from 1988)
Rumpole Of The Bailey (Thames/Euston 1978–81) GB.
The Saint (ITC 1962–68) GB.
The Simpsons (Fox/Gracie Films from 1989) USA.
The Singing Detective (BBC 1986). GB.
Star Trek (NBC/Desilu/Paramount 1966–69) USA.
Star Trek: The Next Generation (Paramount 1987–94) USA.
Star Trek: Deep Space Nine (Paramount from 1993) USA.
Star Trek: Voyager (Paramount from 1994) USA.
Twin Peaks (Propaganda Films 1990) USA.
The Twilight Zone (CBS/Cayuga 1959–63) USA.
Two Point Four Children (BBC 1991–94) GB.
The Untouchables (ABC/Desilu 1959–62) USA.
The X-Files (Fox from 1993) USA.

Other relevant sources
Ang, Ien (1985). *Watching Dallas: Soap Opera and The Melodramatic Imagination*. London: Methuen.
Barthes, Roland (1968). *Elements Of Semiology*. (transl. Annette Cavers and Colin Smith). New York: Hill and Wang.
Bazin, Andre (1967). *What Is Cinema?* Berkeley: University Of California Press.
Bennett, Tony and Woollacott (1987). *Bond and Beyond: The Political Career of A Popular Hero*. London: Macmillan.
Black, Peter (1972). *The Mirror In The Corner: People's Television*. London: Hutchinson.

Bordwell, David and Thompson, Kristin (1979). *Film Art: An Introduction. Reading,* Massachusetts: Addison-Wesley.

Cook, Pam (ed.) (1985). *The Cinema Book.* London: BFI Publications.

Collins, Richard (1990). *Television: Policy and Culture.* London: Unwin Hyman.

Eco, Umberto (1977). *A Theory Of Semiotics*: London: Macmillan.

Ellis, John (1982). *Visible Fictions: Cinema, TV, Video.* London: Routledge.

Fiske, John (1982). *Introduction To Communication Studies.* London: Methuen.

Gallanter, Marc (1989). *Cults: Faith, Healing and Coercion.* New York: Oxford University Press.

Gane, Mike (1991). *Baudrillard's Bestiary: Baudrillard and Culture.* London/ New York: Routledge.

Gitling, Todd (ed.) (1968). *Watching Television.* New York: Pantheon.

Halliwell, Leslie and Purser, Philip (1979). *Halliwell's Teleguide.* London: Granada.

Hardy. Phil (1986). *The Encyclopaedia of Science Fiction Movies.* London: Octopus.

Hawkes, Terence (1977). *Structuralism and Semiotics.* London: Methuen.

Kuhn, Annette (1985). *The Power Of The Image: Essays on Representation and Sexuality.* London and New York: Routledge.

Lofficier, Jean-Marc (1991). *Dr Who, The Terrestrial Index.* London: Virgin.

Masterman, Len (ed.) (1984). *Television Mythologies: Stars, Shows and Signs.* London: Comedia.

Metz, Christian (1972). *Psychoanalysis and Cinema* (English transl. Celia Britton, John Hopkins, Anthony Williams) London: Macmillan.

Monaco, James (1977). *How To Read A Film.* Oxford: Oxford University Press.

Mulvey, Laura (1996). *Fetishism and Curiosity.* London: B.F.I.

Skeggs, Beverley (ed.) (1995). *Feminist Cultural Theory: Process and Production.* Manchester: Manchester University Press.

Smith, Anthony (ed.) (1995). *Television: An International History.* Oxford: Oxford University Press.

Stacey, Jackie (1994). *Star Gazing: Hollywood Cinema and Female Spectatorship.* New York/London: Routledge.

Toolan, Michael J. (1988). *Narrative: A Critical Linguistic Introduction.* London/ New York: Routledge.

Willis, Roy (ed.) (1993) *World Mythology: The Illustrated Guide.* London/New York/Sydney/Toronto: BCA.

Wyver, John (1989) *The Moving Image: An International History of Film, Television and Video.* Oxford/New York: Basil Blackwell /B.F.I. Publishing.

Zolla, Elemire (1981). *Archetypes.* London: George Allen and Unwin.

Index

225